SPECULUM LAPIDUM

MAGIC IN HISTORY

General Editors

RICHARD KIECKHEFER AND CLAIRE FANGER

The Magic in History series explores the role magic and the occult have played in
European culture, religion, science, and politics. Titles in the series bring the
resources of cultural, literary, and social history to bear on the history of the magic
arts, and they contribute to an understanding of why the theory and practice of magic
have elicited fascination at every level of European society. Volumes include both
editions of important texts and significant new research in the field.

A complete list of books in this series is located at the back of this volume.

MAGIC *in* HISTORY

SPECULUM LAPIDUM

A RENAISSANCE TREATISE ON THE HEALING
PROPERTIES OF GEMSTONES

CAMILLO LEONARDI

TRANSLATED WITH AN INTRODUCTION
BY LILIANA LEOPARDI

THE PENNSYLVANIA STATE UNIVERSITY PRESS
UNIVERSITY PARK, PENNSYLVANIA

Library of Congress Cataloging-in-Publication Data

Names: Leonardi, Camillo, active 1502, author. | Leopardi, Liliana, translator, writer of introduction.
Title: Speculum lapidum : a Renaissance treatise on the healing properties of gemstones / Camillo Leonardi ; translated with an introduction by Liliana Leopardi.
Other titles: Speculum lapidum. English | Magic in history.
Description: University Park, Pennsylvania : The Pennsylvania State University Press, [2023] | Series: Magic in history | Includes bibliographical references and index.
Summary: "A full translation of Camillo Leonardi's Speculum Lapidum, with an introduction and annotations. Examines the role that medical astrology and astral magic played in the life of an Italian court in the early modern period"—Provided by publisher.
Identifiers: LCCN 2023012983 | ISBN 9780271095394 (cloth)
Subjects: LCSH: Precious stones—Early works to 1800. | Gems—Religious aspects—Early works to 1800. | Lapidaries (Medieval literature)—Early works to 1800. | Medicine, Magic, mystic, and spagiric—Early works to 1800.
Classification: LCC BF1442.P74 L46513 2023 | DDC 133/.25538—dc23/eng/20230504
LC record available at https://lccn.loc.gov/2023012983

Copyright © 2023 Liliana Leopardi
All rights reserved
Printed in the United States of America
Published by The Pennsylvania State University Press,
University Park, PA 16802–1003

The Pennsylvania State University Press is a member of the Association of University Presses.

It is the policy of The Pennsylvania State University Press to use acid-free paper. Publications on uncoated stock satisfy the minimum requirements of American National Standard for Information Sciences—Permanence of Paper for Printed Library Material, ANSI Z39.48–1992.

A Mio Padre
Che mi ha dato le ali per volare

CONTENTS

LIST OF ILLUSTRATIONS / ix

ACKNOWLEDGMENTS / xi

A NOTE ON THE TRANSLATION / xiii

Introduction: "Whatever Jewels Mother Earth Brings Forth for the Uses of Men . . ."; Camillo Leonardi and the Tradition of Magical/Astrological Lapidaries / 1

THE MIRROR OF STONES

 Epistle and Proemium / 39

 Book 1 / 46

 Book 2 / 59

 Book 3 / 113

Appendix: Lodovico Dolce's *Libri Tre*; An Unacknowledged Appropriation of the *Speculum Lapidum* / 145

NOTES / 147

BIBLIOGRAPHY / 197

INDEX / 211

ILLUSTRATIONS

1. Camillo Leonardi's commemorative tombstone / 11
2. Detail of Camillo Leonardi's commemorative tombstone / 11
3. *Hortus sanitatis*, 1516 edition / 31
4. Entry for the dyacodos stone, *Hortus sanitatis*, 1516 edition / 32
5. Frontispiece to Camillo Leonardi, *Speculum Lapidum* (Venice: Baptistam Sessa, 1502) / 37

ACKNOWLEDGMENTS

This book would have not been possible without the generous help of numerous librarians and archivists in Italy and in the United States. I am particularly indebted to Rose Tozer, senior librarian, and Paula Rucinski, library manager (retired), at the Gemological Institute of America, Carlsbad, California. They were indefatigable in providing me with all the resources I was seeking.

Luciano Baffioni Venturi, independent scholar and history connoisseur of Pesaro, was unstinting in sharing his knowledge, his work, and his remarkable hospitality. His guidance through the Pesaro archives was essential to the project.

The writing and editing of the introduction presented a formidable task: it would not have been possible without the close reading and constant encouragement of my partner, Aaron W. Hughes. I am ever so grateful for his generosity and critical eye.

Finally, I would also like to thank Penn State University Press editor Ellie Goodman for her shepherding of the project, and the two anonymous readers who provided me with helpful comments. Their constructive interventions made this a much better work. Last but not least, I would like to thank Nicholas Taylor, Laura Reed-Morrisson, and Alex J. Ramos for their impressive and patient editing of the volume.

All problems and shortcomings of the present work are my own responsibility.

NOTE ON THE TRANSLATION

The following translation of Camillo Leonardi's *Speculum Lapidum* uses the 1502 edition of Giovan Battista Sessa.[1] Given the advent of COVID-19 in March 2020, I was unable to compare various 1533 editions to the original 1502 edition. The reader should know that some 1533 editions feature the following additional sections inserted at the end of book 3: "Excerpts of Solomon's Lapidary from the Book of the Angel Ragiel" and "On Draconite as per Chapter 4 of Albertus Magnus' De Mineralibus."

Companions on the journey included the Perseus online Latin reference, a faithful copy of the Campanini and Carboni *Latin to English/Italian to Latin Dictionary*, and a very old but ever so useful copy of Cappelli's *Dictionary of Latin Abbreviations*.[2] While I consulted Lecouteux's and Monfort's work on volumes 2 and 3 of the *Speculum Lapidum*, I believed it important to engage with the text directly.[3] I have endeavored to translate Leonardi's language as faithfully as possible with the aim of preserving the work's original tone and conceptual implications. Rather than translate the word *virtus/tis* with the more appropriate English word "property," for example, I have opted to use the word "virtue," which retains something of the original Latin word as well as connotations that attribute to the stones strength, excellence, and worth.

The translation also engaged in a close comparison of Leonardi's original text with Lodovico Dolce's translation/appropriation and the partial English translation executed by an anonymous translator in 1750. I have detailed in the footnotes when and where both Dolce and the anonymous translator misunderstood, dropped, or added words.

INTRODUCTION

"WHATEVER JEWELS MOTHER EARTH BRINGS FORTH
FOR THE USES OF MEN . . ."

Camillo Leonardi and the Tradition of Magical/Astrological Lapidaries

The lapidary—a genre that discusses the natural, manifest, and occult (in the sense of hidden) properties of precious and semiprecious stones as well as of their graven images and applications—testifies to the medieval and early modern periods' great interest in the magical properties of gems. Such properties—*proprietas, vis, virtus,* or *natura*—were usually considered to be an aspect of natural magic, because they were believed to derive from both the natural elements and the occult properties of a stone's matter in addition to the influence of zodiacal powers associated with the planets, stars, and other celestial bodies.[1]

The *lapidarium* (from the Latin *lapis,* stone) was a popular genre of the medieval and Renaissance periods. Late nineteenth- and early twentieth-century English scholarship, though, largely ignored this genre.[2] Paul Studer and Joan Evans's 1924 work on Anglo-Norman lapidaries notwithstanding, it was only in the 1960s that these important primary sources began to receive closer attention.[3] Dorothy Wyckoff's 1967 translation of Albertus Magnus's (ca. 1200–1280) *Book of Minerals (De mineralibus)* represented an important step in expanding our understanding of lapidaries.[4] Though the 2007 edition of Isidore of Seville's (ca. 560–636 CE) *Etymologies* by Barney, Lewis, Beach, and Berghof and Attrell and Porreca's 2019 study and translation of the *Picatrix* are important correctives, much work remains to be done.[5]

A similar pattern of scholarship—late nineteenth- and early twentieth-century studies generally overlooking the subject followed by a burgeoning interest in the 1950s and 1960s, before more systematic efforts in the last twenty years—may be noted for the study of the engraved gems to which both the classical world and the early modern period attributed magical properties. This

was especially the case within the discipline of art history. Indeed, we can trace the general state of disregard in such circles to Winckelmann's 1764 framing of Greco-Roman art solely within the confines of a rational, sublime aesthetic.[6] As a result, many ancient, medieval, and Renaissance gems once appreciated for their magical properties were often neglected and largely uncatalogued in major European collections, since they were seen to be of little aesthetic value. Even scholarly interest in the subject is relatively recent. Only after Bonner published his 1950 study of ancient magical amulets and talismans did scholars begin to pay closer attention to this class of objects.[7] Bonner's work was followed, in 1964, by Delatte and Derchain's study of ancient magical gemstones held at the Bibliothèque nationale in Paris.[8] Attilio Mastrocinque has written extensively on ancient gems, while Simone Michel, Peter Zazoff, and Hilde Zazoff cataloged those of the British Museum.[9] The team behind the Campbell Bonner Magical Gems Database, launched in 2010, wants to go so far as to make the entire corpus of magical gems available online.[10]

The present volume contributes to the scholarly discourse on lapidaries and gems to expand our range of known primary sources. The ultimate aim is to better understand lapidaries and the gems and jewels that Renaissance individuals collected and used. Unfortunately, if and when we talk about the hidden properties of stones, the overwhelming tendency has been to consult "great" texts, such as those of the medieval bishop Marbode of Rennes (ca. 1035–1123) or the Renaissance philosopher Marsilio Ficino (1433–1499). What follows, by contrast, offers a lesser-known treatise but one no less important for examining the place, role, and function of stones, gems, and jewels in Renaissance society. Camillo Leonardi's (second half of the fifteenth century to first half of the sixteenth century) magnum opus *The Mirror of Stones* (*Speculum Lapidum*, 1502) was a bestseller in its day, offering a glimpse of the use of magical rings within a medical practice governed by astrological notions, according to which the signs of the zodiac and the planets ruled different parts of the human body and therefore its various illnesses.[11] Unlocking the hidden connections between these promised health and prosperity. Such a study also helps us appreciate that the magical properties and aesthetic qualities of rings were intrinsically intertwined.

Encyclopedic in scope—summarizing as it does all classical and medieval sources on the healing properties of stones (lithotherapy)—Leonardi's *Mirror of Stones* is often cited but has never been fully translated into English. Carla de Bellis briefly examined it in her 1985 study published in the Italian language and, more recently, Claude Lecouteux and Anne Monfort annotated and translated the third volume into French.[12] Following the lead of de Bellis, the treatise is surely deserving of attention, if for no other reason than it provides a

convenient summary of previous texts. But more than a summary, the treatise also allows us to investigate the role of medical astrology and astral magic in the life of an Italian court in the early modern period. Furthermore, the third volume features a discussion of engravers who would have been the author's contemporaries, thereby contextualizing images of astral magic within up-to-date notions of artistic practice.

The historians Lecouteux and Monfort focus primarily on Leonardi's list of astrological images, providing a close comparison of each one to its most likely earlier source (e.g., ancient lapidaries attributed to Ragiel/Raziel, Thetel/Tethel/Chael, and King Solomon).[13] Unlike their study, however, what follows provides a much better sense of the range of sources the author used and is attuned to the broader context in which he advocated for the use of precious and semiprecious stones. In terms of the history of art, Leonardi's work shows us the deep-rooted connections between magic and artistic production.

Since heavenly influences governed a variety of activities—from the political appointments of military generals to the medical choice of appropriate potions—this treatise helps us better understand how Renaissance thinkers, and the communities for which they wrote, conceptualized the complex relationships between stones, the images engraved on them, and the planets and other astral bodies. The wearing of rings with stones, whether engraved or not, served a number of purposes. The rings could be used for adornment as well as for healing and protection from all sorts of misadventures, from poison to illnesses to curses.

It is safe to say, then, that *The Mirror of Stones*, as a classic example of the genre of lapidaries, is concerned with medical and astral magic.[14] As Signorini and Azzolini have suggested, experienced physicians commonly made use of magical amulets and talismans.[15] While the physician-astrologer, as Azzolini argues, might at first appear to be a minor professional figure, he can actually facilitate our understanding of practices of natural magic and astrology at Italian courts.

The Genre of *Lapidaria*

The lapidary genre has remained relatively constant since antiquity, with most examples discussing the natural, manifest, and occult virtues of each stone as well as their applications. However, the works' form and content could vary. Stones listed included gemstones, minerals, fossilized materials, animal products, and stones of mythical origins. The descriptions and properties of those stones reputed to have both manifest and occult aspects often verged on the

4 SPECULUM LAPIDUM

fantastical. The doctrine of signatures—the idea that God had marked certain properties in them—suggested some of the stones' uses.[16] Stones with vivid red colors (e.g., hematite or red coral), for example, were believed to be suitable for the stanching of blood. Occult properties instead required learned knowledge, though such properties, on occasion, could be easily recognized. The classic example was the power of certain minerals to attract others, known today as the phenomenon of magnetism.

It is possible to distinguish three types of lapidaries.[17] The first type is mineralogical or scientific, that is, lapidaries that generally eschew references to magic, such as the works of Theophrastus (ca. 371–ca. 287 BCE), Pliny (23/24–79 CE), and Dioscorides (ca. 40–90 CE). The second type of lapidary is magical or astrological. Such lapidaries emphasize magic, from charms to talismans to incantations, and include Damigeron's (second-century BCE) *De virtutibus lapidem* (The virtues of stones) and the *Kyranides* (or *Cyranides*, a collection of magico-medical texts compiled sometime in the fourth century CE). The third type of lapidary may be called Christian symbolic or allegorical. In these works, stones are associated with religious symbolism of both Christian and Jewish origins, such as the *De duodecim gemmis* (On the twelve gems) by Saint Epiphanius (ca. 315–420 CE), bishop of Constantia in Cyprus.[18]

Although all medieval and early modern lapidaries were influenced by Greek sources, direct connections between antiquity and the Renaissance are clear only in the first type, the scientific or mineralogical lapidary. Astrological lapidaries were reintroduced to the West through Arab sources. The Christian symbolic lapidaries reveal only distant echoes of their Greek origins. Sometimes the differences among the three types are rather slight, as was the case in antiquity. This is true as well for Leonardi's *Mirror of Stones*. Encompassing both mineralogical and magical aspects, the text securely straddles the first and second categories. It discusses the mineralogical formation of a stone, its magical and occult properties, and the astrological and magical images that could be engraved on it to better capture all manner of heavenly influences.

Magical Elements in Lapidaries

Even though many ancient references to the medical properties of stones are considered to be scientific (e.g., the works of Hippocrates, Theophrastus, Dioscorides, Galen, and Pliny), there still were allusions to magic. For example, we read of the importance of rituals when it comes to the handling of certain plants only with the left hand. In the case of Dioscorides's *De materia medica*, some stones are said to be useful not only in the making of potions to be ingested but

also as medical amulets to be worn on the body. Moreover, an analysis of Pliny's sources, though difficult to reconstruct because of their fragmentary nature, reveals both magical and scientific antecedents.[19] One such source, that of Xenocrates (396–314 BCE)—also known to Arab authors, whose citations correspond with those of Pliny[20]—is believed to be behind Pliny's idea that diamonds may be dissolved in the blood of a goat.[21] According to some of these Arab authors, Xenocrates also described the therapeutic use of "eagle stones" for pregnant women, something repeated virtually in almost all lapidaries of the medieval and early modern period. Xenocrates is also credited with numerous other beliefs: that Egyptian galactic whitens cloth; that hematite halts the flux of blood, eases urine retention, and protects against snake venom; that the Indian red crystal possessed its own light; that the emerald was useful against poisons, leprosy, women's illnesses, snakebites, and illnesses of the eye; and that hyacinth placed in the mouth could detect poison in wine.

Pliny also mentioned a certain Babylonian named Zachalis, believed to be a Chaldean, who attributed to stones the virtue of influencing human destiny.[22] Pliny might have also been aware of the work of the third-century BCE Neopythagorean Bolus of Mendes on universal sympathies. The latter was thought to have popularized theories of natural virtues of stones in relationship with the cosmos and thus possibly influenced Pliny's conception of sympathetic correspondences.

Such scientific lapidaries were known and cited throughout the medieval and early modern period. However, it is those Hellenistic lapidaries that emphasized magic—from charms and talismans, to incantations, and conjurations—that captured the imagination of medieval and Renaissance readers. Within this context astrological lapidaries, which were even more syncretic in nature, reveal multiple influences. A stone's power could just as easily be attributed to its ratio of the four elements as to its planetary influences. The engraving of specific images on stones, such as specific zodiacal signs or symbols, could either further enhance an item's powers or bestow new capabilities. We see this, for example, in astromedical treatises such as the *Sacred Book of Hermes to Asclepius* (first to fourth century CE).[23]

Although at first glance the range of marvelous properties in such treatises might appear varied, David Pingree subdivides magical astrological lapidaries into three categories. First are those texts that discuss the magical power inherent to the stone itself (e.g., those of Pliny, Isidore of Seville, Damigeron Evax, and Marbode—all sources that Leonardi used). Second are those texts that considered stones and engraved images as equally important to the functioning of the stone through ritual activation (e.g., texts such as the one attributed to Thetel, Tethel, or Techel, which Leonardi also referenced). Third, and finally, are

those texts in which engraved stones derived their power directly from planets, stars, and constellations (e.g., the composite text scholars refer to as the "Techel/Azareus Complex").[24] Such subdivision is certainly more reflective of our contemporary scholarly needs than any historical taxonomy, and many texts resist such tidy distinction. Indeed, as we shall see, Leonardi was interested in the occult magical powers of stones in addition to those produced by graven images inscribed on them.

Leonardi was certainly aware of the idea that images on stones could confer new, non-intrinsic properties. This proved to be a problem. If the marvelous properties of stones were not simply the result of their natural elements, but could also be imposed by images on them, one risked entering the problematic realm of ceremonial or "addressative" magic—that is, magic in which spoken words were used to activate images.[25] Hence it became necessary to distinguish between licit and illicit images. If stones without graven images or symbols could generally be considered natural (today referred to as amulets), engraved stones (today referred to as talismans) presented a much more problematic category.

Lecouteux is therefore correct in proposing that in trying to distinguish amulets from talismans, what we really must pay attention to are medieval and early modern notions of the licit and illicit use of these objects. By stating that "amulets are licit; talismans are superstitious and illicit," he reminds us that premodern writers were engaged in establishing whether the use of any amulets or talismans was appropriate for a good Christian.[26]

Not every scholar, though, agrees with Lecouteux's proposed distinctions. Though late nineteenth-century and early twentieth-century scholarship often used these terms interchangeably, it is now customary to distinguish between them and to further distinguish between licit and illicit talismanic images.[27] In the 1980s, David Pingree argued that talismans and amulets could be differentiated according to material—amulets in stone and talismans in metals—and by the type of ritual that activated the image. Thus an amulet could be said to be "a stone of inherent supernatural powers that may be engraved and/or consecrated, and that is either used as a seal or worn as a phylactery."[28] In contrast, a talisman was "an image either made of metal (though sometimes of wax, or even mud, is used) in the round or engraved on a metal plate, over which image a ceremony or incantations and suffumigations is performed in order to induce a spirt to enter the talisman and to endow it with power."[29] Brian Copenhaver, however, has suggested the difference between the two was whether an image was engraved on any material.[30] According to him, amulets were stones or any object hung from the neck or worn on the body, without sign or image, but believed to have wondrous powers; a talisman was engraved with artificial marks, either image or word.

Nicolas Weill-Parot goes even further and argues for the distinction between licit and illicit talismanic images on the basis of the distinction made by the unknown medieval author of the *Speculum astronomiae* (*The Mirror of Astronomy*, ca. 1260), whom he calls Magister Speculi.[31] Licit astrological talismans, on this reading, would not only bear images of the specific astrological configuration but derive their powers solely from the stars, not from demons.[32] Furthermore, the astrological aspects of such licit talismans "does not reside in the shape of these images . . . but in the conditions under which they are made, i.e. under the appropriate constellations."[33] Such talismans may be referred to simply as *imagines*. Illicit talismans, instead, could be of two types: the first, images requiring suffumigations (e.g., the use of incense) and invocations for their activation; and the second, images requiring "the inscription of characters and the oral exorcism by means of certain names."[34] This second type of talisman usually bore inscriptions with various characters (Hebrew, Greek, Arab, Latin), which—according to al-Kindī's (ca. 800–870s) *De radiis*—were meant to influence and control men, animals, and the natural elements.

To complicate matters, though, by the beginning of the fifteenth century a number of Italian authors, including Antonio da Montolmo (ca. late 1300s to early 1400s) and Giorgio Anselmi (1385–1450), began using the concept of licit talismans, or astrological images, as a shielding word that concealed addressative magic practices or any ritual activity involved in their construction.[35] The misappropriation of the label "astrological images" thus renders ambiguous contemporary classifications of licit and illicit talismanic images. If ambiguity were a characteristic of Renaissance magic, as already pointed out by Zambelli, Leonardi certainly exploited it, particularly in book 3, where he lists all sorts of talismans or "astrological images" that implied aspects of addressative magic.[36]

However ambiguous the matter became by the fifteenth century, Weill-Parot points out a fundamental element used by medieval and early modern writers in their assessment of a licit versus illicit use of an object—that is, its ritual preparation, including invocations of a demonic power. In this sense, an amulet was mostly a protective object involving no invocations, but an illicit talisman manipulated the universe's energies through rituals and invocations.

The demonic potential of illicit talismans was recognized early in the history of the Christian church. The first Christian condemnations of astrology and magic, and thus of engraved images with characters, were issued in 363–64 CE during the regional synod in Laodicea (Phrygia Pacatiana in modern Turkey) and followed by Augustine of Hippo's (354–430 CE) own condemnation.[37] Augustine sanctioned the use of stones of wondrous properties as long as they bore no marks, images, or signs of any kind, since the presence of occult properties in material things could only be the result of God's will. Thanks to such

early condemnations, by the eleventh century a great many of the lapidaries in circulation studiously avoided any mention of astrological images or ceremonial magic. Bishop Marbode of Renne's *De lapidibus* (ca. 1090) is perhaps the best known of such texts.

Marbode's text drew heavily from the acceptable preexisting lapidary tradition. This included texts such as Damigeron/Evax's *De lapidibus* (second century BCE), a fictive epistle directed to the emperor Tiberius by a certain Evax, king of Arabia. Although Damigeron traced his knowledge back to the ancient Egyptians, the contents of the epistle were acceptable to medieval writers like Marbode because the ultimate source of a stone's property could easily be attributed to God. The text was translated from the Greek into Latin in the fifth century and became widely popular both in the medieval and the early modern period. The incipit is quoted in countless manuals.[38] Even those authors who did not consult Damigeron directly still could quote him through Marbode.

Marbode's notion of the planets' influence as "natural" was further articulated by William of Auvergne (bishop of Paris, 1228–49). He reiterated that using engraved talismans was demonic and illicit, whereas no evil could come to those who believed that the inherent properties of a stone were influenced by the planets. The planets were natural bodies and as such under direct divine control; no evil spirit could reside within them.[39] Not every writer subscribed to such a benign notion of the universe, however. The problem of images engraved or drawn on any material endowed with occult properties continued to occupy writers and thinkers of the thirteenth and fourteenth century. For Albertus Magnus (ca. 1200–1280 CE) it was possible to accept the use of talismans (licit astrological images, or *imagines astronomicae*), as described in works such as Thābit ibn Qurra's *De imaginibus*, because these texts reflected William of Auvergne's notion of benevolent cosmological influences.[40]

However, the notion of *imagines astronomicae*, according to Weill-Parot, was probably not of Albertus's own making but introduced by the previously cited anonymous author of the *Speculum astronomiae* (ca. 1260).[41] As mentioned above, the latter envisioned licit talismans that derived their power from the planets and stars rather than spirits. Thus licit engraved images or astrological images could be considered acceptable, as long as no invocations had been used—that is, there was no addressative ritual magic involved. Albertus, in accepting this notion, discussed images to be engraved on stones at a propitious time, such as when specific constellations governing the wished-for celestial influence were in the most favorable position. Such licit astrological images could be considered a component of natural magic, for the image received its properties from the celestial element, which was created by God. If the Magister Speculi introduced the notion of licit talismanic images, it was the popularity

of Albertus's treatise that ensured its widespread reception. Four hundred years after its conception, Albertus Magnus's *De mineralibus* (*Book of Minerals*) was the fundamental text that Leonardi relied on to craft his own treatise.

In juxtaposition, Thomas Aquinas (1225–1274) in his *Summa theologica* argued that planetary influences were not always so benign, since he believed the planets could be inhabited by evil spirits.[42] The practice of wearing talismans was singled out as especially problematic.[43] Subsequent writers continued to struggle with the question of whether the planets and stars could indeed fall under demonological influences. If William of Auvergne presented what Page calls an orthodox cosmological model, others envisioned powerful planetary demons that could influence all sorts of human activities.[44]

This aversion to the use of astrological talismans mirrors the difficulty of defining and describing magic. Medieval and Renaissance critics of magic often tried to group alchemy and astrology with other black magic practices, such as necromancy or the summoning of dead spirits.[45] When they did not go that far, they tried to keep alchemy and astrology as distinct forms of natural magic. Definitions of magic, natural magic, and necromantic magic—including all their subcategories—varied from century to century, from geographical location to location, and were deeply shaped by political and social forces.[46]

This problem persists today. There is, in fact, little scholarly consensus on the definition of magic and the phenomena it is meant to encompass (from amulets to conjuration, from exorcism to incantation, from sorcery to potions). Anthropologists, social historians, and intellectual historians often pursue differing categories of semantic analysis and thus often reach disparate conclusions. Such critics have long looked at notions of magic in opposition to those of science or religion and have addressed epistemological issues within the framework of magic's rationality. It is for this reason that we are using the term *magic* as understood in reference to those properties—*proprietas, vis, virtus,* or *natura*— that operate in the world or that affect the world through the use of astrological images or talismans.

Historically, we witness some of these problems of definition in Marsilio Ficino's *De vita libri tres* (1480), a treatise that envisioned magic as a practice grounded in Neoplatonism and Hermeticism and went on to influence ideas of ritual magic in fifteenth-century Italy.[47] Because Ficino saw himself as both a magus and a philosopher, it is difficult to assess whether his notion of astrological images and natural magic were purely intellectual or whether he engaged in the practice of magic rituals.[48] Yet it seems clear that Ficino is yet another representative of the Italian tradition of physician-astrologers who authored texts advocating the use of astrological images in the context of medical practice.[49]

Throughout the medieval period, we witness numerous magical texts pseudo-epigraphically attributed to ancient authorities such as the biblical King Solomon or the legendary Hellenistic author Hermes Trismegistus, thereby giving texts a revelatory source.[50] It is only in late fourteenth-century Italy that we begin to witness authors using their real names, such as Antonio da Montolmo[51] (ca. late 1300s–early 1400s) and Cecco d'Ascoli (1257–1327).[52] However, such claims of authorship continued to remain fraught with peril well into the seventeenth century. Cecco d'Ascoli, for example, was ultimately executed for his beliefs, and even the great Marsilio Ficino—writing some 250 year later—was forced to repudiate his *De vita*.[53]

For these reasons, Leonardi styles himself as a mere collector of hallowed knowledge, as opposed to one of its creators. He frequently uses the word *magic* but never defines it. He uses even more frequently the formulaic expression "if you find an image of . . ." to avoid charges of active talismanic manufacture.

Most talismanic images that Leonardi describes—he calls them *imagines* or seals, as other earlier and contemporary writers do—were meant to be worn as rings, not hung from the neck. Rings, then, not only were markers of one's social class but also functioned as the conduit between wearer and heavenly forces.[54] They evoked an aesthetic response while simultaneously signaling a range of other possibilities that included social status, political allegiance, and belief in magic.[55] Similarly, the lapidary text makes sense when situated against a broader historical social and intellectual context. In fifteenth- and sixteenth-century Italy lapidaries were usually produced in a courtly setting, by a physician or philosopher who meant to address a learned reader for whom notions of magic were not disconnected from everyday life experiences, but instead were instead imbedded in a daily practice of medical welfare.

Camillo Leonardi

Although little is known about the Renaissance physician and astrologer Camillo Leonardi, author of the *Speculum Lapidum*—including the dates of his birth and death—it is still possible to outline a biographical sketch from a few secure elements and a number of tangential ones.[56] As his commemorative tombstone reads, he was from Pesaro and lived there for the majority of his life (figs. 1 and 2). The city at the time was an important cultural center on the Adriatic coast of the Marche region. As per his wishes, he was interred with his wife and his brothers in the former church of San Francesco d'Assisi, now known as the Santuario di Santa Maria delle Grazie.[57] Although the marker does not mention his date of birth or death, he was probably born in or near Pesaro in the second half of the fifteenth century and died sometime around 1532.[58]

Fig. 1 Camillo Leonardi's commemorative tombstone, Santuario di Santa Maria delle Grazie, Pesaro. Photo: author.

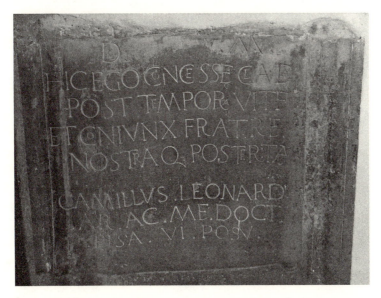

Fig. 2 Detail of Camillo Leonardi's commemorative tombstone, Santuario di Santa Maria delle Grazie, Pesaro. Photo: author.

As far as his immediate family is concerned, Camillo Leonardi—whose first name also appears as Camillus, and his last name as Lunardi, Leonardus, and de Leonardis—was the son of Stefano Leonardi and a certain Cicella.[59] We also know that he had a daughter by the name of Basilia (or Basilea) who married another physician from Pesaro, Francesco Arduini. An eighteenth-century transcription of original documents states that he was granted a medical degree in Padua on September 7, 1471.[60] Given the date of the degree and the rough time frame of his death, he must have been born sometime around 1450 and thus died in his mid- to late eighties. According to his own account, he studied in Padua with Gaetano da Thiene (1387–1465), a physician and professor of natural philosophy.[61] In book 1, chapter 5, Leonardi refers to him as his teacher ("praeceptore meo"), as well as an eminent philosopher and absolute authority of our times ("summo philosopho ac nostris temporibus monarcha").[62] Considering that Gaetano da Thiene died in 1465 and that Leonardi did not receive his degree until 1471, he must have met his teacher very early on in his university studies. Even if Leonardi frequented the lessons of Gaetano da Thiene only for a brief time, it is not surprising that he cited him as his *praeceptor*, as the latter's fame alone would have been sufficient for Leonardi to claim to have been his pupil. Upon completion of his studies, he returned to Pesaro, where he became one of the official court physicians, first to Costanzo Sforza and his son Giovanni, and then to their successor, Cesare Borgia, duke of Valentinois, who conquered Pesaro in 1500. Cesare, who was the illegitimate son of the Spanish cardinal Rodrigo Borgia, later Pope Alexander VI, lost the duchy a mere three years later upon his father's death, at which point Giovanni Sforza returned to power. Leonardi managed to keep his role as court physician, and upon Giovanni's death in 1519 he continued as court physician to the new lord, Francesco Maria I delle Rovere.

Leonardi started writing the *Speculum Lapidum* under Sforza rule and originally intended it for Giovanni, but then adapted it and dedicated it to Cesare Borgia, under whose rule it was published.[63] In book 1, chapter 5, Leonardi describes the type of marble found in Cesare's study—most likely the same space Giovanni had used—stating that a similar kind could also be seen in the church of San Marco and throughout Rome. Beyond the author's suggestion of his proximity to the ruler, the reference is interesting because it might also indicate that Leonardi had traveled to or sojourned in Venice and Rome. Venice would have been a day's journey from Padua, and it is likely that Leonardi would have undertaken just such a journey during his student years. It is not necessary, though, to imagine Leonardi traveling through Italy to expand his interests and intellectual preparation, for his writings confirm that he actively participated in the rich and varied intellectual life of the Pesaro

court, both under the Sforza and the Borgia princes. The city had been a vibrant center of scholarly life since the early fifteenth century thanks to the numerous humanists the Sforza had invited to court. It is there that Leonardi met the Tuscan humanist and military captain Lorenzo Bonincontri, a key figure in understanding Leonardi's preparation and knowledge on the subject of lapidary medicine, medicinal amulets, talismans, and astral magic. While de Bellis had already noted the importance of Bonincontri on Leonardi, it is worth closely examining the connection, for it is through the former's intellectual background and output, which are better known to us, that we may gain insight into Leonardi's own intellectual interests.[64]

Leonardi and Bonincontri

The Italian astrologer and physician Lorenzo Bonincontri (1410–1491?) lived in Pesaro from 1479 to 1483 at the express invitation of the city's ruler, Costanzo Sforza. Exiled from Florence in 1432 because of his involvement with San Miniato's revolt against the Florentines, Bonincontri eventually settled in Naples around 1450 and remained there until 1475. At the Aragonese court, a veritable crucible of humanists, philosophers, and scholars interested in astrology, Bonincontri became deeply involved in the discipline. This was not an unusual interest for Italian humanists of the first decade of the fifteenth century, especially given Poggio Bracciolini's (1380–1459) rediscovery of Manilius's *Astronomicon* in 1416–17.[65] Copies of the manuscript soon circulated throughout Italy, one of which was owned by none other than Giovanni Pontano (ca. 1426–1503), one of the most interesting humanists active at the Neapolitan court.[66] Pontano's own interest in astrology led him to translate into Latin Ptolemy's second-century CE *Tetrabiblos* (Four books), a work that would become one of the most popular and consulted works of classical astrology after it was printed in 1535. Given Bonincontri's and Pontano's close friendship—Pontano called Bonincontri *familiares meus* (my relative, in the sense of family, a close family member)—we can assume the Neapolitan humanist spurred Bonincontri's interest in astrology. We know, for example, that Pontano loaned him his copy of the *Astronomicon*, which the latter then copied in his own hand. Bonincontri's interest in the astrological sciences seems to have been further driven by the fact that his wife and two of his three children perished during a virulent outbreak of the plague in 1458, which he blamed on the negative influence of two comets. Knowledge of such subjects would enable him to predict—and possibly prevent—such tragedies. In these years, Bonincontri began to write the *De rebus coelestibus* as well as a commentary on Manilius's *Astronomicon*, the *De rebus naturalibus et*

divinis.[67] He worked on this commentary alongside Tolomeo Gallina (active in the fifteenth century), a well-known astrologer from Catania who was the author of a *De rebus astrologicis* and had also been one of Giovanni Pontano's astrology teachers. Once he was allowed to return to Florence in 1475, Bonincontri became a close friend of Ficino, who called him *familiares*, just as Pontano had done in Naples, and referred to him with a clever play on words as *poeta astronomicus, astronomusque poeticus* (a poet astronomer and an astronomer poet).[68] By 1484, Bonincontri was active in Rome, had been admitted to the Accademia Pomponiana, and held the astrological professorship in the Studium Urbis at the express invitation of Pope Sixtus IV.

Bonincontri maintained numerous contacts with important figures of the time. In addition to Pontano and Marsilio Ficino, these included Cardinal Raffaele Riario, Cardinal Ascanio Sforza, and Pope Sixtus IV. Between 1478 and 1483–84 he brought all the knowledge accumulated in Naples and Florence, along with his important humanist connections, to the city of Pesaro, where he served as the official court astrologer, first to Costanzo Sforza and then to his son Giovanni.

The Sforzas' passion for and belief in astrology is well documented and certainly not unusual for the period.[69] An inventory of Giovanni's library taken on October 20, 1500, nine days after Cesare's conquest of the city and Giovanni's escape from it, shows that the collection was replete with works of literature, philosophy, theology (especially the works of Aquinas), astrology, medicine, and cosmography.[70] Among the titles inventoried, the library featured a number of tomes on astrology that Leonardi must have certainly consulted. Even a partial inventory is helpful to render the idea of the ruler's interest: *Algorismus* by Abraham Ries (a sixteenth-century German mathematician); a *Kalendarius et numerus aureus*; *Liber de astrologia* by the brothers Gregorio and Leonardo Dati; *Liber astrorum et judicii*, also known as the *Liber novem judicum in Judicijs astrorum* by Masha'allah ibn Atharī; *Astronomy* by Iulius Formius Mastinus (Giulio Formio Mastino?); *De imaginibus* (*Fabulae* or *De deorum imaginibus*) by Gaius Julius Hyginus (ca. 64 BCE–17 CE), who was also the author of a *Poeticon astronomicon*; *Astronomica* by Marco Manilio (first century CE); *Introductio astrologiae* by Lorenzo Bonincontri; *Vitae Aristotelis et de secretis secretorum*, possibly authored by Ramon Llull.[71] The Sforzas' passion for the subject is further confirmed by the fact that Bonincontri even dedicated one of his works, the *Integer tractatus de revolutionibus nativitatum*, to Giovanni Sforza.

It is perfectly feasible then to assume that while in Pesaro, Giovanni Sforza brought Bonincontri and Leonardi together, for they shared a common interest in all things astrological. It is easy to imagine that Bonincontri shared with Leonardi his own experience and knowledge of Manilius's *Astronomicon*. It is

further easy to imagine that he discussed with the Pesaro physician the ideas of Pontano, Gallina, and Marsilio Ficino on astrology and Neoplatonism. Bonincontri, like Leonardi, was interested in the healing properties of astrological images and the application of such images according to the specific needs of an individual birth chart. This is confirmed by a note in Pontano's commentary to the Pseudo-Ptolemy's *Centiloquium*.[72] He mentions that his friend Laurentius Miniatus—Lorenzo Bonincontri, who was from San Miniato al Monte—had healed another companion by the use of astrological images.[73] Such suppositions about Leonardi and Bonincontri's mutual interests and interactions are solidly corroborated by their close collaboration on a series of coauthored astronomical tables, *Tabulae astronomicae*, published in 1480.[74] Though the work is the only definitive proof of the two men's friendship and intellectual exchange, it is a significant one, given that such a project would inevitably entail prolonged contact, discussion, and exchange of ideas. Leonardi's interest did not end with his friend's departure; in fact, he continued publishing and producing a number of works on astrology.

In 1496, Leonardi edited the third edition of a planetarium treatise by Willem Gilliszoon (a.k.a. Guilelmo Aegidio or Guillermus Egidius) titled *Liber desideratus canonum equatorii coelestium motuum absque calculo*, published in Pesaro by Soncino and in Venice by Giorgio Arrivabene.[75] The work further underscores the physician's interest in astral medicine for it "included horoscopes and astrological rules for bleeding and administering drugs."[76] This is a subject that Leonardi returned to in 1508 with the publication of *Theory of the Planets* (*Tehorice* [sic] *planetarum*)[77] and then again in 1524 with the publication of *Lunar Calendar* (*Lunario al modo de Italia calculato* [sic]).[78] The 1525 edition of the latter was written in collaboration with Paul of Middelburg (1446–1534), who was in those years the bishop of Fossombrone. It is almost certainly due to his friendship with Paul of Middelburg that Leonardi became interested in the reform of the calendar, a subject on which Paul had written extensively.[79] The association with Paul further substantiates that Leonardi's background and knowledge were equal to those figures better known to us today, and that these same individuals esteemed him as their intellectual equal.

Indeed, Leonardi's skills as physician and diplomat must have been such that he was highly regarded by both rulers who employed him, the mutual enemies Giovanni Sforza and Cesare Borgia. His intellectual activity continued unabated under both, despite the political turmoil that Pesaro experienced in those years. As mentioned above, Leonardi's *Mirror of Stones* was published in 1502 and dedicated to Cesare, who one year later would lose the city back to Giovanni Sforza, whose vicariate of Pesaro was confirmed by Pope Julius II in 1504. Six years after the publication of *The Mirror of Stones* and four after Giovanni's

repossession of the city was confirmed, Leonardi appears not to have had any difficulty publishing the *Theory of the Planets* under the aegis of his former ruler. His allegiance to Cesare in the intervening years of Giovanni's absence had therefore not harmed his reputation or standing. It is certainly true that upon the Sforza's return Leonardi decamped to Ancona for a period, most likely to ensure he would not incur Giovanni's wrath, but he must have been a truly apt diplomat, as Giovanni Sforza not only readmitted him at court but trusted him enough to have him witness his own testament on July 27, 1510, the day he died.[80] Leonardi continued to be involved in Pesaro's affairs even during the rule of Francesco Maria I della Rovere, who succeeded Giovanni. Julius II bestowed on his nephew Francesco the city of Pesaro on February 20, 1513. A few months later, the city swore him fealty through the representation of three *procuratori*, all physicians: Aurelio Superchi,[81] Girolamo Maroni, and our Camillo Leonardi.[82] In fact, the author indefatigably continued his own intellectual activities right up to his death in 1532, the year in which he reedited the *Lunario al modo de Italia calculato* [*sic*], originally published in 1525.

The Mirror of Stones

The Title: Meaning and Specular References

Leonardi's sensitivity as an author is borne out by his insistence on framing the text within the broader movement of humanism, but in such a manner that it invokes the medieval encyclopedic tradition of the speculum as a mirror of nature. Thus his choice of title reflects the idea that a book may be both a tool and an object of contemplation meant to reveal the secrets of nature.[83] As Leonardi states in his prefatory epistle, "We titled this book *The Mirror of Stones*, so that the nature and strength of stones, the engraved images, and the knowledge of many other things may be seen in it as in an actual mirror."[84] He was aware that speculum would evoke the hallowed writers of the medieval past, from Augustine onward.[85] Leonardi, in fact, states that his own work derived from a serious consultation of the opinions and writings of ancient and medieval authors.

If, as I suggested above, the book was first conceived under the Sforza rule, its title would also have had especial resonance for that ruler. As first advanced by de Bellis, Leonardi's choice might have been inspired by the way mirrors had been used to stand in for or evoke the appearance of stars during the elaborate celebration of the marriage of Costanzo Sforza to Camilla of Aragon in May 1475.[86]

Fresh from having obtained his medical degree in Padua in 1471, the young physician would have been deeply impressed by both the magnificence of the

spectacle and the profoundly symbolic program deployed to acclaim the couple. Given the subjects of his writings throughout his life, he may very well have participated in the creation of the wedding's rich astrological scheme. During the days-long festivities, the marriage was symbolized by innumerable components, with those of an astrological nature foremost among them. On May 28, the day the elaborate banquet began, the feast was organized by a series of floats representing gods and goddesses, which enabled participants to partake allegorically in the retinue of either the sun or the moon.[87] It was all held in the court's great hall, which had been transformed for the occasion into a heavenly vault featuring all the zodiacal signs, planets, and stars. Each of these was represented by a mirror, 2,500 in all, both large and small: "They were attached with their associated stars according to the writings of astrologers, and these stars were all made of mirrors surrounded by silver rays. Around each sign outside the zodiac were depicted the principal and the best-known images of each, such as the Pleiades, Hydra, Perseus, the Crown and others with their symbols, also made from stars of large or small mirrors, according to size. . . . There were five planets made from larger mirrors with many rays, chiefly gold and silver." And "the rest of the sky in the hall, throughout the length and breadth of the room, was covered by large and small stars of different sizes with gold and silver, made from 2,500 mirrors, twinkling with gold and silver, which made it really look like the night sky, although somewhat clearer."[88] The mirrors created the rich background against which the floats of pagan gods and goddesses appeared. Each element, whether in the background or the foreground, was designed to symbolize the union. Mirrors were chosen not only because they stood for the stars, but because they were envisioned as communication tools between humans and the cosmos. Symbolizing the stars, planets, and zodiacal constellations, the mirrors also received and reflected the influence of these same stars. This enabled the newly married couple to receive the universe's benevolent energies.

The ceremony's description, as well as its illustrations, cannot but call to mind the magnificent frescoes of the Hall of the Months (late 1460s to early 1470s) in the Este family's Schifanoia palace in Ferrara, a court with which Costanzo had close contacts.[89] Such a parallel further confirms the role that astrology held in the worldview of the elite class of the early modern period. Mirrors could also evoke astrological signs and their cognates. *Speculum Lapidum*, as a title for a work devoted to astrology and its influences, would have been immediately recognizable to readers, especially to a Sforza, who had physically been immersed in a universe made of mirrors. Given the use and popularity of mirrors in Renaissance courtly culture, the title did not have to

18 SPECULUM LAPIDUM

be changed once Cesare assumed the reins of power and became the official dedicatee of the work.

Mirrors also featured prominently in rituals and tales of magic. They were considered to be such powerful tools used for summoning the spirits that it was not unusual for people to cover them up with cloth or wood when not using them. Would learned readers have made the conceptual leap between the title of Leonardi's work and the common use of mirrors in magic? Might they have recognized literary references from further afield? Leonardi might have thus intended the book not only to explore magical occult virtues but also to resemble the magical revelatory powers of mirrors as used in magical rituals. The text would reveal to Cesare Borgia all there was to be known about the properties of stones, gems, and jewels and thus put him in touch with those universal energies that could be protective or offensive against others.

Dedication to Cesare Borgia

In dedicating the *Speculum* to Cesare Borgia, Leonardi sought to ensure his position at the newly established court. The introductory epistle, for example, glorifies the prince for his great virtue and intellect while alluding to the conquest of Pesaro and the prince's long-standing campaign to conquer the whole of the Romagna and Marche region ("several and grave troubles because of the wars").[90]

One wonders with how much anxiety Leonardi was approaching the Borgia prince, given the rather difficult circumstances that led to the ousting of the Sforzas and how close he had been to them. Giovanni Sforza had taken Lucrezia Borgia, Cesare's sister, as his second wife on June 12, 1493, via proxy since the bride was a mere twelve years old at the time, thus the wedding contract specified that the marriage would not be consummated for another year.[91] The marriage, though, did not prove to be the successful political alliance Giovanni envisioned, and in 1497 he made the unwise decision to resist the Borgia pope's politically motivated request for a marriage annulment on the fictitious grounds of his impotence. The marriage was annulled despite his protestations, which in 1500 earned him, in quick succession, an excommunication, a series of assassination attempts against him, and finally expulsion from the city of Pesaro at the hands of Cesare, Lucrezia's brother.

Dedicating the work to Cesare was certainly a politically motivated move on the part of a court physician intent on ingratiating himself with his new master. It was perhaps made easier, however, given the leader's love for expensive gems and jewels. The anonymous chronicler who described the duke's entry into Chinon in France's Loire Valley[92] has left us a delightful written portrayal noting

Cesare's love of gems and preference for wearing them on his person, from his bonnet to his boots.[93]

While we have no information regarding Cesare's actual collection of jewels, he most certainly was not alone in his love for these precious materials, as most Renaissance princes avidly collected gems, stones, as well as ancient and contemporaneous jewels. By way of comparison, we might look at the collection inventories of Lorenzo de' Medici and Isabella d'Este, marchioness of Mantua.

Lorenzo de' Medici's inventories list a rich collection of precious stones and engraved gems, with more than a third of Lorenzo's collectibles being gems, jewels, cameos, and engraved stones.[94] In contrast, paintings, sculptures and small objets d'art constituted only a twentieth of the total inventory.[95] This suggests how important gems and jewels were for collectors at this time. The inventory shows a particular penchant for cameos (forty-seven in his studio alone), unset gems (five, four of which were engraved), and loose pearls (thirteen in number). The majority of stones and gems, though, were set in rings—forty rings with engraved or plain gems and an additional thirteen rings in Pietro's study—which is of particular interest because Leonardi's discussion of magical gems in book 3 of *The Mirror of Stones* almost always envisions such stones as set in rings of various materials (e.g., silver, gold, copper).

The inventories also list a ring with an engraved shell, seven enameled rings, a mounted engraved shell, two mother of pearl shells with their pearl still inside, four strings of corals, and twenty strings of paternosters made of semiprecious stones (chalcedony, jasper, crystal, and amber). That this collection might have also have been appreciated for the occult and magical virtues of each singular stone will be discussed below, but it is certain that the notion is not to be excluded considering that in the same *studiolo* were also recorded objects whose occult virtue was indeed believed to be magical: a unicorn horn (along with twenty-five paternosters also carved in unicorn horn) to which tradition ascribed numerous healing virtues, as well as an ostrich egg and a mirrored ball with a silken cord in the bedroom, and three fish teeth with gold ferrules.[96] Lorenzo, like other elite collectors of the time, made sure to pursue objects not only because of their intrinsic pecuniary value or luxury status, but also because of their occult virtues. Cesare Borgia may well have done the same.

Lorenzo's collection was not even the largest or the most important of the second half of the fifteenth century. That honor goes to Cardinal Pietro Barbo (1417–1471), the future Pope Paul II (1464–71), whose 1457 inventory listed a remarkable 243 cameos and 578 intaglios.[97] Indeed, many of Lorenzo's objects were originally part of the Barbo many, as were some of the objects that eventually entered the collection of Cardinal Francesco Gonzaga (1444–1483).

Men were not the only collectors; Isabella of Mantua was just as passionate of a collector of precious and semiprecious stones, many of which she also wore on her person. A 1542 inventory of the marchioness's possessions shows the size of her collection, which included at least thirty intaglios. The prominence of her holdings was recognized by her contemporaries. Cardinal Pietro Bembo, for example, writing to Cardinal Cesi on June 27, 1537, expressed his joy at having had the opportunity to see and hold many of the duchess's rare treasures.[98] She was an indefatigable collector who paid closed attention to the various materials and fashioning of an object, especially of those she intended to wear such as rings.[99] Leonardi's whole third book, as mentioned above, focuses on magical and astrological images to be worn as rings and pendants, precisely because elite-class individuals like Giovanni Sforza, Isabella d'Este, Cesare Borgia, and Lorenzo de' Medici, wore gems and jewels for their hidden virtues and used lithotherapy to treat their maladies.

Gems had long been used, with debatable degrees of success, to treat physical and mental illnesses. Records show that medicinal potions made of ground gems were routinely administered to Lorenzo de Medici and Pope Leo X. In the weeks prior to his death on September 25, 1534, Clement VII is said to have ingested forty thousand ducats' worth of stones.[100] Michaele Paschali, a sixteenth-century Spanish physician, claimed to have used emeralds to cure Juan de Mendoza, third marquis of Montesclaros (1571–1628), from dysentery: one emerald was suspended over his abdomen, while the other was held in his mouth.[101] Wolfgang Gabelchover of Calw, Württemberg, author of the *Curationum et observationum medicinalium centuriae* (1611–27), made similar claims as to the healing virtues of emeralds.

Gems did not have to be ingested: Leonardi assured Cesare that protection against illnesses could also be achieved by the wearing of amulets or talismanic rings engraved with specific mythological or astrological images. Talismans, particularly those with images reputed as highly effective, were widely employed. Catherine de' Medici, for example, made assiduous use of talismanic magic. She employed the renowned magus and apothecary Nostradamus and the infamous Ruggieri, probably more appreciated for his knowledge of poisons than astrology (though the two were not unrelated). Numerous sources attest to her ownership of a variety of talismans, including one engraved with images of Jupiter, the eagle of Ganymede, Anubis, and Venus,[102] and another "rumored [to be] made of human blood, the blood of a goat, and the metals that corresponded with her birth chart."[103] Talismans and gems were also believed to induce death, as Benvenuto Cellini recalled in his colorful autobiography when he recounted an episode that occurred during his Roman imprisonment. Accused of stealing some gems from the papal tiara, the Florentine artist feared having been poisoned by finely ground diamond powder administered to him by a soldier sent

INTRODUCTION 21

by Pierluigi Farnese, son of Pope Paul III.[104] The belief that diamond dust could be a deadly poison was well recorded in both *lapidaria* and stories that circulated about the manner of death of various rulers: Holy Roman Emperor Frederick II was said to have died after ingesting diamond dust; the Ottoman sultan Bajazet II was said to have been assassinated in 1512 by his son Selim, who fed him diamond dust mixed in with his food; and in 1613 the countess of Essex was accused of poisoning Sir Thomas Overbury with diamond dust and mercury.[105]

Given this larger cultural context of belief in the healing and magical properties of precious and semiprecious stones, it is safe to assume that Leonardi believed his master would be interested in his *Mirror of Stones*. Considering that his position at court would have given him early access to Pesaro's new lord, it is also likely that he was able to confirm Cesare's interest early on in their acquaintance. Furthermore, as mentioned above, in book 1 Leonardi references the lord's study and describes its entryway as decorated with stone plaques showing all sorts of scenes and objects—in all likelihood agate or moss agate plaques.[106] As court physician, he would have had ample opportunity to meet his employer in person and spend time in his *studiolo*. Indeed, he would have seen that same room much earlier, when attending to the needs of the Sforza family. Thus he would have also seen how it was being reused by Cesare. It is also likely that Leonardi had permission to use the library for his own research. The mention of the *studiolo* allowed him to remind Cesare of their close acquaintance and might have been a calculated gesture of ingratiation. Similarly, the mention of Cesare's Caprarola estate in book 1, chapter 4, suggests the author's familiarity with the ruler's land holdings. Given the specific mention of the calcareous spring found on the ruler's land, Cesare and Leonardi must have had ample opportunity to engage in conversation that ranged over a wide variety of topics. Leonardi was paying attention and wanted Cesare to be aware—after all, he knew that the subject of his writings would be directly relevant to the Borgia prince. Ingratiation is part of the author's strategy. Leonardi presents himself as similar to the prince: just as Cesare is described as fully absorbed by the numerous problems of running his newly conquered state, the author shows himself as spending most of his days absorbed in the countless cares of a physician. What little spare time Leonardi may have had, he claims to have spent on humanistic studies meant to further the human condition.[107]

The Text

Of all Leonardi's published works, the ambitious *Mirror of Stones* would be the one that met with the most fortune both at home and abroad. His attempt to

22 SPECULUM LAPIDUM

write the most comprehensive compendium on the intersection of lithotherapy and astrological magic found an appreciative audience.[108] *The Mirror of Stones* was republished a number of times prior to the Enlightenment period, when such topics fell out of favor. The text saw Latin editions appear in 1510, 1516, 1533, 1610, 1611, 1617, and a 1716–17 edition, a French and a German edition, as well as a partial English edition published in 1750.[109] The English translation lacks book 3, presumably because by this time traditional astrological magic was no longer of much interest to a general reading public. The most influential unacknowledged appropriation and "translation" was the one executed into Italian by the Venetian polymath Lodovico Dolce, who published it under his own name as the *Libri tre di m. Lodovico Dolce nei quali si tratta delle diverse sorti delle gemme che produce la natura e della qualità, grandezza, bellezza e virtù loro.*[110]

Leonardi's *lapidarium* embraces the style of the aforementioned medieval authors Marbode and Albertus Magnus, so stones are discussed in terms of their origins, formation, and occult properties. Yet, as will be discussed below, he also discusses astrological images engraved on stones, following the work of Techel/ Thetel/Tethel/Chael.[111]

While it is not possible to know how long it took Leonardi to compose *The Mirror of Stones*, it would not be implausible to surmise that he was already at work on it during the Sforza years, when Bonincontri was at court. It is therefore likely that he originally planned to dedicate it to Giovanni, but the intervening reign of Cesare must have changed his plans. The great number of sources consulted or mentioned in the work, to be discussed below, suggests that Leonardi had long been at work on the manual.

He envisioned an all-encompassing treatment of the healing properties of precious and semiprecious stones, the images that could be engraved on them, the manner in which such stones were generated, and the effect that this had on their healing properties. The work is subdivided into three books. The first discusses the known theories of generation and formation of precious and semiprecious stones. The second lists 250 such stones along with their occult (i.e., hidden) virtues. The third lists ninety images that could be found engraved on gems, their magical and occult virtues, and the way the occult virtues of a specific stone could interact with that of the image engraved on it.

The work does not add much in the way of new knowledge on the subject, but instead assembles in three volumes all available material regarding healing stones that could be found in a number of ancient and medieval sources.[112] The relative lack of innovation and the author's need to reiterate all he came across in his sources occasionally led him to repeat information, and in some cases he

seems not to have recognized the errors of earlier authors. Such mistakes drew fierce criticism from the celebrated physician Antonio Musa Brasavola (1500–1555) in his *Examen omnium simplicium medicantorum*, in which he bluntly stated that Leonardi had treated the subject in a most inept manner.[113] Brasavola, for example, accused Leonardi of not having realized that cyaneum and coeruleum were the same stone even though he had used the same words to describe them.[114] In his defense, Leonardi did not actually use the same words in these entries, though he used identical terms to describe the stones' colors.[115] Like his contemporaries and the earlier sources he used, he had a tendency to describe the same stone under different names without noticing the redundancy. This error stems from the way the stones were classified: first and foremost by color. Stones could appear similar in color but their properties could be different, hence authors had a difficult time establishing when a source they were consulting was describing a stone that had been mentioned previously. Even today, in reading medieval *lapidaria*, it is difficult for us to establish which stones' names are being used to refer to the same mineral (this problem that is particularly acute in the case of lapis lazuli).

Structure and Content

Leonardi organized his text so that his ideal reader, his patron, could easily find whatever information might be most pertinent to his interests. The volume's three sections progress from a general discussion of the generation of stones to detailed descriptions of specific astrological, thaumaturgical, and magical images that could be found engraved in rings. After the necessary dedicatory epistle and proemium, Leonardi presents a list of chapters within each book, including an alphabetical list of all the stones in book 2.

The epistle and proemium are preceded by an epigram by a colleague and friend of Leonardi, the physician Valerio Superchio (ca. 1460–1540), renowned for his rhetorical and poetic skills. The latter praises Leonardi for his marvelous work in the hope that Cesare will recognize its immense value.[116] The epigram serves as a foil to Leonardi's own epistle, in which he humbly presents "this small book of ours" in the hope that it may be an addition to Cesare's "excellent" library, even though "this will be of small use for your many duties." The epistle could not but use self-effacing language: it was customary for early modern authors to present their work to a patron in the humblest possible light. Yet a more conceited note seems to emerge when the author explains his reasoning for the title: that the work would function as a mirror in which to discern all that is possible to know about the nature and virtues of stones and their engraved images.[117]

Summary

Book 1

Book 1 is divided into nine chapters. While the first eight are concerned with the physical nature of gemstones, the ninth chapter focuses on how to distinguish counterfeits from genuine samples. In those first eight chapters, Leonardi closely follows Aristotelian concepts with direct and indirect quotations from *De caelo, De meteora, De generatione animalium, De anima,* and *De sensu,* often as mediated through medieval commentators such Albertus Magnus, Avicenna (980–1038), and Averroes (1126–1198). Mention is made, for example, of Avicenna's *Canon of Medicine* and *Congelatione et conglutinatione lapidum* (*On the Congelation and Conglutination of Stones*), and of Peter of Abano's (1257–1316) *Conciliator differentiarum philosophorum [et] praeciupe medicorum* (*Reconciler of the Differences Between Philosophers and Physicians*). The latter work, first published in 1472 in Mantua and then Venice in 1476, tried to reconcile Aristotelian philosophy with the medical systems of Avicenna and Averroes. Gaetano of Thiene (1387–1465) is also important to the author's analysis, for if he were indeed Leonardi's teacher at Padua, as he maintains, he would have been the one responsible for introducing Leonardi to the key texts of and commentators on Aristotle. It is Albertus Magnus's thirteenth-century *De mineralibus,* though, that appears to be Leonardi's principal source, providing our author with a model in both organization and substance that he closely follows throughout the book. Albertus himself had followed the aforementioned Marbode and Thomas de Cantimpré (1201–1272), which Leonardi must have realized, since he also consulted those sources.

The general content of materials presented in chapters 1–8 is therefore similar to Albertus's own, although the order in which the arguments are presented is often different. The last chapter is an exception, as Albertus did not discuss issues of gem counterfeiting in his *De mineralibus.*

Chapter 4 is of particular note since it is there that Leonardi introduces the notion that the geographical origin of stones is paramount in assessing their absorption of cosmological energy and hence their healing and magical properties. Leonardi uses the esoteric writings of Hermes to establish that a gem's properties are dictated by the climate under which the gem arose, because "the straightforwardness, or rather the obliquity of the rays of the stars,"[118] infuse matter differently in different places. This explains why in book 2 he painstakingly sets out whenever possible the geographical origins of a specific gem and then assigns it a value judgment. If oriental diamonds are considered superior to occidental ones, it cannot then be said to be a mere case of exoticizing—that

is, the farther away the locale the more powerful the gem—but rather one of the greater potency of that locale with respect to the four elements and the cosmos.[119]

Chapter 9 stands out as a possible original contribution. As mentioned above, Albertus never discussed the subject of counterfeit gemstones.[120] This distinction might have been particularly important to Leonardi since, as a physician, the genuine quality of his materials would have been an overriding concern. He recommends four principal methods to establish whether a stone is genuine: (1) resistance to the mark of a chisel, (2) appearance, (3) weight, and (4) imperviousness to fire.[121]

Leonardi considers the test by fire to be the best since no authentic stone would melt or disintegrate in its flames. But it is vision—judging a stone's appearance—that is most significantly rich in implications. The sight of a real gem is said to elicit pleasure in the viewer—a theory repeated in many sources of the time—and such pleasure may then be a guiding principle in assessing whether a gem's resplendent qualities are revelatory of its occult properties.

As he mentions in chapter 1, the word "gem" is derived from the "Greek *gemmo*, which in Latin signifies *resplendo*." The incorrect or fictitious etymology—namely, that *gemmo* (gem) derives from the Latin word *gemma* (bud), for there is no such Greek word—points to an important association of meaning between a precious stone and its visual quality of glittering brilliance. The fictitious etymology is important to Leonardi's conceptual notion of gems, since a real gem may be distinguished from a counterfeit by virtue of the fact that the former delights the eye. The Latin *resplendo*—to brightly shine back or to shine forth, to glitter—was probably used because of its active implications: the gem radiated light. Because of this, true gems were able to radiate light, thereby affecting an individual's faculty of vision through their *vis naturalis*, which elicited pleasure and in turn provoked a reaction of recognition. The recognition of a true gem was also the recognition of its *vis naturalis* and therefore its properties in matters of apotropaic protection, fortune, magic, and healing.[122]

Book 2

Book 2 comprises six short introductory chapters, followed by two alphabetical lists. Chapter 1 outlines the contents of book 2. Chapters 2, 3, and 4 are little more than a heavily edited version of Albertus Magnus's *De mineralibus* book 2, tractate 1, but with mention of other sources thrown in for good measure (e.g., King Solomon, Aristotle, Isidorus of Seville, Bishop Marbode). His goal seems to have been to impress the reader with the sheer number of authorities he had

26 SPECULUM LAPIDUM

consulted, as well as to establish the long "scholarly" tradition supporting the existence of occult properties in stones.

In chapter 2, King Solomon's authority becomes the chronological point of departure to establish lithic properties. Leonardi then appeals to a Pythagorean understanding of the faculty of imagination; he also calls on the authority of Virgil, whom he quotes directly, to assert that sight and imagination, or the fascinator's soul, play a role in receiving a stone's benefits: "The soul of a man, or of any animal, can enter into another man, or animal, through sight, and hinder the actions of that animal." Returning to the issue of the primacy of sight, with which he had concluded book 2, Leonardi informs his readers of the role of the eye in magic or bewitching: "Virgil is of this opinion when he says in the *Bucolics*: *I do not know which eye fascinates and corrupts / my tender lambs.*"[123]

He next informs the reader that he witnessed such a fascination: "I myself have seen in Italy that when an [unseen] wolf gazes at a man, the latter's voice becomes hoarse, nor can he scream, even though earlier he had not experienced such a problem."[124] The example he gives is particularly fascinating—pun intended—for he states that he "saw" (i.e., with his own eyes) a wolf that "fasci-nated" a man who then lost his voice. The wolf's sight, and his having seen the man prior to the man seeing him, ensured that the brute soul of the animal exerted its power and deprived the unwitting man of his voice, and thus presum-ably of his ability to call for help. It is to be also presumed that since Leonardi witnessed the whole episode himself, he had seen the wolf first. In this wonderful game of sight, where Leonardi is the supreme eye that beholds the scene and witnesses the exchange between the wolf and a second man, he is the powerful seer whose foresight protects him from magical fascination and leads him to knowledge. He is not deprived of his voice or words, for his vigilance and sight have allowed him full control of his faculties. The second man's lack of attention and therefore his "blindness" let the beast have the advantage.

Leonardi calls on the authority of Niccolò dei Conti (ca. fourteenth century), whom he refers to as "sir Nicholas de Comitibus Patavinus, the greatest astrono-mer of our times," to confirm the capacity animals have for weather prediction. From this, he argues that great properties may be found in things that appear at first to be inferior to humans. He is making the case for the existence of powers or properties (*vis*) within stones that assert their influence on individuals.

After using chapter 3 and 4 to securely establish through "scientific" reasoning what he asserts was already apparent to the reader's very own eyes—"Can we not see that the magnet attracts iron? And that sapphires cure anthrax ill-nesses?"[125]—chapter 5 lists all the sources he consulted.

Chapter 6 lays out brief instructions on how to use the two alphabetical lists that follow. The first list is organized by color and the second consists of 250

entries dedicated to specific stones. Since gems could only be recognized and evaluated by sight, Leonardi tells the reader that the first list serves as a key to identify the various stones. He warns his reader that since some stones may have similar colors, each entry should be read carefully.

Leonardi's attention to color and his careful distinction of tints, tones, and shades is therefore not surprising. To cite but one example, he uses two terms for red—*russus* and *Rubeus*—that he further subdivides as *russus lucidus transparens* (bright transparent red), *russus pulverentulus* (dusty red), *russus citrinus* (citrine red), *rubeus obscurus* (dark red), *rubeus rutilans* (fiery red), *rubeus lucidus* (shiny red), *rubeus aqueus* (watery red), and *rubeus corallo simili* (similar to coral red).

Translating and assessing the color nomenclature he uses is not as simple as it might first appear: cultural traditions and mental associations influence conceptions of color. To further complicate matters, terminology of the premodern period often significantly varies from modern designations for the same color.[126] In modern English, for example, *crimson* refers to a bluish red and *scarlet* to a tomato red, but in Renaissance Venetian this color was actually defined by the dye being used: *scarlatto* (scarlet) was a bright red grain dye for wool, whereas *cremisino* (crimson) referred to a silk dyed with red kermes.[127] It would seem that Leonardi's color classification and description was at least in part based on his awareness of the writing of Leonardo da Vinci and Marsilio Ficino on color. As mentioned above, Leonardi's close attention to all tints, tones, and shades is necessary, for only after the color had been carefully identified in the first list could the reader then learn the stone's proper "scientific" name and consult its corresponding entry in the second list, which would catalog and describe in detail its innate occult properties.

The second list begins with Adamas (diamond) and ends with Zoronysios (an unknown stone supposedly found in the Indus River). For Leonardi, even shades of a single color could be connected to different healing and magical virtues, not to mention monetary value. Color and healing or protective properties were often associated according to the principle of sympathetic magic. Red stones such as hematite, carbuncles, and rubies, for example, are listed as having the power to treat blood hemorrhages.[128] Red was traditionally associated with an increase of passion, yet some red stones, like carbuncles, were also believed to halt lust.

Carbuncles are exceptionally endowed—as few stones were thought to be— with a male and female gender. Similarly gendered is the stone referred to as sardius/a (most like carnelians, though in some cases this label could be used to indicate a sard or red sardonyx). The notion that stones could be gendered and reproduce—an idea sometimes also applied to the eagle stone—reinforced

28 SPECULUM LAPIDUM

the perception that they were animated by a living force—or, in other words, the celestial influence of heavenly bodies.

Color, though, was not the only aspect a physician would consider in choosing a suitable gem. The image engraved on a stone could be more crucial than its color. A physician had to take into account images, whether astrological or not, as well as the wearer's astrological chart and the celestial influences on the particular situation or illness to be addressed. According to Ptolemy's *Tetrabiblos*, humors were directly influenced by planetary energies. Thus healing itself was ruled by these energies, which could be deployed using astrological talismans, the subject of book 3.

Book 3

In these fourteen chapters Leonardi furthers his discussion of the occult properties of stones by delving into the variety of possible images that could be engraved on them. While he continues following aspects of Albertus Magnus's *De mineralibus*, he also embarks on an endeavor larger in scope. It is also in this section that Leonardi offers us his original and knowledgeable discussion of contemporary artists familiar with the art of engraving.

Albertus Magnus had begun section 2.3 of his *De mineralibus* with a discussion of talismanic images (*imagines* or sigils) by stating that the "necromancy of images and sigils" was a good doctrine and that even his religious order wished to know more. Readers would therefore have been reassured that they were not embarking on a quest for knowledge that contravened Christian tenets. However, Albertus also stated that few could truly understand what ancient wise men had written on the matter.

Leonardi begins chapter 1 by directly responding to Albertus's words. Though he concedes that few people are well versed in the subtleties of astrology, magic, and necromancy, he also states that he would not "let Albertus's words frighten me."[129] Thomas Aquinas provided him with the perfect antidote in an Aristotelian paraphrase that stated "it is better to know a little of a noble subject than of an inferior matter."[130] For good measure, in case Aquinas's authority were not sufficient to convince his readers, Leonardi made sure to also quote Aristotle's original words: "It is better to know something than to be ignorant of all things."[131] Thus armed, Leonardi embarked on his encyclopedic project of listing those talismanic images recorded by the ancient sources he consulted.

In chapter 2, the author presents the reader with an artistic genealogy of ancient sculptors and engravers from antiquity to his own time. The originality of this chapter cannot be underestimated. It is here that Leonardi states that an individual's desire to receive the stars' benefic influences, and not the desire to

ornament oneself with luxury baubles, has kept alive the art of gem engraving. While he appears to imply that even in the fifteenth and early sixteenth century the art of gem engraving is mostly concerned with astrological talismans, he certainly never states this clearly. He does take pains, however, to clarify that any talismanic image listed in book 3 is meant to be a licit image, created without the use of addressative magic, whose power derived solely from the stars. To support his claims he cites Thābit ibn Qurra (826–901), the very same source that both the anonymous author of the *Speculum astronomiae* (ca. 1260) and Albertus Magnus had used in establishing the idea that certain talismanic images could be considered licit.

The first gem engravers Leonardi mentions are as remotely located in time as the textual sources he uses. The power of words, symbols, and images of Hebrew origin is contrasted with those executed by the Romans, whose images Leonardi praises for their realism even though their makers lacked the knowledge of magic, astrology, and necromancy.

From the ancient Romans, he jumps directly to those artists active during his own time, thus linking any recent achievements to those of the hallowed past. Fifteenth-century artists such as Annichini of Ferrara, Tagliacarne in Genoa, Francesco Bologna (also known as "il Francia"), and Leonardo da Vinci are extolled for creating "images of such precision and elegance that it is not possible to add or detract from them."[132] Except for Giovanni Maria from Mantua, who is unknown to us, the other artists' lapidary activities are familiar.

In chapter 2 we are hence reminded that these images are not simply theoretical; there were, in fact, excellent contemporary artists who engraved such images on stones. Yet Leonardi does not make clear whether these contemporary artists had knowledge of magic. The author's familiarity with artists who engraved gems indicates his keen attention to all matters lapidary and his participation to the artistic circles of the Pesaro court at the time, but does not clarify anything in terms of the actual practice of making magical images.

He does further expand his discussion of artistic engraving to include the painterly arts in an effort to place his *lapidarium* within a larger cultural context, one in which there is a perceived continuum between painting and gem engraving, between the ancient and the modern, between the engraved image and astral magic.[133] In the aforementioned 1985 study, Carla de Bellis argues that Leonardi's comparison of contemporary to ancient artists is a way to suggest that all contemporary artists were implicitly seen as repositories of the ancients' occult wisdom.[134] While I am not sure about this sentiment, I think the best we can say is that our author leaves the matter purposely ambiguous, often contradicting himself. Given that none of the images he lists later in book 3 is prefaced by words such as "carve" or "make"—but rather always by "if you find"—Leonardi

appears to be studiously avoiding giving any directions about the making of talismanic images, even if licit.

In his *De vita*, Marsilio Ficino had explicitly stated that contemporary artists did carve talismanic images. This notion, among others, had earned him the severest of censures, and he was forced to abjure the whole work a mere six months after its publication. Leonardi appears to be taking all due precautions to avoid a similar fate. He seems to follow the examples of other early modern *lapidaria*, such as the German *Hortus sanitatis* (1491; fig. 3). In the latter work, for example, the entry for the dyacodos stone is illustrated with a woodcut showing a man searching for raw gems and rings in a landscape, implying that these stones were found rather than fabricated by humans (fig. 4).

Chapter 3 is dedicated to distinguishing between naturally occurring and human-made images. Leonardi envisions three categories: the first comprises images that naturally occur on stones, such as the fernlike patterns on dendritic agates; the second comprises naturally occurring fossils and cameos, though their descriptions indicates that Leonardi is also including human-made cameos; and the third comprises human-made images, which may be carved with or without a specific purpose in mind.[135]

In assessing which images may be considered natural, Leonardi, not for the first time, shows that he read his sources carefully and made decisions on how to use them based on personal experiences. He departs from his trusted model, Albertus Magnus, and follows instead Pliny and Marbode by including picture agates in the first category. He states that he saw with his own eyes an agate in which he could discern the representation of a flat plain with seven trees. Nature—or, better yet, heavenly influences—could be seen as the first engraver of gems and cameos.

Heavenly influences also played a vital role in the artistic creation of gems and cameos included in the third category, which Leonardi further divides into two subcategories: (1) ornamental images and (2) magical and healing images, that is, images carved with a specific intent in mind. Interestingly in the first subcategory he includes almost all Roman or contemporary intaglios, while in the second he includes all those created by the Israelites. His later descriptions of licit magical talismanic images, though, clearly include a number of Roman gems, suggesting that his connoisseurship in matters of ancient intaglios and cameos could be rather nebulous. His guiding principle on this account remained firmly rooted in theoretical and historical considerations, rather than practical knowledge: if his sources mention an image, he mentions it, too.

In chapter 4, he continues his discussion of magical images to securely assert the notion of free will even when graven images exert an influence on people's

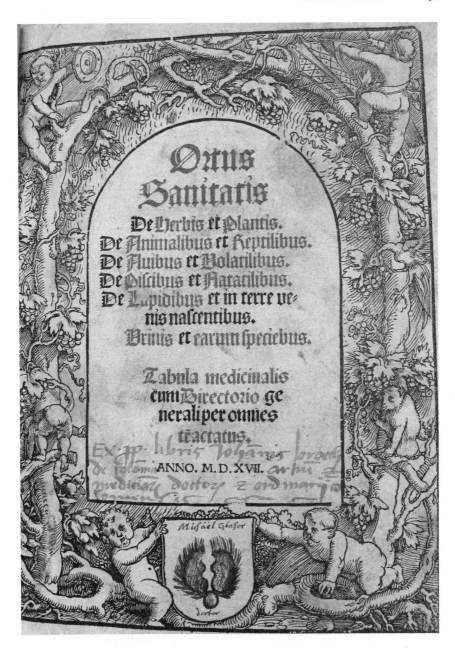

Fig. 3 *Hortus sanitatis*, 1516 edition. San Diego Natural History Museum Research Library. Photo: author.

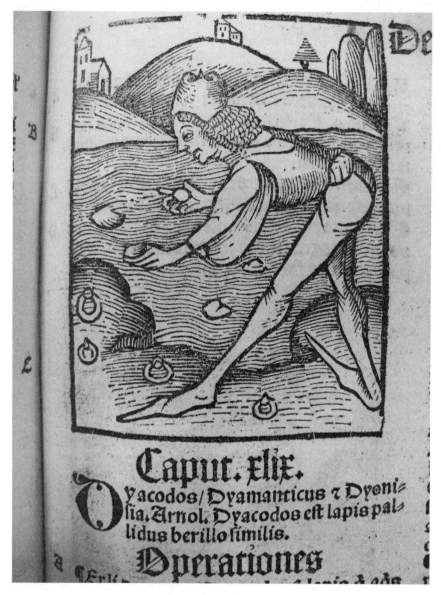

Fig. 4 Entry for the dyacodos stone, *Hortus sanitatis*, 1516 edition. San Diego Natural History Museum Research Library. Photo: author.

bodies, their health, their psyches, and their fortunes. Contradicting his earlier protestation of being a mere collector of knowledge, Leonardi clearly says for the first and only time that for images to have power they must be sculpted at a specific time of day under the influence of a particular star. His subsequent list of magical images does not include any element of addressative magic that could guide anyone wishing to create the image described. The assumption is perhaps that all such images were carved at some point in the past according to the appropriate instructions, so the modern wearer could innocently find and use them.

Unlike Albertus Magnus, Leonardi does not believe that stones could lose their properties; rather, he follows a source attributed to the biblical King Solomon and states instead that "if the stone is not broken, and if the image is not wholly abraded, then its virtue is not lost." Similarly, paraphrasing Ptolemy's *Quadripartite*, he states that a "virtue impressed on any thing lasts until that thing endures."[136]

In chapter 5, again unlike Albertus Magnus, he divides astrological images into universal and specific. Images of zodiacal signs are considered universal because their power is not dependent on the material on which they were engraved, though the material could magnify and contribute to the image's power. Images of planets and constellations are considered specific because they either symbolize a stone's properties (without possessing any power of their own) or receive the influence of heavenly bodies. Such images, he asserts, are easy to decode: "In this manner knowing the virtue of the constellation, we may know the virtue of the stone."[137]

In chapter 6, Leonardi calls non-astrological images "magic or necromantic" and asserts that they require specialist knowledge, as is the case for an Abraxas in his possession. Such gems present syncretic iconography and draw elements from a multiplicity of cultural references: Hebrew, Roman, Greek, Egyptian, and Babylonian.[138] They were often inscribed with the word "Abraxas," which is why they are today referred to as Abraxas gems, although a number of examples without any inscription have also survived (including the one Leonardi is referencing). For him, just like for all his predecessors, the key to decoding the function and properties of such images was to be found in the image itself—that is, in the consideration of each of the elements that made up the syncretic figure.[139]

Regardless of the power of such images, in chapter 7 Leonardi reinforces the notion that no image or stone can force individuals to become what they are not. All individuals preserve their free will. Having established the extent of the influence of these sorts of images, Leonardi goes on in chapters 8–13 to describe

34 SPECULUM LAPIDUM

various talismans (including images of the twelve zodiacal signs, subdivided in four groups of threes), while in chapter 13 he discusses images of other heavenly bodies such as the constellations.

The last chapter is subdivided into various sections, each listing images that derived from the Hermetic and Jewish mystical sources, in addition to Jewish sources of astrological magic including Hermes, Raziel, Chael, Thetel, and Solomon. Leonardi's extensive use of Jewish sources is logical, considering that he had begun book 3 by stating that the most powerful seals had been first executed by the Israelites in the desert. It is difficult to say whether these were sources Leonardi encountered in the Sforza/Borgia library or he owned them himself. In that period, Pesaro had a thriving Jewish community, which might have provided the city's intellectuals with such textual resources. The community was important enough to have attracted the presence of the Soncino family, who briefly established their press in the Marche region, first at Fano from 1503 to 1506 and then at Pesaro from 1507 to 1520.

Eighteen of Leonardi's entries in chapter 14 bear a strong similarity to book 6 of the *Liber Raziel*.[140] Since the book also dealt with magical rings, and since all of Leonardi's magical stones were also meant to be worn as rings, this source would have been of great interest to our author. Similarly, twenty-three of Leonardi's images derive from the writings of Sahl ibn Bishr al-Israili, also known as Rabban al-Tabri or Haya al-Yahudi, or more simply as Chael or Thetel. The latter two names were probably a corruption of the name Zael or Zehel. It is also possible that Chael/Thetel may be identified with Sahl ibn Bishr or Zahel Benbriz, a Jewish writer of the ninth century. Books of talismanic and astral magic usually included the seals of Chael/Thetel as Leonardi's does, even though they were sometimes instead attributed to King Solomon and vice versa.[141] In *The Mirror of Stones*, for example, those seals attributed to Solomon are elsewhere attributed to Thetel.

Regardless of such confusion, Leonardi would have not questioned the attribution of an astrological lapidary to King Solomon, as it was believed he had owned a ring that gave him power over demons (the so-called seal of Solomon). Thus it would make sense that King Solomon would have also authored a lapidary manual concerned with those magical images that could be engraved on stones.

With regards to the Hermetic tradition, he drew specifically from Hermes Trismegistus's *Liber Hermetis de quindecim stellis quindecim lapidibus quindecim herbis et quindecim imaginibus*, also known as the *Quadripartite*. The figure of Hermes was believed to have been a contemporary of Moses, and the writings circulating under that name were invested with great authority with regard to magic. Given his scholarly ties with Lorenzo Bonincontri, Leonardi

most certainly knew the *Corpus Hermeticum*, Marsilio Ficino's translation of the writings attributed to Hermes. His interest in alchemy might hence be reflected in the inclusion of alchemical symbols for a number of sigils or seals given to Chael.

Leonardi ends his manual by suggesting that more images may still be discovered and that his *lapidarium* is meant to be understood as a work in continuous progress. By concluding with the idea that more stones may be "found," he reminds the reader that both the text and their discovery of talismanic images will continue to grow.

Reception

Although we are not privy to Cesare Borgia's reaction upon receiving Leonardi's opus, the book certainly met with the general favor of a wider public; as mentioned above, it was republished a number of times throughout the sixteenth and the seventeenth centuries. In 1629, however, the work met with censure: Jacques Gaffarel (1601–1681) in his *Curisiotez inouyes* mentions, albeit vaguely, that Leonardi had been considered by some as impious and atheistic.[142] Although there is no evidence of formal proceedings against the author or his work during his lifetime, Gaffarel's accusations may have been a symptom of changing perceptions. By 1674, nearly two hundred years after its publication, *The Mirror of Stones* was included in the Holy See's *Index Librorum Prohibitorum* (List of prohibited books).

It was not until the end of the seventeenth century, however, that Leonardi's text began its descent into oblivion. This was not only because the work was now forbidden, but also because those beliefs that precious and semiprecious stones and gems had any magical or healing properties began to be seriously questioned. The advent of the Enlightenment saw the decline of the magical lapidary, especially when it came to medical practice.

In the late nineteenth and early twentieth century, when scholars began to examine premodern theories and practices of magic, Leonardi appeared as an imitator and was generally neglected. Modern devotion to innovation, including the "great man" theory of history, relegated Leonardi to the status of an unoriginal thinker. Despite such an assessment, we have to acknowledge that premodern notions of creativity were based on who could do what with preestablished themes and motifs.[143] Renaissance authors saw themselves as collecting and digesting the knowledge of the past in the same manner—to paraphrase Seneca's (ca. 4 BCE–65 CE) aphorism in his *Epistulae morales* 84.3—that a bee collected pollen and digested it into honey.[144]

To retain the tenor of this aphorism, Leonardi's work is a perfect example of a text that sought to imitate by transforming models from the past, both distant and near, with the aim of creating an "original" product reflective of a personal identity. Imitation was not an end in itself, but a vehicle for the author to become more creative and, in the process, more oneself. However much Leonardi relied on lapidary texts of the past and their theories of astral magic and talismanic images, he offered a novel discussion of the art of gem engraving and of artists in general. Through his text, we witness the life of a physician active at a humanist court at the height of the Italian Renaissance. Within this milieu, the triangulation of theoretical ideas of magic within artistic practices and medical notions of astral magic played an important role in the daily practice of wearing sumptuous gems and jewels.

Throughout the sixteenth and the seventeenth centuries, lapidaries were commonly sold in both apothecary and jewelry shops (the practice began its decline in the eighteenth century).[145] While we encounter more skeptical texts—for example, Anselmus Boetius de Boodt's *Gemmarum et Lapidum Historia* (1609) and Thomas Nicols's *Lapidary, or the History of Pretious Stones* (1652)—at the beginning of the seventeenth century, it was not until the eighteenth century that talismanic magic ceased to play any role in orthodox medical practices. It is most likely for this reason that the 1750 anonymous English translator of Leonardi's text omitted the whole of book 3.

Even though lapidaries are no longer seen as a valid medical orthodoxy—though interestingly, they have made a comeback in certain New Age circles—Leonardi's *Mirror of Stones* remains a testament to what was, at the time, a valid form of knowledge production. When we situate him within the complex system of sixteenth-century intellectual, cultural, and social history and its rich artistic practices, we witness the intersection of material culture and knowledge of the natural world. In him, we clearly see the role that magic and stones played in everyday Renaissance life.

THE MIRROR OF STONES

Fig. 5 Frontispiece to Camillo Leonardi, *Speculum lapidum* (Venice: Baptistam Sessa, 1502). Wellcome Library, London. Licensed under CC BY 4.0.

THE MIRROR OF STONES

BY THE MOST DISTINGUISHED DOCTOR OF MEDICINE

Camillo Leonardi

Epigram by Valerio Superchio, Physician of Pesaro

Whatever jewels Mother Earth brings forth for the uses of men, and whatever the waters of the vast sea [produce], you, Leonardi, have encompassed within this book, a marvelous work to benefit greatly later generations. I pray that Caesar may sometime lay down his weapons and peruse it, and that it be kept among his treasures, and decree your honors appropriate to your merits, and preserve your name for all time.

Dedicatory Epistle[1]

Camillo Leonardi, Physician of Pesaro, gives his most cordial greetings to the Most Excellent and Glorious Prince Caesar Borgia of France, Duke of Romandiola.

Although we know Your Highness to be hindered by the several and grave troubles caused by the wars at this stormy hour, nonetheless, given your inborn refinement, discretion, and knowledge of the good and literary arts, for which you are gifted—literary men and those inclined to virtues [like you], easily, and gladly listen to the truth and are in the habit to fully grasp it in their mind—we do not hesitate to submit to you this small book of ours, so that your mind, exhausted by continuous cares and works, in reading the novelty of this book, may certainly be delighted and may this work be able to restore to you some degree of pleasantness. Oh illustrious Prince, the entirety of your city of Pesaro is witness to the fact that we have not been idle: for we have given all our cares and thoughts to the practice and theory of medicine. We willingly intend to

[continue] spend day and night studying and laboring for the health of its citizens. Therefore, you may easily discern how seldom we rest, prevented as we are by these and other concerns, and by private and public affairs. Nevertheless, if sometimes there is some leisure time, it is eagerly passed in literary studies, and we are wont to return whatever we can to the advantage and usefulness of men as we are bound [to do] by our common duty. Therefore, moved by this cause, we composed this booklet on the nature of stones that contribute to the health and advantage of men, which we could only carry out by being thorough and with much effort and gathering [of information]. As already noted by various authors and learned men, the writings [on this subject] are voluminous and scattered, still with the greatest care, and with as much diligence and care as we could, we collected in this book [the knowledge] gleaned from men of the greatest regard and excellence. We titled this book *The Mirror of Stones*, so that the nature and strength of stones, the engraved images, and the knowledge of many other things may be seen in it as in an actual mirror. And united in holding your majesty, faith, and love since in you rests our hope, for you are father and prince of our country, we dedicate this booklet to your name, for you are assiduous and truly dedicated not only to weapons and military skills, but also to the noble letters, so that at any time of leisure, you may review it with eyes and mind. In which booklet, if by your correct judgment you find something awry, ascribe it to our paucity of intellect and extend us your forgiveness: for we cannot know everything on all matters; but where you discover a worthy lesson, attribute it to the most worthy learned men from whom we quoted. Given their utmost authority and tested worthiness, do not disdain to place and add our book among your countless other books, so to speak, in your excellent library, so that you may regard its author, Camillo, with love or at least more ardently. Certainly, most illustrious and magnanimous Prince, this [book] will be of small use for your many duties. But with your usual clemency and benign will, do not consider such a book nor the surface of these pages, but the spirit and mind of its author. [Wishing you] Farewell and Prolonged Prosperity, Pesaro, in the year of salvation, 1502, Ides of September.

Proemium of the Book Titled Mirror of Stones
by Camillo Leonardi, Physician of Pesaro[2]

Even though various learned men, both ancient and modern, have written on the subject of stones, still, I have not recovered any complete writings, thus I decided to treat the subject matter thoroughly in this book. In fact, there are many things to be considered when treating stones, first their substance, and

then the virtues and images that are carved on said stones. This work, titled Mirror of Stones, is divided in three books. The title of Mirror was used for the following reasons: since in a mirror the true appearance of things that are reflected on it may be understood, so in this book all that may be rationally said about stones is discussed and manifested.

Chapters of the First Book[3]

The first book discusses the substance and form of stones, and of the accidents that take place in their composition, and it contains nine chapters.

The first chapter inquires into or investigates the nature of mixed matter and especially of stones.

The second chapter concerns the effective or generative causes of stones.

The third chapter notes what is the substantive form of stones.

The fourth chapter discusses the sites where stones are generated.

The fifth chapter discusses the accidents of stones and how they result in good or bad mixes.

The sixth chapter discusses the transparency and opacity of stones, and their colors.

The seventh chapter is on the hardness and softness of stones.

The eighth chapter is on the weight, lightness, density, and porousness of stones.

The ninth and last chapter is on the manner in which natural stones may be discerned from artificial ones.

Chapters of the Second Book

The second book discusses the virtue of stones as well as how it comes to be present in them, and the names of all the stones, and their virtues.

The first chapter of the second book is an introduction in which we briefly set forth the order the whole book.

The second chapter investigates whether there are virtues in the stones. In this chapter we report various opinions from antiquity.

The third chapter investigates how and where virtues are found in stones.

The fourth chapter gives the true opinion of how virtues come to be in stones.

The fifth chapter lists the names of all the learned men from whom we took what we have written.

42 THE MIRROR OF STONES

The sixth chapter discusses how we may come to the stones' names through their colors.

The seventh and last chapter lists each stone by alphabetical order beginning with A.

A[4]
Adamas
Achates
Ametistus
Alectorius
Androdamanta
Astrites
Alabandina
Agapis
Andromantes
Antracites
Amandinus
Abeston
Asius
Amianton
Augusteum
Alabastrum
Alabandicus
Aspilatem
Abistos
Asinius
Alabandica
Amiatus
Antiphates
Amites
Aquilinus
Anancithidus
Agirites
Amphitaneus
Aquileus
Androa

B
Balasius
Berillus

Borax
Bezoar
Bolus
Beloculus
Basanites
Bronia
Balanites

C
Carbunculus
Calcedonius
Chelidonius
Corallus
Cornelius
Cristallum
Crisoprassus
Crisoletus
Crisolitus
Celonites
Cogolites
Ceraunius
Corvina
Cimedia
Calchophanus
Caldaicus
Crisocollus
Crisoptasius
Chemites
Chrisanterinus
Cysteolithos
Cathochites
Corvia
Cambnites
Cepocapites
Calorites

Cepionidus
Chorintheus
Cianica
Caristeus
Calminaris
Crisopassus
Coaspis
Cimilianitus
Crisolansis
Crisites
Camites
Celonia
Crisopilon
Crisoberillus
Coranus
Crisopis
Calcitis
Carcina
Crapondinus
Celicolus
Chrysopteron

D
Demonius
Dionisia
Diacodus
Draconites
Drosolitus
Doriatides
Doctus

E
Eliotropia
Emathitis

Ethices
Enidros
Epistides
Exacolitus
Estimion
Execonthalitus
Exebonos
Eumetis
Emites
Egitilla
Emetrem
Esestis
Elopsites
Eunophius
Election
Echistes
Echidnes

F

Filaterius
Fingites
Fongites
Falcones
Frigius

G

Granatus
Galatides
Garatronicus
Gelachides
Gagates
Gerades
Gallerica
Garamantica
Gasidana
Grogius
Glosopetra
Grisoletus
Garamantides

Galasia
Galacidem

H

Hyena
Hieracites
Hamonis
Hormesion
Horcus
Hysmeri

I

Iacintus
Iaspis
Iris
Ideus
Iscistos
Indica
Iudaicus
Iouis gemma
Ion
Iagumitia
Ierarchites

K

Karrates
Kamma
Karabe
Kenne
Kimedini
Kinocetus

L

Lichinus
Lincurius
Lincis
Lippares
Limatie

Lacteus
Leucoptalmus
Lisimacus
Leucocrisos
Limoniates
Ligurius
Lignites
Lepidotes
Limphicus
Ligolinus
Lauraces
Lychnitem
Lazolus
Litos
Leucostictos
Lunarius

M

Margarita
Medus
Marmor
Murina
Mirites
Malachites
Memphitis
Magnes
Magnasia
Marchasita
Medea
Mirion
Mitridax
Melites

N

Nitrum
Nicolus
Nasomonite
Nemestitis
Nose

THE MIRROR OF STONES

O

Onix
Onicinus
Opalus
Obtalius
Orites
Orfanus
Obsius
Obstracites
Ophites
Ostratias
Ophicardelon
Okitokius
Onagari
Ombria
Ornicus
Olea

P

Prassius
Panthera
Ponthica
Peonites
Pirites
Phrigius
Prophirites
Podros
Panibonis
Punicus
Preconissus
Pavonius
Pumex
Paragonius
Pheonicites
Philoginos

Q

Quirinus
Quaidros

R

Radaim
Ranius
Rubinus

S

Saphirus
Smaragdus
Succinus
Sardius
Sardonix
Selenites
Samius
Smirillus
Sirius
Solis
Sagda
Sandastros
Sarcofagus
Sifinus
Siderites
Struxites
Samothratia
Sanguineus
Senochitem
Spongius
Sedeneg
Sirites
Specularis
Sanctus Lapis
Sarda
Sinodontides

T

Topatius
Turchion
Trachius
Thirsitis
Tale
Tartis
Tegolitus
Trapendanus
Telitos

V

Varach
Vernix
Veientana
Vulturis
Virites
Vatrachius
Vnio [Unio]

X

Xiphinos

Y

Yectios
Yarinus
Ysoberillus

Z

Zumemellazoli
Zirites
Ziaraa
Zimilaces
Zoronisios

Chapters of the Third Book

The third book discusses engraved gems; the manner in which nature engraves stones with images; and who were the first sculptors, and what influences such images have on us, and what their virtues are.

The first chapter is on the difficulty of the science of stone engraving.

The second chapter lists, according to tradition, the first sculptors, and by what manner their art was passed down, as well as the best contemporary sculptors and painters.

The third chapter discusses which images were created by nature, which not, and which ones have virtues.

The fourth chapter proves and articulates the virtues of the sculpted image in accordance with the particular virtue of each stone, and how its effect is not totally lost over time but is appropriately replaced.

The fifth chapter examines how the universal and particular virtues are said to be in images, and how they are indicative of the virtues of stones.

The sixth chapter concerns images that are not astronomical, and how we can attain knowledge of them even though it is difficult.

The seventh chapter discusses how the images engraved on gems are said to have effect.

The eighth chapter discusses the virtues of the signs of the first triplicity, when found engraved on stones.

The ninth chapter discusses the virtues of the signs of the second triplicity.

The tenth chapter discusses the virtues of the signs of the third triplicity.

The eleventh chapter discusses the virtues of the signs of the fourth triplicity.

The twelfth chapter discusses the images of all the planets.

The thirteenth chapter discusses the figures or images that are similar to the constellations of the heavens and their influence.

The fourteenth and last chapter treats magic images discovered by various learned men, and what their virtues are, as discussed by the same.

BOOK 1[1]

Chapter 1. Investigating the Nature of Mixed Matter Substances, and Especially That of Stones

All philosophers, my most Illustrious and Magnanimous Caesar, have no doubt that all things produced by nature under the moon's orb are composed of four elements: and, depending on their species, some partake more or less of these four elements and consequently of their virtues. This is confirmed by that highest of philosophers, Aristotle, in his third book, *On the Heavens and the World* [or *Cosmos*], whose exact words are: the elements are principal bodies, from which other bodies are created.[2] The same author states similar things in the second book of *On Generation and Corruption*: it is necessary that mixed bodies be made of a mixture of all four elements, and not of only one.[3] This was also the opinion of the most illustrious prince of physicians, Avicenna, who said thus: elements are bodies—they are the principal parts of the human bodies and of other things—which cannot be divided into bodies of various forms without the mixing of those elements generating different species.[4] Therefore according to this source and to many others which we will for now omit, it may be concluded that elements are those things that participate in and give essence to mixed or composite matter. But to further investigate the manner in which the elements participate in creation would be a long and vain effort, because this subject is variously discussed in [Aristotle's] treatise *Physics*[5] and especially in the sixteenth difference by *The Conciliator*.[6] And given that these two elements, water and earth, have more body and more solidity than the other two, we can here say that mixed stones contain more of these two elements than the other two.[7] But because there are two types of minerals, some that are fluid and liquid and some that are not, we may say that those that are fluid or liquid contain more water, as metals do, as is known from Aristotle's *Fourth Book of Meteors*.[8]

True stones do not liquefy, even though they abound in watery humor, because they are mixed with dry earth. Therefore, setting aside those bodies that liquefy, such as gold, silver, and similar metals, we will only write of stones. And as our principal foundation we will remit ourselves to the authority of the prince of philosophers [Aristotle],[9] who in his *Book of Minerals* says the following: the elements of stones, then, are either claylike or unctuous, or of a substance wherein water prevails,[10] where clay is understood to be the earth element. Nor shall we neglect the authority of the great philosopher Albertus Magnus, who in his *Book on Minerals* states that stones are of two types: some abounding in water mixed with dry earth, such as crystals, beryls, and the like; and some [mixed] with a dry aqueous element, but with a prevalence of earth, such as marbles, jaspers, and similar. However, those stones wherein water and dry elements abound should be more appropriately called gems from the Greek *gemmo*, which in Latin signifies *resplendo*, for these stones are resplendent. And as mentioned above, some stones that abound in dry earth do not liquefy, and they sink when thrown into water. Thus, if they were free of such dryness, they would float in water, as well as liquefy, as ice: there are no stones that do not sink, because of the nature of the earth element, which is dry, unless perchance that stone is porous, that is, full of air. But true stones, which are richer in the earth element, are hard and opaque, yet they are not wholly without the water element, as may be read in the aforementioned book of Aristotle, *On Minerals*. His words are thus: pure earth does not become stone, because it does not have an increasing but diminishing effect, that is, its dryness does not allow it to solidify, so that stones are made by mixing water and earth elements.[11] Water is understood to be a humid and unctuous, or rather viscous, humor proportionally [mixed] with the earthy element through heating, which dries it. Different stones are produced according to the proportions of each element, that is, according to the quantity of humidity mixed with dry earth, wherefore it often happens that this humidity is not sufficient or subtle enough to permeate the earth element. It is because of this deficiency that the earth element does not turn into stone. This explains why in stone quarries one often finds among the stones great thick earth separating them: for if there had been sufficient and proportioned humidity, the stone would have been continuous, as it happens in many places, where we see mountains made of one [solid] stone. And many times this same humidity is not proportionally fluid, even though it is sufficient in quantity. And thus it stagnates more in one part than in another, and when it condenses because of the heat, it creates knots in the stones. Hence such knots appear in stones, as there are in the mountains of your domain. Because of great humidity, these knots can just barely be cut or be broken, as it happens with other stones that abound in water. Therefore, to conclude, the substance of stones

48 THE MIRROR OF STONES

is made of elements, and as it has been said, some abound in the watery humor together with dry earth, whereas others abound in earth alone or less in water, so that these stones may not be wholly free of other elements, as we will discuss in chapter 6 when we shall consider the color of stones.

Chapter 2. On the Effective or Generative Causes That Produce Stones

[Learned men] discuss the effective or generative causes of stones in a variety of ways. Yet, setting aside futile opinions, and proceeding with the truth, we stand with the great philosophers in asserting that the effective or generative cause is a certain virtue found in minerals, which exists not only in stones, but also in metals and in those substances that are halfway between the two.[12] And since we do not have a name for this virtue, philosophers call it the *mineralizing* virtue. In fact, things that cannot be explained by their proper name can be understood by comparison; even though we cannot adduce examples by which we can prove how this virtue exists in minerals, as Aristotle asserts. Yet, we use examples not because the thing [mineral virtue] is so, but because through examples, learners come to understand it. Thus, through the example of sperm, we may account for how the mineral virtue that we speak of generates stones, and how it operates in those stones.[13] We say that animal sperm is nourishment in excess that descends from its own ducts to the sperm ducts. The effective or generative virtue infuses the sperm itself, by means of which the spermatic matter is rendered generative, as it is said in *Physics*. Thus this virtue does not operate through the modality of essence, but through inherence. Just as we say that the artificer may be found within that which his art makes, similarly, we may say that in matter suitable to generating stones there is a virtue that shapes—that is, generates—a stone of this or that species, according to the disposition or exigency of that matter, and of the place and influx where such ready matter is found.[14] Some call this virtue a celestial virtue,[15] by which Plato means that the celestial virtues infuses are imparted according to the merits of the matter.[16] It is also said in *Physics* that every virtue that forms or generates anything whatsoever has the proper instruments to carry out that operation. Therefore, following Aristotle's opinion from the *Book of Minerals*, we say that the proper effective or generative virtue of stones, found in the stones' matter itself and called mineral virtue, consists of two instruments; these instruments may be [further] diversified according to the different nature or species of the stones.[17] Of these instruments, one is the digestive and extractive heat—that is, it dries up

humidity, which generates the stone's shape through a coagulation [process] that hardens that part of the earth element that had begun as unctuous humidity. And this heat arises from the stone's own mineral virtue, which Aristotle calls the drying hot cause. Nor is there any doubt that if this heat were not regulated, but were excessive beyond the stone's own nature, it would turn it into ashes, and if the heat were not strong enough, it would not desiccate [the humid element] well, so that the heat would not be able to shape that matter to the good and perfect form of a stone. The other instrument is the constrictive cold found in the humid aqueous matter, expelled by the dry earth; this is the constrictive cold [property] of the humid [element]: because through such constriction humidity is forced out; neither does it remain in matter, unless it is necessary for its existence; and Aristotle refers to this as the drying and congealing virtue of the earth [element]. And this is the reason that stones cannot be liquefied by drying heat, as metals are liquefied. For in metals this humidity is not wholly expelled: it is because of this humidity that the matter of metals can be liquefied. Hence, we say that the digestive and extractive heat of the humid [element], and the cold constrictive part of the humid [element], expelled by the dry earth, are the proper instruments of the generative virtue, or mineral virtue of stones. And this is what Aristotle says in his *Book of Minerals*, that stones are made in two ways, either by congelation or by conglutination, as was mentioned above.[18]

Chapter 3. On the Substantial Form of Stones

We shall not say much now on the essential form of stones, as we reserve treating this subject in the second book, where we shall also discuss the virtues found in the stones themselves: which forms give its specific quality to each stone and which virtues are derived from it. Therefore, at present we will only report the Philosopher's authority:[19] we say that the essential form of stones is that stone's specific essence, which results from the mixing of elements in specific proportion, resulting in a specific type and not another; through this essence, as we shall see in the second book, stones have specific virtues. Yet this form does not wholly emanate from matter, neither is it wholly external to matter, but something divine above created the matter in which it is infused and the celestial virtues from which it emanates. We [may] therefore assert that the substantial form is the simple essence of that stone, and that a stone's virtues are manifested through it. These virtues vary not only according to the several types of stones, but also according to species, either because of the qualities of its place of origin, or because of the purity or impurity of its matter, as it happens in living things.

Chapter 4.[20] On the Places Where Stones Are Generated

Given that place necessarily plays a role in the generation of all things, so that without it nothing is produced, we shall now discuss the places where stones are generated.[21] These places not only characterize the various species of stones, but in each species also cause varieties, as one may learn from the writings of Hermes,[22] who says that stones of the same species vary in potency and in material essence according to the variety of location in which they were generated, and who explains that the variety of climates, by which he means the straightforwardness, or rather the obliquity of the rays of the stars,[23] which have influence on inferior bodies. We say therefore that there is not one specific place that generates stones, since each part of the world generates various and different stones. Neither does each specific element boast a specific place, seeing that certain [stones] are generated in earth, others in water, as well as in other various places, as we know from Solomon's *Book of Precious Stones*,[24] wherein he says that there are various kinds of stones and that they are created in various places: thus some are produced at sea, some in various soils, some in rivers, some in the nests of birds, some in the entrails of animals, and others in the kidneys of dragons, snakes, beasts, and reptiles.[25] And stones are not generated only in the aforesaid places, but also in the air, as we know from philosophers, and especially from that greatest of philosophers and greatest of teachers of our time, and my most worthy master Gaetano of Thiene[26] who says in his *Comment on Meteors*, at the end of the second treatise of the third book, that stones can be generated in the air, when an exhalation has large particles of earth mixed with a great viscous humidity.[27] Therefore when the more subtle parts are resolved and the earthly parts are condensed by heat, the stone is formed, and by reason of its weight it comes down to earth. In our own times a stone of great size fell from the clouds around Lombardy. Pliny, too, in chapter 60 of book 1 [of his *Natural History*] wrote that Anaxagoras foretold that a stone would fall from the sun, which happened around the river Egos in Thrace; this stone was the size of a small cart, and of a rather burned color.[28] I do not marvel at this, nor do I marvel when Aristotle says in the *Book of Minerals* that a piece of iron of notable size fell from the air.[29] But as it is understood in *Physics* that because of their quantity, light, movement, and placement the stars govern this inferior world according to whether each matter is generative or corruptible; and as the virtue of all the stars is found in every part of the world, wherever there also is appropriate matter, there shall also stones be generated, wherefore we cannot indicate any specific or appropriate place. Nonetheless, it is still necessary that the virtue of the place that generates a stone be itself composed of three virtues: the first

being the virtue of the mover, which moves the world;[30] the second is the virtue of the moved orb, which many consider being part of that world, as are all the planets and constellations; the third is the elemental virtue that is the principles of heat, cold, humidity, and dryness, or a mixture of these.[31] The first virtue acts as form directing and shaping everything that is generated: for example, this virtue is imposed on those inferior sensible things, like the virtue of [an] art is imposed on matter by workmanship. The second has a similar effect as that which is wrought by the manipulations of the hands of a craftsman [*artificem*].[32] The third is akin to the operations of the instrument moved and directed by the hands of the craftsman so that the work begun may achieve perfection. It is from this, as Aristotle says, that we may posit that the work of nature is the work of the intellect.[33] Therefore we say that stones are generated where unctuous earth is mixed with reflected vapor, or where the strength of the earth absorbs the nature of water, and changes it, strongly inclining it to dryness. Thus we conclude by saying that the appropriate and most apt place to generate stones is earth that has a dense surface with sufficient humidity, for vapor cannot be lost through such density. Because thin, sandy, and muddy earth is of an opposite type, if stones are generated in these places, they are imperfect. Oftentimes even water possesses great virtue for the generation of stones; not that water is the best place, but when water runs through mineral veins it takes on the virtue of these minerals, as we see in thermal waters that are hot. Thus, when this water is poured on the earth, or things are placed in this water, we see it turn into stone, as Albertus Magnus states.[34] This may also be clearly observed in thermal baths where all appears to be petrified and the petrified deposit continues to grow. This effect is also mentioned in Aristotle's *Book of Minerals* wherein he says that water becomes earth when the qualities of earth overcome it, or when, on the contrary, earth is created from water.[35] But we need not adduce far-fetched examples, for this phenomenon can be clearly seen, oh magnanimous Caesar,[36] near your own city, at the fount called del *Capriolo*[37] wherein all the channels through which water flows become stone, so that they become blocked and water cannot flow through it.

Aristotle also says in his aforementioned *Book of Minerals* that the strength of the virtues of the mineral element is sometimes so strong that it turns the water into stone, and everything found therein. And it is for this reason that sometimes in many stones we find parts of aquatic animals and other things changed into stone.[38] And on this we could speak for a very long time, since petrified things have been found sometimes on earth and sometimes in water, as Albertus writes of a tree found on the shores of the Baltic Sea,[39] which was petrified along with a nest and the birds in it.[40]

Chapter 5.[41] Of the Accidents of Stones, but First of Their Bad and Good Composition

Since in the previous chapters we have discussed the generative process of stones, the nature of their substance, their form and the places where they are generated, now, to fully complete the discourse on all that pertains to them, it is time that we inquire into their accidents, for even accidents lead men to the knowledge of the subject by which they are categorized, as is understood by Aristotle's *Book of the Soul*.[42] Yet, since accidents in stones are many, we will for now speak only of their good and bad composition, which causes a variety of different stones. Hence a bad composition—that is, a stone's bad quality—is sometimes caused by humidity, sometimes by the earth element, sometimes by a fault in the heating or cooling agent that is at work in them, and sometimes by the unfit locale [in which they are generated]: all of these things, according to their virtues, cause various types of gems. Therefore if the earth element were to be inappropriately dry and not well mixed with humidity, or if there was not enough humidity, or if the place in which such matter was found was similarly porous, then the heat caused by the stone's effective virtue, and necessary to its production, would evaporate, and so it [the heat] could not break down well parts of the earth element, and thus not properly mix with the humid element. Hence this stone would remain sandy and grainy to such an extent that it would very easily break apart and be returned to sand. But if such a place were not porous, and if it should retain heat tempered by sufficient humidity, such dry earth element would generate hard, unbreakable stones, though sandy in appearance: as one can clearly see in porphyry, flint, and other stones, in which may be seen small grains of sand, varying in size and color, depending on the dryness of the earth and the heat that was at work. If this heat should be superior to the humid element, it would burn those parts of the earth element, and so the stones would not be solid and appear [as if made by] little stones. If, instead such dry earth element should absorb the viscous humidity, and be therefore immutable, and even if it should have regular heat from the mineral virtue but would be in a place conducive to the generation of stones, this earth would have no unity or continuity, rather it would be divided up into stones of various quantities and colors, according to the diversity of matter, which contributes to the essence of those stones. And if such humidity were to be in part mutable and sufficiently hardened by regulated heat, and if it were in a suitable locale, and in part viscous, there would be the creation of a solid stone of various colors and parts, as if the parts of such stone were glued together; as it may be seen in many places in the church of the patron saint San Marco in Venice; similarly in many places throughout Rome and on the door of Your Highness's study[43] and even

in half-sawed columns, in which it is possible to see a diversity of colors and marvelous things, as we will say further ahead. Yet, a good composition is achieved through the opposite processes of the aforementioned: that is, it may be achieved when matter is not very dry, humidity is proportionate and fluid to every part of the earth, the heat is proportionate and regulated by the mineral, or by the effective virtue of the stone itself, and if it be found in a place deemed appropriate and apt because of its solidity and rarity. If these things are so disposed and ordered, they generate uniform stones; these stones have an exceptionally good composition and are often shiny depending on the mixture of earth and water, or on the proportion of air element. Conditions contrary to what we just mentioned will produce opposite results. However, the perfection of stones is very much due to proportionate heat, being that this is the operative principal element through which diversity happens in said stones: and especially in those in which earth is the matter's principal element. But in stones in which the watery element abounds and is the principal matter, there are not many differences because their operating virtue is the cold and dry earth. Hence, because of their aqueous element, all parts of such stones are well mixed together, being that the liquefaction is well distributed and such parts have great clarity and hardness, too.

Chapter 6.[44] On the Transparency and Opacity of Stones and Their Colors

Transparency and opacity cause many differences in stones, for it is through their means that colors appear in them, as we learn from the Philosopher [when he writes] about it in *On Sense and the Sensible*: he says that color is the extreme expression of clarity in any given body.[45] Aristotle's commentator, Averroes, says the same thing in the same place: color is caused by mixing a lucid with a diaphanous body.[46] Therefore, before we discuss some of the accidents of color difference in stones, it is necessary that we state the reasons why transparency or opacity happens in stones, and what transparency and opacity really are. We first assert that transparency is the material existence of a stone, accompanied by clarity or a kind of brightness, and that opacity is accompanied by dimness and density. Thus, it follows that a stone is transparent when a number of causes merge in its matter giving rise to clarity, such as fire, air, and water. On the contrary we label a stone opaque when in its matter the opaque is more prevalent, such as the earth element. Thus, having said that these causes are perceived by [human] sight solely through color, it is necessary to properly label such colors. As said before, since color determines transparency and opacity,

54 THE MIRROR OF STONES

and since the latter are highly in contrast [to each other], and it is these that we use to classify the colors at each of the extreme [end of the spectrum]. So white is used to label transparency and black opacity. Thus we say that white is produced by the mixing of bright fire with the most diaphanous of elements—that is, air. Black is produced by the mixing of opaque fire with the least diaphanous of elements—that is, earth. But since these two colors, the white and the black, are in extreme opposition [to each other], it is necessary that they should partake in [the creation of] intermediate colors, and according to whether this participation is of a greater or lesser [degree], it results in various colors, which are of three types: namely, red, green, and yellow. And so, all the stones between the extremes [opposite ends of the spectrum] mentioned above are reduced to one of these colors, and are contained in these just like a species under its genus. But to arrive at a perfect notion of these colors, it is necessary to declare how these intermediate colors are caused in stones, and we will begin with red. We say that a red color happens in transparent stones, when a bright smokiness and a subtle fire are infused in a transparent luminosity, and all such stones are said to be hot;[47] and to this kind belong all species of carbuncles, such as balas, ruby, jacinth, and all the others, which are all similar for their red quality but differ depending on whether they partake more or less of the smoky fire and of transparency. In the same manner we may speak of the transparent yellow color, whose various species are produced according to its subtle and clear earthiness, burned and altered by heat. Green is caused by the transparent watery quality along with that of burned earth, which appears differently in stones depending on the [preponderance of] watery or earthy quality, as in the two middle colors mentioned above, and green varies according to this difference and thus there are various green colors in stones. Colors may also vary within the same stone, as it happens in Panther and Agates and many others, whose variety follows solely from a diversity of substance, or matter that concurs to its existence. Thus, as Solomon, whom we cited above, says: color is diversified in stones because there is no color to be had in heaven, air, earth, sea, rivers, herbs, [or] trees that is not also found in stones. There is much to be said on color, but it must be omitted for the sake of brevity and not to tire out the reader; and given what has already been said of these particular colors, we may understand the others. In those stones that are not transparent, whiteness is produced by the mixing of the thin earth element with water; black is made by the burned and smoky earth element. And just as stones at the extreme [end] of opacity—that is, those that are not transparent—abound in the earth element, similarly all the middle-range colors of those opaque stones—that is, vermillion, yellow, and green—abound in the earth element as they participate in the nature of the extremes. Earth is mixed with fire, air, and water, and thus they produce colors in the middle range:

as we have said of transparent stones, which abound in water. And still, opaque stones may be more or less clear, depending on [their having] more or less water or air, as these are the elements that cause transparency. Colors of opaque stones may vary within one substance or essence of a specific stone, depending on the diversity of the parts that compose each stone, and may also vary according to the strength of the heat element, as we said in the previous chapter.

Chapter 7.[48] On the Hardness or Softness of Stones

We assert that the hardness or the softness of a stone happens for two reasons: first, it depends on the matter of the stone itself; second, it depends on the effective[49] or mineral virtue of said stones: as we have already said in the chapter on the mixing [of elements], or on the good and bad composition of stones. Starting with matter, we state that when this matter is well mixed, this is due to the aqueous [water] component.[50] Hence, stones whose composition abounds in the water element are equally very hard and transparent. All gems with this composition cannot be easily filed down, except for the topaz, as we will say later on. Of those stones, instead, in which the earth element is more abundant, some are very hard and some not. But they are not as hard as the aqueous stones, for reasons stated above. Those stones that abound in water mixed with earth in the proper proportions are also hard. And because of the humid element, even though they may be opaque, they have a bright surface, almost transparent. These stones are: porphyries, serpentines, and similar; all of which cannot be carved with iron nor scarcely with steel. And those stones abounding in earth, but not with the appropriate humor [humid element], are soft. According to their effective virtue, they become soft or hard: therefore, when the virtue is not perfectly proportioned to the matter in drying the excessive humidity, they do not become hard, since hardness comes from tempered dryness, as all experts say. Therefore, as we have said, and we will say, topazes are not hard since their effective virtue lacks in dryness; that is it cannot dry humidity, which thus remains in excess and by virtue of which [these stones] do not become hard. And as we have said of the topaz, so it may be said of all other stones, whose effective virtue has a diminished heat and dryness. Here many things should be said: but for now, we end, and we say that hardness comes from a tempered dryness, which must be regulated by the effective virtue with a good disposition of matter and place: as we have said in the fifth chapter of this first book. Many accidents happen to stones because of these opposing elements: therefore, some stones are fire-resistant, some are burned by it, and some are split by frost and turned back into dust. Some are rendered hard by air, and some are eroded by

it. Such similar and different effects are wrought on stones by water and by sun [heat]; and by other extrinsic events that cause change: the reasons for all of this would be needless to enumerate at present, since they may be easily deduced from what has been said, and from what will be said,[51] especially by those with intellectual acumen, since all these things come together in a creative and imaginative mind.

Chapter 8.[52] On the Heaviness and Lightness, Density, and Weight[53] of Stones

The heaviness and lightness of stones are the result of two causes. One of which stems from bad composition, accidents that occur more often in those stones whose substance is earthly: and this happens because of a reciprocal bad mixture of earth and water elements. Therefore, when the effective virtue dries up those watery parts—that is, it dissolves those that were not mixed well with the earth—there remains in the stones some porosity, and consequently they become light. This can also happen in those stones whose essence has too much air or fire.[54] Such lightness, produced in said manner, happens less in opaque than in transparent stones, and still nonetheless this heaviness is first caused in opaque ones by the previously mentioned opposing causes. However, such lightness is not natural in stones, which usually cannot float in water, because of the earth element that contributes to the essence of the stone. And even though some types of wood are heavier than stone, still they do not sink in water as do stones. The reason is that wood does not possess the same earthy dryness [as do stones], and therefore we can say that solidity and porosity result from the same causes that produce lightness or heaviness. And even though still many other events may happen [to cause a stone's weight], these shall suffice for the present, since from what we say and have said thus far,[55] we may trace a cause for all the accidents that may occur, and these may be known especially by those who are expert in physic [medicine], since these things depend on it [that knowledge].

Chapter 9.[56] How to Recognize Natural and Fake Gems

Since there are nowadays many forgers of all sorts of things, especially in the art of gems because of their high value; and since few are the experts whose knowledge of stones is based on long familiarity, particularly of stones already set. Thus, to ensure someone is not tricked, and not keep silent on matters that might be of help, we shall conclude this first book by saying a few things on this

matter. We say that stone forgers have many tricks. First, they make gems of lesser value and of a particular species appear to be of another and thus of greater value [by substituting one type of gem with another].[57] They make a balas [ruby] appear to be an amethyst by piercing it, and filling the hole with tincture; or by setting it in a ring first thinned with a slice of balas ruby, or by making diamonds with a citrine-colored sapphire or with a beryl, and tying it all with a tincture, thus passing it for a real diamond. And many a times they fabricate a gem whose surface is made of granate, and its center made of crystal, then they glue them together with a certain tincture; when the stone is set into a ring it appears to be a ruby. And so many other tricks may be used to create various stones, all of which are known to the experts. Thus, when stones are already set in rings it is difficult to determine [their authenticity]. Therefore, when there is any doubt, it is necessary that gems be taken off their ring settings, and thanks to what we shall say in the second book, we may easily judge them [and distinguish the real from the fake]. Deception may also happen in another manner, such as when a fake gem is made to mimic the shape and color of a real gem. This deception may be achieved in many ways: especially with glass, with enamel, and with a certain stone with which our master glassmakers whiten their vases, to which may be added various colors that are then sealed by fire: as is known by those who work with these materials, and as I myself have seen many times these stones made into emeralds that were not that bad for their intended use. These fake stones may be recognized in a variety of ways. First of all, with a file: being that all fakes will bear its mark, while real ones will resist it, except for the emerald and the western topaz, as we will say in the second book. Therefore, forgers choose to counterfeit especially these stones as they are affected by the file, and thus fakes cannot be recognized by [this expedient]. The second manner by which natural [authentic] gems may be recognized is their aspect, as the more they are gazed upon the more the eyes are delighted with them; and when they are brought close to a candle's flame they shine clearly and appear fulgent.[58] While in the case of those stones that are not natural, or artificial, the more they are gazed upon, the more the eyes are displeased and wearied, as the stones' splendor appears to progressively wane, especially when they are placed close to a candle's flame. Stones may also be recognized by their weight once out of their ring setting: natural stones, except for emeralds, weigh more than artificial ones, which are light.[59] There is another proof remaining that never fails: and it is preferable to all the others; that is artificial stones do not remain intact in fire, but they liquefy; they lose their color and shape as they melt away in a strong fire. And, in fact, it is impossible that in some of their parts do not appear some bubble-shaped points, that are caused by the fire's heat, which will reveal the disproportion in their composition and their difference from those true stones

made by nature. Such fake stones can also be made of additional material other than glass: namely by some minerals, such as salt, ink,[60] metals, and many other things as I have seen and as many learned men have said: especially friar Bonaventura[61] in the second book of his small treatise,[62] which says that knowledge of stone and their species is acquired through experience and continued use: as those who are lapidaries by profession know very well. And here we shall put an end to the first book.[63]

BOOK 2

Chapter 1. Proemium

Having finished, oh most illustrious Prince, the first part of this book of ours in which we have discussed the generation of stones, and their accidents in general terms, now in this second [part] we shall speak of the individual stones and begin [discussing] whether there may be virtues in these same stones, and how they transmit these qualities to us, by putting forth the opinion of the ancients, along with the true judgment of philosophers. In fact, I shall name those learned men, from whose works we compiled this book, so that readers may have confirmation that what we have written was taken from them.[1] And since stones are first known by sight rather than by their names, and since we come to name stones by their colors, I shall order them in alphabetical order by their color along with the stones' proper names, so that, once their name is known, their virtues may also be known by reading the proper entry.[2] Lastly to complete this book we shall place the names of each stone according to their alphabetical order. We will also list their colors, the places in which they are found, and lastly their virtues as ascribed by learned men.

Chapter 2.[3] Whether Gems Have Virtues: Various Opinions

Among the most acclaimed doctors, disagreements on whether stones possess any virtues are considered neither small nor futile, since some say that stones have no virtues, which is false. Therefore, we will set their opinion aside since they are far from the truth. Others assert that stones contain only elemental virtues, such as heat, cold, hardness, and volatility; and that such conditions, which are inherent to their composition, come from the elements that produce

them. Thus they deny that stones contain any kind of virtue produced by the specific form or substantial essence of a [specific] stone,[4] such as to repel poisons, to achieve victory, and the like. They support their reasoning with frail arguments and methodology by saying that nobler things must perforce have nobler virtues, and since animated beings are nobler than the inanimate, it follows they have nobler virtues than the inanimate do; or by saying that since animate beings lack these virtues, it follows that the inanimate do not have them either. They make use of other, similar explanations that, for the sake of brevity, I here omit. First [of all], experience bears out against such reasonings, as we have seen stones' virtues with our very own eyes. Can we not see that the magnet attracts iron?[5] And that sapphires cure anthrax illnesses?[6] And other similar phenomena in many other stones? Only a madman would negate those things clearly known as the first principle. Further on, I will argue against these deniers by using a known topos: what most proclaim to be true, cannot be wholly unfounded, and since both ancients and moderns have always thought that there were virtues in stones, we must then believe that they exist, as is also believed by many doctors. On this subject, Solomon's authority is of great import, as when he says that stones possess various virtues: some bestow the favor of noblemen, some are resistant to fire, some render men amiable, others wise, others invisible, others repel lighting, some repel poisons, some protect treasures and increase riches, others make husbands love their wives, some quell sea tempests, others heal illnesses, others protect the head and the eyes. Thus, to conclude, whatever need may be devised by man may be aided by stones' virtues. It is not less important to know that in some stones sometimes there is only one virtue, sometimes two, sometimes three, and sometimes many: and these virtues do not stem from the stones' beauty, since there are some very ugly ones, which have great virtues, and there are some that are very beautiful, that have no virtues at all. Therefore, we may conclude, along with many famous doctors, that virtues may be found without a doubt in stones, as well as in other things. Yet, there are controverting opinions on how this comes about. According to the Pythagoreans, the soul infuses all things with virtues; they also asserted that stones and all inferior things were animated.[7] Thus they said that souls could enter into, and also exit from, any matter through animal operations: that is in the same manner in which the human intellect extends to [encompass] all intelligible things, and the imagination to all things imaginable. They asserted that it is in the stones' [nature] for their souls to reach out to men from wherein they reside [within the stones], and to impress their virtues onto men's substance. And, thus, they stated that virtues resided in souls and that they operated through the soul's mediation, in the same way as fascination is wrought by the eye through the soul. They also said that the soul of a man, or of any animal, can enter another

man, or animal, through sight, and hinder the actions of that animal. This fascination was also thought to proceed from other means besides sight, since seeing happens by receiving and not by emitting. Virgil is of this opinion when he says in the *Bucolics: I do not know what evil eye bewitches my tender lambs.*[8] This kind of fascination is seen not only in men, but also in brute animals, as Solinus[9] and Pliny state;[10] I myself have seen in Italy that when an [unseen] wolf gazes at a man, the latter's voice becomes hoarse, nor can he scream, even though earlier he had not experienced such a problem. This kind of fascination, as we said before, cannot happen only through sight, but even through other causes— that is, through the fascinator's soul. Democritus, too, shared this opinion, when he said that the gods were in everything.[11] Orpheus similarly said that gods and divine virtues were found in all things and God was nothing other than that which shapes all things and is found in all things.[12] And thus, he thought the gods were souls and attributed virtues to things through the mediation of the soul; [the latter is] a false and absurd belief as stated by all philosophers.[13] Therefore, leaving aside all such empty opinions, we come close to the truth. But first we must answer those of contradicting opinions whom we mentioned above: let us leave aside those who deny that there is any virtue in stones, which is absurd and contradicts all philosophers. But let us answer [instead] those who affirm that there is only the virtue of the elements in stones, when they say that the more noble virtues should exist in things that are more noble, et cetera. I grant that this is true and state that in animate beings there are nobler virtues than in stones. But as to brute animals, this much may be said: there are many brute animals in which we may see [the ability to perceive a] change in time or air: as we know from many learned men, who have written of such changes in the air particularly that most famous knight, Sir Nicholas de Comitibus Patavinus, the greatest astronomer of our times, who asserts in chapter 7 of his book *De mutatione aeris* that there are many animals that foretell the changes of the weather by their singing or assembling together.[14] Don't cockerels mark each of the day's hours with their crowing? Such animals demonstrate that virtue is not found only in superior things, but that great virtue may also be found in inferior things and thus we may deduce from the effects produced in them [animals] that there are greater virtues in men, as we learn from physicians' books, all of which I estimate to be nobler than the virtues of stones. From these we can conclude that their arguments have no basis and no force or efficacy. Against the third group of dissenters, I will answer in short that virtues found in stones do not proceed from the soul, nor from the elements alone; instead, as we will say further on, they proceed from the very species or substantial form of the stone as we will clearly show through the writings of philosophers.

Chapter 3. How and From Which Place Stones Have Their Virtues

Having greatly digressed: it is now time to return to our first argument so as not to bore our readers.[15] It is certain that there are virtues in stones: but until now we have not shown from whence these virtues come. Some say that both the stones' unique and complex virtues issue forth from those elements that formed them. They support their statements with this reasoning alone: anything that is composed has the virtue of the composing elements, just as the river water bears the imprint of its source. But we have already made clear that stones are composed by elements. Thus all that is found in stones comes from the elements alone and not from any other virtue. Plato and his followers say this is all due to the ideas; that all composite bodies, of whatever species they may be, possess an idea that infuses virtues in them: and how much such mixed, composed bodies partake of the elements' purer substance depends on the idea infused in pure matter, which induces a greater perfection. But precious stones are such that their ideas produce in them a greater virtue than in other composite bodies that are not so pure. And thus they attribute particular virtues to stones by means of the intervening ideas.[16] Hermes [Trismegistus], and many other astronomers,[17] considering the nature of superior spheres, say that all the virtues in things inferior emanate from the stars and from the figures in the heavens;[18] and according to whether the composed body is made by more or less pure elements: so the virtues of the stars and of the figures in the heavens infuse more or fewer virtues. And since precious stones have the purity of the elements and have almost [so to say] a heavenly composition or mixture: as in the sapphire, in the balas ruby, and many other stones: it is clear that these stones have more virtue than composite ones that are not composed by such pure elements. Hence Hermes [Trismegistus] says this on the causes of the virtue of stones: we know without a doubt that the virtues of all inferior bodies come from the superior.[19] Therefore the superior bodies with their substance, light, position, and movement, and even with their image, infuse the inferior with all the noble virtues found in stones. It is thus made clear by these words and by those of Ptolemy that the virtues of stones come from the stars, from the planets, and from the constellations through the mediating purity of their composition.[20] We could propose further opinions on the matter, but since they have no substance we will leave them aside, nor shall we offer any more arguments to discredit [the opinions] of those mentioned above for none come nearer to the truth than that of Hermes [Trismegistus] and other astronomers, who have always asserted that inferior bodies are governed by the superior: as it is also firmly believed by all the philosophers.[21]

Chapter 4. On the True Opinion of the Virtues of Stones[22]

Even though the opinions thus far brought forth may still appear true, they are not philosophical, since philosophers state that virtues proceed only from the form and substance of a thing; this Aristotle states in the first book of *Physics*, where he says that matter with form is the cause of all things that are made into an object; just as matter, or substance, is the cause of all occurrences.[23] Albertus Magnus, who was a proficient philosopher and a close observer of nature, is of the opinion that the virtue of stones comes from the stones' very own species and substantial form. Therefore, there are some things in composites that are caused by the virtues of the elements—such as hardness, weight, and [other] similar things—and other things whose specific virtue is caused by a stone's own species. For example, the magnet owes its hardness and iron color and similar qualities to the virtues of its composite elements. But that its ability to attract iron is due to the magnet's species, which shows us that this species is an aggregate of matter and form: as said by the commentator[24] in his first book of metaphysics where he asserts that a species is not just form but all the aggregate composed of matter and form: which gives the individual essence to this matter.[25] Therefore, the essence of all things has its own operation and specific virtue according to the species in which it is formed and perfected into a natural being. And all composed bodies are the instruments of their own form: therefore, if form is lacking, the whole composite is corrupted or destroyed, thus showing that form is contained in matter, as its divine and excellent part. Therefore, form is something divine, below the celestial virtues from which it issues forth, and yet above composite matter, into which it is infused. And thus form is a simple essence only operative on one thing: that one proper to its own species, whichever that may be. Therefore, one thing [form] may affect only one thing [species], since one is productive of only one. We may also consider form in a different way: as a celestial virtue multiplied in inferior things by the images and circle of heaven, which is divided into twelve signs with their stars over the horizon of the thing in which it is infused. And, therefore, form takes many shapes, according to the elemental virtues in which it is molded, and according to those natural powers that contribute to its simple essence. And so, form will produce many effects, even if perhaps it may only have one operation. And from here it follows that not all things are limited to one virtue by its known operations. But only that form that shapes matter is more powerful than any other form: even though very often the proper form might not be visible and operate because of indisposition of the matter. Therefore, Hermes [Trismegistus] speaking of stones says that stones of the same species vary in power because of the commixture

64 THE MIRROR OF STONES

of matter and because of their place of generation through changes in the directness or obliqueness of the rays that correspond to those places, so much so that many times it does not induce on that species any particular effect.[26] Hence, from a philosophical point of view, we shall say through the authority of Albertus Magnus that the virtues of stones emanate from the species through mediation of the substantial form of the stone itself, generated in an appropriate place and of proportionate matter, suitable to the essence of such a stone. And this was also the opinion of Plato, who says that nature gave properties to everything, for everything has in some way that which from its species makes it act in such a way that is proper to its own species.

Chapter 5. The Names of All the Learned Men from Whom We Borrowed What Shall Be Said on the Subject of Stones

So that it may not seem that what we are about to write, particularly about stones, was done solely on my own authority, I will list in this chapter the names of all the learned men from whom which we have drawn. And even though I have found some difference [of opinion] among them, nonetheless I will only state those opinions on which the majority agrees. No one should marvel, then, to see me state a different opinion from any specific doctor, but prior to moving any accusation against me, they should consult those others [writers], whom I here list, for they will see that what I say is approved by most. Since I have wished to be a faithful transcriber of words of all those learned men who wrote on this subject, I will here list their names:[27] Dioscorides,[28] Aristotle,[29] Hermes,[30] Evax,[31] Serapio,[32] Avicenna,[33] Giovanni Mesue,[34] Solomon,[35] Physiologus,[36] Pliny, Solinus,[37] the *Lapidarius*,[38] Heliamandus,[39] Isidorus,[40] Arnaldus,[41] Juba,[42] Dionysius of Alexandria,[43] Albertus Magnus,[44] Vincentius Historialis,[45] Thetel Rabanus,[46] Bartholomaeus de Ripa Romea,[47] Bishop Marbode,[48] Ortolanus,[49] *Liber pandectarum*,[50] the *Cornu copiae*,[51] the *Kyranides*,[52] and the book on the nature of things.[53] Now, as mentioned above, those who well know the writings of learned authors, will realize that I did not stray from what they all agree upon but closely followed them for I took them all as guides for this book. For it often happens that when gems are shown to us, we do not know their name, therefore to quickly learn it, and learn to recognize their virtues, I have made an alphabetical list of the stones' colors, to which I have added the names of those stones.[54]

But the reader should be warned that many stones have the same color, and yet they are not the same. And since we cannot say everything in the alphabetical list, once they have found the name, readers should go to the chapter which

BOOK 2 65

discusses that stone: thus being fully aware of their differences we shall know them better. And thus through color we shall come to our intent.[55]

[Alphabetical List][56]

A

Argenteus/Silvery

Aluminosus/Bright

Argenteus/Silvery
Argenteus/Silvery
Albus. Aqueus / White. Watery
Albus/White
Albus cum pupilla nigra / White with a black center
Albus/White
Aqueus albus / Watery white
Albus opacus / Opaque white
Aureus/Golden
Aureus Ignitus / Dusky gold
Albus citrinus / Citrine white
Aureus purpureus / Purplish gold
Albus/White
Aureus/Golden
Aureus/Golden
Aureus rutilans / Resplendent gold
Albus speciosus / Beautiful white
Aureus/Golden
Albus cum multis coloribus / White with many colors
Albus admixtus nigro / White mixed with black
Aureus/Golden
Alba candida / Candid white
Aureus/Gold
Argenteus/Silvery
Aureas venas / Golden veins
Albus perspicuus / Transparent white
Albus ungueus / Fingernail white
Albus Rubeus / Reddish white

Andomamanta [poss. Adamant or Diamond]

Amiantus [Amianton, a white variety of asbestos]

Agirites
Androa. Azurinus. Armenus.
Berillus [Beryl]
Borax
Belloculus

Corallus [Coral]
Cristallus [Crystal]
Corvina
Crisocollus
Crisolantis
Cistolitus
Crisopassus
Coranus
Crisopis
Calcites
Estimion
Exebenos
Hammonus
Kamam

Lincis

Lisimacus
Margarita [Pearl]

Marchasita [Marchasite]
Medea
Nitrum [Niter]
Onix [Onyx]
Onichinus [Onychinus]

66 THE MIRROR OF STONES

Auereis guttis seu stellis / Golden drops, or stars	Pontica
Aqueus ut glaties / Watery, like ice	Peanites
Albus grevis / Dark white	Sanius
Albus argenteus / Silvery white	Tale
Albus aluminosus / Shattering bright	Tegolitus

B

Bicolored	Demonius lapis [Devil's stone]

C

Cristallinus/Crystalline	Alectorius
Candidus Crystalline / Crystalline white	Astrites [Asteria]
Ceruleus/Cerulean	Alebandina
Croceus leoninus / Color of a lion's skin	Agapis
Candidus levis / Pale white	Asius
Cineritium / Ash colored	Asini lapis
Candidus intersectus croceis coloribus / White with saffron-colored veins	Alabastrum [Alabaster]
Coralinus croceus / Saffron-colored coral	Ceraunius
Candidus oblongus / Egg white	Cimedia
Candidus venosus / White veined	Cepocapites
Candidus/White	Cheronia
Citrinus corintheus / Corinthian citrine	
Ceruleus purpureus / Purplish cerulean	Cianica
Cristallinus/Crystalline	Cambites
Crocei coloris cum pupilla / Saffron colored with a spot	Draconites
Cristallinus/Crystalline	Enidros
Candidus transparens / Transparent white	Fingites
Citrinus aureus / Golden citrine	Falconites
Cineritius / Ash colored	Galatides
Candidus lucens / Bright white	Gelatides
Citrinus/Citrine	Gagates
Cristallinus varius / Varied crystalline	Iris
Croceus / Saffron colored	Isistos
Croceus / Saffron colored	Lincurius
Cristallinus/Crystalline	Ligurius
Cristallinus nebulosus / Cloudy crystalline	Kabrates
Citrinus lucidus / Clear citrine	Karabe

Cerulea sanguineis guttis / Cerulean with blood drops	Pontica
Candidus/White	Podros
Cristallinus/Crystalline	Panconus
Citrinus lucidus / Clear Citrine	Succinus [Amber]
Candidus mellinus / Honey white	Silenites
Croceus / Saffron colored	Sirites
Candidus/White	Solis gemma
Cineritius/Ashen	Siphinus
Croceus cum viriditate / Saffron with green	Topatius [Topaz]

E

Ex multis venis seu coloribus / With many veins and colors	Achates [Agate]
Eburneus / Ivory colored	Arabica
Eburneus / Ivory colored	Chemites
Ereus cum vena flava / Brass colored with a yellow vein Balanites	
Ex multis coloribus / Multicolored	Cepionites
Ex multis coloribus / Multicolored	Exacolites
Ex sexaginta coloribus / Of sixty colors	Exacontalitus
Eburneus/Ivory	Emites
Ereus cum nigredine / Copper colored with black spots	Frigius
Ex multis coloribus / Multicolored	Hiena
Ex quatuor coloribus / Four colored	Licoptalmus
Ex varijs coloribus / Varied colors	Lepiolotes
Ex tribus coloribus / Three colored	Murena
Ereus / Copper colored	Marchasita [Marchasite]
Ex multis var. color. / Various multicolors	Mitridax
Ex multis var. color. / Various multicolors	Oppalus [Opal]
Ex multis coloribus / Multicolored	Pantherus
Ex duobus coloribus / Two colored	Sardonix [Sadonyx]
Ex multis coloribus / Multicolored	Ziazia

F

Ferrugineus cristallinus / Iron-clear color	Adamas [Diamond]
Ferrugineus / Iron colored	Abeston [Asbestos]
Ferrugineus / Iron colored	Basanites

Flavuus/Yellow	Calaminaris
Ferrugineus / Iron colored	Magnes [Magnet]
Flavus ac niger / Yellow and black	Nicolus
Ferrugineus / Iron colored	Orites
Ferrugineus perspicuus / Transparent iron color	Pirites [Pyrite]
Flavus perspicuus / Transparent yellow	Saphirus [Sapphire]
Ferrugineus / Iron colored	Smiriglius [Emerald]
Ferrugineus / Iron colored	Siderites
Flavuus albescens / Whitish yellow	Turchion [Turquoise]
Flavuus cum . . . / Yellow with little golden flames	Zumemelazoli

I

Igneus cum . . . / Igneous color with white veins	Antracites
Igneus / Igneous color	Spilitem
Igneus / Igneous color	Carbunculus [Carbuncle]
Igneus aureus / Golden igneous color	Crisoletrus
Igneus rutilans / Fiery igneous color	Ceraunius
Igneus aureus / Golden igneous color	Hormesion
Igneus obscurus / Dark igneous color	Sardius
Igneus / Igneous color	Sandastros

L

Lucidus filosus / Shiny and stringy	Amianton [Asbestos]
Lucidus nitrosus / Shiny and niter colored	Amites
Lucidus/Shiny	Cogolites
Lucidus ut speculum / Shiny like a mirror	Esestitis
Lineis albis lineata / Crossed with white lines	Pontica
Lucidus/Shiny	Ranius

M

Mareus / Myrrh colored	Mirites
Mareus cum Glauco / Myrrh colored with glaucous coloring	Zinilaces

N

Niger cum venis albis / Black with white veins	Achates [Agate]

Niger cum punctis rubeis / Black with vermillion spots	Absinthes
Niger maculosus / Black with spots	Augusteum
Niger purpureus / Purplish black	Alabandicus
Niger/Black	Aspilatem
Niger cum venis rubentibus seu albis / Black with red or white veins	Abistos
Niger Lucens / Bright black	Antifates
Niger/Black	Andromantius
Nigri coloris / Black colored	Amites
Niger fuscus / Cloudy black	Borax
Niger/Black	Celidonius
Niger/Black	Calcofanos
Niger ferrugineus / Black, iron colored	Dionisia
Niger/Black	Doriatides
Niger/Black	Egipilla
Niger/Black	Gelachides
Niger/Black	Gagates
Niger cum sanguineis venis aut candidis / Black with blood-red or white veins	Galaxia
Niger/Black	Medus
Niger/Black	Magnasia
Nigerriumus / Deep black	Morion
Niger/Black	Pirites [Pyrite]
Niger. Sonorous. / Black. Deep.	Trachius
Niger/Black	Onix [Onyx]
Niger cum albis zonis / Black with white circles	Onix [Onyx]
Niger cum russedine / Black with a yellowish color	Onix [Onyx]
Niger/Black	Orites
Niger translucens / Translucent black	Osius
Niger cum venis albis / Black with white veins	Opphicardelon
Niger translucens / Translucent black	Radaim
Niger/Black	Samotracia
Niger cum venis candidis / Black with white veins	Veientana

O

Oleagenus / Olive green color	Berillus [Beryl]
Ocreus / Oyster colored	Crisites

Oleagenus pallidus / Pale olive green	Diacodos
Ostreus / Oyster colored	Ostraces
Ostreus / Oyster colored	Philoginos

P

Purpureus roseus / Purplish rose	
Purpureus vienus / Purplish, with veins	Amatistus [Amethyst]
Purpureus vinaceus aqueus / Watery purplish wine colored	
Pallidus fuscus albescens / Dusky pale whitish color	Calcedonius
Purpureus/Purplish	Celonites
Palliolus/Pale	Diacodos
Puniceus/Scarlet	Ethices
Poraceus/Poraceo	Emetrem
Pallidus gravis / Very pale	Phrigeus
Prassius viridis / Prassius green	Sagda

R

Rubeus cum venis croceis / Red with yellow veins	Achates[Agate]
Russus/Red	Alabandina
Russus lucidus transparens / Bright transparent red	Balaxius [Balas ruby]
Russus pulverulentus / Dusty red	Bezoar
Russus citrinus / Citrine red	Bolus
Russus/Red	Celidonius
Rubeus/Red	Corallus [Coral]
Rubeus Obscurus / Dark red	Emathites [Hematite]
Rubeus Rutilans / Fiery red	Epistites
Rubeus/Red	Fongites
Rubeus/Red	Falcones
Rubeus lucidus / Shiny red	Granatus [Granate]
Rubicundus/Reddish	Gerades
Russus croceis venis / Red with saffron veins	Gagatronicus
Rubeus acqueus / Watery red	Iacintus [Jacinth]
Rubeus/Red	Lachinus
Rubeus/Red	Ligurius
Rubeus cum albis venis / Red with white veins	Porphirius [Porphyry]

Rubeus Corallo similis / Red similar to coral — Tirsitis

Rubeus/Red — Varach

S

Subbrusus / Ruddy color — Indica [Indigo]

Sanguineus cum venis nigris / Bloody with black veins — Nassomonites

Serpentinus / Serpentine spots — Ophites

Sanguineus/Bloody — Frigius

Sublividus / Livid color — Ranius Subalbiolus / Off-White [or tending to white]

Vernix

Sanguineus/Bloody — Yectios

V

Varii coloris / Various colors — Amandinus

Viridis/Green — Amites

Viridis/Green — Oleagenus

Viridis. Aureus. / Green. Gold. — Berillus [Beryl]

Viridis Pallens / Pale green

Viridis parum rubescens / Slightly reddish green

Viridis cum vena. Flava. . . . / Green with a vein. Yellow. — Balanites

Viridis poreus / Green and gold color — Crisoprassus

Viridis marinus / Sea green — Crisolitus

Viridis pallens / Pale green — Caldaicus

Viridis herbosus / Grassy green — Calorites

Viridis/Green — Caristeus

Viridis aureus clarus / Light golden green — Crysopilon

Viridis aureus / Golden green — Coaspis

Varius / Various colors — Drisolitus

Viridis clarus / Light green — Doctus lapis

Viridis cum guttis. Sanguineis. / Green with drops. Blood-red. — Eliotropia [Heliotrope]

Viridis aureus / Golden green — Filaterius

Viridis/Green — Frigius

Viridis non iocundus . . . / Unpleasant green — Galerica

Viridis cum venis rubeis / Green with red veins	Iaspis [Jasper]
Violaceus/Purplish	Ion
Viridis/Green	Ligurius
Viridis cum venis albis / Green with white veins	Leucocrisos
Viridis/Green	Limoniates
Viridis/Green	Medus
Viridis Crassus / Rough green	Melochites
Violaceus/Violet	Orfanus
Viridis Prassinus / Prassius green	Prassius
Viridis cum guttis sanguineis / Green with blood-red drops	Prassius
Viridis cum liniamentis albis / Green with white lines	Prassius
Viridis clarus / Light green	Pontica
Viridis cum Serpentinis maculis / Green with serpentine spots	Porphirus [Porphyry]

Chapter 7. On Specific Stones in Alphabetical Order

After these general discourses, my most illustrious Prince, we come now to the specifics; that is the discussion of the names and virtue of each stone. Thus, from this chapter onward, until the beginning of the third book,[57] we shall discuss stones according to their alphabetical order. Hence, first we shall list the names of each stone, adding any other name, if they have more than one, and then the origins of their names. Subsequently, we shall discuss the colors and species of the stones, and if they have more than one, which species is the best, listing as well the places where they were generated or found. Lastly, though perhaps more valuable and interesting for all men, we shall describe their virtues, in order to understand that everything made by the supreme artificer [God] is for the benefit of humankind: to Him we must render infinite gratitude, since not only does He care for the well-being of our soul, but also that of our body.

A[58]

Adamas [Diamond][59] is a most precious stone that has a clear, iron-like color, almost like a crystal. It is never bigger than a hazelnut: nor is it weakened by any other substance, nor fire, nor iron. From this it took its name, which in

Greek means indomitable virtue. Some say that it softens only with the blood of a goat.[60] I believe this is false, since I have seen many [diamonds] broken by a hammer. Nor is there any similarly hard substance that the diamond does not surpass [in strength]. It is a marvelous thing, if it be true, that placed near a magnet and bound to it, it will prevent it from attracting iron.[61] Learned men believe there are six species of diamonds, all named after the places where they may be found. Thus there is the Indian, Arabian, Syrian, Macedonian, Ethiopian, and Cyprian diamond, listed in order of virtue.[62] The Indian diamond is small but excels in virtue: it is resistant to the hammer, heavy, and has the color of a very clear crystal. The Arabian is similar to the Indian but is paler and smaller. The Syrian and the Macedonian have the color of resplendent iron. The Ethiopian is darker than all others. The Cyprian tends to a golden color but is baser and softer than the rest.

All these diamonds have the virtue of repelling poison: that is, all those deadly poisons that may be drunk. It protects against acts of sorcery and removes empty fears. It gives victory in all quarrels and contentions. It benefits the lunatics and those possessed by demons. Worn tied to the left arm, it renders a man victorious. It tames wild beasts. It is good against phantasms and night terrors. It makes the wearer daring and skilled in all dealings. The Indian or the Arabian diamond, as many believe, has the virtue of a magnet: that is, to turn the iron needle toward the artic pole. Hence some call it the diamond magnet [loadstone].[63]

Achates [Agate][64] is a stone of various colors, and its colors vary according to the place of its generation. There are many species of this stone, but the most famous are seven particular varieties that vary not only in color but also in virtue, as confirmed by [all] lapidary texts.[65] Sicily was the first to produce agates, which were found near the river Acheus.[66] Hence, for this reason, the Sicilian is ranked first. Then come the Cretan, Indian, Egyptian, Persian, Arabian, and Cyprian.[67] The Sicilian is black intersected by white veins. Crete produces agates similar to coral,[68] with various veins or drops. The Indian has varied colors and veins that sometimes form various images, such as beasts, flowers, or woodlands; sometimes birds and true effigies of kings, as it is said of the agate that King Pyrrhus had. I have also seen an agate on which there appeared seven trees on a flat plain.[69] These [agates] are the best of all. The Egyptian is neither reddish, nor whitish, but is intersected by various veins. Some say that the Persian smells like myrtle when is burned.[70] Dionysius in the *Sight of the World* affirms that the Persian agates are in the shape of a cylinder, which carried by rivers from the tops of the mountains are driven along the river Choaspes and are found in the sand.[71] The Arabian and the Cyprian are variegated by assorted colors and transparent like glass. The virtues of agates vary according to their

74 THE MIRROR OF STONES

diverse species, but they all have this in common: they render men solicitous. The Sicilian, instead, has the virtue of being an antidote to the venom of vipers and scorpions, when placed directly over the puncture, or if ground and drunk in wine. The Indian repels all venomous things. Sight is strengthened by looking at it. It quenches thirst if placed in the mouth. Whoever wears it gains victory: it strengthens [the body],[72] repels tempests, and stops lightning. The Cretan sharpens sight. It extinguishes thirst and poisons, it renders its wearer gracious and eloquent, it helps to conserve and give strength. It seems superfluous to discuss the singular virtues of each when they coincide, thus I shall omit them for the sake of brevity.[73]

Ametistus [Amethyst][74] is among those stones that are purplish and transparent, mixed with violet color, emitting rosy sparkles. There are five species of amethyst: and they all tend to be of a purplish color but mixed with various [other] colors. The Indian amethyst surpasses all others in color, beauty, and price; it is purple mixed with rose and somewhat violet tones. Those that are simply purple are not much valued. Those that tend to a violet color, or wine color, or a watery violet, are baser than the rest.[75] The places where they are found give the stones their names. The Indian is the best, followed in order by the Arabian, the Armenian, the Galatian, the Egyptian, the Tarsian, and the Cyprian: even though the last two are the baser of them all, so much so that learned men do not even mention them. They are all fit to be engraved. Their virtue is to drive away drunkenness: and thus, placed over the navel, they lessen the effect of wine; and hence dispel drunkenness.[76] They repress evil thoughts and encourage good understanding. They render man skillful and expert in his actions, they render barren women fruitful, if they drink water in which the stones have been washed. They extinguish poison, protect soldiers, and allow them to win against the enemy. During a hunt they make it easy for a man to capture various wild beasts and birds.

Alectorius [Alectory][77] is a stone of a crystalline color, with a slight opacity, resembling limpid water; sometimes on its surface there are flesh-colored veins. Some call it gallinaceus, from its place of origin: since they are found in the intestines of roosters, or capons castrated at the age of three, and that have lived for seven years. This stone should not be extracted earlier, since the older it is, the better it is. When the stone has reached perfection, the capon will not drink. However, no stone has ever been found bigger than a fava bean. And as Solinus writes, this stone was first prized at the time of Tarquinius Superbus.[78] Its virtue is that of rendering its wearer invincible.[79] Held in the mouth, it quenches thirst, hence it is appropriate for fighters.[80] It renders the wife pleasing to her husband. It bestows honors on those who do not have it, and preserves those honors already acquired. It frees those who have been bewitched. It makes man eloquent,

constant, gracious, and amiable. It helps to regain lost kingdoms and to conquer foreign ones.

Androdamanta or Andromadas[81] is a heavy and very hard stone, just like the diamond, which has the clarity of polished silver. Its form is defined by squares and lines. It is found in the sand of the Red Sea. It is believed that it bears the name of its virtue, since it stops anger and the impulses of the mind to act rashly. Its name comes from the Arab tongue.[82] Its virtue is that of mitigating lust and lessening the body's weight.

Astrites, Astrion, Asterius, or Asterites[83] is a white stone, similar to crystal; it encloses a light like a moving star; in the part where it receives the light there may be seen a shape similar to a blazing star or a burning flame. It takes its name from *astrum*, as its image is like that of a star and of Ion.[84] They originate from Thrace, or in Carmania, where touched by the sun's rays, it seems, they turn white.

Alabandina[85] is a reddish[86] and cerulean-colored stone, like the sardius,[87] to which is so similar that one can barely discern them by color; it takes its name from a part of Asia so called and where it was first found. Its virtue is that of bringing on the flux of blood. Drunk, it extinguishes all types of poisons. I find diverse opinions on the color of this stone, but all I have said is confirmed by the majority of sources.[88]

Agapis[89] is a yellow stone, similar to the color of a lion's pelt; it derives its name from [the Greek] *agape* since it brings delight [love], and is thus loved by men for its virtue. It has marvelous properties against scorpions' stings and vipers' bites. If tied to a wound, and wetted in water, it immediately takes away and mitigates the pain of that wound.

Andromantes[90] is a black-colored stone, heavy and hard. It is said to attract silver and brass, as the magnet does with iron. Rubbed and placed in water, it stains it the color of blood, just like hematite does.

Antracites or Antrachas[91] is a stone of a fiery color that sparkles like the carbuncle.[92] It is encircled by a white vein and cannot bear fire. Anointed with oil, it loses its color, but wetted in water, it lights up and sparkles. Albertus Magnus calls it a carbuncle. But it is not a carbuncle, as others sustain, even though it is similar to it in color and virtue. Its virtue is that of driving away pestilential air and thus rendering safe its wearer. It benefits [skin] swelling and abscesses called by its name [i.e., called anthraxes], in the same manner as we have said before of the *agape* [and wounds].

Amandinus[93] is a stone of various colors. Its virtue is marvelous as an antidote to poison and renders the wearer victorious. It teaches the interpreter of dreams and enigmas to solve the various questions proposed to him.

Abeston or Abestus [Asbestos][94] is a stone the color of iron, which is generated in Arcadia and Arabia, and is called *abeston*, or inextinguishable: in fact, once it is lit, its flame burns perpetually. Hence gentiles[95] used it in temples' candelabras, because it keeps the flame very strong and inextinguishable, neither rain nor storms can put it out. It has a wooly texture, and many call it the Salamander's feather.[96] The fire is nourished by a humid unctuousness that cannot be separated from its matter. Hence once it is lit, it perpetually gives light, without the addition of any type of liquid.

Asius[97] is white and light as the pumice stone; if licked with the tongue it tastes like salt, and when squeezed in the hands it easily turns into dust. It is imported from Alexandria; and though its appearance is not beautiful, its virtue is paramount. It heals the consumptives when taken with pink sugar,[98] in the manner of an electuary. It heals scrofula, fistulas, gout, and many other illnesses, as may be read in doctors' books.

Amianton[99] is a thready and luminous stone, similar to feathered alum, but more unyielding. Many call it live flax, because it can only be ground after having been placed over the fire. It produces threads like flax: a result of its inseparable viscosity, which is not altered by fire. And thus just like flax it can be spun. When the ancients wanted to preserve the ashes of the dead, they would make sacks of amianton, in which they burned the corpses. This occurred without any damage to the sack, so that no strange matter would mix with the ashes. They say its virtue fights the incantations and sorceries of magicians.[100]

Agusteum[101] is a black stone of the marble species. It has spots in the shape of snakes. At the time of Tiberius Augustus it was found in Egypt and from him it takes his name.[102]

Alabastrum or Alabastrites[103] is a white stone streaked by internal white and citrine veins, it belongs to the marble species, and it is excellent for making vases to keep unguents, for it preserves them without spoiling. The best type is found near Thebes and Damascus, though the whitest of them all is found in India and in Carmenia. Cappadocia produces some that are colorless, which are quite inferior. The best ones are those that have a honey color and are not very transparent. It is useful in medicines, as Dioscorides and other physicians say. Its wearer will win his lawsuits.

Alabandicus[104] is a black stone that tends to the purple, and it takes its name from the place it was first found. It liquefies in fire and melts, just like metals; it is useful in glassmaking since it renders glass polished and white. It is found in many places in Italy; master glassmakers call it manganese.

Aspilaten[105] is a black-colored stone originating in Arabia, and mostly found in the nest of Arabian birds. It heals those who suffer from spleen problems when it is bound over the latter with camel dung.

Abistos[106] is a black-colored stone, streaked and crossed by vermilion and white lines. Heated up it preserves the heat for eight days. It is weightier and heavier than it appears considering its size.

Asinius or Asininus[107] takes its name from the ass because it is found inside the wild ass. It is almost white and tends to a citron color with a round and oval shape; the size of an average nut, it is not hard and has some crevices that do not run very deep. When it breaks, is resembles bright smalt, tending to the citron colored. This stone is of two types: maxillary and cephalic. The cephalic, placed over the head, relieves pain and heals epilepsy. The maxillary,[108] so called because it is found in the jaw, renders the wearer tireless, so that he shall never be defeated in battle, and on the contrary he will tire all his enemies as he will gain strength and beat them. It resists all poisonous animals;[109] taken in wine, it keeps away the quartan fevers; and it has the marvelous property of killing worms that afflict children, when they, too, take it in wine. It renders innocuous poisoned water that has already been drunk, and it heals snake bites.[110] It helps women in giving birth and aids in expelling a fetus who died in the womb.

Arabica or Arabus[111] is an ivory-colored stone that takes its name from Arabia, where it is mostly found. It is said to be good for nerve pain.[112] It is also found in Egypt, has the color and odor of myrtle,[113] and may be used as a scent. Burned, it becomes a good toothpaste.[114]

Amiatus or Amiantus[115] is an alum-colored stone that cannot be destroyed by fire. It resists potions made by magicians;[116] it is most useful in medicines.

Antiphates[117] is a shining black stone. It has the odor and taste of myrtle[118] when boiled in wine or in milk; it is useful against enchantments.[119]

Amites[120] is an alum or niter-colored stone, but it is harder. It originates in Egypt or Arabia. The Ethiopian kind is green and if dissolved in water turns milky colored.

Armenus[121] according to Avicenna is an azurine-colored stone, and according to others its color is between dark green and black. It is fragile, light to the touch and smooth, and has the marvelous property of healing melancholic states.

Aquilinus Limphaticus,[122] so called for it may be found in some fishes; it is useful to human life. Hung around the neck or carried [on one's person] it drives away and wards off the misery of quartan fevers.

Anancithidus[123] is a necromantic stone for it has the virtue of calling forth demons and spirits.[124]

Agirites[125] is a silver-colored stone with some gold spots.

Antitaneus[126] is the same as *Crisocollus.*

Aquileus[127] is the same as *Ethices.*

Androa[128] is the same as *Androdamanta.*

B

Balasius [Balas Ruby][129] is a purplish or rosy-colored stone that sparkles and flames and that some call *placidus* [pleasant]. Some think it is a carbuncle of lesser color and virtue, just as the virtue of the female carbuncles is different from the males.[130] It has been seen that the external part of this stone is like that of the balasius, and the inside that of the carbuncle, so much so that some say that balassus is the carbuncle's matrix. Balasius's virtue overcomes and represses bothersome and luxurious thoughts, reconciles quarrels among friends, and brings good health to the human body. If ground and drunk with water, it heals illnesses of the eyes and aids in liver disorders. And what I believe is even more marvelous is that if you should touch with a balasius the four corners of a house,[131] garden, or vineyard, these will never be hit by lightning or storms, or be infested by worms.

Berillus [Beryl][132] is an olive- or seawater-colored stone. They say there are nine types, all of which tend to a pale shade of green. It bears the name of the country, or the people, where it was first found, and it has a very beautiful hexagonal shape. India produces white beryls, the color of seawater struck by the rays of the sun; these are rarely found elsewhere. Curious collectors from antiquity valued most those similar to the seawater- and olive-colored varieties. The moderns, instead, value most those that have the color of a dusky crystal, since they are most similar to diamonds. Some call this type catel. There is another species, which is paler, and is called false beryl, which shines with a gold or blue-green color.[133] These come from Babylon. Chrysopilon is close to it, but it is paler. These are followed by hyacynthizonthes, heroides, cervine, dark olive-colored ones, and crystalline ones, which are similar to crystal. But the Indian beryls are far more precious than all others since they are very transparent. And when these beryls are moved, it seems as if water inside them moves too. And this is the opinion of Albertus as well, though it differs from others. If these are shaped in the form of a ball and are exposed to the rays of the sun, they reflect these rays just like concave mirrors. This stone has a great virtue: it renders the wearer solicitous. It protects and increases conjugal love. Hung from the neck, it chases away idle dreams. It heals and prevents all illnesses of the throat, the jaw, and the mouth—that is, all those illnesses that originate from humidity of the head. If taken mixed with a similar quantity of silver, it heals leprosy. Water, in which it has been for a certain period, is good for the eyes,[134] and if drunk it dispels sighs, and it heals disorders of the liver. It also aids pregnant women, preventing abortions and birth pains.[135]

Borax, Nosa, and Crapondinus[136] are all synonyms for the same stone extracted from a toad. They are of two species: white, which is the best, and is more rarely found; the other is dark black with a cerulean color, and its center

resembles an eye. It must be taken out of a dead toad whose heart is still beating. These stones are better than those extracted after being underground for a long time. They have a marvelous virtue against poison: if someone has drunk poison, he should swallow this stone, which immediately will brace the intestines and extinguish the poisonous quality lodged in the intestines, then it passes through the lower parts and can be saved. It is helpful against snakebites, eliminates fevers, and heals ailments of the stomach and kidneys, if one drinks water in which it was put. Some say it has the same effect if carried on one's own person.[137]

Bezoar[138] is a vermillion-colored stone, dusty, light, and brittle. Some describe it as a [yellow] citrine.[139] Everyone says that it is the first remedy against poison. Hence by taking just a dram of it, it counteracts and eliminates any poison. Because of its excellent virtue, anything that frees the body of a specific ailment is called the bezoar of that illness. And thus, its name has come to generally mean the reconciler of poisons, as many other learned men have stated.[140]

Bolus Armenus[141] is a vein of earth found in Armenia, and even though it is not a stone, it is counted among the stones because of its virtue.[142] Its color is reddish bordering on the citrine, with a dusky green tone. Its complexion is cold and dry. All doctors attribute to it great virtues. It is an efficacious remedy against fever and fluxes of the belly; it helps emoptoics,[143] the splenetics,[144] and other similar disorders of the stomach.[145] There are many counterfeits and only few [bolus armenus remedies] that are true and good, and I have never seen a good one.

Beloculus[146] is a white stone whose center has a black pupil. Because of its beauty, the Syrians used it in all sacrificial ornaments dedicated to the god Belus.[147] It is also said to render its wearer invincible on the battlefield.[148]

Basanites or Basaltem[149] is an iron-colored stone found in Egypt and Ethiopia. When ground in water, it emits a saffron-like color.

Bronia[150] is a stone that resembles the head of a turtle.[151] Its virtue is that of resisting lightning.

Balanites[152] is a stone of two types: one is green, the other the color of brass with a flaming vein running through its center.

C

Carbunculus [Carbuncle],[153] which some call anthrax, shines forth fiery violet rays from every side and, because of it, shines like a fiery coal in the dark. Among the fiery gems, the carbuncle is the first for color, beauty, and price. There are twelve species. The most valued are found in Libya[154] among the Troglodytes. Fire does not hurt it, nor does it absorb the color [light] of any other gem close to it, but other gems will absorb its color [light]. It is of male and

female [gender]. Stars appear to be burning within,[155] however the female stones emanate more light. Some say that the Indian ones are more valuable than all others.[156] And though we have said that there are twelve types of this fiery stone, we will only mention the five we know. In the first place we should list the carbuncle, followed by the ruby and the balas, reputed to be of that species too. Rubith, similar to the spinel, is in fourth place, and in last place is the granate. The virtue of the carbuncle is of that of driving away pestilential and poisonous air, to quieten lust and induce and preserve good physical health. It drives away evil thoughts, reconciles fighting friends, and increases all prosperity.

Calcedonius or Calcedon,[157] as some call it, is pale in color, but nobler still is the sapphire colored one. Scholars list three species of note, though some list more. Thus in our times Germany produces a diversity of species, [so much so] that it would be in vain to list them all. The sapphire-colored stone takes first place, followed by the dusky pale, tending to white. The last is a dead vermillion color, not transparent. Oftentimes these species are found in one stone alone that presents the various colors mixed together. All of Ethiopia produces the most perfect of them all. They are even found on the shores of the Adriatic Sea near your city,[158] and these chalcedonies are white, pale, and even dusky, and are extremely hard. If worn around the neck, they drive away the fantastical illusions born out of melancholy. If worn with a hole in which has been placed an ass's hair, that person will win all civil lawsuits as well as prevail in battle. It conserves the body's strength. The black or sapphire-colored ones prevent a man's hoarseness and renders the voice clear and strong. All species of this stone harness lust and spare men from tempests and similar adversities.

Chelidonius[159] is a stone found in the stomach of swallows. There are two species. The vermillion-colored one, if carried in a clean linen cloth, aids lunatics and mad people, and it heals patients from long infirmity. It renders gracious and eloquent those who wear it. Ground in water and made into eyedrops, it heals eye illnesses. The black type conducts any undertaken affair to a happy end. It calms anger. It also renders its wearer gracious and pleasant. It mitigates the wrath of lords. Tied to the neck in a yellow linen cloth, it drives away fevers; and it halts and extinguishes any noxious humor. It has been noted that worn around the neck, it heals epilepsy and jaundice. Some say that it must be wrapped in calfskin or in unborn deerskin[160] and tied to the left arm. These stones must be extracted when the swallows are still small in their nests and during the month of August, and to ensure that they may be most perfect, the little swallows should have not yet touched earth, nor should their parents be present when these stones are extracted.

BOOK 2 81

Corallus [Coral][161] grows in the sea like a tree without leaves, and it is never taller than two feet. They say there are two species: red and white. Avicenna lists a third species, black in color. I have seen on the same stem both the white and red species. The whites are usually perforated, and these are useless, while those that are not perforated, and are intensely white and extremely red, are most useful. Their virtue, especially that of the reds, is to stop the flow of blood. Carried wherever a man goes, whether be home or ship, it will drive away ghosts, demonic spirits, illusions, dreams, lightning, winds, and tempests. Methrodorus calls it the Gorgon, which he interprets as resisting whirlwinds and lightnings, and protecting from all incursions by wild beasts.[162] It is useful for stomach and heart pains. Hung by the neck, so as to touch the stomach, or if taken internally, it strengthens the stomach's weakness. It is also useful for abscesses of the stomach, it halts the corrosion of gums, it eliminates putrid ulcers, and it stops anything that might be a hurtful medicine. If its shavings or scrapings are drunk with wine, they help those who pee small gravel. Ground and hung among fruit-bearing trees, or mixed with the seeds in the field, it induces fertility, and it keeps off hail and rain. I have heard the following from people deserving of being believed and I have often experienced it myself:[163] that in order to prevent epilepsy in young children, as soon as they are born, just out of their mothers' uterus, and before the child has tasted anything, half a scruple of well-ground red coral should be placed in the child's mouth to be swallowed; this will be a most helpful remedy.[164] It still has many more virtues, which for the sake of brevity I omit.

Cornelius [Carnelian][165] is a red and transparent stone that comes from the Orient. In the Rhine River there can be found very red ones, almost the color of vermillion. Some tend to a transparent citron color, similar to clean flesh tone. This stone halts menstruation and calms the pain of hemorrhoids. It heals those that suffer of dysentery. Worn around the neck, or on the finger,[166] it appeases angry disagreements and fiery minds.

Cristallum [Crystal][167] is a stone similar to ice in color and transparency and is moderately hard. Some think it is snow that has been iced and hardened for thirty years and turned into a stone by age. Others say it acquires its lapidity from the earth and not from the cold element.[168] Others are of the opposite opinion and say that crystals are generated like other [similar] stones with a great deal of water. They sustain their position by noting that crystal has been found in the South where there is no snow. The first opinion is agreed on by many who have noticed that there is great abundance of crystal in the northern Alps where there is always snow and ice, and where the sun in summer never shines its hottest rays, if not but obliquely, because of the polar elevation. They

are also generated in Asia and Cyprus. But the most excellent crystal is the one generated in the Ethiopian alps and in the island of the Red Sea, called Meron, situated off the coast of Arabia. Scythia, too, so abounds in crystal that they use it to make drinking cups. A ball made of crystal and placed under the sun's rays ignites any matter that has been placed underneath it, but not before the ball is heated. This is well-known by philosophers, but it does not pertain to our present investigation. Crystal hung over a sleeper dispels bad dreams, freeing those who have been charmed; held in the mouth, it lessens thirst, and if ground with honey, it fills the breasts with milk. Yet, crystals are mostly used to make drinking cups.

Crisoprassus or Crisopressus [Chrysoprase][169] is a stone whose green color is similar to the juice of cypress, with some golden drops that give it its name, as *crisos* in Greek means gold, since it is composed of gold and green colors. India and Ethiopia produce it. Its highest virtue is of aiding sight, it renders man assiduous in good works, it banishes avarice, it gladdens the heart, and it removes strong passions.

Crisoletus, Crisolimus, or Crisolensis [Chrysolitus][170] has a golden and sparkling fire color and is transparent. But it is properly called crisoletus from the Greek *crisis* [*Chrysós*], which means gold, and *oletus*, which means whole; thus in Latin it translates to wholly gold. Those that are produced in Ethiopia are the best. Those found in India and Arabia are baser and less transparent: they have a dusky quality and tend to be citron colored. In the morning, the Ethiopian stones appear to be on fire, and during the day they appear golden. Bound in gold and carried on the left hand, the stone chases away demons, nightmares,[171] and melancholic visions. Its principal virtue is to render ineffectual the enchantments of abominable women[172] and to put an end to their charms. If one bores through it and then passes through the hair of an ass, its virtue is all the greater in driving demons away. If held in the hand it dispels feverish heats.[173]

Crisolitus.[174] One species of this stone is translucent and the color of gold because of some blazing sparks. Another type, which is praised by many, is cerulean and green colored, like seawater tending more to the green. Under the sun's rays, it shows a golden star. It was found in Ethiopia. Set in gold, it chases away night terrors. It offers wisdom and honors and dispels folly. Ground and drunk is useful to asthmatics.[175]

Celonites or Celontes[176] is a stone of three types, as some say. It is extracted from a large tortoise[177] whose shell is the color of a pearl. There is another type called uterine, which may be purplish or of varied color, and its property is that of not being destroyed by fire. Because of this virtue the stone deserves particular praise: at an appropriate time, having washed one's mouth, whoever shall place it under the tongue, it is said that immediately that person will foretell things

BOOK 2 83

to come as if he had received a divine spirit. The appropriate time for this is the whole day of the first day of a new moon as well as all the fifteenth day following the moon's waxing, throughout the day from sunrise till the sixth hour.[178] But during [the moon] waning phase, the stone pours forth its virtue before the day dawns. The other two species are called cephalic and hepatic, and their virtues are not small. The cephalic is so called for having been found inside the head of the tortoise. It is therefore useful for headaches and resists lightning. The hepatic, too, takes its name from the place where it is found, the liver. This stone, if ground and drunk with water, prevents quartan fevers, if taken just before its onset. These stones are also called drome: if carried with peony roots, they render the wearer highly powerful.[179]

Cogolites or Cegolites[180] is called Iudaicus (the Jewish stone) by medical doctors because it has often times been found in those lands. It is similar to an olive pit. Its insides are the color of alum or silver; it is not pleasant to see, but is useful in medicines. Ground and dissolved in water, and drunk, it dissolves kidney stones and purges the bladder of gravel. And drunk with a proper quantity of water it heals strangury.[181]

Ceranius or Cerraolus[182] is a pyramidal-shaped stone. This stone is of two types: one is crystalline tinged with a saffron color, the other is pyrite colored. It said that it falls from the clouds, close to where lightning has fallen. The type found in Germany is the best. The Spanish comes second, and it is resplendent like the flames of a fire. Socatus proposes the existence of another type that is black.[183] Evax contradicts this, saying that there are various colors.[184] It is very hard and has great virtue. It indeed saves the wearer from drowning, nor can he be hit by lightning or tornadoes.[185] It renders man victorious in legal cases and in battles.[186] It also renders dreams sweet and pleasant.

Corvina[187] is a stone found in the head of the *corvi* fish,[188] and there are always two species. Its color is darkish white, it has an oval shape, and it is convex on one side; on the other is concave with some ridges in the middle. It is extracted from the still-breathing fish when the moon is waxing in the month of May. Carried so that it touches one's body, it keeps away intestinal disorders. Ground and drunk, it has the same effect.

Cimedia[189] is a stone extracted from the brain of the fish by the same name. Two kinds may be found in the head; a third may be found near the third vertebra, near the joint of the backbone, toward the fish's tail. It is round and seven fingers long; its head is large and transparent so that when it is placed against the light the spine becomes visible. Magicians say that its virtue is that of foretelling calmness or storminess of air and sea.[190] If drunk with water, it renders man lusty during the day.

Calchophanus[191] is a black stone that held in the mouth keeps away hoarseness and renders the voice sonorous.

Caldaicus or Callayca[192] is a big, pale green stone, dull, not limpid, unpleasant to the eye; it appears decent if set in gold.[193] It is found in the cold and icy river's bank of Media[194] and Germany, and it is visible to the naked eye.

Crisocollus [Chrysocolla][195] is a stone similar to gold. It is produced in Media, where ants [*formicae*] extract gold. It has the property of a magnet and increases wealth.

Crisoprasius [Chrysoprase][196] is a stone that shines in the dark; it is of a fading and muddled color, like a rotten oak placed in a dark place, but in the light it withers and is of a pale golden color, without any brightness.

Chemites is a stone that resembles ivory, but is not heavy and hard like marble. They say that it conserves the bodies of the dead for a long time, so that they will not putrefy, nor will they be eaten by worms.

Crisanterinus[197] is a stone whose color borders on gold and is brittle, and though it is rough, its virtue is not be disparaged. Worn at the neck it heals consumptives. Worn around children's necks, it makes them feel no pain when teeth come in.

Cysteolithos[198] is a stone of whitish coloring bordering on the citron and found in sea sponges. And though it is not beautiful, it heals those that are troubled with kidney stones, if it is drunk with strong wine. Hung around the neck of children, it protects them from coughing.

Catochites.[199] Some think it is a Sagda, which is not true, as we will discuss below. Solinus writes that it is found in Corsica. It removes any sticky material that clings to the hands of whoever touches it and then fastens itself to the body like glue.[200] It has the virtue to render a person victorious in battle, and it resists the magic arts, if one takes a scruple of it.

Corvia or Corvina[201] is a reddish-colored stone. It is produced artificially in this manner: on the first day of April, boil the eggs taken from a crow's nest until they become hard; left to cool, let them be placed back in the nest where they originally were. The crow will recognize this, will start cawing, and will fly a long way to find this stone. Once found, the crow will come back to the nest and touch the eggs with the stone, which then become again fresh and fertile. Then it is time to quickly take the stone out of the nest. Its virtue is that of increasing riches, bringing honors, and foretelling many future events.

Cambnites[202] is a crystal-colored stone, slightly dark. He who wears it will as a result be gracious to all, affable, and amiable. If tied to the left arm, it heals dropsy. I believe this is the same as *Kabrates*.[203]

Cepocapites or Cepites[204] is a white stone that has knots and veins the color of bright white marble that run into each other, and it is possible to make out a group of various images in it, as is seen in agates.

Calorites[205] is a green-colored stone, as if it were made of herb juices, which magicians say is found in the stomach of a bird called Sille.[206] It is useful in the magic arts if it is set in iron.

Cepionidus[207] is a translucent stone of various colors. Because of its translucent reflective surface, this stone takes on the appearance of various other stones, now jasper, now crystal, and sometimes emerald.[208]

Corintheus[209] is a stone of the marble kind, citrine colored in diverse hues; it takes its name from Corinth, where it is found in abundance. It is an appropriate material for buildings: columns, thresholds, beams, and many other things are made of it; they all last a long time.

Cyanica or Cyaneus[210] is a cerulean stone with purplish sparkles, varied with golden drops; and sometimes with little shining spots intermixed of different colors. It is found in Scythia and is both male and female. The male is more limpid and pure and pretty than the female, as is rendered pleasant by some resplendent golden particles found in it.

Caristeus[211] is a green-colored stone, which takes its name from its appearance, since it is pleasant to the sight, which it soothes with its greenness.

Calaminaris is a yellow-colored stone, neither bright nor transparent. If it will be ground nine times in vinegar, and finely pulverized with bird's blood, it is a good salve for inverted eyelids.

Crisopassus,[212] according to Solinus, is a stone of the beryl species; it has a golden color mixed with purple.

Coaspis[213] is a green-colored stone with the brightness of gold that takes its name from a Persian river, where it was found.

Cimilanitus is a marble-colored stone that has at its center a golden or saffron-colored pupil and is found in the Euphrates River.

Crisolansis[214] is the same as *Crisoletus*.

Crisites[215] is an oyster-colored stone found in Egypt.

Camites[216] is the same as *Ostracites*, as discussed below.

Celonia[217] is the same as *Sirites*.

Crisopilon[218] a species of *Berillus*, is discussed in that heading.

Crisoberillus[219] is discussed above in the *Berillus* heading.

Coranus,[220] white, is a marble species harder than the Parian.

Crisopis[221] is a stone that looks like gold.

Calcitis[222] is a copper-colored stone.

Carcina[223] is a crab-colored stone.

Crapondinus[224] is the same as *Borax*.

Celiculus[225] is the same as *Beloculus*.

Chrysopteron[226] is a species of topaz similar to the crisoprassio.

D

Daemonius[227] is a double-colored stone, like the rainbow, which is called iris, from which it takes its name, and is also called the demon's bow.[228] They say that its virtue is useful against fever, expels poisons, and renders its wearer safe from and victorious against the enemy.

Dionisia[229] is a black stone, scattered with red spots. Some say it has a dark or iron color sprinkled with spots white as snow. It is found in the East. If dissolved in water, it emanates the smell of wine; and with its own smell it dispels drunkenness, and it eliminates and causes the smell of wine to evaporate.

Diacodos or Diadocus[230] is similar in color to the beryl, but pale. It especially commands the devils, making them appear in any matter. Therefore, thrown in water while one utters the proper charm, it makes various demons appear, who will answer those who question them. If held in the mouth, anyone may summon any demon they wish out of hell and will receive satisfaction to any question posed to it. It abhors dead bodies; thus, if the stone comes into contact with any dead body, it will be deprived of its virtues.

Draconites, Dentrites, Draconius, or Obsianus,[231] also called the Vespertin Kimedius, is a stone of a bright and transparent crystalline color, according to some. Albertus Magnus says that it is black, dull, and in the shape of a pyramid. Some say that its blackness shines like a mirror. Many people search for this stone but never find it. It is brought from the East, land of the great dragons. Thus, by cutting off the head of a still-breathing dragon, it can be extracted from it. It loses its virtue if the stone remains too long in the dragon's head after its death. Courageous men go looking for the dens where the dragons live in parts of the Orient and there they place grass mixed with narcotic substances. When the dragons come back to the den and eat that grass, they immediately fall asleep. Then they cut their heads off and extract the stone, which has the greatest virtue of expelling any poison, especially those of snakes. It renders the wearer invincible and courageous. For this reason, the eastern kings boast of having such a stone.

Drosolitus[232] is varied-colored stone, from which it takes its name. If placed close to fire, it seems to emit a kind of sweat.

Doriatides[233] is a stone found in the head of an animal called murilage,[234] when the head has been suddenly cut off, and it has been given to the ants to eat it; its color becomes bright black. Some say that it can be extracted from a

BOOK 2 87

rooster's head and more may be found under the *Radaim* heading. Its virtue ensures that a man may have his every wish satisfied.

Doctus is a green stone, somewhat clear; I believe that this stone is actually the *Crisolitus*, as mentioned above.

E

Elitropia or Elitropus [Heliotrope][235] is a green gem, as some like to think, similar to the emerald, and spotted with blood-colored drops. Necromancers call it the Babylonian gem. It is found in Africa and Ethiopia. It is named after its virtue, by which it can be easily recognized. If it is placed in water, first anointed with the juice of the plant by the same name, and placed under the sun's rays, it will appear red; and the sun will appear bloody, as if there were an eclipse.[236] Water will start boiling and spill over the basin, as if boiled by fire. Placed outside the water, it absorbs the sun like a mirror; thus by looking into the eliotropia, we can see the sun's eclipses. It can be found in Cyprus, but the most perfect may be found in Libya, as Solinus states.[237] Magicians say that if consecrated with some verses, and if some characters are inscribed on it, it will allow its owner to foretell the future; and if anointed with the juice of the plant by the same name, it deceives sight by making the wearer invisible.[238] Its virtue is of rendering its wearer safe and giving him a long life. It stops the flux of blood and expels poisons.[239]

Emathitis or Emathites [Hematite][240] is a dusky, reddish,[241] opaque, hard stone, which has the brightness of iron with veins the color of blood; if carried in the hand, it stains it the color of blood. If ground with some liquid, it renders the latter the color of blood, too.[242] It takes its name from its virtue. Since *emeth* means blood, and *titel* to stop, thus its principal virtue is to stop bleeding. There are five species according to their place of origin: Arabian and African, which are better than the others. The Phrygian and the Ethiopian are thought to be of the least value, although Socatus may disagree.[243] But the German is the worst of them all. Its principal virtue is styptic [hemostatic], if washed as directed by the medical arts. Galen believes that it is warming and extenuating, though this is not the case for stones that have not been wetted.[244] It is a most excellent and beneficial remedy for those suffering of bloody sputum [*emoptoics*], dysentery, and those troubled by their menses and any flux of blood, if placed in the mortar with a proper amount of water, until the latter turns the color of blood. Adding to the aforementioned a well-beaten egg white, or honey and pomegranate juice,[245] it heals styes on the eyelids and hazy sight.[246] If drunk with wine, it heals those bitten by serpents.[247] Its powder heals external fleshy growths. If mixed with honey it heals pains in the eyes. It is said that it helps

88 THE MIRROR OF STONES

to expel or to dissolve bladder stones. If placed in hot water, it makes it luke-warm, emanating heat. The Phrygian is burned to make it more efficacious for the abovementioned purpose.[248]

Ethices or Endes,[249] by some called aquileus, is a reddish or scarlet stone. It is called aquileus because eagles on the shores of the Persian Ocean sometimes place it among their eggs in their nest. By some it is also called the pregnant [*praegnus*] stone, because just as if it were pregnant it holds a little stone within that rattles; and, as already said, some think it to be of a scarlet color, others [maintain it is] flesh colored, plain and bright, of average size. Some say that it has an oblong shape, slightly round. The variety of authors' opinions depends on the variety of places in which it may be found; still, it has an admirable virtue. They say that given to someone who is [about to eat] poisoned food he will not be able to swallow it, but once the stone is removed from his person, he will swallow it. Some say that it must be placed in food. Tied to the left arm of a pregnant woman, it prevents an abortion. Placed on the thigh during birthing, it removes all dangers and speeds the birth. It heals those suffering from epilepsy and chases away poisonous animals; for this reason, eagles place it in their nests: it protects the eggs and the eaglets from poisonous animals. It renders its wearer amiable, sober, and rich, and it similarly protects him from adversities.

Enidros or Eryndros[250] is a crystal-colored stone so called from *hydros*, which means water, which it perpetually exudes in small drops. Philosophers well know the reason for this: since this stone is extremely cold, it continually converts air into water with its frigidity. It heals all burning fevers.

Epistides or Epistrites[251] is a glittering, red-colored stone. It originates from Corinth. They say that if it is fastened to the heart with appropriate magical ties and spells, it renders man immune to any misfortunes. It chases locusts and noxious birds away from fertile land, as well as bad clouds and tornadoes from wherever this stone will be placed.

Exacolitus[252] is a stone of varied colors all mixed in. It has a dissolving virtue, as learned physicians write. Ground, steeped in wine, and drunk, it heals colics and iliac passions.[253]

Estimion or Exmisson[254] is a very pleasant stone of a resplendent golden and fiery color, with a pure and white light at its borders.

Execonthalitus or Hexaconta[255] is a stone that has sixty colors in a small circle and is very often found in Libya.[256] They say that it has as many virtues as the ornaments [colors] of precious stones it contains.

Exebonos or Exebenus[257] is a white and fair stone, used by goldsmiths to burnish gold, if smelted with it. Ground and drunk, it heals madness, and similarly those who suffer from stomach pains. It is useful to the fetus still in utero.

Tied to the femur, it dissolves bladder pain, hastens birth, and halts venereal pleasures.

Eumetis[258] is a flint-colored stone, which when placed under the head while sleeping turns the night's dreams into oracles.

Emites[259] is ivory colored and similar to white marble, but less hard. They say that the sepulcher of King Darius was wholly made with this stone.

Egyptilla[260] is a black stone, which on the surface has a cerulean color with golden veins, and takes its name from the place where it is found. If ground in water, it turns the latter the color and taste of wine.

Emetrem is a green-colored gem,[261] which the Assyrians thought sacred to God. It is a gem used to make charms to ward off the evil eye.[262]

Effesstis or Effestites[263] is a mirrorlike stone in that it reflects images. It is found in Corinth. They say that if placed in water it turns lukewarm, and if placed under the sun it burns matter that is apt to be burned.

Elopsites[264] is a stone without beauty, but its great virtue compensates its lack of beauty. If hung by the neck, it stops encephalitis and migraines.

Eunophius[265] is similar to *Ethices*, as it rattles just like it; some think it is same for it has similar virtues.

Electioni[266] is similar to *Gagates*.

Echistes[267] is the same as *Ethices*.

Echidnes[268] is a stone with serpentine spots.

F

Filaterius[269] is a chrysolite-colored stone. It chases away terrors and melancholic passions. It induces cheerfulness and wisdom, it renders its wearer well-behaved, and it comforts the spirits.

Fingites[270] is white colored, hard as marble, and transparent like alabaster. It is imported from Cappadocia. They say that a king made a temple without windows with this stone, and because of its transparency it was possible to see inside, as if it were wide open.[271]

Fongites[272] is a stone on whose color learned men have doubts. I believe that this is because there are a variety of them. Some say that it is like a burning gem. Others say that it is of a crystalline color and its insides are like a flame. It is found in Persia. Not many know of its virtue. But Evax tells us that if anyone carries red fongites in his left hand, it removes bodily aches and calms anger.

Falcones [Urpine][273] is vulgarly called arsenic or golden pigment, because when it is sublimated it becomes white. This stone tends to be of a golden red color, and it has a similar nature to sulfur, which alchemists call one of the spirits. It has a warming and drying virtue, and it turns black by calcination. But after

sublimation it reaches the albedo [stage], and when it is sublimated two or three times, it becomes corrosive so much so that it corrodes all metals, except gold. Pulverized, and placed on a wound, it removes any matter growing off the flesh. Swallowed, it is poisonous to all animals.

Frigius[274] is a green-colored stone, and when burned it turns reddish.[275] It is useful for dyeing cloth. It is much used in medications, as Dioscorides writes. Thus, if drunk with sabina tree juice,[276] it heals fistulas and gout.

G

Granatus[277] is considered a burning gem of the carbuncle family. There are three species. One is dark red like the pomegranate flower. Another that is red colored with some citron to it, sort of like a jacinth. The third species, called surian, is of a reddish violet color and the most expensive of them all. It is found in Ethiopia among the sands of the sea. Its virtue is that of cheering the heart and chasing sadness away. Some say that it protects the wearer from the plague.

Galactides or Galaricides[278] is an ash-colored stone, or as some say, white like milk. It is found in the Nile and in a river called Athaleus. If ground in water, it has the color and taste of milk. Some say that it is an emerald encircled with white veins. Because of its different virtues, it has different names. Some call it elebon, magicians call it senochitem, some graffitem, others galbatem or anachitem. Magicians celebrate this stone with infinite praises, for they say that it renders magical writings intelligible and forces summoned spirits to give answers. It also makes man forget past quarrels and problems. If carried on one's person, it immediately placates the anger and restores the lost benevolence of any king that a person might have offended. It renders man victorious in legal causes, astute, amiable, and eloquent, and makes it possible that he may not be charmed through magic. Hung by the neck, it fills [a woman's] breasts with milk. Tied to the thigh with a wool thread from a pregnant sheep, it eases delivery.[279] But it can disturb the mind, if held in the mouth until it melts. If ground and mixed with salt, and that mixture is spread over a sick sheep's pen,[280] as the Egyptian shepherds say, it fills the sheep's' udders with milk and renders them fertile and frees them from mange. They also say that it cures mange in men as well. Tied around the neck, it eliminates toothaches.[281] It pacifies any discord it if is ground three times in water and, having been dried, is then drunk with clear water. It joins in love those who are at odds and thereafter their love can never more be rendered asunder or come to an end.

Garatronicus or Galgatromeus,[282] as some say, is a reddish[283] stone sprinkled with small saffron-colored veins similar to those of a roe deer's skin. This [stone] is useful to soldiers. They say that Achilles had this stone and carried it along

in battles, and he was never beaten by anyone—in fact, he always won against his enemies—and when he did not carry it, he was felled by his enemies. Easterners have a great abundance of them, and they use it to make the hilts of their swords, so that when they go into battle they may not do without it, since their virtue is that of rendering the bearer victorious in battle.

Galatides, Galactica, or Gelatia[284] is a stone that has many different names. It is white, bright, shaped like an acorn, and very hard, just like a diamond; it is so cold that it can be barely warmed by fire. This is the result of its pores being very small, and thus not letting fire in. Because of its cold nature, it halts lust, calms wrath, and is a good remedy for all those feverish illnesses of the human body.

Gelachides or Garatides[285] is a stone of a rather black color. It renders its wearer amiable, pleasant, and gracious. Held in the mouth, it allows a man to pass correct judgments and to well discern between various opinions. And furthermore, it has the benefit of letting him know what others are thinking of him. To recognize this stone, learned men give us this proof: anoint a human body with honey and place it where there are flies, holding the stone in the hand. If the body remains untouched by flies and bees but it is molested when the stone is let go of, then it is true garatides.

Gagates,[286] even though many think it is a gum, is nonetheless listed among the stones. It takes its name from the place where it was discovered. There are two species: the citron colored, which is called amber and of which we will say more below; the other is black, which many call "black amber." The latter is the true gagates, even though Pliny has a different opinion. It is found in Lycia. And Solinus writes that it is found in abundance in Britain.[287] Gagates, as I said, is black, light, dry, bright, and not transparent. If set on fire, it almost gives off the smell of pitch. Warmed up by rubbing it, it attracts straws and chaff, and its smoke chases away demons and dissolves spells and enchantments.[288] Worn, it is useful against dropsy. Ground in water, and given to pregnant women, it hastens the birth of a child, and in whatever manner a woman drinks it, it forces her to void foul urine, but it does not have this effect on a virgin. They even say that its smell brings forth menstruation in women, and cures epilepsy; it chases away snakes, it heals their bite if mixed with a stag's marrow, and it keeps loose teeth in place.

Gerades is a red and fiery stone that when placed against the sun emits fiery rays. Its virtue is that of protecting men from birds of prey.

Gallerica is a pale green stone, very big, and not pleasant to the sight; it is flecked with gold, from which it takes its name.[289]

Garamantica[290] is similar to the emerald [*Smaragdus*] and is crossed by a white line; it is very useful to the magic arts.

Gasidana[291] is a swan-colored stone. It is said that this gem may even conceive. If shaken, it shows the fetus within. Some believe that this is the same as *Ethices*.

Grogious is the same as *Corallus*. It takes its name from its virtue, which is that of stopping typhoons and lightning.

Glosopetra or Gulosus[292] is a stone similar to a human tongue, from which it takes its name. They say that is not generated by the earth, but that it falls from the sky when the moon wanes. Magicians attribute it a not unsubstantial power in their arts, therefore they say that with it they can incite lunar motions.

Grisoletus[293] it is the same as *Crisoletus*.

Garamantides[294] is the same as *Sandastros*.

Galaxia[295] is a black stone that has bloody and white veins within it.

Galacidem is the same as *Smaragdus*.

H

Hyena[296] is a precious stone worthy of being protected; it takes its name from the animal by the same name, since it is found in its eyes. It is of various colors. Its virtue is such that, if reports be true, having washed one's own mouth[297] and having placed it under the tongue, it makes a man foretell the future. Whoever carries it with him will never suffer quartan ague or gout.[298]

Hieracites[299] is a stone similar in color to the feather of a kite but varied in color. Some say that it is the same black color as the gelachides, since it has the same virtue.

Hamonis[300] is a golden-colored stone listed among the most sacred of gems, since it has the shape of a ram's horn. It is found in Ethiopia. When someone is in contemplation, it shows his mind all sorts of divine things.

Hormesion[301] is a very beautiful stone glittering with a fiery and golden color; it emits a white light at its edges.[302]

Horcus[303] is a stone the Alexandrians call catimia; it is a black stone, easy to grind, used in silver soldering.

Hysmeri[304] is the same as *Smeriglius* [*Smirillus*].

Hammochrysos[305] is a stone with small, square golden sands mixed within.[306]

I

Iacinthus [Hyacinth][307] is a stone the ancients say has three species. It takes its name from its shining quality. In fact, some are citron colored, some granate, and others Venetian [blue], but they are all transparent and can be recognized well enough by their names. As the citron ones are of a citron color, the granates the color of the pomegranate flower, and the Venetians of a cerulean color, which when they are placed in the mouth are colder than the

others, thus these are also called aquatic. To these some add another species that they call sapphirine. All of these have shades of red and yellow mixed with the already-mentioned colors. This stone above all others delights in daylight and fades in the dark. The most prized ones are those that do not have too deep or too rare a color, but that possess in moderation both qualities; it shines of a perpetual light, yet not too glittery. However, Albertus writes that zaphirine jacinths are superior to all. It is yellow and bright, does have many watery qualities, and is from Ethiopia. Some think that the granates are better, because they resist fire and are of a purplish color. The citrons have little red in them. The worst type are the Veneti or the ceruleans, for they only have a subtle hint of citron with a bit of reddishness,[308] yet they are harder than the others, are barely scratched by diamonds, and are very cold. Other species have warmth and dryness in the first degree. They all have similar virtue, even if they are of different colors. They invigorate the body and especially the heart. They chase sadness and imaginary suspicions away. They increase a mind's ingenuity [*ingenium*], fame, and wealth. They make man safe from lightings and enemies. They offer safety to travelers so that they are not hurt by pestilences of various countries; it makes its wearer achieve noble honors and makes them safe from all contagious diseases. However, Aristotle writes that it makes pregnant women miscarry.

Iaspis [Jaspers],[309] so called in both Greek and Latin, means green, because the green is of the best type and is valued above the others. As just mentioned, it is a green-colored stone with a certain depth since it has red veins; and of these there are many species. Therefore, some are translucent in a deep green. Some are green colored with blood-red drops.[310] Some are red like a roof tile. Some are not dissimilar from red porphyry. They are of such varied colors that learned men say there are of seventeen species, though some say more. Thus today Germany is very rich in jaspers, and they export so many and in such variety of colors that it would be in vain to list them all. It is our intention to discuss only the most noble. As I said at the beginning, green emeralds with red veins are more valuable than the others, especially because they are rather transparent. After the green come the clearer ones tinted with red, and after these, the dark red. The citrons are of the lowest quality of them all, but all are of equal virtue. When worn it heals all fevers and dropsy. It clears eyesight and chases away noxious phantasms. It also eliminates lust and does not allow a woman to conceive; the green with saffron veins is particularly helpful to pregnant women, helping them to give birth. It renders its wearer powerful, victorious, and gracious, but above all other virtues it has the ability to stop the flux of blood from whatever part [of the body] it arises from. It must be set in silver,[311] which increases its virtues.

94 THE MIRROR OF STONES

Iris[312] is a crystalline-colored stone, found in the Arabian Red Sea; nowadays it may be found in Germany, near the river Rhine, and it is hexagonal and extremely hard. Placing one part under the sun's rays and the other in the shade, under a roof, it will throw beams of light on the opposite wall that are similar to those of the rainbow; it is from this effect that it takes its name.

Idaeus[313] is an iron-colored stone. It is found in Mount Ida in Crete, from which it takes its name, and it is shaped like a man's thumb.

Iscistos or Iscultos [Schist][314] is a rust-colored[315] stone that is found in some parts of Spain, near the Pillars of Hercules. Some say that it is the same as amantes, as they have the same virtue.

Indica[316] is a reddish-colored stone; if ground, it turns purple. Another type identified by the same name is white in aspect. It takes its name from the place where it was found. It seems to have no virtue.

Iudaicus,[317] so called from Judea, is the same as the *Cogolitus* [*Cogolites*].

Iovis[318] is Jupiter's gem. It is white, soft, and not heavy.

Ion[319] is of a violet color. It is found in India.

Iaguntia,[320] which some say it is a granate.

Ierarchites[321] is the same as *Hieracites*.

K

Kabrates or Kakabres[322] is a crystal-colored stone with a dusky whiteness. It has the virtue of rendering man eloquent and cheery. It gives him honors, renders him amiable, protects him from evil accidents, and heals dropsy.

Kamam or Kakamam[323] is a white-colored stone distinguished by various colors; and it takes its name from kaumate, because it carries fire. It is found in hot and sulphureous localities; and it is most often mixed with onyx. It does not have any particular virtue, but it does take its virtue from the sculptures and images engraved on it. On which subject will be said more in the third book.[324]

Karabe[325] is the same as *Succinum*, of which more will be said later; some [learned men] think that they are different, though they are not different in color or in virtue. But its vapors chase away epilepsy.

Kenne[326] is a stone said to be generated in the eyes of stags in the eastern regions of the world.[327] Its virtue is good against poisons.

Kimedini Limphatici is the same as *Cimedia*.

Kinocetus[328] is not wholly useless since it casts out demons.

L

Lichinus or Lychinites[329] is noted among the burning gems. It is red and generated in many places. The type found in India is the most prized. It is called *Lichinus* because it vigorously throws light, as if it were a lamp. There are said

to be two species. The first, as we said, is thought by others to be a lesser carbuncle. The second is close to a purplish color; and warmed in the sun, or with friction, it attracts straw. It is hard and difficult to engrave; and when its sculpture is impressed in wax, its [image] holds fast to it, as if its grip were an animal bite. Some say that there are four species, but I cannot find their details.

Lyncurius[330] is a stone generated out of the lynx's urine, hardened by time. It is found where these animals live and especially in parts of Germany. Therefore, it is said there are three species, one of which is sparkly like the carbuncle. The other is saffron colored and tends to be dark. The third is green, and its virtue is that of healing stomach pains: it also heals jaundice,[331] staunches the flux (of blood), and is useful against the king's evil.[332]

Lyncis,[333] too, is a stone generated by the urine of the animal by the same name, but it is different from the abovementioned, because as long as it is hidden underground it is soft, but when it is put in an arid place, it hardens. It is white in color, mixed with black. And if it is kept underground or in a humid place, before it dries up, it will generate funguses [mushrooms]. Its virtue, and the virtue of its funguses [mushrooms], is to heal those troubled by [kidney] stones. It heals stomach pains, halts the flux of the belly, and cures jaundice.[334]

Lippares or Liparia[335] is a stone to which every kind of animal is willingly attracted, as if moved by their own instinct. Therefore, some say that whoever has this stone will not need any type of device to catch wild animals. It is often found in Libya.[336] Others say that it has the wonderful virtue of protecting animals. Therefore, when a wild animal is attacked by dogs or a hunter, it hurries to find this stone as its protector and defender. Thus, for however long the animal beholds this stone, it cannot be seen by a dog or hunter, which would be a marvelous thing, if it were true. This is however what the learned write. And I believe that Pliny's words are true when he says there is no great lie lacking in authority.

Limacie[337] is stone that takes its name from the animal in whose head it is found. Thus it is extracted from the head of slugs without shell, whose natural habitat is damp and rocky. It must be extracted by squeezing its head as soon as the slug is sighted. It is of a white color with little transparency, and it is small in size and similar to a fingernail cutting. They say that hung by the neck it frees man from fever.

Lacteus[338] is a citron-colored stone. Placed in any liquid, it turns it the color of milk. If placed on rheumatic eyes it halts the course of that humor; it is similarly helpful to cure the onset of abscesses in inflamed eyes.[339]

Leucoptalmus[340] is a four-colored stone that resembles a wolf's eye, from which it takes its name. Some believe that it is the same as *Obtalius*.

Lisimacus[341] is a marble type of stone; it has veins or golden spots.

Leucocrisos[342] is a green-colored stone girded by white veins. Some believe it to be a type of emerald, as said in that entry.

Limoniates[343] is a green-colored stone similar to the emerald but not as green and transparent.

Ligurius,[344] as some say, is similar to the electorius and attracts straw. It appeases stomach pains, halts the flux of the belly, and cures jaundice.[345] It sharpens sight and, because of this, doctors make eyedrop medications with it.

Lignites[346] is a glass-colored stone of some beauty. Hung around the neck of a child, it protects him from the charms and spells of foolish women, whom the common people call witches. Tied to the forehead, it halts the flux of blood from the nose. It cures folly and renders man able to foretell the future.

Lepidotes[347] is a stone similar to fish scales and comes in different colors.

Limphicus is a stone of great virtue. Displayed,[348] it frees [a person] from seizures. Wrapped in silk[349] it protects against all infections of the eyes, jaw, and throat, and cough and headaches, not only in the present moment but for the future.[350]

Ligdinus[351] is a stone of a marvelous whiteness, big as a cup or a basin, first found in Arabia. Asia generates a species called coralline no larger than two cubits. In this same country there is also a species that is sort of white, like ivory.

Lauraces is a stone that heals man from headaches and migraines.[352]

Lychnitem[353] is a type of bright white marble.

Lazolus is a stone described under the heading of *Zumemelazoli* [*Zumemellazuli*].

Litos is the same as Magnes.

Leucostyctos is the same as *Prophirites*.

Lunarius[354] is the same as *Selenites*.

M

Margarita [Pearl][355] takes first place among the white gems and is generated by celestial dew that enters some seashells, as the authors write. This is the pearl. It is said that these shells leave the bottom of the sea in the mornings of a certain season of the year, to draw in air, from which the pearls are made. And depending on the clarity of the air element, they generate pearls that are more or less clear. The pearl's shape is mostly round, by some called an unio,[356] but in each shell there is no more than one. And if because of an abundance of air there is more than one in a shell, they are all globular, of which I have seen seven together, though all showed their roundness if placed against the light, and often one can see two or three of them. The most perfect are those that are silver colored with some clarity. Their size, as the learned write, does not exceed an ounce. There

are two species of pearls. The first, the oriental, is of a candid color like polished silver, with a transparent surface; this is the most perfect. The second type is the occidental, which is carried by the British seas. Its color is dull with some whiteness, tending to a golden color. The oriental are the most perfect of all. And as they are big and round, they can be easily bored through by art and sometimes are naturally so, though not as regularly: these are inferior and useless as ornaments, and they are different from those that are not perforated. And this is what is said about them: the perforated pearls are more perfect and have less of a binding[357] quality than the non-perforated. It would be ridiculous to affirm that the opinions of the most learned physicians are without meaning when they state in their recipe whether the pearl needs to be perforated or not, for when they say perforated they should clarify perforated by art: otherwise the difference is wholly to be attributed to accident and not intention. Therefore, so as not to be led into error, and to judge better than the unskilled, we should know that [naturally] perforated [pearls] are those that stayed in their shells for a long time, and when ripe are spewed out to the sea. The long stay and perfect maturity make them perforated and they thus lose their binding quality: and these are the pearls that the doctors are speaking of when they say perforated, as they are not useful for ornament and are not brought to us. But they who understand how to try them out draw comparisons between the pearls and the oak apples, because those that are not perforated have more binding power than those that are. Pearls also have physical virtues that much exceed their usefulness in ornament.[358] These pearls still retain their virtue; if cooked in food they heal quartan fevers. If macerated in milk and drunk, they heal deadly ulcers; taken in similar fashion, they greatly clarify the voice. They comfort the heart, lend aid to those who suffer of fainting spells,[359] and remove epilepsy. They halt the flux of the belly. If taken with sugar, they are of great aid against pestilential fevers. Whoever wears them becomes chaste.

Medus[360] is a stone that takes its name from the country in which it was found. There are two species: black and green. The green is called medinus. If the black is placed in a green mortar and is liquefied in the milk of a woman who gave birth to a boy and is placed on the eyes,[361] it restores lost sight. If ground in the milk of an ewe who has given birth to a male lamb, it heals the gout if placed on the affected parts; taken by mouth it is a deadly poison. Hence this stone is rightly said to give death and health. The green is called medinus; if ground and mixed with gall ink[362] and with some magnet and rainwater, and then placed on the eyes for seven days, it aids sight and makes one discern things so small they are almost invisible.

Marmor [Marble] is a well-known stone. There are different species that take their names from the countries in which they are found. Nonetheless the true

98 THE MIRROR OF STONES

marble that is much praised since antiquity is the green, from which it takes its name, since in both Greek and Latin marble means green. But not all species are generated in *lipiciniis*[363] places and are cut out from the mountains. Some are generated under the earth, as we have mentioned many other times in this book and as we are about to say now. At present we shall list only its species and their color. Their virtues will be discussed under their own separate headings. The Lacedemonian is green, as we just said, and is the most prized of them all. After this follows the Augustan, which is found in Egypt and has spots gathered in clusters. The Ophitean is black and white with serpentine spots. The Purpurite, or porphyry from Egypt, is red colored with white spots or round lines. The Basamite is iron colored and found in Ethiopia and Egypt. The Thebaic is white girdled by golden veins or drops. The Syenite is found near the city of Syene.[364] The Parian, which is extremely white, is generated in the island from which it takes its name. Onichiata is found in the Arabian mountains, and some believe that it was generated only there. But there is also a great quantity of it in Germany, which has almost an alabaster color with small white veins. There is the Lesbian, Corinthian, Caristean, Numidian, Lucullan, which is found in Chios, the Limensian, and the Eburnean [ivory like], so called [for it is similar to the ivory obtained] from a black elephant. The Carrara marble, so called from its place of origins, is white with red, sometimes black spots. It is also found in many places with a variety of different names, which would be superfluous to mention, since they are similar in color and beauty to those mentioned above.

Murina[365] is a stone of various colors all mixed together, such as purple, white, and fiery [red], with a kind of reflection one of the other, as seen in the rainbow. It is found among the Parthians. They believe that it is generated in the humidity of the earth condensed by the heat of the sun. Its virtue is not mentioned by the learned, but it is useful for vase making. Pompey was the first who brought murrhine vases to Italy, which were greatly prized for their beauty.

Mirites[366] is a stone similar to myrrh in both color and odor; if rubbed with a cloth, it emanates the sweet odor of muskroot.

Malachite[367] is a stone that has the bright color of an emerald, with a kind of rough vigor without transparency; it takes its name from mallows,[368] since it is almost the same color. It is a soft stone and is found in Arabia, Cyprus, and Persia but of different colors. Therefore, the Arabian type has the color of mallows, the Cypriote tends to a grayish color, and the Persian is of a green color still retaining a brass hue. The virtue of this stone is that of protecting infants from various accidents and hurtful phantasms, so that they may grow up in prosperity.

Memphitis[369] is so called from the city by the same name, in which it was first found; it is useful to surgeons for its virtue is greater than opium.[370] Mixed

in a drink, or ground in vinegar, applied to those limbs that need to be amputated or cauterized, it makes them numb so that the patient does not feel any pain.

Magnes [Lodestone][371] is a stone of marvelous and incredible virtues, and if experience had not taught us what we are about to say, without a doubt it would not be believed. It is an iron-colored stone tending to the cerulean. Sometimes of a dusky and different color, it was first found among the troglodytes on the ocean shores. Learned men speak of five species of magnets, which have different virtues and colors: the Ethiopian, Macedonian, Antiochian, Alexandrian, and Asiatic; though the greatest praise given by the ancients is for the Ethiopian magnet. It takes its names from its discoverer.[372] In our times it is found in many different places. It is said that it is dangerous to navigate with ships carrying iron from whence the magnet is generated because they would be held fast and would not move any farther; I believe this to be a ridiculous idea. Now, as already said, its virtue is stupendous and marvelous. And had we not seen the truth, we would believe it to be a lie. In attracting iron, it seems to have an animal virtue, and not only in attracting it, but in imprinting on it its virtue by similitude [*symbolitate*], since iron attracted by a magnet will attract to itself another, as if it were itself a magnet. It seems that diamonds oppose its virtue; in fact, when a diamond is placed near it, the magnet does not attract iron. Similarly, garlic, too, opposes its virtue. For this we have no explanation, since philosophers do not know it, and can only say that this happens because of an occult property. I have found that there are three species [of magnets]: one that attracts only iron, one that attracts human flesh, and the third, called hymmon, they say that it attracts iron on one side and repels it with the other, which is the only one we have experienced. The others we have not seen. It repels iron in this manner: thus, as we have said, if touched on one side, it attracts it, on the other it repels it; as experience shows with a needle hung by a thread. It would be dangerous to navigate on the high seas without its virtue and guidance; it shows navigators the way, for if there are clouds or it is a dark night, the North [Star] would be hidden and they would not be able to navigate. The first navigators, not having any knowledge of the navigational compass, fitted a needle onto straw, or wood and placed it in a basin with water so that the needle could float. Afterward, they drew a magnet around the cup: the needle followed it, and once the magnet was removed, the point of the needle in an almost natural motion moved toward the star of the Arctic pole. Having thus located the place of the North Star, they directed their course accordingly. Modern navigators, being ingenious and apt to improve on things, made a mariner's wheel [a compass]. Through this, they not only locate the Arctic pole, but they can also discern all the parts of the sky, as well as the winds. This is the most marvelous thing that the magnet possesses: that it has the virtue of all the parts of the heavens, according to the

corresponding part of the heavens; thus by touching the iron, it makes the needle spin in the mariner's compass and turn toward that part of the sky; and this may be read in Albertus Magnus's book on magnets,[373] and I have verified this fact many times through experience. Some call it the sacred stone. The divine creator gave this stone not only these marvelous effects, but also many other virtues. Thus, when worn, it heals *artheticum*'s spasms and pains.[374] During birthing labors, held in the hand, it eases delivery. If ground and taken with honey it heals dropsy. In likewise manner, placed over a wound, made by a poisoned iron, it heals it. Those given to melancholia may take it with the juice of fennel[375] to heal. By anointing the head with it, it heals alopecia. If the quantity of a dram is mixed with the fat of a snake, and the juice of nettles, and is given to anyone to drink, it renders that man mad, and it drives him away from family, homeland, and his own house. The same mixture makes a woman reveal her adulterous ways. Thus, if placed hidden in a wife's bed when she sleeps, if she is chaste she will embrace her husband; if she is not, and has committed adultery, immediately, while still sleeping, she will throw herself out of the bed, as if forced by a terrible stench. Worn, it reconciles wives to husbands and husbands to wives. It removes fears and suspicions; it renders man gracious, persuasive, and elegant in speaking. If it is ground and spread over hot coals in the corners of the house, as soon as the smoke rises up, the inhabitants of the house will flee because it will seem to them that the whole house is about to fall; and they will fear evil spirits to the point that they will flee leaving everything behind, and by this artifice, in the meantime, thieves will enter the house and will steal all that they will find within. It is said that the walls and the roof of a temple made of this material remained upstanding even though the floor was removed. In this temple an iron idol weighing a thousand pounds was suspended in the air by virtue of the magnet. Thus the crux of the matter is this; that if many heads[376] and points of needles were rubbed on this stone, and joined one to the other, by holding only the first, all the others will be lifted in the air. The role this stone plays in the magical arts, and the marvelous things that can be done, I am here ignoring as they belong to another discussion.[377]

Magnasia or Magnosia[378] is black in color and useful in the glass arts. It is the same as the *Alabanticus* [*Alabandicus*].

Marchasites [Marcasite],[379] of which there are many different species, is different according to the diversity of metals. Thus some are the color of gold, others of silver, others of copper,[380] and others of iron: they have more diversity in color according to the type of metal of which they are made. Alchemists know this stone very well. It is not liquefied by fire, but it burns on its own. Some call it the stone of abesteni, or of light, because it is useful when one has lost eyesight.

Some say that it is called the stone of light because when struck with steel it creates fire and kindles it in apt matter.

Medea[381] is a stone that takes its name from the witch Medea who found it; it has a black color with golden veins, and when ground in water it tastes like wine and has the color of saffron.

Morion[382] is a stone found in Cyprus[383] and France, very black in color, and very transparent, it is good for gravestones.

Mitridax[384] is a stone generated in Persia, which when struck by the sun shines with various colors.

Melites or Melitites[385] is a stone that when ground in water tastes like honey. It is useful to make various medicines: as said by many authors, especially Pliny.[386]

N

Nitrum [Niter][387] is listed by the learned among the stones, though it is not a stone: as we have said of others. It is clear and the color of salt.[388] Its virtue is that of dissolving and attracting. It is created by artifice with the earth's salts, there where animals and men have urinated. Its usefulness in instruments of war is well-known as it is notably used to launch stones. Thus, kindled by fire, it rarifies and violently expands; by means of opposition and pressure it launches stones in the air.[389] It was never discovered by the ancients, but it is a discovery of modern inventiveness: by taking three things in proportion and mixing them together they make a certain composite that no force can resist, and thus it breaks, leads, drives away, and destroys everything.[390]

Nicolus is a stone of two colors, yellow on the surface, black underneath, and sometimes completely black. Some believe that it is a kind of chalcedony. They say that it takes its name from the Greek. Its virtue renders the wearer victorious and well-liked by people.

Nassomonites[391] is a blood-colored stone, distinguished or shaded by black veins. It is found among sandbanks.[392]

Nemessitis[393] is an excellent stone that, as the Athenians say, emerged from the altar of the goddess Nemesis.

Nose or Nisus[394] is the same as *Alabastrides* [*Alabastrites*].

O

Onyx[395] is a stone the color of a man's nail, in fact *onix* in Greek and in Latin means nail. It is transparent and rarely found on its own. Its species varies according to the variety of colors [of the material] to which it is attached, and the place where it is found. Some say that there are two species,[396] some five. The first, the true kind, has already been mentioned, the other is said to be extremely

black. The third kind is black with white veins or bands. And this one comes from Arabia. And in India there is a reddish-colored[397] species with white veins; the fifth type is black mixed with reddish.[398] Some say that the true onyx is the color of amethyst, carbuncle, and chrysolite,[399] and that these colors are mixed with white and black. This stone brings forth many horrendous things in sleep. Worn, it attracts quarrels and fights. It increases spittle in infants and accelerates birth. Worn around the neck it prevents falls for those who suffer from epilepsy. Onyx is said to be marvelous because of this: placed under a sick eye, it enters it of its own volition as if it were endowed of intellect, and it goes around it without any trouble; and if it finds in it any illness, it extinguishes it. It tempers noxious and contrary humors.

Onicinus[400] even though it is a gum, from the tree with the same name, it is listed among the stones for it hardens in the same manner, as it will be said of succinus [amber]. It is white mixed with some red. If placed over coals it emanates a sweet smell, whitens one's countenance,[401] and heals scabies.

Opalus [Opal][402] is a stone by a marvelous aspect, for it is composed of many diverse colors of shiny gems, like the carbuncle, amethyst, emerald, and many other gems of a certain variety that are equally shiny and wonderous to behold. It is found only in India. Its size is no bigger than a hazelnut. The high regard in which the ancients held it may be read in Pliny's thirty-seventh book, where it says that its value was estimated at twenty thousand sesterces.[403] Its virtues are useful against all sorts of eye diseases. It sharpens and strengthens sight. It is not improper to attribute it so many virtues, seeing that it partakes of the nature of many stones and colors.[404]

Obtalius or Obtalmius is a stone whose color is not given by learned men, although some say it may be multicolored. Its marvelous virtue is that of preserving the eyes from various illnesses. If a laurel leaf is added, and the appropriate charms are pronounced and the stone is appropriately carried, it sharpens the sight of whoever wears it, and obfuscates the sight of those around it, to the point that they are unable to see; this is a marvelous virtue.

Orites[405] is a stone said to be of three species; one is black and round. When this stone is ground and mixed with oil of roses, it completely heals the wounds inflicted by wild beasts and noxious bites, rendering the wearer safe from all sorts of strong wild animals. The other species is green sprinkled with white spots. When worn, it prevents adverse casualties. The third species is thin, like an iron blade marked by sparse spots. Hung by the neck, it ensures that women do not conceive; and if they are pregnant, it makes them miscarry.

Orfanus[406] is violet in color. Because of its beauty and value Roman emperors wore it on their crown. It shines in the darkness. It is called orfanus because at

that time only one had been found. It is loved by emperors, as it preserves royal honors.

Obsius or Obsianus[407] is a black stone that is translucent in color and similar to glass. When made even and polished, it shows images and shadows like a mirror. It is placed on the walls of buildings because of its beauty. It is equally found in Libya, Germany, and Italy.[408]

Ostracites[409] is a stone similar in shape to an oyster shell, from which it takes the name. It is used like a pumice stone to smooth the skin. Its virtue is that of halting bleeding if taken in a drink. If ground with honey, it heals breast pains.

Ophites[410] is a type of marble, as said above under that heading [*Marmor*], which has serpentine spots. It is of two species: the soft and white, and the hard and black (or dark) with a certain greenish [tint] sprinkled with yellow spots. The ancients adorned the walls of buildings with it. When hung by the neck, it has the virtue of healing headaches and serpents' bites. It is believed that the white kind restores to health the insane and the lethargic. It is found in Germany, where they make drinking vessels with it. Some think that ophites is that stone with which they made cauldrons. Because of its softness it may be cut and smoothed out. In the Belgian[411] provinces they saw it into planks to make roof tiles for the homes. It hardens with fire.

Ostratias[412] is a stone similar to iacintus [hyacinth] but harder, so much so that its hardness is similar to the diamond.

Ophicardelon[413] takes its name from a barbarian's last name.[414] It is black with some white lines within.

Okitokius[415] is a minor stone, of lesser importance than echites, and just like it, it resonates from within. It is smooth to the touch and rather fragile. Liquefied with echium's juice and mixed with the blood of a swift and the head of an omide [*omidis*] and mixed with water and placed in a glass vase, it will show its virtue.[416] Thus those who will dip a finger in that unguent, and will touch any hard wood, metal, or stone of any kind, immediately that will break.

Onagari[417] is the same as *Asinus*, of which we spoke above, since in Greek *onager* means the same as the Latin *asinus*.

Ombria[418] is the same as *Ceranius*, of which we spoke above.

Ornicus is the same as *Saphirus*.

Olea[419] is a stone of a yellow, black, green, and white color.[420]

P

Prassius[421] takes its name from an herb with the same name to which it is similar in color. They say that prassius is the emerald's matrix [i.e., it is generated by the emerald]. They say that it is found in Ethiopia near the Nile River. There

are three species. One, as just said, is transparent green with a degree of dullness and thus not clear. Another is green marked by blood-colored drops.[422] The third is also green lined with white or calchedony's streaks.[423] It is of no small virtue: thus it comforts sight and has all the virtues of the emerald, though it is not as efficacious.

Panthera[424] is also called evanthus; it is a stone that has various colors mixed in one body whose shape is similar to the animal by the same name, so called because of the variety of its colors. Just like it, this stone may have black, red, pale, green, rosy, and purple marks. It is found in Media. If anyone looks at this stone as the sun rises, he will be victorious on all actions of that day. It is also said that the same stone has various virtues, as many as the mixtures of other stones in it, because each stone lends it its own virtue.

Pontica[425] is a transparent cerulean gem.[426] I find that there are three well-known species. It takes its names from the Pontus Sea, where it is found, and because it is similar to its seawater. [In one species,] the sea blue color is sprinkled with red stars or blood-colored drops.[427] The other shines with golden marks. The third is streaked with long red lines mixed with its cerulean color. They say that thanks to this stone one may speak with the devil as well as chase him away and is compelled to answer whoever questions him.[428]

Peantes or Peantides[429] (as some say) is a stone of the female sex, as it is able to conceive at certain times, and it gives birth to a stone similar to herself. Even though some have written thus, I do not like it; rather, I believe that such writers are in error because they misunderstood the words of the ancients. For when they say that this stone is of the female sex, they mean not that it conceives, but rather that its virtues lend help to women in conceiving and in giving birth. Whether this opinion is correct, I leave others to judge. It is found in Macedonia.[430] The color of this stone is like water turned to ice by the cold.

Pirites,[431] also called Pyr—that is, fire—is commonly called the firestone, for struck with steel it sparks with fire. By some it is called Ypestionus—that is, Vulcan. Therefore, in a general sense, we may call all stones that spark fire pyrites. And thus, even the marcasite, because it produces fire, is called pyrites. Even coral for its redness is by some called pyrites. But the true pyrites is the one that as soon as it is struck sparks fire, is of a yellow color, rather blunt and solid, and becomes rough and polished like a baked stone because of the powerful action of the sea waves. Dioscorides affirms that it has the color of brass, and that ground and held between the fingers of the right hand it burns them. It is found in many places and is said to be of great use to make medicines; it particularly aids in healing sore eyes and many other illnesses as the learned state.

Phrygius[432] takes its name from Cyprus, the province in which it is found. Its color is pale and it is of medium weight, like Punic earth.[433] By heating it three times and sprinkling it with wine, it becomes red in color; it is useful to dye cloth. We find that there are three species. One we have mentioned, the other is similar to burned brass, for it is the scum [dross] of brass. The third type is not a true species since it is created by artifice, and it is made of pyrites by calcination in the furnace, until it acquires a reddish blood color; nonetheless it is listed among the *phrigius* species. Its virtue is styptic [binding]; it calms a wound's swollen flesh, it heals growing and malignant ulcers, and it stops the flux of the eyes.

Prophirites [Porphyry][434] is a blunt, heavy, and very hard stone of a red color, distinguished by various white marks. We have spoken of it above under the *Marmor* heading since it is of the marble species. The ancients used it a lot in their buildings.

Podros[435] is a burning white gem, which surpasses all others for its candor, except for the pearl.

Panconus[436] has a crystal color, its size is no larger than a finger, and it has an oval shape. It is different from a crystal because it has no angles [facets].

Punicus.[437] There are two species of this stone. It is found in the Aeolian Islands. The whitest is the most perfect and heavy. Its virtue is important in medicines. Thus this stone when burned, washed, and dried is very useful for the eyes. It cleanses ulcers and aids in the scabbing process. If it is taken prior to drinking wine, it prevents drunkenness.

Praeconissus[438] is almost all sapphirine in color, dull but pressed together with calchedonian marks, and delights the eyes with its agreeable embellishments.[439]

Pavonius[440] is a stone that when mixed in a drink with a bit of sweat forces the person whose sweat it is and who drinks it to burn with love.

Pumex[441] is a stone known to all; it is porous, very light, and soft. It is sometimes an alchemical and sometimes a physical stone. It is not useless to writers.[442]

Paragonius[443] is of two species, black and gold. The black is used to achieve a knowledge of metals, as goldsmiths do, when they bring the metals to it.[444]

Pheonicites[445] is a stone that is similar to an acorn in color and shape.

Philoginos[446] is the same as *Crisites*.

Q

Quirinus or Quirus[447] is a conjuring stone[448] found in the nest of the hoopoe. If placed on the chest of a sleeping person, it has the virtue of forcing him to reveal all his misdeeds.

Quaidros[449] is the same as the *Vulturis Lapis*, as we will say later on.

R

Radaim[450] is a black and transparent stone. It is found in the rooster's head, even though some say in the head of a catfish, as mentioned above in the *Doriatides* entry. When cut and immediately placed somewhere so that ants may eat its flesh, once the latter is eaten, the stone can be retrieved. It brings honor to whoever wears it, and it is useful in governing.

Ranius, Rabri, and Rami[451] are synonymous. According to some, it is also the same as the bolus armenus, but it seems different from the bolus armenus because it is of a livid color tending to transparent white. It is heavy, and its virtue is to resist poison, like the bolus armenus.

Rubinus[452] is a species of carbuncle, as already stated. Nor is it wholly different from it except for its size, and it has a similar virtue. There are two species: one we already mentioned; the other darker and of almost no value.

S

Saphirus [Sapphire][453] is a yellow-colored stone, or a very light azure like the purest azure color; the deeper and more transparent the yellow, the better the quality of the stone. But the most precious one, which surpasses all, emits an almost burning brightness when struck by the sun; no image, however small, is ever found within it. It is found on the Libyan shoals,[454] but the Indian ones are better. Some call it the gem of gems because of the grace of its color, but some say that it has received its name not from its color but from its virtue. It fortifies the body and gives it good coloring; it cools off the ardor of lust and renders man chaste and virtuous; it stops too much sweat. It removes filth from the eyes and aches from the forehead. If drunk with milk, it calms the spasms of the belly. It renders the wearer peaceful, lovable, pious, and devout, and it turns the soul to good work. It uncovers frauds and chases fears away; it is useful in the magical arts; and it is also said that it is of prodigious efficacy in necromantic magic. It discharges boils by touch alone. If touched to the eyes it preserves them and protects them from smallpox.[455]

Smaragdus [Emerald].[456] There are many types, but the Scythians are superior to all. Their green is so intense that placed under a light or the rays of the sun, not only does their color not dim but rather its green, intensified in strength, coloring the surrounding air with its hue. From this it takes its name, because everything that is so deeply green may be called an emerald. I find that lapidaries describe twelve species, though, as we mentioned, the Scythian kind is more precious and noble then the others. After this, it follows the British, the Egyptian, the Hermitian, the Persian, and those that are found in the copper mines. Even though they are all transparent, they differ in the intensity of green. Its green is so delightful that certainly no other gem delights the eyes as much. When its

surface is evened out [polished], then they reflect images as mirrors do. It is said that the Emperor Nero had an emerald of marvelous size through which he saw gladiators' battles.[457] There are other species that vary in color, with varied small spots, which are called fake emeralds;[458] these, along with the aforementioned, add up to twelve. The six species mentioned above, though, are the only ones of great value.[459] There are some big ones, but not as big as fake emeralds; however, Pliny writes of an obelisk that was fifty cubits high, of another that it was four cubits high, and of another two in the Temple of Jupiter in the Babylonian kingdom that was made of four emeralds. Theophrastus, too, reports having seen an emerald that was four cubits in size.[460] It is also said that in Rome there used to be a large [emerald] sphere[461] in the Temple of Hercules. But, as we said before, there are not many perfect specimens. The emerald surface shape is flat and thus hides its faults because its color is equally fulgent and images may be impressed on it.[462] This stone is useful to those who love chastity, thus it does not tolerate that a virgin be defloured, for then it breaks, as Albertus reports. It stops lascivious inclinations.[463] It increases wealth. It halts demons' illusions and tempests. It heals tertian fevers and propitiates the wearer to god and men.[464] It opposes epilepsy, sharpens memory, and lends strength to the arguments of rhetoricians, and it is useful for them, as they worry about foreknowledge of future cases.[465] It restores fatigued sight and renders it sharper. It is useful against poisonous bites, especially those of a rabid dog. It is the best remedy for leprosy, kidney stones, and poisons, if taken pulverized.[466]

Succinum [Amber],[467] which belongs to the *gagates* species, as said before, even though it is a gum, nonetheless it is listed among the gems because of its beauty and the use ancient people made of it. It is of a transparent yellow with a sort of blue tint within mixed with saffron color. Pliny reports how much the ancients esteemed it. It is said to be the gum from a tree by the same name that is similar to a pine tree. However, it clear that it is not the *gummi populi* as the poets suggest based on Phaeton's fable.[468] It is found in many locations, such as Dacia, England, and Brittany.[469] But it is most abundant along the Northern Ocean, opposite Gessaria Island,[470] which the Germans also call Amber Island. This gum solidifies under the sun, with the cold and with the passing of time. Since it oozes out of the trees at various times, it traps inside it anything it encounters in its path. Thus at times we can find enclosed within it small animals and straw; in fact, sometimes counterfeiters will soften succinum and place something within. When this gum is hardened on trees, and if these are close to the shore, the wind shaking the branches makes the amber fall into the sea. Here it hardens further and becomes more polished; finally, it is brought to the shores by sea tempests and can be caught with nets. Just as the magnet attracts iron, so does heated amber attract straw,[471] if rubbed on a cloth. Its virtues are

the same as those of the gagates, although more numerous and powerful. Its nature halts the flux of the belly. Similarly, it is an efficacious remedy for all the infirmities of the throat. Thus the ancients, to avoid these illnesses, prescribed women and children to wear [amber] necklaces.[472] It repels poison.[473] And if placed on a wife's left breast, while she sleeps, it makes her confess all the ill deeds she committed. If ingested, it increases the urine flow, quickens the menstrual flow, and eases birth. It holds loose teeth fast. Its smoke drives away poisonous [animals].[474] If one wishes to discover if a woman has been corrupted, he must leave the amber in water for three days and have her drink it. If she has been corrupted, she will immediately be forced to urinate.

Sardius or Sarda[475] is listed among the burning gems. The ancients frequently used it, even though it is worthless. It is red or bloodlike in color, but darker and duller than carnelian, as if it had [generated in] those places [rich] in red earth.[476] It has a gender, which can be identified by its color.[477] Since it was first discovered by the inhabitants of Sardis, it takes its name from them.[478] There are five species, though all are surpassed by the Babylonian, followed by the Indian, the Arabian, the Egyptian, and last the Cyprian. In many places where stones are extracted, it is found within them as if it were a heart, as [it happens] on the island of Paros.[479] The males are more resplendent than the females, and the females are bigger and have a murky shine.[480] It binds the powers of onyx, for when it is present the other cannot hurt. It prevents one from seeing horrible things in one's sleep. It increases wealth, brings about cheerfulness, sharpens the mind. It restrains the flux of blood[481] and makes one victorious over his enemies. Some think that the sardius is the same as the carnelian, which is false.

Sardonyx or Sardonius[482] is a composite stone [made] of sardius and onyx,[483] and often also of calcedonius; at times it is of three distinct colors, black, calcedonian, and sardian. The more distinct the colors, the better quality the sardonyx. It once was well esteemed by the Romans. Its virtue is that of removing lascivious inclinations and rendering a person amiable and merry. It is excellent for making seals, as wax does not stick to it.

Selenites, Sirites, or Siderites[484] are synonyms for the same stone. Some say this stone is transparent with a clear and honey-like brightness and containing [within it] the image of the moon, or of a clouded star. It glitters in the dark. It takes its name from the place where it was found. Learned men list various species of this stone. The first has already been discussed. The second was discussed in the entry dedicated to *Celonites*, as some think it to be of the same species. The Persian [selenites] are similar to jasper because of their green color, and they duly follow the phases of the lunar progress; and, as if they were anxious of heavenly damages,[485] they increase or decrease just like the moon increases or decreases. It is very powerful in reconciling love. During the time that the moon increases, it is very useful for those who suffer of tuberculosis. When the

moon decreases, it shows marvelous effects, for it enables to foretell the future to come. Placed in the mouth, which has been first washed with water, it makes man think about those things he should be doing and those that he should not. Those things to be undertaken are thus exactly impressed in the mind so that they cannot be forgotten. And if they should not be undertaken, they quickly leave the mind.

Samius[486] is a stone so called after an island that bears the same name [Samos], where it was first found. Craftsmen use it to polish gold. It is white, heavy, and fragile. Its virtue is to take vertigoes away and to allay insanity. If drunk, it prevents miscarriages. If carried in the left hand, it is useful to halt tears shed for a long time,[487] and it is also useful in other illnesses of the eyes if it is first ground with milk and then placed over the eyes.

Smirillus[488] is the file and serpent of all things, except of the diamond; it consumes and corrodes all things. It is a stone of an iron color and is very hard; it is found in many various localities. It is used to cut and plane stones and to clean [polish] weapons.

Syrius[489] is a stone so called from Syria, and as long as it is whole it cannot be sunk in water, but if cut it sinks to the bottom. The reason for this effect is that it retains air within, and because of the lightness of air it floats, but when broken, the air escapes and thus if placed under water, it sinks because all that remains is the stone's weight.

Solis Gemma [Jewel of the Sun][490] is white in color, similar to a beryl. And placed under the sun's rays, under the full blaze of that celestial body, it emits resplendent beams all around and from this it takes its name. It is a stone of great virtue against deadly poisons that have been drunk.

Sagada or Sadda[491] is a stone the color of prassius. It is so attracted to ships that it flings itself from the bottom of the sea up to the ships and fastens itself to it so solidly that it cannot be plucked off, unless one cuts away that part of the wood where it has fastened itself.

Sandastros or Sadasius,[492] a stone of igneous clarity, sprinkled with gold-like drops, appears to be similar to a star: the starrier the sparkle, or the greater the number of drops it has shining from within, the more valuable it is. It is listed among the burning gems. It took its name from the place where it was first found. Arabia still generates them, and it is used in Chaldeans' ceremonies.[493] It is both male and female, according to its color. Thus the milder flame is found in the females. In the males the flame is brighter and more yellow [in color].

Sarcophagus,[494] from which the ancients made their tombs, takes its name from its effect. In fact, in Greek *sarco* means coffin, and *fagos*, eater. Thus sarcophagus means body-eating coffin. Indeed, in the space of forty days it consumes the human body, except the teeth, so that nothing remains. Afterward tombs were not all made with this stone alone, but all sepulchers of stone were

called sarcophagi. If this stone is bound to a living man, it has the virtue of eating away at his flesh.

Sifinus[495] is an ash-colored stone that is not hard. It is useful in the kitchen and cauldrons are made of it. Smeared with oil it hardens on the fire and turns black.

Siderites[496] is a stone not unlike iron in color. Its virtue is such that if used in sorceries, it induces discord.

Struxites[497] is a stone content with its little beauty, but it is not of small virtue. Thus ground, and hidden in food with satyrion,[498] it gives a prodigious rigidity to the penis.[499] If hung by the neck, it gives good digestion and arouses carnal desires.

Samothracia,[500] a black-colored stone and light [in weight], is similar to burned wood. It takes its name from the island so called. It is found in the mountains between Fano and Pesaro under Monte Castigliano.[501] For under this mountain is a black vein, in which these stones are found. Placed on the fire they emanate the smell of pitch. Its smoke is useful against a mother's pains [birth pains].

Spinella [Spinel][502] is one of the burning gems, as we said in the *Carbuncle* entry; its color is clearer and more open than the ruby's, but its virtue is similar; some call it rubith.[503]

Sanguineus Lapis[504] is the same as *Ematites* [*Emathitis*].

Senochitem is the same as *Galatides*.[505]

Spongius is a stone that is the same as *Cysteolithos*.

Sedeneg[506] is the same as *Ematites* [*Emathitis*].

Sirites is the same as *Saphirus*.

Specularis[507] is the same as *Phengites* [*Fongites*].

Sanctus Lapis [Holy Stone] is the same as *Saphirus*.

Sarda is the same as *Sardius*.

Sinodontides[508] is the same as *Corvia*.

T

Topatius or Topasion [Topaz][509] is a most splendid and noble stone among the blue-green burning gems, of which there are two species.[510] One of a yellow color, bordering on gold with some green to it. This is the oriental: it defies the file and is more valuable than the others. The other is the occidental: greener than the former, of a dimmer gold hue, it erodes with use; it tolerates the file and is of lesser value. Some believe that the Crysopteron is of this species. This stone was first found on an Arabian island called Chitis [Cytis].[511] Some say that Troglodyte raiders were once driven here by a storm at sea, and since they lacked provisions, they found this stone while digging up herbs and roots to eat. Thus the stone took its name from the manner in which it was found, for *topasion* in the Arabian language means *search*.[512] It is true that Pliny is of the contrary

opinion about the origin of the name, for he says that the stone was first found on an island in the Red Sea, about three hundred stadia from the shore, which was naturally at an incline and always misty with fog; hence even though it was sought by sailors it was shielded from their sight. And thus the stone was called topazin from the act of searching for it. It is said that Ptolemy Philadelphus had a three-cubit topaz. It is also said that if a topaz is thrown in boiling water, it immediately cools it and that this tepid water drives away any lasciviousness. It heals the delirious [*freneticos*] and injured of mind; it heals hemorrhoids and cures and prevents lunatic suffering [madness]. It increases wealth and drives away anger and sorrow. It halts sudden death and stops blood flowing from wounds if it is bound above them.[513] The bearer of this stone thus obtains the favor of his prince.

Turchion or Turchesia[514] is a yellow-colored[515] stone tending to white, as if milk had been strained through yellow.[516] It is very pleasant to behold and takes its name from its country of origin.[517] Common opinion holds that it is useful to horsemen, so that as long as a rider wears it, his horse will never tire nor will he be bothered by any riding accidents. Its appearance strengthens sight, and it is also said that whoever carries it will be protected from outward and evil accidents.[518]

Trachius[519] is a stone of two types: one resounding black, and the other almost green, but not transparent.

Thirsitis[520] is similar to *Corallus*. It is said that if it is ground and drunk it induces sleep.

Talc Alchimicus[521] is a bright and luminous stone the color of silver.[522] The worst poisons are made with it through sublimation.[523]

Tartis is a stone of a most beautiful color similar to the peacock; it is noble and delightful to behold, and its virtue is no less renowned than its appearance.

Tegolitus[524] is the same as *Cogolites*.

Trapendanus is a species of *Pirites*.[525]

Telitos is as famous as *Tegolitus*.[526]

V

Varach[527] is a stone not easily found. Among us it is esteemed for its virtue of halting any type of flux. In its place doctors use dragon's blood.

Vernix or Armenian Stone[528] is said to have the virtue of being useful to those who sufferer of melancholia, to splenetics, those who suffer from liver problems, and even those suffering from heart problems.

Veientana Italica[529] takes its name from its place of origin.[530] It is also found in many other places, and from this it took its patronymic.[531] It is a black stone with white lines and spots.

Vulturis Lapis[532] is so called from the bird by the same name; by suddenly cutting its head off, the stone is found in its brain. It heals those who wear it. It fills a woman's breast with milk. It ensures success to those who ask for it.

Virites[533] is the same as *Pirites*.

Vatrachius[534] is the same as *Ranius*.

Unio[535] is the same as *Margarita*.

X

Xiphino[536] is the same as *Saphirus*.

Y

Yectios[537] is a blood-colored stone, hard and opaque; it is used as a paragon to discern metals, as some say.

Ydrinus[538] is called serpentine by some. It heals rheum and heals the human body of too much humidity; it restores the bodies of dropsy sufferers to their pristine health if they stand in sun with it for three hours; by sweating, they will release a most fetid water. They say it must be used with caution because this stone eliminates not only extraneous humidity, but the natural and internal humidity as well. It drives away poisonous worms and heals their bites. They say that if it is ingested, it breaks the bladder stones.

Ysoberillus[539] is a species of beryl.

Z

Zumemellazuli or Zemech[540] is called *lapis lazuli* in Latin. It has a yellow[541] hue contained within the color of the sky when it is at its most serene, not transparent; it glitters with gold flecks like the night sky and endures [being exposed to] fire. Because of its beauty, it is called the celestial or starry stone. Prepared as doctors instruct, it cures melancholic illnesses. From this is made that color called ultramarine azure.

Zirites[542] is similar in color to glass. Hung around the neck, they say that it halts the flux of blood, as well as insanity of mind.[543]

Ziazaa takes its name from its place [of origin]. It is mixed with white, black, and various other colors, so that none remain distinct from the other.[544] It renders its wearer litigious and makes him see horrible things in his sleep.

Zmilaces or Zmilanthis[545] is a stone the color of marble, mixed with blue. It is found in the Euphrates, and at its center it has a blue-green [or gray] colored pupil.

Zoronysios[546] is found in the Indus River. They say it is the gem of the Magi. And thus we here put an end to this second book.[547] May God be praised.

BOOK 3

Chapter 1. On Engraved Stones, and on How Difficult Their Science Is, So That We Must Refer Back to the Knowledge of the Ancients

Most illustrious Prince, I have undertaken a most arduous and difficult task in this section of our book; one that in the past many others have not attempted [precisely] because of the great difficulty it presents, but since I promised to achieve heights deserving of your grandeur, I will write of engraved stones as executed by the ancients. And I will not let Albertus's words frighten me when he says that few among the ancient scholars understood engraved stones [*sigillis*] and that they could have not understood it without having knowledge of the science of astrology, magic, and necromancy.[1] And since these sciences today, as in other bygone periods, are understood by few, it follows that there is little information found on the subject. Thus it comes to mind that well-known saying by the Commentator on the Heaven and the World that says it is better to know a little of a noble subject rather than a lot of an inferior matter.[2] As even the Philosopher said: it is better to know something than to be ignorant of all things.[3] Even though I have no full knowledge of these sciences, nonetheless I decided to gather what I have found here and there in various books by learned writers, ancient and modern, so that things of such nobility may not be forgotten, and that they may be fully known by us moderns. And this may be for the glory and grace of your excellency, sole object of my trust and devotion.[4]

114 THE MIRROR OF STONES

Chapter 2. In Which We Discuss Who Were the First Sculptors and How the Art Flourished Through Time, and Who Are Today the Most Excellent Sculptors and Painters[5]

In his book on the nature of things, Thetel, a most ancient and excellent author, writes that the first sculptors were the Israelites, when they were in the desert. As they were very wise in astronomy, magic, and necromancy, and no less excellent in sculpture, they carved signs on gems: their expertise stands clear not only in their scientific discourses, but also in all their works: their engravings are recognized for such refinement that no one among posterity dares to attempt imitate that kind of work. And as he [Thetel] said, since in all sciences there are supremely proficient practitioners, there is no doubt at all that they knew both the nature and the science of stones: on these stones they carved signs or images governed by the appropriate constellation or according to the nature of the stone itself: so that the symbols could be empowered by virtue of the images. We must place great faith in Thebit's words when he says that the images the ancients carved on gems were no simple ornament,[6] and that many strange things were carved on rough unpolished stones; but it must be believed that the stones received their virtues from those images carved on them to the same degree that they received virtues from the heavenly influences. Such virtues penetrate a stone according to the configuration of the heavenly houses, the aspect and position of the planets and various other things, and as the masters remind us, [virtues penetrate a stone] even according to the time when the stones were engraved, which is thus preserved in the stone. And it is because of our wish to receive their celestial properties that this practice flourishes with us still today. After the Israelites, the best sculptors flourished during the Roman period,[7] but they were not learned in those sciences concerning the celestial virtues of engraved images as was the case in the first [practitioners], thus they carved images of emperors, kings, and various other subjects so realistically that, in Pliny's book 37, Pyrgoteles[8] is said to have sculpted a statue of Alexander the Great of such perfection that the latter forbid anyone else to portray him.[9] Following him, Apollonides and Cronius achieved great glory for their representation of an image of Augusts of great exactitude.[10] It would be useless and tedious, my most illustrious Prince, to enumerate all the famous sculptors of the Roman period, who were no less worthy in this art than the Israelites. But it is here that I will mention our contemporary sculptors: I believe I do not err in placing them ahead of those already cited: as their works circulate throughout Italy, [isn't it true that] they cannot be distinguished from the ancients? In today's Rome we celebrate Giovanni Maria from Mantova;[11] in Venice, Francesco [Luigi] Nichinus [Annichini] of Ferrara;[12] in Genoa, Giacomo called Tagliacarne;[13] in

Milan, Leonardo of Milan.[14] They sculpt in stone images of such precision and elegance that it is not possible to add or detract from them. Only in the art of engraving or sculpting silver, which works are called Niello, and of which there is no memory among the ancients, I find there is only one artist amongst the moderns. I know a man extremely famous in this art and by the very illustrious name of Francesco di Bologna, also known as Francia,[15] who sculpts or engraves on a miniscule disk or on a very small piece of silver, many men, animals, mountains, trees, cities, and so many objects varied by nature and position, that it is astonishing to see and describe; and it is for this reason that our Italy is not only known for this art, but also for all types of art. In fact, in painting, who is superior to Piero dal Borgo[16] and Melozzo da Ferrara,[17] who established the rules for painting with the aid of geometry, arithmetic, and perspective, with admirable order, diligence, and method? Their works speak for themselves: even the ancients have never treated this subject to such an extent. Who excels more in the art of the brush than the Venetian Giovanni Bellini[18] and Pietro Perugino,[19] whose representations of men, animals, and all other subjects are so perfect that they seem to lack only [animating] spirit? The most famous among the ancients was Zeuxis, who painted grapes that attracted birds; he decided to give away his works as gifts because, according to him, no price could have been established worthy of their value.[20] There were also Protogenes and Apelles, who painted their self-portraits and images of objects.[21] And to challenge each other, they traced with their brush such narrow and very fine lines, on top of their work that they were nearly invisible. They also painted lightning and thunder and objects impossible to paint with an exceptional art and diligence. Our Italy celebrates now a man no less worthy of praise and admiration for whose excellence he has been knighted,[22] Andrea of Padua, called Mantegna, who revealed to his followers all the rules and all the methods of paintings. He surpassed all others not only in the art of the brush, but also in quickly grasping and rendering with the pencil or with charcoal the true image and effigy of men of various ages, of different animals, as well as the costumes, habits, and gestures of diverse nationalities: to the point that they all seemed to be living. I reckon that he is to be placed ahead not only of all other modern artists, but of all the ancient ones as well. Especially ahead of Pansius Sycionicus,[23] who always painted himself in all portraits, and even ahead of Apelles, who, having been invited to dine at the royal palace, when he was asked by the king who had invited him, since he did not know the name of the person, he suddenly seized a charcoal from the hearth and executed his portrait: the king recognized him utterly. How many fine works by Andrea's hand exist in Padua, Rome, Mantua, and other cities of Italy? It is thanks to them that we may, with our very own eyes, recognize his excellence.

Chapter 3. Which Images Are Produced by Nature and Which Not; and What Virtues They May Have[24]

We have said much on the merits of the art of engraving [*sculptoria artis*]; let us then turn to our initial intent and begin with the distinction made by Albertus Magnus in his aforementioned works, thus we can say that images may be made by nature in three ways. The first manner is twofold. One way happens when a stone itself is stained by nature with diverse colors, whose veins compenetrate each other, thus giving rise to various and diverse [color] mixtures and images; as it may be seen in marbles, in agates, and in many other stones of different colors. It is said that King Pyrrhus had an agate in which were naturally reproduced the nine muses with Apollo, who played his lyre in their midst;[25] and I, too, have seen an agate in which could be distinguished a plain with seven trees. This first manner of naturally occurring images may also ensue in another way—that is, when an unusual color is superimposed over another thus creating an image, as Albertus wrote of a stone found in Cologne, in the chapel of the Three Kings, in which there could be seen two very white heads which overlapped yet each with very distinct traits: on their foreheads there was a very black snake[26] [on the stone]. There was also the figure of an Ethiopian with an onyx[27] mantle decorated with flowers. Pliny[28] also writes of having found a figure of a Silen on a marble piece.[29] Were not some tablets discovered in your domain of Pesaro[30] which were cut from a column of various colors and which appear to form various figures? Many admire such phenomenon, though it seems impossible to those who have not beheld such things with their own eyes. But those who are experts in philosophy do not doubt such things nor others even more surprising: for example, Albert the Great mentions it in his second book *On Physics*, as well as in his book *On the Secrets of Women*, and the fourth chapter of his second treatise.[31] Henry of Saxony also spoke of this in his commentary,[32] and as many other philosophers say and demonstrate sometimes that the influence of a constellation is so strong in producing or forming some things, which seems impossible per se as well as under other aspects. As it transpires from what philosophers say, they themselves are not surprised, because they understand the causes; in fact, marvel proceeds out of ignorance.[33] According to them, then, heavenly influence, resulting from the placement and aspects of the planets, constellations, and their configuration has sometimes such power that human issue born out of human seed is not the only form to take life, but thus come to life as well beasts or beings that are part animals.[34] And as this happens to animated matter, so it can also happen to stones and other inanimate things. Would it

not be ridiculous for intelligent people to believe that satyrs, centaurs, and similar monsters were first created by the brutal act of a carnal union of a man with a wild animal? Have we not seen many times women give birth to monstrous things? Yet it is not to be believed that these women coupled with wild animals. For, as we have said, these and other more surprising things are the result of heavenly influence.[35]

The second manner in which images may be sculpted on stones by nature occurs when a part of any stone is attached to the surface of another—that is, when some parts of a stone are diminished, and this subtraction causes some images to appear, as in the art of cameos. And so, in this second manner, stones may be carved by nature and by artifice; unlike in the first case [where images may be produced] only by nature, and not by any art. The third manner, which corresponds to our subject, happens when stones are carved by art and not by nature, and this occurs when some instrument cuts or carves some part of a stone and impresses on it an image.[36] And of these images some are carved spontaneously, some with a goal in mind, as we have mentioned at the beginning of this third book. Those that are carved spontaneously, without any specific goals, derive no virtue from the image but possess the virtue of the stone alone; these stones were mostly carved at the time of the Romans or in our times. But those images that are carved so that they may impress on us something are those whose virtue is no less in the figure than in the stone itself; and these were carved, as already said, by the Israelites. Those who were fully knowledgeable in those sciences sculpted them; and even in our modern times this type of stone may be carved by the learned; and perhaps some were also carved at the times of the Romans, whose inferior virtue I will demonstrate later on. I will also discuss the manner in which the stars influence us through these images, and [further discuss] if this virtue impressed on stones through such images lasts forever.

Chapter 4. On How the Virtue of Images Carved on Stone Modifies[37] the Particular Virtue of the Stone Itself, and How This Effect Is Not Wholly Lost with Time[38]

Even though we digressed from the proposed subject matter, nonetheless for better clarity of the arguments to follow, it is necessary to add some words here even though some have already been mentioned above. Nature does not produce any material thing that does not have its own species, and that it is not placed under heavenly influence; as we said at the beginning of book 2, and as it is

believed by all philosophers. Therefore, since stones are material things, they receive the virtue from the matter they are made of, as well as from their specific form, depending on how reason intervenes; furthermore, they are not devoid of the influence of the stars that always effects this lower world. But if these stones are carved with a specific goal in mind under some celestial influence by those with appropriate knowledge, they acquire an additional virtue from the heavens just as if these images brought them to life. Thus the stone's virtue, which can produce one or more particular effects, derives from the engraved image.[39] In a similar manner, we say that man's will is free but is guided to act rationally and with determination by reason, without which it would not act so. Just the same, we can also say that the power of a stone is restricted to a specific virtue or effect, which it did not have prior to the graven image. And if we have a similar effect to the one which we intended to produce by the engraved image, this already existed within the stone's own essence: the stone's virtue will be strengthened by the image [simboleitatis] and it will become more efficacious because of the two combined properties. To clarify what we have just said, let us use an example, even though it is not perfectly similar: let us follow here Aristotle's mind when he says: in fact we consider examples not because they are such, but because they aid us to understand; they present us with some similarity.[40] We say, then, that in man we find two things: will and essence. Since will depends on the soul, it is wholly free and it is not dependent on any other things. The essence is corporeal and since it is formed by elements, it is under the influence of the stars. Hence reasonable will, guided by the soul, guides man to do good; and this operation is not under the influence of the stars even though they might be physically interposed; moreover, the soul transforms the power of the body, even when the body should do the opposite following some specific influence. Thus it follows that, as said by Ptolemy, a wise man will govern the stars.[41] But if the will truly depends on the corporeal being without the intervention of reason or the guidance of the soul, then we say that man is subjected to an influence.[42] Thus it also follows that, as Plato says, children are guided by an infallible intelligence, even though they are without reason and instruction; thus all that they do, they do because of the stars' influence which have an effect on the body and [in turn] the body moves the soul to action.[43] Now let us look for the similarities between this example and the stones: since a stone's essence is made of elements, it is corporeal, as we discussed in the first book. As such it is subject to the stars, and from these it takes its virtue. Another virtue of the stones comes from their specific and particular form, which is never dissociated from it, otherwise the stone would crumble; form alone gives one singular stone many different virtues according to its overall essence. And thus many different

virtues may be found in a single stone just as many wills may be found in a man according to the different reasons appearing in that man's soul. Similarly, even in a stone, the engraved image executed for a specific purpose reduces that stone's virtue to a particular effect, as clearly stated by those who wrote about [stone] engraving. And when the virtue of the stone corresponds to the virtue of the engraved image executed for a specific purpose, then the stone will be more powerful and more efficacious: as is said by doctors. Therefore, we can conclude that stones engraved with images are more powerful in regard to certain virtues than the same stones without images. Furthermore, Albertus Magnus in his book *On Minerals* says that the virtues of images engraved on a stone do not last forever; but rather they expire by a certain date.[44] The authority of such a good man is well recognized by all, just as his conclusion is not doubted; yet we cannot dismiss the opinion of other learned men, and especially that of Solomon as found in his book on precious gems. Here are his words: If the stone is not broken, and if the image is not wholly abraded, then its virtue is not lost.[45] Thus it does not seem incongruous to me to say: we are not embarrassed to state things that may be supported with reasoning and references. It is evident that the virtue of an image sculpted on a stone does not wholly disappear, nor does it end by a certain date. To support such an opinion, I take as fundamental [the notion] that the specific essence or individuality of a thing from which its virtue depends cannot be removed from an individual if this is not corrupted or broken. No one of a sound mind would deny this. Furthermore, I say that for the sculpted images to have a certain effect they must be executed according to specific choices; that is, we choose the hour influenced by the specific star under which we intend to carve the stone.[46] And thus by selection the virtue of the influence is passed onto the stone, and it remains in the stone as long as that image lasts. If then these images were removed, it would follow that the writings of Hali Zachus,[47] Guido Bonatti,[48] and all other astronomers would be untrue, for they teach that the virtue of the stars and the planets remain in the stone by choice. This is especially clear in Ptolemy's second chapter of his *Quadripartite* where he says that the virtue impressed on anything lasts for as long as that thing endures.[49] We conclude, then, with the words of these learned men: that neither the virtue of a particular stone, nor the virtue imparted by a specific image, leaves the stone unless that stone is first broken, and its figure abraded, as it has been demonstrated. And if we want to well consider the words of Solomon, thus we must also believe that the virtue of engraved images sometimes weakens but it is never totally lost. The weakening may be explained by various causes, but we shall not discuss them for the sake of brevity, since the astrologers have spoken so clearly on it.[50]

Chapter 5. How to Distinguish the Universal Properties and the Specific or Significative Properties of a Stone Through Their Virtues

Having discussed those ideas which are in agreement with the universal doctrine of image engraving on stones, we will now turn our attention to discuss specific properties and then continue with discussing the differences according to which images knowingly engraved on a stone may be either universal, or specific, or they signify the virtue of the stone. I call universal those images that retain their own virtue regardless of the type of stone they are engraved on, such as the zodiacal signs. Thus, since Aries is a fire sign,[51] it will impart heat to whichever stone it will be engraved on. It is true, though, that this heat grows or diminishes according to the virtue of the stone, as said before. But we speak of specific images when we refer to those of the planets and the heavenly constellations. To this [group] we may add magic images, as their virtues have a specific or determinate effect. But those [images] that represent the virtue of the stone on which they are carved may be divided in two [categories]: some only denote the virtue of the stone, through a symbol, while others instead denote the virtue of the stone and receive the influence of the heavens through a constellation. In this manner knowing the virtue of the constellation, we may know the virtue of the stone, as written by Thetel. Without a doubt, the ancients carved images on stones according to the virtue of said gems, so that their virtue could be more effective. But in order to clarify how the latter images represented a stone's virtue we will cite as an example agates. As we said in the second book there are various types of agates: the Sicilian, the Indian, the Cretan,[52] and the Cypriote. And in each species, its particular virtue surpasses the others. For this reason, in each species we find different images denoting the particular virtue of that species. Since Sicilian agate has the virtue to repel the poison of vipers, to denote the effect of its virtue, one may find engraved on it the figure of a man that holds in his hands a viper; hence, the engraved image shows the virtue of the stone. If in the same Sicilian agate is engraved the constellation Serpentarium,[53] found in the heavenly vault, and whose virtue is that of repelling poisons, the constellation will double the virtue of the agate. And what we have learned through the example of agates may similarly be applied to any other stone, of whichever type they may be.

Chapter 6. Nonastronomical Images and How We May Come to Know Them

The magic or necromantic images engraved on stones by the ancients do not resemble [the zodiacal] signs, or heavenly constellations. Thus their virtues are

understood only by those knowledgeable in scientific discourses. Nonetheless, it is very true, as it often happens, that no figure is sculpted on stones, if its function cannot be partially recognized through the stone's virtue. For this reason, when a stone has more than one virtue, like stones on which are engraved images of various animal parts, these show the stone's effect by [the principle of] similarity; as it is the case for my Jasper, on which there is a figure that has the head of a rooster, and the torso of a man in armor, holding a shield on the left hand and a whip on the right;[54] and instead of thighs, legs and feet, there are two vipers.[55] By carefully considering the parts of this figure, the virtues of the stone appear clear, as it has been said in the heading for Jasper. And since these magic and necromantic[56] images have great virtue and power, and since we have mentioned here and there the numerous doctors [who write of these things], I decided to follow them and to list the images of the heavens as discussed by learned writers so that you may have knowledge of their virtues. Though, I do not think I may have assembled them all, thus if your excellency may discover more, they should be added here.[57]

Chapter 7. How Images Sculpted on Stones Are Said to Have Effect[58]

To make sure that it may not seem that my words stray from the [teachings of the] Catholic faith, your excellency may pay attention[59] when I say that a certain stone with a certain image has the virtue of producing this or that effect on a man, do not believe that a man is thus forced to do its specific bidding; for it would be an error to believe that, since, as we have said above, man's will is truly free and is not subject to any specific influence. And when I say that a stone, when worn, makes the wearer an emperor, powerful, victorious, and other similar things, it should not be understood that I am stating it absolutely, for that would be false; for if any stone would be worn by an ignoble person or a woman,[60] then it would be seen that it were not true. But understand all of this with a sound mind [i.e., with a grain of salt], in whatever situation a man may find himself, in some cases the stone may raise him to a higher rank, and in others it may make him mightier. Hence my words are to be understood thus, and not otherwise.

[Zodiacal] Signs of the First Triplicity

Aries, Leo, and Sagittarius. Since these three signs complement one another, whether in active or passive qualities, astronomers say that they belong to a

single trinity. As they state: a trinity is nothing other than the grouping of three qualitatively harmonious signs, active or passive that they be; thus they have divided the zodiac in four trinities, each comprising three signs, and each put in relationship to an element. And in the same manner they have attributed each sign to different parts of the heavenly vault, some of which have more power than others, and also the proper ruler to each sign, and each trinity. Thus, according to them [the astronomers], the ruler of the first trinity during the day is said to be the sun, Jupiter at night, and Saturn at twilight: they consider this to be the eastern trinity.[61] When therefore you find a stone engraved with a figure of a Ram, of a Lion, or of Sagittarius, know that this stone may be used against all those illnesses that are cold in origin; it will be useful against lethargy, paralysis, torture, dropsy, and phlegmatic fevers;[62] but thanks to the dignity of their rulers and to their nature, they say that those who wear such figures ingratiate themselves to [other] men,[63] and it makes them eloquent, joyous, ingenious, and gracious, and it raises them to honors and dignity;[64] and especially the image of a lion, because it owes its dignity to the sun, which is [Leo's] house.

[Zodiacal] Signs of the Second Triplicity

Taurus, Virgo, and Capricorn make up the second trinity, which is called earthy and southern, and is cold and dry in nature.[65] The rulers of this trinity are: Venus during the day, the moon at night, and Mars at twilight. When these signs are sculpted on a stone, they will be useful against all hot and humid illnesses, as in the case of sinoca fevers[66] and in all putrefactions of blood. By the nature and dignity of their rulers, they incline the wearer to agricultural works, such as planting, sowing, horticulture, viniculture, and similar things.[67]

[Zodiacal] Signs of the Third Triplicity

Gemini, Libra, and Aquarius compose the third trinity, which is airy in nature and is called western.[68] Saturn is the ruler of the day, Mercury of the night, and Jupiter of the twilight. Thanks to their nature, these signs carved on stone free men from all cold and dry illnesses; they free men from illnesses dependent from the melancholy humor, such as quaternary fevers[69] and memory loss, rabies,[70] paralysis[?],[71] and similar illnesses. And by their nature the rulers of this trinity incline those who wear these stones to friendship, justice, and harmony [*concordia*]; and they make it so that they love and observe the law.[72]

BOOK 3 123

[Zodiacal] Signs of the Fourth Triplicity

Cancer, Scorpio, and Pisces compose the fourth and the last trinity, which is called watery and northern; it is cold and humid.[73] Venus rules during the day, Mars at night, and the moon at twilight.[74] Thanks to its humid and cold complexion it frees man from hot and dry illnesses, such as from tuberculotic fevers,[75] from inflammations of the liver, and all illnesses stemming from bile.[76] And due to the nature of these signs, and of their rulers, they incline man to injustice, inconstancy, and lies. And they say, in particular, that Scorpio was the sign of Mohammed because he always taught fables and pure lies.[77]

Engraved Images of the Planets[78]

The figure of **Saturn** carved on stones: that is [the figure of] an old man, who has a curved reaper in his hand and a not too hairy beard. If one finds this figure carved on a stone, and the stone has Saturn's nature, its virtue will render the wearer powerful with a continuous increase in strength.

The figure of **Jupiter** is represented as a man, sitting on a chair or a four-footed cathedra, holding in the hand a baton and a globe on the other. I have even found one holding an idol, a Cancer, or a Pisces [fish]; and an eagle at his feet. But magicians represent it differently, for they carve the figure of a man with a Ram's head, and a taloned heel and a thin, elongated chest.[79] If one finds this carved figure on a stone, especially on a kabrates [gagathes] stone, you should know that it renders its wearer lucky, amiable, and allows him to obtain easily what he wishes, especially from the clergy. This stone also raises men to dignity and honors.

The image of **Mars** is carved on stones in many ways: sometimes with a flag in a hand, or a lance, or with some other weapon of war; but nonetheless always armed, and at times he is found on a horse. The virtue of a stone so carved renders its wearer victorious, courageous, warrior-like, and a winner in all conflicts; especially if the image is carved on a stone that has similar virtues.

The figure of the **sun** is rendered in various ways: sometimes in the guise of a sun with rays all around; sometimes it is represented in the shape of a man seated on a chair with hair down and with a rich robe. Sometimes it is represented on a cart, and when it is on a quadriga, sometimes the signs of the zodiac are represented around the cart. The virtue of this figure, if found on any stone, renders the wearer powerful and king-like, and makes him delight in hunting. It makes him also acquire fortunes.

The images of **Venus** are many, as the magicians state; nonetheless this is one [that may be] found carved on stone, such as a woman with a grand garment and a grand robe and holding in her hand a laurel branch. Its virtue bestows ease to all that is undertaken and brings everything to the desired end. It takes away the fear of drowning and gives strength.

Mercury is the figure of a man with a thin, elongated chest, a beautiful beard, [although] at times [he is pictured] without it. He wears winged sandals and holds the caduceus and in many cases there is a rooster in front of or under its feet. Its virtues bestow knowledge and oratorical faculties. And it particularly lends help to merchants in their efforts to amass wealth.[80]

There are different images of the **moon**. Sometimes she is properly rendered as the horned moon, as if she were more than halved.[81] At other times, she is represented as a young woman with horns and a quiver [sitting] on a cart. Other times still she is rendered as a nymph with a quiver and with dogs pursuing a stag. The virtue of this image is to render legates skillful and thus to acquire honors and fortune.[82] And they also say it renders all actions quick and easy and brings all things to the desired end.

Chapter 13.[83] Figures or Images That Are Similar to the Heavenly Constellations and Their Worth

Thus far we have discussed the engraved images that represent zodiacal signs and planets. Now we shall turn to heavenly images or constellations. We shall proceed in this manner: first, we will state the name of the image; second, the manner in which it is represented according to learned writers; third, we will add in which sign of the zodiac it may be found; fourth, we shall list whether it may be found in the Southern or Northern Hemisphere; and fifth, which planet's nature it has. Lastly, as it is appropriate for our intent, [we shall state] what virtue such image will have if found carved on a stone. First, then, just like astronomers do,[84] let's start with Ursa (Bear).

The image of **Ursa** is rendered in this manner: two engraved bears encircled by a serpent. The Ursa Major [Big Bear] is held by the coils of the [serpent's] head and the Minor [Little Bear] by the tail.[85] Because of their size, both Ursa Major and Minor and Draco are never far from either the Arctic pole or from the pole of the zodiac; they are in part found in all signs, which they touch as if they were a ship's shadow: their extremities in the zodiacal pole are demarked by the lines passing through the beginning of the other signs. All constellations encircled by the lines of a [specific] sign are said to be in that sign. And thus, all constellations, wherever they may be in the sky, are contained in one or more signs; as are the Draco and the Bear. The whole constellation is found in the North. Nonetheless

their natures are different, thus the Ursa Major is under the sign of Mars and Venus, the Ursa Minor of Saturn, and the Draco of Saturn and Mars. And all learned men, particularly magicians, say that if this constellation is found carved on a stone it renders its wearer learned, astute, cautious, and powerful.

The image of the **Crown** is similar to a king's crown with many stars. Sometimes it is represented like the crowned head of a king. It is found in the Northern Hemisphere and in the sign of Sagittarius; and it has Venus's and Mercury's nature. If it is carved on a stone that has the virtue of bringing honor and knowledge, it bestows its wearer honors, greatly exalts him among kings, and lets him acquire royal favor.

Sometimes the image of a curved **Hercules** is represented in this manner: a kneeling man holding a club in the hand and killing a lion. Other times he is shown with a lion's skin in hand and a club on the shoulders. It is found in the sign of Scorpio in the Northern Hemisphere. It has Mercury's nature, and if engraved on an appropriate stone, which has the virtue of bringing about victory, such as an agate, it renders the wearer victorious in all things, especially in open battle fields.

If the image of **Cignus** or of **Gallinae** is found on a stone, it is figured as a swan with open wings and a folded neck; it is found in the Northern Hemisphere. Its nature is that of Venus and Mercury. If found carved on a stone it renders the wearer popular and makes him learned and wealthy. It frees him from gout, paralysis, and quaternary fevers.

Cepheus is a man that carries a sheathed sword, with arms and hands open. It crosses Aries, has the nature of Saturn and Jupiter, and is found in the Northern Hemisphere. A stone with this engraved image renders the wearer prudent and wise. If it is placed under the head of a sleeper it makes him dream delightful things.[86]

Cassiopea is the image of a woman sitting on a cathedra, with hands open like a cross. Sometimes it bears a triangle on her head. It is found in the sign of Taurus and in the Northern Hemisphere. It has Saturn's and Venus's nature. If this figure is sculpted on an appropriate stone, its virtue will bring health to men and restore ill and fatigued bodies after any labor; it brings quiet and peace to its wearer, as well as sweet and friendly sleep.

Andromeda is the image of a young woman who has unbound hair and open hands. It is found in the Northern Hemisphere in Taurus. It has Venus's nature. Its virtue is such that when it is sculpted on a stone it pacifies conflicts and disputes that have risen between husband and wife and it strengthens a steady love;[87] it preserves human bodies from many different injuries.[88]

Perseus is an image that has a sword in the right hand, and in the left the head of Medusa.[89] It is found in Taurus in the Northern Hemisphere. It has the strength of Saturn and of Venus. If it is carved on a stone, it protects the wearer

from misadventures, it preserves him from lightning and tempests, it protects [from similar threats] even those spaces where it is placed; and it also protects from enchantments [witchcraft].[90]

Serpentary[91] is the figure of a man encircled by a snake, with the head in the right hand and the tail in the left. It is in the sign of Scorpio in the Northern Hemisphere. It has the nature of Saturn and Mars. Its virtue is such that sculpted on a stone it acts against poisons, and it heals the bites of poisonous animals. And if the water in which the stone is washed is drunk it makes men vomit the poison without any damage.

Aquila or Vultur Cadens[92] is the image of an eagle that flies with an arrow under its feet.[93] It is found in Cancer in the Northern Hemisphere. It has the nature of Jupiter and Mars. But the arrow has the nature of Mars and Venus. When these constellations, or one of them, are carved on a stone, they protect the honors the wearer has already achieved and bring him new ones; they say it is useful to obtain victory.

Pisces or Delphinus[94] is the image of said fish in the sign of Aquarius in the Northern Hemisphere; it has the nature of Saturn and of Mars. They say that if this figure is carved on a stone, and it is tied to the nets, it fills them with fishes; it also renders its wearer lucky in fishing.

Pegasus, or the winged horse, is represented by some as a half horse with wings and by others as a whole horse with wings without the bit. It is found in the sign of Aries in the Northern Hemisphere. It has the nature of Mars and Jupiter. If found carved on a stone it renders the wearer victorious in the battle-field, as well as fast, prudent, and courageous. If the stone is hung by the neck of a horse, or if it is placed in the water from which a horse drinks, it will free him from many illnesses.

Cetus[95] is the figure of a great fish with a curled tail and a large mouth. It is found in Taurus and in the Southern Hemisphere. It has the nature of Saturn. When this figure is found on a stone, and on its back it has a crested serpent with a great trumpet, it protects the wearer at sea and endows him with foresight and amiability, returning him what was lost.

Orion is the image of either an unharmed or armed man, with a sword or scythe in one hand. It is found in the sign of Gemini, in the Southern Hemisphere. It has the nature of Jupiter, Saturn, and Mars. This figure carved in stone renders the wearer victorious and brings him victory against the enemy.

Navis[96] is a ship represented with a bow pointed toward the back, a raised sail, and sometimes with or without oars. It is found in Leo and in the Southern Hemisphere. It is of the nature of Saturn and Jupiter. If carved on a stone it renders the wearer secure in all things to be accomplished, he cannot perish in water or at sea, nor receive any ill from water.

Canis[97] is the image of a greyhound with a folded tail. It is in the sign of Cancer in the Southern Hemisphere, and it has the nature of Venus.[98] If found carved on a stone it renders the wearer able to free lunatics, maniacs, and those possessed by demons.

Lepus is an image in the likeness of a hare with extended feet and ears, as if running. It is placed in Gemini, and in the Southern Hemisphere. Its nature is that of Saturn and Mercury. The virtue of this graven image is to heal phrenetics, it is useful against demonic illusions, and whoever wears it will never be assaulted by any evil spirit.

Centaurus is the image of man with the head of a bull holding in the left hand a javelin that lies on his left shoulder and from which hangs a hare. In the right it holds a small, stretched-out animal and a suspended kettle [or basin].[99] It is found in Libra and in the Southern Hemisphere. It is of the nature of Jupiter and of Mars. The virtue of this image is that of rendering constant and forever healthy whoever wears it. Since the legends say that the Centaur was Achilles's teacher, then whoever carries a stone with the effigy of the Centaur impressed on it will continually enjoy its power.

Canis Alabor[100] is the image of a seated dog; it is found in Cancer and in the Southern Hemisphere. It is of the nature of Jupiter; if found sculpted on a stone its wearer does not have to fear dropsy, and it frees him from the plague and from being bitten by dogs.

Censer[101] is the image of an altar, or of a brazier with a lit fire. It is found in Sagittarius and in the Southern Hemisphere; it has the nature of Venus and Mars. It is said that whoever wears a stone in which it is engraved will have the power to call forth the spirits, and will have the ability to manage them and force them to obey.[102] They also say that it adorns the wearer with perpetual virginity as it induces chastity.

Hydra, or an image of a serpent that is represented as a serpent with an urn over its head and a raven near the tail.[103] It is found in Cancer in the Southern Hemisphere. It is of the nature of Saturn and Venus. Its virtue is that of rendering the wearer rich and opulent in all things, astute, cautious, and prudent; it frees him from any evil thing. They also say that it resists any evil heat.

Corona Australis [Southern Crown] is represented as the image of an imperial crown. It is placed in Libra in the Southern Hemisphere.[104] It is of the nature of Saturn and Mars. It has the virtue of increasing wealth and of rendering man joyful and cheerful.[105]

Auriga or Charioteer[106] is the image of a man in a cart with a goat on the left shoulder.[107] It is placed in Gemini and in the Northern Hemisphere. It has the nature of Mercury. This figure carved in stone renders the wearer a hunter and lucky in catching animals.

Vexillus [Flag/Sail/Vela?][108] has the likeness of an unfurled flag on the topmost part of a lance. It is placed in Scorpio, in the Southern Hemisphere. If carved in stone, it brings its wearer military success and will make him victorious in open battlefields.

Chapter 14. On Magical Images: But First Those Given by Raziel[109]

Having finished explaining astronomical images, we now will list those remaining magical images, as defined by various learned men. We cannot fully explain them, but we have to remit ourselves to the opinion of the learned, and those who are masters of such matters, because in our times we lack the knowledge of such sciences, which flourished in centuries past, and on which many have written, especially the illustrious Raziel in his *Book of Wings*, in which he set down the perfect art: and without it, no one can be fully knowledgeable of the magic arts. Thus, in the first wing [*sic*] of this work he identifies these images and says that they have many virtues when found on the appropriate stones, which need to be kept and worn with great reverence.

Dragon; if the image of a beautiful and timorous dragon is found on a ruby, or on any other stone of similar virtue and nature, know that its virtue is that of increasing worldly goods, and of rendering the wearer happy and healthy.

Falcon; if this image is found on a topaz it is useful to gain the benevolence of princes, kings, and monarchs.

Astrolabe; the image of an astrolabe carved on a sapphire will have the virtue of increasing wealth and of foretelling things to come.

Leo; if this well-formed image were to be carved on a garnet, it will have the virtue of confirming honors, and the wearer will be cured of any illness; it also gives honors and protects man from any dangers while traveling.

Donkey; the image of this animal carved on a chrysolite will have the virtue of making a man guess and predict things to come.

Ram; or the image of a bearded man's head, if [it is] sculpted on sapphire, it has the virtue to heal and free man from many infirmities, and from prison and from all burdens. It is a royal image, it bestows dignity and honor, and it elevates its wearer on high.

Frog; if this figure were sculpted on a beryl it has the virtue of reconciling enemies and bringing friendship among men if they were at odds with each other, when they are touched by it.

Camel; the image of this animal or of the head of two goats among myrtle trees, if sculpted on onyx, has the virtue of calling forth, congregating, and enslaving demons. And if worn,[110] it makes a person see horrible things.

BOOK 3 129

Vulture; if this image is found on chrysolite it will have the virtue of commanding, stopping, and gathering demons and winds, and to protect any locale where it is placed from evil spirits and their ravages. And if someone will wear it, demons will obey him.

Bat; if this image is sculpted on heliotrope, the wearer will have power over demons; and it is useful for enchantments.

Gryphon; if this image is found sculpted on crystal it has the supreme virtue of filling the breasts with milk.

Man; the image of a man beautifully adorned and holding any beautiful thing in his hand: if found on a carnelian it has the virtue of halting blood and of conferring honors on the wearer.

Lion; the image of Leo or Sagittarius, if found on jasper, will be useful against poisons and frees man from fevers.

Armed Man with a bow and arrow; if this image is found on iris, it has the virtue of protecting the bearer, and the locale in which it is placed, from all evils.

Man with a sword in hand; such an image, if found on a carnelian, has the property of protecting the locale where it is placed from lightning and tempests; and it protects the wearer from vices and enchantments.

Bull; if this image is found on prassius,[111] it is said to be useful for hexes [*maleficia*] and it gives mercy in judgments.

Hoopoe; if the figure of this bird, and the herb dragon arum [*dragontea*][112] in front of it, is found on a beryl, it will have the virtue of calling forth all water spirits and force them to speak; and to invoke one's own dead to make them answer questions.[113]

Swallow; if this image is carved on a stone called celonites, it has the virtue of making and preserving peace and concord among men.

Man; if the image of a man with his right hand lifted up to the sky is found on calcedonius, it will have the virtue of making man win civil wars and the wearer will remain healthy and it will preserve him from any contrary accidents while traveling.

God. If the names of God are sculpted on ceraunius, they will have the virtue of protecting those places, in which they may be placed, from tempests, and they will give power over and victory against the enemy to those that will wear them.

Bear; if the image of this animal is found on an amethyst it has the virtue of chasing demons away, and of defending and protecting man from drunkenness.

Armed Man; if this image is found on a magnet, it will have the virtue to fight against enchantments, and it will make the wearer a winner in war.

Images, or Seals of Chael[114]

The most ancient doctor Chael, one of the sons of the sons of Israel, during his stay in the desert, saw and made many figures of the zodiacal signs and the planets and he especially knew the greater effects of each. And to make sure that the virtues of such images were learned by posterity, he composed this book, in which he set down all the virtues they all contain; and thus, may God be blessed, for he gave such virtues on earth for the health of humankind.[115]

♀ **Man;**[116] the figure of a man sitting behind a plow with a long beard, a long face, and curled lashes, and in his hand holds a fox or a vulture, and on whose neck are four recumbent men. If a stone on which there are these figures will be hung around the neck it will be useful in all planting, and in finding treasures. Thus, if placed under the neck of a man that goes to bed, he will see treasures while sleeping, as well as the way to find them. Its virtue is also useful in discerning animals' illnesses if they drink the water in which the stone has been washed.[117]

♂ **Man;**[118] if the image of a man with a shield around the neck, a helmet on the head, a sword in the hand, and a serpent under his feet, is found sculpted on red jasper, and is hung about the neck, it will render man victorious against his enemies in battle, especially if it will be made on the day ruled by Mars.

♃ **Horse;**[119] if the image of a horse with a crocodile on its back is sculpted on hyacinth, it has the virtue of making the wearer victorious in civil lawsuits, well-mannered, kind, as well as amiable; but it must be bound in gold because its virtue is increased by gold.

♀ **Man;**[120] if the figure of a man sitting and looking up to a woman standing in front of him, with loose hair all the way down to her lower back, is found sculpted on carnelian, and someone is touched with this stone, the stone will have the virtue to bend that person to the will and obedience of the person who touched him; that person will conquer everyone's benevolence. When this stone is set, there must be placed some amber and terebinth [trementine] resin under it.[121]

♄ **Horse;**[122] if a foaming fiery horse, with a black rider with a scepter in hand, is sculpted on hematite, it will give the power to reign and to recover any lost grace; it has to be set in equal measure of silver and gold.

♂ **Man;**[123] if a man sitting with a lit candle in the hand is sculpted on chrysolite, it has the virtue of rendering its wearer rich; it has to be set in the purest gold.

☽ **Stag;**[124] or a hunter, dog, or rabbit, if the figure of one of these animals is found sculpted [on a stone] it has the virtue of halting demons, lunatics, phrenetics, and those who fight at night.

☽ **Woman**;[125] if the image of a woman with a bird in one hand and a fish in the other is found sculpted, the stone will have the virtue of allowing its wearer to catch fishes and birds. It must be set in silver. It is useful for all those that engage in said activity.

☿ **Horned Figure**;[126] if a horned figure is made in such a way that the front is a horse and the back is a goat,[127] if this is sculpted on a stone, it will give the ability to breed and dominate animals and beasts of any type; it has to be set in lead.

♀ **Woman**;[128] if a woman sitting with a trumpet on a horse, or if a soldier running at full speed with a horn around his neck and with a tree in front of him, is found sculpted on any stone, it will give hunters the ability to hunt, if they will carry it with them.[129]

☿ **Man**;[130] if the figure of a man, with knees bent and looking upward, and with a cloth in hand, is sculpted on a stone and carried on one's person, it lends grace and wealth in the selling and buying.

♄ **Vulture**;[131] if the image of this bird with an olive branch in its beak is sculpted on pyrite and set on a silver ring that is then worn, you will be called to many banquets and when you will be there all will look at you and forget to eat.[132]

☽ If the figures of **Sagittarius [Archer]** and of **Scorpio**[133] engaged in fighting [with each other] is found on a stone, and if this is used to impress [a seal] on wax, and if afterward you will touch someone with that seal, it will render benevolent those who are malevolent and disagreeable. But it is necessary that it be set in silver.

Ram and Lion; if a figure that is half ram and half lion will be found sculpted on any precious stone, it will reconcile enemies into amiability if they are touched with it.[134] It must be set in silver.

Woman; if a figure composed of the body of a woman above and below that of a fish is found sculpted on hyacinth, holding a mirror in one hand and on the other a branch, then set it on gold ring, and place it on a finger, when you wish to become invisible, turn the stone on said ring toward the palm of your hand and close the hand, and you will be invisible.

Armed Man;[135] if this image with a cross of stars over the right hand is found carved on any precious stone, it will be useful to the harvesting and gathering of crops; and any locale in which it will be placed cannot be damaged by tempests.

Basilisk or Mermaid; if a figure whose top half is female and whose bottom half is that of a snake is found on any precious stone, it will have the virtue of chasing away poisonous animals.

132 THE MIRROR OF STONES

Basilisk, fighting with a dragon, with above the head of a man; if this figure is found on carnelian and is worn at the neck, it will give its wearer the ability of prevailing over any land or sea creatures.

Nude Turgid [Erect] Man; if this image, along with another figure of a well-dressed man, holding in the hand a drinking vessel and on the other a blade of grass, is sculpted on a gagates stone, know that it has the virtue of chasing away all fevers if worn for three days.

Man; if the image of a man with the head of a bull and the feet of an eagle is found sculpted on any stone, and if you will wear it, no one will speak ill of you.

Man; if the figure of a standing man of great height, holding a coin [*obulum*][136] in the right hand and a serpent in the left, with a sun above him and a reclining lion under his feet, is sculpted on a diadochos[137] and is set on a lead ring with a bit of mug wort and root of fenugreek, and is then carried along a river's bank to call evil spirits, they will answer all your questions.

Man; if the figure of a standing man with a small bundle of herbs hung at the neck, with a strong back and large shoulders, is sculpted on green jasper, know that it will lend aid to those who have a fever and it will free them from it. And if whoever exercises the art of medicine carries it with them, they will be very efficient in recognizing infirmities, medicines, and herbs, and thus they will give their patients the right potions. It is useful in case of hemorrhoids or during the menstrual cycle, and in all cases of loss of blood it will immediately stop it.

Dove; if the image of a sea dove is found on a black stone, as the *parangon*,[138] and if it is set on a lead ring, the wearer will not be hurt by anyone and will be loved by old men and rulers of the world.

Aquarius; whoever wears this image found sculpted on green jasper will profit in selling and buying; merchants will seek his counsel and will carry goods to his house.

Bird; if the image of a bird with a leaf in its beak, and a man's head in front of him looking at said bird, is found sculpted on a *parangon* stone and is set in gold, and carried along, it will render you rich, fortunate, and respected by all.

Jupiter; if the image of a man sitting on a four-footed throne, with four men in front of him, and if Jupiter's hands are turned to the sky and on his head is a crown, is sculpted on a hyacinth,[139] and set in gold, whoever will wear this ring, or wear its wax impression around his neck, will obtain all that he wishes from wise men and kings.

Man; the image of a man with a lion's face, eagle's feet, and under its feet a two-headed dragon with an unfurled tail; and the man's hand holds a baton with which he hits the dragon's head.[140] If [this image] is sculpted on crystal, or on any precious stone, bound in brass, with some musk and amber placed under

the stone, and it is worn, he will bend both sexes to his will, spirits will obey him, he will increase his abilities, and he will gain great wealth.

Man; if the image of a man sitting on top of an eagle, holding a rod in his hand, is found on a hephaestus stone,[141] or a crystal, and is bound in a gold[142] or copper ring, anyone who will see this ring in a day ruled by the sun, prior to the sunrise, will beat and surpass all his enemies. And if the ring is looked upon on a day ruled by Jupiter, he will be victorious in battle and all men will voluntarily obey him. But it is necessary that its wearer should dress in white clothes and abstain from eating pigeon.[143]

Man; if the image of a man riding a horse, holding the reins in one hand and in the other a taut bow, with a sheathed sword, is carved on pyrite, set in a golden ring, and is worn, the wearer will be victorious in battles, so much so that no one will be able to resist him.

Woman; if the image of a woman with hair spread over her breasts and in the presence of a man shown going toward her, and making any gesture of love, is carved on hyacinth or crystal, set in gold, and under the stone [is put] some amber, aloe, and the herb called *polium*,[144] whoever will wear this stone in a ring will be obeyed by all. And if you will touch any woman with it, immediately she will obey your will. And if placed under the pillow[145] before going to sleep, you will see whatever you wish in your dreams.

Man; if the image of a man seated over a fish, with a peacock above his head, is sculpted on a red stone, and if you place that stone under the table at a banquet, no one eating with the right hand will be full.

Man; if the figure of a nude man, standing on his feet, with a young woman on his right, her hair bound and tied around her head, and the man's right hand is on her neck while the left is on her chest and he gazes on her face while she looks to the ground, is carved on any stone and set on an iron ring and under the stone there is the tongue of a hen sparrow or of a hoopoe, myrrh, and allume in equal measure with human blood, the wearer of this ring will be invincible and no one will be able to resist him; nor any beast will be able to harm him. It will be useful for epileptics,[146] if they will use it to create impressions on red wax. And if one will place it around the neck of a dog, the dog will not be able to bark.

Man; if the image of a man holding flowers in the hand is carved on carnelian and is made into a tin[147] ring on a day governed by the moon or by Venus, on the first, eighth, or twelfth hour, and afterward if you touch anyone with that very ring, that person will obey you.[148]

Man; if the image of a bearded man, with a long face, curled lashes, seated over a plow between two bulls, and holding in the hand a vulture is found sculpted on a stone, know that its virtue will be useful in the planting of trees,

finding treasures, and rendering man victorious in battle. Serpents will flee in front of its wearer, it heals epileptics, and it chases all fears and worries of evil spirits.[149] It must be worn set in an iron ring.

Man; if the figure of a man holding a sickle above his head with a crocodile under its feet is sculpted on any stone and is set in a lead ring under which has been placed some sea onion root [*squillae*],[150] whoever will wear this ring will be safe from enemies and from thieves while traveling.

Man; if the image of a man holding a knife and sitting over a dragon is sculpted on an amethyst set in a lead or iron ring and worn on a finger, it will make all spirits obey and reveal treasures for him and respond to any questions.[151]

Eagle; the image of an eagle standing still, carved on ethices stone and set in a lead ring, will give its wearer the ability to capture many fishes; no wild beast will hurt him and he will be loved by all men.[152]

Man; a man shown standing and holding a dagger, if you find it sculpted on onyx, know that it has the virtue of rendering its wearer honored by all sovereigns and princes, as well as by all men.

Hare; the figure of a hare carved on jasper has the power of preserving its wearer from demonic shadows nor will they harm him.[153]

Man; the figure of a man holding a palm in his hand,[154] carved on any stone renders the wearer gracious and amiable to princes and to the powerful.[155]

At this point the author Chael discussed astrological images.[156] But since this matter has been previously treated, there is no reason to repeat them.

Images, or Seals of Thetel

Thetel is, as said above, a most venerable doctor, who in discussing images carved on stones, said that if the images, which we will list below, are placed on appropriate stones they magnify their virtues. Let us begin.[157]

Man; the image of a man carved on jasper with a shield on the left and on the right hand an effigy, or other warlike symbol, with vipers instead of feet and a rooster's, or a lion's head instead of a man's, and wearing a cuirass, such a carved image, will have power against enemies; it renders its wearer victorious, is good against poisons, and halts the flux of blood from whichever part of the body it issues forth.

Man; the figure of a man that has a small bundle of herbs around his neck, found sculpted on jasper, has the virtue of allowing its wearer to identify and recognize illnesses; it halts the blood from wherefore it issues forth. They say that Galen had this stone and always carried it with him.

Cross; carved on green jasper, they say it has the power of freeing its wearer from dying by drowning.[158]

Woman; if the image of a woman with a bird in one hand and a fish in the other is carved on chrysolite, it will be very useful in negotiations.

Wolf; if the figure of a wolf is found carved on jasper, it is good against deceptions and prevents one from speaking like a fool.[159]

Stag; the figure of a stag carved on stone has the virtue of healing and freeing lunatics and phrenetics.[160]

Lamb; the figure of this animal[161] carved on a stone renders its wearer safe from paralysis and from quaternary fevers.[162]

Hunter; this figure carved on jasper has the virtue of healing the possessed and phrenetics.

Emperor; this figure, head held high, carved on jasper, renders its wearer amiable to all and able to obtain whatever he asks for.[163]

Virgin; if this figure, in a flowing gown,[164] holding in her hand a laurel branch is carved on jasper, it will render its wearer safe from drowning and no demon will torment him, and it will make him powerful and able to obtain all he wishes.[165]

Man; this image with a palm inscribed on his hand and carved on Jasper renders its wearer powerful and beloved by princes.[166]

Engravings or Images of Solomon

I have found these images in a very old book of stone seals whose title lacked the author's name. But I believe it was by Solomon because in it there were many works by Solomon.[167]

In the name of the Lord,[168] this is a most precious book that was made in the desert by the sons of Israel, according to your name Lord, and according to the course of the stars.

Man; the image of a man seating on a plow, with a short neck and a long beard, with four men laying on his neck, and holding a fox in one hand and a vulture in the other. If you will hang this seal around the neck it will be useful for planting trees and finding treasures. To test whether this stone is worthy, you will do this. You will take pure black wool, free of any dye, and you will wrap the stone in it, you will place it in wheat-straw, you will lay your head on it and in your dreams you will see all the treasures that are found in that local where you are; and the means by which you will become the owner of all these treasures. It has a further virtue; it heals all animals' illnesses if they drink water in which the stone has been washed.[169]

136 THE MIRROR OF STONES

Man; the figure of a man carved on green jasper with a shield hanging from his neck, a helmet on his head, a sword lifted up and stepping on a snake with his feet. If you place this figure around the neck, you will not fear any enemy. And as long as you will not stand by idly, you will be victorious in all things, particularly in all matters of war. It must be set in brass.[170]

Horse; if the figure of horse bearing either a serpent[171] or a crocodile on its back is found on white hyacinth, know that it is good in all discussions, which will be all measured, and whoever wears it will immediately be loved by men as well as animals. It must be set in gold.[172]

Man; if the image of a man sitting with a woman in front, whose hair reach her thighs, and whose eyes are raised up, is found carved on carnelian, know that it has the virtue to make any man or woman that you touched with that seal obey all your wishes. It must be set in gold, equal in weight to the stone. Underneath it there should be placed bishop's wort[173] and amber.[174]

Horse; if the image of a horse foaming at the mouth ridden by a man holding a scepter in his hand is found sculpted on an amethyst, know that this seal will be useful in all things to its wearer, and every prince and powerful man will obey him. It needs to be set in gold or silver weighing double than the seal.

Woman; if the image of a woman holding a bird in one hand and a fish in the other and is found carved on crystal, know that it is good to catch birds. It must be set in silver.[175]

Horned; if the image of a horned animal with underneath it a horse whose hindquarters are those of a goat is found carved on any precious stone, know that it will be useful to tame any beasts. It must be set in a lead ring.[176]

Soldier; if the image of a soldier riding a horse with a horn around his neck and in front of him a tree is carved on a precious stone, know that it will be useful in all forms of hunting.

Man; if the image of a man with bent knees, looking up, and holding a cloth in his hand is found carved on turquoise, know that it will be useful to buy and sell various things and to behave chastely.[177]

Strawberry[178] [*sic*]; the image of a strawberry, with an olive branch in its beak, carved on pyrite and set in a silver ring: if you will wear it, you will be invited by everyone to banquets. And all the other invitees will not eat but will be intent in looking at you, if you wear it on the right hand during the banquet.

Scorpio and Sagittarius; if you find the image of these animals fighting with each other carved on any stone, set it in an iron ring; and if you wish to know its power, [just] press down this figure on wax and all those you will touch with it will immediately become each other's enemies.

Ram. If the image of this animal whose half body is that of a bull is found carved on any gem and set in a silver ring, and you touch whomever you wish, they will become your friends.[179]

Woman; if the carved image of a figure that is half woman, half fish, who is holding a mirror in one hand and in the other a branch,[180] is found on a sea hyacinth, and is set in a gold ring, and the engraved seal is covered with wax, and is worn on a finger, when you wish to go somewhere and do not wish to be seen, hold the stone tight in the palm of the hand; and you will be invisible.[181]

Man; if the image of a man plowing the ground,[182] with above him the hand of his lord making the sign of the cross with a carved star near it, is found on any gem and if you will live most honestly, in whichever place you will be, tempests will not harm you and similarly the fruits of the earth of that place will not be harmed.[183]

Head and Neck; if you will find this image carved on green jasper, set in a silver or copper ring, bring it with you and you will never die in any fashion. Write on the ring these letters, B. B. P. P. N. E. N. A.,[184] and your body will be spared any illness particularly fever or dropsy and it will give you great skill in catching birds. And you will be amiable and reasonable in all things both in times of war and peace.[185] This ring will also help women to become pregnant and to give birth. Peace, harmony, and all other good things are bestowed on those who wear it. But it must be worn while behaving with much fairness and honesty.[186]

Basilisk and Sea Mermaid;[187] if this image, whose top half is female and whose bottom is that of a serpent, is found on any gem, and if you carry it with you, you will be able to touch any poisonous animal without damage.

Basilisk and Dragon; the image of these animals shown entangled, along with the head of a bull, if you find it carved on a carnelian and place it around the neck, you will easily be victorious if you wish to fight any woodland or sea beast.[188]

Man; the figure of a man, proud, nude, and crowned, holding a cup in one hand and a blade of grass in the other, if you find it carved on a gagates, set it in a ring of any metal, any man bothered by fevers will be immediately healed upon wearing it.

Man; if you find the image of a man standing, whose head is that of a bull and the feet of an eagle carved on any stone, press it on wax and carry it on you, you will find no person that will ever speak ill of you.

Man; if you find carved on diadochus the image of a big man standing and holding a small coin [*obolum*][189] in one hand and a serpent in the other, with the sun above him and a lion under his feet, set it in a lead ring with underneath it root of artemisia and fenugreek. Carry it with you along the bank of any body of water, calling on any evil spirits, you will receive answers to all your questions.

Man; if you find carved on a green jasper the image of a standing man, with big hands and big lower back, and with a big bundle of herbs on the neck carved,

wear it and you will be freed from acute fevers. And if you were a doctor, it will aid you in diagnosing illnesses. But if the stone is spotted, set it in a silver ring, it heals hemoptycs—that is, those who vomit blood.

Dove; if you find the figure of a dove on a *parangone*[190] stone, set it in a lead ring and whoever carries it on their person will never be wounded nor will receive any ill and will be honored by all, in particular by the elders.

Bird; if you find the image of a bird holding a leaf[191] in its beak, along with a man's head or a vulture's head, found on a gold *parangone*[192] stone and set in any ring, you will become excessively rich and will be accepted and honored by all men.

Aquarius; if you find the engraved image of Aquarius found carved on green turquoise, it will make its wearer gain much in selling or buying to the point that buyers will go looking for him.

Man; the image of a crowned youth, sitting on a four-footed throne carried by four men, so that the chair's legs rest on their neck, and over the seated youth there is a circle and his hands are lifted up to the heavens. If you will find this image carved on white Hyacinth, set the stone in a silver ring of equal in weight to the stone, place under the stone some mastic and turpentine resin and make a wax seal with it, and give it to whomever you wish, and if this person wears the ring or the seal around his neck, or on his person and goes to a king, or other powerful person, or to a wise man with a pure and chaste mind, he will obtain whatever he wishes.[193]

Woman; the image of a woman with unbound hair, naked breasts, and in her presence a threatening man, looks at her face; if one finds this image carved on hyacinth, granate, or crystal and sets it on gold ring of the same weight as the stone, and if one places some amber, aloe wood,[194] and *polium*[195] under the stone, its wearer will be merciful, and all will obey him. And when it is placed under the head, he will see whatever he wishes in his sleep.

Man; if the image of a man sitting over a fish is found engraved on red jasper and is placed on the clothes of anyone at a dinner party, he will never be satiated if he be a right-handed eater.[196]

Man; if you find the image of a bearded man holding a flower in his hand engraved on carnelian and set in a tin ring, and if this ring is made during the moon's phases, either on a day governed by Venus under the first moon, or on the eight moon, then touching whomever you wish, you will bend them to your will.

Serpent; if the image of a serpent with a man on its back, and over its tail a crow, is found carved on any stone, whoever will wear it will be rich of all things and astute.[197]

BOOK 3 139

Man; if you find the image of a standing man holding in one hand a sickle above its head, and under its feet a crocodile, engraved on any stone, set it in a lead ring, and under the stone place a bit of sea onion [*squillae*] root, whoever will wear it will be safe from enemies, nor will any of them speak ill of him.

Man;[198] if you find the figure of a man standing over a dragon, holding a sword in one hand, engraved on hematite, set it in a lead or iron ring, all the spirits that live in darkness will obey you, and by sweet charm, they will reveal to you the location of treasures and the means to find them.

Lion or Dragon; if you find the image of a lion's head or of a dragon with two heads and a small tail or the image of a man, with a baton in his right hand, hitting the lion's head or the dragon's heads, carved on crystal, set it in brass and under the stone, place some musk and amber, and if you wear it, everyone will obey you and your wealth will increase. Create a wax seal with that stone, and give it to whomever you wish, it will have that same virtues.

Man; the image of a man riding and holding the reins in one hand and in the other a bow with a sheathed sword, if this image is found engraved on pyrite and set in a gold ring, it will render its wearer victorious in battles; and no one will be able to resist him. And if anyone will place this ring in nutmeg oil and will anoint his face with that oil, all who will see him will fear him and will not be able to resist him.

Man; the image of a standing man, clothed in armor, with a helmet on the head and with an unsheathed sword, if this figure is found engraved on any stone and is set in an iron ring of similar weight as the stone, whoever wears it, no one will be able to resist him in combat.

Man; if the image of a standing nude man, and on his right a standing nude young woman, her hair bound on her head, is found carved on magnet, and if that man holds his right hand on the young woman's neck, and the left on her breast; and if the man looks at her face while she holds her gaze to the ground, [if this image] is set in an iron ring equal in weight to the stone with underneath it an hoopoe's tongue, with some myrrh, allume, and human blood in amount equal to the weight of the hoopoe's tongue, no enemy will prevail against anyone that will wear such a ring, whether in war or in other circumstances; no thief nor evil beast will be able to enter the house in which said stone would be. And anyone suffering of epilepsy, drinking the water in which this stone was washed, will be healed. If you will make a seal with this ring in red wax and place it around the neck of a dog, this dog will not be able to bark. If anyone will wear this wax among thieves, dogs, and enemies, he will receive no harm.

Man; the image of a bearded man, who has a long face and curved eyebrows, sitting over a plow between two bulls, holding cultivations in his hand, and on

its neck the image of a man's head and of a fox's head. If [this image] is found engraved on any stone, it will be useful in planting and any other labor of the earth, in finding treasures and in fighting: it turns enemies charitable, and it is useful in many illnesses. If anyone will wear it, all snakes will flee from him, and it will even heal epileptics.[199] And if a child wears it around the neck, it will chase away all fears as well as protect him from torments by evil spirits; and if it is worn by a man who is ill, it will make him recover his health. And so that it may have a greater virtue, it must be set in an iron ring double the weight of the stone.

Eagle; the image of a standing eagle engraved on ethices[200] and set in a lead ring, whoever will wear it will be liked and loved by all, and animals will obey him. And if in this stone, there be carved a fish, and if the wearer will go fishing, he will catch many fishes.

Man; if the image of a man holding *mutationem*[201] [*sic*] is found engraved on an euchilus, and if it is placed in any ring one wishes, its wearer will be feared and worshipped, and potentates and princes will honor him.

Ram and Half Lion; if the image of these animals is found engraved on any precious stone and set in a silver ring, by touching enemies with it, they will immediately reconcile.

Winged Horse, called Pegasus; this image found engraved on any precious stone[202] will be useful to soldiers; it gives them courage and speed on the battle-field. It is also said that horses that carry this stone are freed from all future illnesses that may befall them.

Bear and Serpent; if the figure of a bear encircled by a snake is found engraved on any stone, it will render man astute and resolute in his intents.[203]

Hercules; if the image of Hercules holding the club in the right hand, showing him killing the lion or any other monster, is found engraved on any stone, know that it will give its wearer victory on the battlefield.[204]

Tree, or vine, or ear of wheat;[205] if their image is found engraved on any stone, it renders its wearer rich in food and clothing, and princes will be benign and conciliatory toward him.

Armed Mars; if armed Mars or a virgin wrapped in a toga, holding a laurel branch in her hand, is found engraved on jasper, it renders its wearer powerful and capable of everything, and it saves him from violent death, drowning, or any other contrary accident.[206]

Mars;[207] if the figure of Mars—that is, of a soldier with a lance—is found on any stone, it renders its wearer bold, courageous, and invincible.

Jupiter; if the image of Jupiter in the guise of a man with the head of a ram is found on any stone, it will render the wearer amiable to all creatures and will obtain anything he desires.

BOOK 3 141

Capricorn; if you engrave the image of this zodiacal sign on carnelian, or any other stone, and set it in a silver ring and carry it with you, your enemies will not harm your person nor your wealth, nor will any judge pass an unjust sentence against you. Your affairs and honors will be great and will earn the friendship of many, and all charms made against you will be dispelled.[208] In battle, no enemy, however strong he may be, will be able to resist you.

Seals or Images According to Hermes

Hermes in his book, the *Quadripartite*, lists fifteen images. And since it is possible to find these images, I will discuss them here.[209]

Head of a man.[210] If the head of a man with a long beard and a bit of blood around his neck is found engraved on a diamond, know that it gives victory and courage and protects the body from physical harm.[211] It is also useful in obtaining the favor of kings and princes.

A Virgin or Young Woman or a Torch found engraved on crystal.[212] Know that it has the virtue of preserving sight.

Man shown arguing or the figure of a god.[213] If such an image is found engraved on a ruby, it confers honors and wealth.

Man.[214] The image of a man wishing to play a musical instrument engraved on sapphire elevates man to greater honors and renders him gracious to all.

Dog.[215] The image of a *leporini* [sic] dog found engraved on beryl. Know that it is useful to gain very great honors, fame, and benevolence.

Rooster.[216] If the image of a rooster, or of three young women, is found engraved on agate, it renders man gracious to other men,[217] lends him power over the spirits of the air, and is useful in the magic arts.

Lion.[218] If the image of a Lion or of a *murilage* [sic] is found on a granate [garnet], it will bring wealth and honors; and it will cheer the heart and chase sadness away.

Stag or Dove.[219] If the image of these animals is found engraved an onyx know that it gives its wearer courage, it will chase demons away and force them to gather, and it pacifies all ill winds.

Man.[220] If the image of a man in the guise of a merchant, carrying goods to be sold, or if the image of a man sitting under a *centurion* [sic],[221] is found on an emerald, it brings wealth and it renders its wearer victorious in all things, freeing him of any distress and evil.

A Bull or a Veal Calf.[222] If the image of either of these animals is found on a magnet, it will make sure that whoever carries it will be safe to walk into any

place and not be harmed or bothered. It is also useful against all spells and illusions and it transfers them from one thing to another.

Horse or Wolf.[223] If the image of either is found on jasper, it chases fevers away and it coagulates blood.

Man.[224] If the image of a man of elevated rank, or a crowned man, is found on topaz, it renders its wearer good, obliging, and endears him to God and men alike,[225] bestowing on him honors and dignity.

Man.[226] If the image of an armed man with a sword in hand is found engraved on a sardion or on an amethyst, it will give its wearer a good and perfect memory and will make him wise.

Stag.[227] If the image of a stag or of a billy goat is found engraved on chalcedonius, it will have the virtue of increasing wealth, [particularly] if placed in a chest with money in [already in] it.

Seals or Images Identified by Various Other Learned Men, and If More Will Be Found, They May Be Added Here[228]

Stag. The image of a stag or of a hare is found on jasper along with a dog, or even if the dog is alone, it has the virtue of calming lunatics, melancholics, phrenetics, and sleepwalkers.[229]

Hare. If the image of a hare, which is not that of the celestial constellation, is found on jasper, and you will carry it with you, you will not be harmed by any demon or spirit.

Crayfish.[230] This image engraved on beryl pacifies disputes and preserves love in a marriage.

Emperor.[231] If this image with the head held up high is engraved on stone and carried on one's person, it will render that person loved by all creatures, and he will obtain anything he demands from others.

Virgin.[232] A young woman dressed in long toga, holding in her hand a laurel branch, carved on jasper: it will render its wearer powerful, to the extent that he will be able to easily obtain satisfactions, nor will he drown.[233]

Man.[234] The image of an armed man or of a virgin wrapped in a toga, holding a laurel branch in her hand, it frees its wearer from any ill accidents, particularly from drowning, if it is sculpted on sapphire.

Man.[235] The figure of a man with a sword in his hand will render the wearer victorious in war.

Man.[236] If the image of an armed man on a horse with a lance in his hand is found engraved on an emerald, it will render its wearer victorious in on the battlefield.

Owl. If the image of an owl, which is the bird of Pallas Athena, is found engraved on a stone that inclines to science, it will render the man who wears it very learned and eloquent.

Peacock.[237] The image of a peacock engraved on a stone suitable to increase wealth, it has the virtue of rendering its wearer rich.

Armed Mars.[238] The image of an armed Mars, if worn carved on sapphire, will not let its bearer be drowned in water.

Man.[239] The image of a man killing a lion, or any other animal, with a sword renders its wearer astute, powerful, victorious, and beloved by all.

Woman.[240] The image of a crowned woman sitting on a throne with folded hands renders its wearer industrious, devout, and pious.[241]

Hunter, Stag, or Hare.[242] The image of either of these figures carved on jasper has the virtue of freeing anyone tormented by the spirits and healing phrenetics.[243]

Man.[244] The image of a man, holding a laurel branch or a palm in the right hand, will render its wearer victorious in all [law]suits and in battles as well as amiable, gracious, and powerful in his region.[245]

Man.[246] The image of a winged man, with a serpent under his feet, and with the serpent's head in his hand, renders its wearer wealthy, prudent, and amiable to all.

Man.[247] The image of a man with a billy goat's head in place of its own is useful to earn favors and riches.

Ant. The image of an ant carrying an ear of wheat, or a wheat grain, found engraved on any stone, it is useful in acquiring wealth.[248]

Rooster.[249] The image of a rooster with a crown or a belt in its beak brings victory in duels, particularly if the image is found on gallinaceo.[250]

Falcon or Goshawk. If this image is found engraved on a carnelian, it will render its wearer victorious and quick to act in all matters.

Eagle. This image found on a kabrates or crystal renders its wearer rich, victorious, and eloquent.

Winged Horse.[251] If the image of a winged horse, especially in its entirety, is engraved on agate, it will render man victorious and well prudent in all his actions.[252]

The End

Book of Camillo Leonardi of Pesaro titled *Speculum Lapidum* which successfully ends here. Printed in Venice by Giovanni Battista Sessa in the year of our Lord 1502, first of December.

APPENDIX: LODOVICO DOLCE'S *LIBRI TRE*; AN UNACKNOWLEDGED APPROPRIATION OF THE *SPECULUM LAPIDUM*

An early Italian translation of Leonardi's *Speculum Lapidum* was published by the Venetian author Ludovico Dolce in 1565, albeit with a number of modifications—omissions and additions of a number of passages—along with an updated list of painters and sculptors and a new dedicatory epistle.[1] Dolce published it not as a translation but under his own name as *Libri Tre di Messere Lodovico Dolce nei quali si tratta delle diverse sorti delle Gemme che produce la natura e della qualità, grandezza, bellezza e virtú loro.*[2]

The Venetian humanist was no stranger to this sort of plagiarism. He arrogated for himself around 250 titles during his literary career, which implies that his appropriation of Leonardi's work was unremarkable. Some of the changes he made, however, are noteworthy. He changed the title, inserted an original dedicatory epistle and proemium, and last but not least updated Leonardi's discussion of artists and gem engravers found in book 3.

Dolce changed the title from the medieval *Speculum* to the humanist *Trattato*, thereby substantiating, on the one hand, the claim that the subject was worthy of careful study by his humanist contemporaries of the latter half of the sixteenth century, and on the other, as already noted by Carla de Bellis, suggesting that he, too, like Leonardi, felt strongly the impulse to create new categorizations of knowledge that could surpass both the classical and medieval ones.[3] He wanted to be sure that the work could reach a wider audience through the use of the Italian vernacular. This new humanist intent on Dolce's part is further underlined in both the dedicatory epistle and the proemium. Dedicating the work to Giovanni Battista Campeggio, bishop of Majorca,[4] who was renowned for his humanist interests—in favor of which he neglected most of his bishopric duties—makes clear that the work's intent is wholly different from that of Leonardi, which we discussed above.

Dolce had been long been involved with the Accademia degli Infiammati, founded in Padua in 1540 by Leone Orsini (1512–1565). Though short-lived—it was dissolved sometime between 1545 and 1550—the academy played a vital role in popularizing the Tuscan and Venetian vernaculars in place of the more commonly used Latin.[5] Its members promoted the capacity of Italian to express any and all sophisticated academic concepts, thus giving impetus to a number of original compositions in *volgare* as well as translation projects. Dolce's vernacular version must then be seen within the frenzy of translations in all fields that swept Italy in the second half of the sixteenth century. Dolce's translation, too, enjoyed a wide fortune and was reprinted in 1617. His choice of this particular text is significant because of Dolce's role as a theorist of the visual arts. In 1557 he had published what would become his most famous work, the *Dialogo della pittura intitolato l'Aretino*, edited by Giolito in Venice, and in the same year (1565) in which he published the translation of Leonardi's *Speculum*, he also published the *Dialogo nel quale si ragiona delle qualità, diversità e proprietà dei colori*, edited by Sessa in Venice.

As already seen, in book 3, chapter 2 Leonardi listed those artists held in high esteem for their work as designers and gem engravers, as well as listing a few of the most renowned painters of the fifteenth century. Given Dolce's interests in the visual arts, he, too, was sensitive to framing intaglios within the context of the visual arts. Indeed, I suspect that the principal reason Dolce translated this work was his artistic interest in gems and intaglios. Dolce did not modify any other passage in Leonardi's text. He did not update any of the literature on or

146 APPENDIX

references to magic that Leonardi had used. But when it came to the visual arts, Dolce was clearly in his element and rewrote chapter 2 of book 3 in an effort to update the references to artists contemporary to the decade in which he was working.[6] He repeated only three artists from Leonardi's lists—Leonardo da Vinci, Giovanni Bellini, and Mantegna—all famous for reasons other than gem engraving. His passage reads thus:

> So did Pirgoteles who portrayed Alexander the Great, and Phidias, Lysippus, and many other artists celebrated by writers. In our times we have had and we have sculptors not inferior to those ancient ones, such as the divine Michelangelo, who is equally a sculptor and a painter, Messer Jacopo Sansovino, Messer Danese Cataneo, Messer Alessandro, a youth of great spirit, and a polished and delightful master, and others. Similarly, in painting we have had the most singular masters, such as Leonardo Vinci, Giovanni Bellini, the same Michelangelo, Raphael of Urbino, Mantegna, Antonio da Correggio, Parmigianino, Titian, and many others, such as Messer Paolo Veronese, Tintoretto, and Messer Giuseppe Salviati.[7]

Unlike Leonardi, whose list of sculptors includes artists who had specifically worked in the art of gem engraving, Dolce seems to tackle the whole category in a more generic manner. He is more concerned with showing the greatness of the age as compared to the past, and thus sacrifices precision. Dolce's disregard of Leonardi's original intent might also suggest his own ignorance on the intersection of magic and cameos, intaglios, and gem engraving as a whole, or that he felt it sufficient to stress the importance of this art by broadly connecting it to the great artists of the sixteenth century.

NOTES

NOTE ON THE TRANSLATION

1. See *Speculum Lapidum* on the Internet Archive, https://archive.org/details/Speculum lapidumoon/.

2. The Perseus Digital Library, ed. Gregory Crane, http://www.perseus.tufts.edu/hopper; Campanini and Carboni, *Nomen*; Lewis, *Elementary Latin Dictionary*; Cappelli, *Lexicon abbreviaturarum*.

3. Leonardi, *Pierres talismaniques*, ed. Lecoutex and Monfort; Leonardi, *De Lapidibus Liber Secundus* and *De Lapidibus Liber Tertius,* both edited by Lecouteux.

INTRODUCTION

1. For a general introduction to the history of magic, see Flint, *Rise of Magic*; Zambelli, *White Magic, Black Magic*; Kieckhefer, *Magic in the Middle Ages*; Draelants, "Notion of Properties."

2. For an early study on Greek lapidaries, see Mély, *Les lapidaires*.

3. Studer and Evans, *Anglo-Norman Lapidaries*. Evans had previously tackled the study of some early Christian, medieval, and Renaissance lapidaries in her earlier study, *Magical Jewels*.

4. Albertus Magnus, *Book of Minerals*.

5. Isidore of Seville, *Etymologies*; Attrell and Porreca, *Picatrix*. Earlier translations: Pingree, *Picatrix*; Greer and Warnock, *Complete "Picatrix."*

6. Winckelmann, *History of Ancient Art*, 282.

7. Bonner, *Studies in Magical Amulets*.

8. Delatte and Derchain, *Les intailles magiques*.

9. Mastrocinque, *Gemme gnostiche*; Mastrocinque, *Sylloge Gemmarum Gnosticarum*; Mastrocinque, *Kronos, Shiva, and Asklepios*; Mastrocinque, *Les intailles magiques*; Michel, Zazoff, and Zazoff, *Die magischen Gemmen*.

10. See the database at http://www2.szepmuveszeti.hu/talismans/visitatori_salutem.

11. On the relationship between astrology and the macrocosm, see chapter 2 of Grillot de Givry, *Witchcraft, Magic, and Alchemy*. For a more scholarly investigation, see Juste, "Impact of Arabic Sources," and Juste et al., *Ptolemy's Science of the Stars*. On alchemy, see Rampling and Jones, *Alchemy and Medicine*.

12. De Bellis, "Astri, gemme e arti medico-magiche"; Lecouteux and Monfort, *Les pierres talismaniques*. Lecouteux has also published online a partial Latin transcription of books 2 and 3. See, respectively, Leonardi's *De Lapidibus Liber Secundus* and *De Lapidibus Liber Tertius*. In late December 2022, at the press stage of this manuscript, I became aware of a non-scholarly publication of a translation of book 3 by Fiorello, *The Mirror of Stones*, but was unable to consult it or take it into account in my own work.

13. Lecouteux and Monfort, *Les pierres talismaniques*.

148 NOTES TO PAGES 3–8

14. This genre had important political connotations, as Azzolini cogently shows in her study of Gian Galeazzo Sforza (*Duke and the Stars*, 135–66).

15. Ibid.; Signorini, *Fortuna dell'astrologia a Mantova*, 33–40.

16. The doctrine of signatures is mentioned in Pliny's *Natural History* and Dioscorides's *De materia medica*. It was a staple medical approach until the end of the sixteenth century. Rembert Dodoens (1517–1585) might be among the first authors to discount it (*Stirpium Historiae Pemptades VI* 1.11).

17. On proposed categories of lapidaries, see Studer and Evans, *Anglo-Norman Lapidaries*, x–xiv; Riddle, "Lithotherapy in the Middle Ages"; *Les lapidaires grecs*, xvi; and Weill-Parot, *Les "images astrologiques,"* 109–10.

18. New Testament references had fostered an interest in stones as symbolic and moral vehicles of Christian messages. Examples include the description of the heavenly Jerusalem adorned with twelve precious stones in Revelation 21:18–21 and the reference to Christ as the foundation stone in Ephesians 2:20.

19. Pliny made use of at least thirty-eight sources, yet only Theophrastus's *On Stones* (*Peri lithōn*) has survived relatively intact.

20. See Ullmann, *Die Natur- und Geheimwissenschaften im Islam*, 97–98.

21. Saint Jerome attributed this reference to Xenocrates as well.

22. Pliny has him living at a Persian court, though it is most likely that he lived at the court of either Alexander or one of his successors. He is known to have written to King Mithridates VI Eupator, who was well known in antiquity for his large gem collection. Pompey offered this collection to the temple of Jupiter Capitolinus after having defeated King Mithridates in 63 BCE; see *Les lapidaires grecs*, xviin1.

23. This Greek-language Hermetic astrological text, which discusses finger-ring amulets, survives in a number of medieval manuscripts datable to the fourteenth century onward.

24. Pingree, "Diffusion of Arabic Magical Texts," 67; Mesler, "Medieval Lapidary of Techel/ Azareus."

25. Ritual, ceremonial, or learned magic envisioned the use of complex rituals. As such, image and ritual magic could often be illicit; see Klaassen, *Transformations of Magic*. Weill-Parot points out, though, that such classifications could be more theoretical than practical; see "Astral Magic and Intellectual Changes."

26. Lecouteux (*High Magic of Talismans and Amulets*) is quoting Valentin Löscher's 1697 definition of amulets versus talismans; Lecouteux, *High Magic of Talismans and Amulets*, 15.

27. Ibid.

28. Pingree, "Diffusion of Arabic Magical Texts," 58.

29. Ibid.

30. Copenhaver, "Scholastic Philosophy and Renaissance Magic."

31. Weill-Parot, "Astral Magic and Intellectual Changes," 168.

32. Ibid.

33. Ibid.

34. The Magister Speculi referred to such images as "abominable" and "detestable," respectively; ibid., 170.

35. Weill-Parot, "Astral Magic and Intellectual Changes," 178.

36. Zambelli, *L'ambigua natura della magia*.

37. Tester, *History of Western Astrology*, 55; Halfond, "*Tenebrae Refulgeant*."

38. This incipit reads "Evax Arabiae rex Tiberio Imperatori salutem" (Evax, king of the Arabs, salutes the Emperor Tiberius).

39. William of Auvergne, *De universo* 1.1.46; chapter title in Albertus Magnus, *Opera omnia*, "Contra Illos, qui dicunt planetas esse malos" (1.654–57).

40. See Burnett, *Magic and Divination in the Middle Ages*, 1–15, 84–96.

41. Although the text was attributed to Albertus by Zambelli in *"Speculum astronomiae" and Its Enigma*, Paravicini Bagliani (*Medicina e scienze*) disagreed on the basis of codicological evidence. Recently, Roy put forth the name of Richard of Fournival ("Richard de Fournival"),

NOTES TO PAGES 9–10 149

while Weill-Parot concluded that it must be considered anonymous (*Les "images astrologiques,"* 30–31).

42. Thomas Aquinas, though, did not believe that such influences could directly affect human free will. On Aquinas's notion of celestial influences, as well as those of Duns Scotus and Guillaume d'Ockham, see Weill-Parot, "Le 'contact virtuel.'" For an overview of the development of the notion of celestial influence, see North, "Celestial Influence."

43. In 1326 Pope John XXII's bull *Super illius specula* excommunicated anyone who dared use magic, invoke demons, or make specific use of talismanic rings.

44. Page, "Love in a Time of Demons"; Page, "Late Medieval Demonic Invasion of the Heavens." See also Grant, *Planets, Stars, and Orbs.*

45. Newman and Grafton's *Secrets of Nature* serves as a good introduction to the status of astrology and alchemy in the early modern period. For a more recent discussion, see Rutkin, *Sapientia Astrologica.*

46. While the many scholarly publications on the subject are too numerous to list, among the key volumes mentioned here, those edited by Otto and Stausberg and by Page and Rider are of particular note for their attempt to summarize the recent status of this scholarly *querelle*; see Garin, *Astrology in the Renaissance*; Kieckhefer, *Magic in the Middle Ages* and "Specific Rationality of Medieval Magic"; Flint, *Rise of Magic*; Otto and Stausberg, *Defining Magic*; Page and Rider, *Routledge History of Medieval Magic*; Bremmer and Veenstra, *Metamorphosis of Magic*; and Willard, "How Magical Was Renaissance Magic?"

47. Copenhaver, "Scholastic Philosophy."

48. On Ficino and planetary influences, see Moore, *Planets Within*, 119–92. On the notion of learned magic as a purely intellectual category, see Weill-Parot, "Antonio da Montolmo's *De occultis et manifestis*," 221.

49. The use of *imagines* had been advocated even earlier, starting with Pietro D'Abano (1257–ca. 1315) and continuing with Cecco d'Ascoli (1257–1327), Antonio da Montolmo (ca. 1330–ca. 1396), Antonio Guainieri (ca. 1380/90–ca. 1455), and Giorgio Anselmi da Parma (1385–1450).

50. Weill-Parot, *Les "images astrologiques,"* 602–38.

51. Weill-Parot, "Antonio da Montolmo's *De occultis et manifestis*," "Cecco d'Ascoli and Antonio da Montolmo," and "I demoni della Sfera."

52. Berengario Ganell might have been the first author to declare his authorship of a book of magic; see Fanger, "Introduction," 10.

53. Weill-Parot, "Antonio da Montolmo's *De occultis et manifestis*," 221–22.

54. The bibliography on the social and commercial importance of gems and jewels is rather vast. The following are only a few of the key studies: Cocks, *Princely Magnificence*; Kornbluth, *Engraved Gems*; Belozerskaya, *Luxury Arts of the Renaissance*; Scarisbrick, *Rings*; Pointon, *Brilliant Effects*; Mirabella, *Ornamentalism*; Hindman, *Toward an Art History of Medieval Rings.*

55. The notion of rings as signifiers of political allegiances has been well explored in the context of the English Elizabethan court; see Scarisbrick, *Jewellery in Britain* and *Tudor and Jacobean Jewelry.*

56. I am indebted to Luciano Baffioni Venturi for having shared invaluable tips and documentary references to fill the lacunae left by the loss of much of the period's documentation on the Sforza and on the city of Pesaro; see Baffioni Venturi, "Camillus Leonardus."

57. A commemorative family tombstone, now relocated to the counter-facade of the church, reads "De max D.O.M / Hic ego concesset claudar / post tempora vite / et coniunx fratres / nostraque posteritas / Camillus Leonardi Ar. Ac Me. Doct. / Pisa. Vi. Posu" (In the name of God, if it will be allowed, here I will be enclosed, after the time of my live [is past], with my wife, my brothers and our descendants, Camillo Leonardi, doctor in the medical arts, lived and set [this tombstone] in Pesaro).

58. The tombstone bears the date of 1487 because it is repurposed marble. The inscription and the eulogy read at Leonardi's funeral may be found in Biblioteca Oliveriana, Pesaro (hereafter cited as BOP), MS 409, vols. 2–4. See also Baffioni Venturi, "Camillus Leonardus."

150 NOTES TO PAGES 12–15

59. Thorndike, *History of Magic*, 6:298. The Leonardi family would gain further importance later in the sixteenth century in the figure of Camillo's grandchild, Giovan Giacomo Leonardi (1498–1572), who served as military man and diplomat under both Francesco Maria I della Rovere and Guidobaldo II della Rovere. The Leonardi family's palace is still standing in via Giuseppe Mazzolari; see Rossi, *Montelabbate*, 35–52; and Baffioni Venturi, "Camillus Leonardus."

60. The original parchment granting him a degree is known through an eighteenth-century transcription executed by Annibale Abbati Olivieri. It was signed by Thadeus Quirino of Brixia (a Venetian nobleman and canon), Jacopus Zeno (bishop of Padua, 1460–81), and the secretary Davide Serrachiani; see BOP, MS 376, vol. 10, cc. 28, and MS 409.

61. Gaetano da Thiene was a Paduan philosopher and physician who subscribed to Latin Averroism for most of his teaching career. He authored a *Commentaria super quatuor libros metheoroum Aristotelis* (published in Rouen in 1476 and Venice in 1491).

62. Leonardi 1.5, 8r.

63. Cesare conquered Pesaro in October 1500 and Urbino on June 20, 1502.

64. De Bellis, "Astri, gemme e arti medico-magiche."

65. The *Astronomicon* or *Astronomica* (ca. 30–40 CE) was written by the Roman poet Marcus Manilius (first century CE) under the reign either of the emperor Augustus or the emperor Tiberius. Although not quoted by any other ancient author, Renaissance astrologers considered it a key work. Gian Francesco Poggio Bracciolini is better known for the rediscovery of Lucretius's *De rerum natura*; see Greenblatt, *Swerve*.

66. Born in Cerreto in the Duchy of Spoleto, Pontano lived in Naples from the age of twenty-two onward. His illustrious career as a humanist and poet began with his tutoring the sons of King Alphonse the Magnanimous, a post that soon led him to be a close political adviser, diplomat, and politician for the Aragonese rulers.

67. See Heilen, "Lorenzo Bonincontri's Reception."

68. Bonincontri was a prolific author in a variety of genres, from the poetic to the astrological to the historical. Among the astrological works, the best known is *In C. Manilium Commentum*; see Thorndike, *History of Magic*, 4:405–12.

69. A number of astrologers are recorded to have been present at Pesaro, such as Giovanni Padovano, who had also been at the service of the Visconti of Milan, and Bartolomeo della Rocca, also known as Cocles, who was often consulted by Giovanni's brother, Galeazzo Sforza. Luca Guarico was there in 1502 and wrote a horoscope for Giovanni Sforza that was published in his *Figure Astronomiche*. Vespasiano da Bisticci mentions Giovanni Sforza's library in the chapter dedicated to Alessandro Sforza in his book on the lives of illustrious men; see *Vite di uomini illustri del secolo XV*, 113.

70. On the history of early libraries, see Manfredi, Curzi, and Laudoni, *Per una storia delle biblioteche dall'antichità al primo Rinascimento*.

71. *Inventario dei libri e dei quadri degli Sforza di Pesaro*, BOP, MS 387, vol. 10, fasc. 7. See also Clough, "Note of Purchase of 1467"; Baffioni Venturi, *Alla Ricerca della libreria perduta*, 15. It is still unclear whether the library burned or was dispersed over the centuries.

72. Pontano's commentary—*Ioanni Ioviani Pontani commentariorum in centum Claudii Ptolemaei sententias, libri duo*—was one of the most influential translations of the *Centiloquium*, a work of astrology that at this time was attributed to Ptolemy until Gerolamo Cardano rightly questioned its authorship. On the work's authorship, see Lemay, "Origins and Success of the *Kitab Thamara*"; Soranzo, *Poetry and Identity*, 100–103; and Akopyan, *Debating the Stars*, 85–87.

73. Thorndike, *History of Magic*, 4:407.

74. The full title was *Expositio super textum Alcabici, de vi et potestae mentis humane tabulae astronomicae* (Exposition on the Alcabici text, astronomical tables on the strength and power of the human mind). See Biblioteca Estense, Modena, codex 208, a.F.6,18; Thorndike, *History of Magic*, 6:298n2; Baffioni Venturi, "Camillus Leonardus," 66.

NOTES TO PAGES 15–19 151

75. A copy of the latter's edition is today in the Bibliothèque nationale de France. The Soncino family, who owned one of the most important Hebrew presses of the fifteenth and sixteenth centuries, was present in Pesaro and Fano between 1507 and 1520.

76. Thorndike, *History of Magic*, 6:298.

77. This was a commentary to a work variously attributed to either Gerardo da Cremona or Gherardo da Sabbioneta; see Camillo Leonardi, *Tehorice* [sic] *planetarum*.

78. There were also editions in 1524, 1525 (reprinted in 1537), 1526, 1527, 1530, and 1532. In those same years he also wrote a number of celebratory sonnets dedicated to Giovanni Sforza; see *Epigrammaton libellum*, Biblioteca Malatestiana di Cesena, MS D12, cc. 234–56.

79. The Flemish scientist held the chair of sciences in Padua in 1479–80 and by 1481 was physician to Federico da Montefeltro, duke of Urbino, and to his successors Guidobaldo and then Francesco Maria I della Rovere. He began working on the reformation of the calendar for Pope Sixtus IV upon the death of the mathematician Johannes Müller von Königsberg, also known by the Latinized name Regiomontanus.

80. BOP, MS 455, vol. 2, c. 199, and MS 2110.

81. Aurelio Superchi, a physician and jurisconsult, was Valerio Superchi's brother, the physician and poet who wrote the opening epigram of Leonardi's opus (1.1).

82. BOP, MS 443, c. 374.

83. See, for example, the illuminated miniature in Vincent de Beauvais's *Speculum historiale* in the British Library, London (hereafter cited as BL), Royal MS 14 E.I, vol. 1, fol. 3r, which shows the author at work in his scriptorium with a convex mirror in front of him to suggest that he was writing down that which was reflected on the mirror's surface.

84. Leonardi 1, 2r.

85. For a history of the use and allusions of the word "speculum," see Bradley, "Backgrounds of the Title *Speculum*."

86. De Bellis, "Astri, gemme e arti medico-magiche."

87. The marriage was celebrated with a series of astrological pageants; see Bridgeman, *Renaissance Wedding*. For the Italian original, see *Le nozze di Costanzo Sforza*.

88. Bridgeman, *Renaissance Wedding*, 57; see 127 for the description of a *girandole*, a firework structure similar to a Catherine wheel, surrounded by mirrors. For the original Italian, see *Le nozze di Costanzo Sforza*, 16–17, 66.

89. Warburg, "Italian Art and International Astrology"; Bertozzi, *La tirannia degli astri* and *Lo zodiaco del principe*; Federici Vescovini, "Gli affreschi astrologici."

90. Leonardi 1, 2r.

91. His first wife was Maddalena Gonzaga, daughter of Federico I of Mantua. Married in 1489, the bride died the next year.

92. Cesare Borgia arrived in Chinon as papal legate to bring the annulment papers that would dissolve King Louis XII's marriage from Jeanne de France so that he could marry Anne of Brittany, which he did in 1498.

93. The description, found in his own family archives, was transcribed by the chronicler Pierre de Bourdeille, abbot and lord of Brantome (ca. 1540–July 15, 1614), sometime in the later part of the sixteenth century; see de Bourdeille, *Memoires de Messire Pierre de Bourdeille*, 524–25; Bradford, *Cesare Borgia*; and Sabatini, *Life of Cesare Borgia*, 182–83.

94. The original inventory is now lost, but a copy was executed by the priest Simone di Stagio delle Poste in December 1512 at the request of Lorenzo's grandson, Lorenzo di Piero de' Medici; see Stapleford, *Lorenzo de' Medici at Home*, 1, 15; Massinelli and Tuena, *Treasures of the Medici*, 22; and Gennaioli, *Le Gemme dei medici*, 41.

95. Stapleford, *Lorenzo de' Medici at Home*, 14.

96. Ostrich eggs were commonly used as decorations in churches in the early modern period, on account of Physiologus 42 stating that the ostrich hatched its eggs by intently staring at them and Durandus's belief in them as a symbol of man's divine enlightenment; see Green, "Ostrich Eggs and Peacock Feathers," 36. It is not clear what type of fish teeth the

152 NOTES TO PAGES 19–24

list refers to, though they might be fossilized shark teeth; see Massinelli and Tuena, *Treasures of the Medici*, 22.

97. Venturelli, "Introduction," 23.

98. Spezi, *Lettere inedite del Cardinal Pietro Bembo*, 27. See also Brown, "Isabella d'Este Gonzaga's Augustus and Livia Cameo," 86.

99. Venturelli, "Gioielli e Oggetti Preziosi"; Brown, *Per dare qualche splendore*. See also Venturelli, "Introduction," 22.

100. Kunz, *Curious Lore of Precious Stones*, 378–79; Belozerskaya, *Luxury Arts of the Renaissance*, 57.

101. The anecdote is reported by Kunz and repeated almost verbatim by later authors and scholars. While no information is available on the physician, Juan de Mendoza was a Spanish nobleman and the tenth viceroy of New Spain. See *Curious Lore of Precious Stones*, 378.

102. Strong, *Way of Magic*, 89. A copy of this talisman may be found at the Bibliothèque nationale de France.

103. Frieda, *Catherine de Medici*, 83.

104. Cellini, *Autobiography*, chap. 25.

105. Diamond dust is not harmful to the gut; see Freitas, "Mechanical Damage from Ingested Diamond."

106. Leonardi 1.5, 10r.

107. Leonardi 1, 2r.

108. Leonardi used the word "magic" throughout his treatise but the word "necromantic" only four times. He dedicated the whole of book 3 to the study of magical images engraved on stone.

109. The 1502 edition was published in Venice "per Ioannem Baptistam Sessam," the 1516, also in Venice, "per Melchiorem Sessam et Petrum de Rauanis Socii"; the 1533 in Augustae Vindelicorum, Augsburg, "per Henricus Siliceus"; the 1610, 1611, and 1617 in Paris "per Carolum Suestre et Davidem Gillum"; Dolce's Italian appropriation/translation was published in 1565 and again in 1617, both in Venice "per Sessa." There is also a French-language edition (1519) as well as a few in German. The 1750 English translation was printed in London "per J. Freeman." Copies of each edition are still extant in various European libraries. A full list of editions may be found in Cantalamessa, *Astrologia*, 532.

110. Terpening was among the first scholars to have noted the appropriation; see *Lodovico Dolce* and the appendix to this volume.

111. Pingree, "Diffusion of Arabic Magical Texts," 67; Mesler, "Medieval Lapidary of Techel/Azareus."

112. Leonardi's awareness of Arab sources is never direct, but rather from manuals available in Latin translation or from other secondary sources. His knowledge of Arab sources might have been filtered through Ciriaco d'Ancona (or Ciriaco de' Pizzicolli, 1391–1453/55). Some of the humanist's notebooks were present in the Sforza library in Pesaro, excerpts of which were published in Pesaro in 1763 under the title of *Cyriaci Anconitani nova fragmenta notis illustrate*.

113. Antonio Musa Brasavola, *Examen omnium simplicium medicamentorum*, 428. Born in Ferrara a generation later than Leonardi, Brasavola (or Brassavola or Brasavoli) became one of the most important physicians of the period, counting among his accomplishments the performance of the first successful tracheotomy.

114. Ibid.

115. The color descriptions of alabandina, pontica, and cyanica, for example, are quite similar.

116. Valerio Superchio or Soperchi da Pesaro, originally from Tomba Castello, near Pesaro, held a prominent role at the Sforza court and continued to do so under Cesare Borgia, Giovanni Sforza, and then the della Rovere duke. See Cicogna, *Delle inscrizioni veneziane raccolte ed illustrate*, 3:447–51.

117. Leonardi 1, 2v.

118. Leonardi 1.2, 8r.

NOTES TO PAGES 25–39 153

119. Leonardi 1.2, 8v.

120. Although Leonardi mentions having witnessed the making of counterfeit gems, it is possible he had access to a *ricettario*—that is, a compilation of recipes for the creation of counterfeit gems, such as Jean d'Outremeuse's *Tresorier de philosophie naturelle des pierres precieuses* (also in Cannella, *Gemmes*).

121. Leonardi 1.9.

122. This was not, of course, the only possible account for the phenomenon of vision. Explanations of visual perception of the early modern period are quite varied, from Aristotelian extramission to Galeno-Platonic intromission theory, often filtered through Arab sources; see, for example, Lindberg, *Theories of Vision*; and Hendrix and Carman, *Renaissance Theories of Vision*.

123. Leonardi 2.2, 14v.

124. Ibid.

125. Leonardi 2.2.

126. See Kay et al., "Color Naming Across Languages."

127. Hills, *Venetian Colour*, 204.

128. Medieval lapidaries such as that of Jean de Mandeville (active 1351–71) or Marbode of Rennes already listed such virtues in connection to redness, although these same properties were also given to green-hued stones like jasper, heliotrope, and topaz. See Gontero-Lauze, *Sagesses minérales*.

129. Leonardi 3.1, 47r.

130. Thomas Aquinas in his commentaries on Aristotle's *De anima* 1.5.

131. Aristotle, *De partibus animalium*. The exact Latin phrase appears in a fourteenth-century handwritten commentary to Ptolemy's *Almagest*, fol. 170r–v. The phrase is also the prologue incipit for the Pseudo-Aristotelian *Liber complexionum*, BL, Harley MS 3843, fols. 100v–115v.

132. Leonardi 3.2, 48r.

133. On the Ficinian connections between magic and aesthetic concerns, see Toussaint, "L'ars de Marsile Ficin."

134. De Bellis, "Astri, gemme e arti medico-magiche."

135. Leonardi 3.3, 49r.

136. Paraphrase of ideas contained in Ptolemy's *Tetrabiblos* 1.2.7 and 3.2, as well as in Albertus 2.3.3 and Leonardi 3.4, 50v.

137. Leonardi 3.5, 51v.

138. Many such gems, which used to be called gnostic gems, appear in Greek Magical Papyri. See Betz, *Greek Magical Papyri*; Bonner, *Studies in Magical Amulets*; Henig, *Classical Gems*; Monaca, "Gemme magiche e divinazione"; Cohen, "Elisabetta Gonzaga"; and Nagy, "*Daktylios pharmatikes.*"

139. Leonardi 3, 57v.

140. Book 6 of the *Liber Raziel* was based on the *Sefer Ha-Razim*, which by then was also known as the *Book of Secrets* (as revealed to Noah).

141. This type of material is found in healing manuals as late as 1743, as exemplified by Boerhaave's *Essay on the Virtues*, which was supposedly translated from an original essay in Latin.

142. Gaffarel, *Curiositez inouyes*, 226.

143. McLaughlin, *Literary Imitation*; Knight, *Bound to Read*; Morra, *Building the Canon*.

144. Seneca, *Epistles* 84.3.

145. Harris, "Idea of Lapidary Medicine," chap. 3.

THE MIRROR OF STONES

Epistle and Proemium

1. Dolce dedicated the work instead to Giovanni Battista Campeggi (1507–1583), bishop of Majorca; see the appendix to this volume.

154 NOTES TO PAGES 40–47

2. In his proemium, Dolce claimed to have extensively researched the subject to write on it as no one had done before; see the appendix to this volume. In the 1750 English edition, the unknown English translator (referred to henceforth as U.E.T.) inserted a preface between the dedicatory epistle and the proemium. In this preface he informed his readers of the rarity of the book and his travails in seeking it out. He then warned them that much of the material in it was informed by superstition, for which reason he omitted the third part of Leonardi's opus.

3. Both Dolce and U.E.T. omitted the index of chapters and gemstones that follows.

4. The following alphabetical list replicates Leonardi's order. As the reader will note, within each letter (*A*, *B*, *C*, etc.), the stones' names are not listed in alphabetical order but appear to be listed in order of importance. This seems to have been the practice in many other lapidaries. I have also chosen to follow the exact Latin spelling given by the author. See each entry for variety of other known spellings, as well as for each stone's known or possible identity.

Book 1

1. Ludovico Dolce bestowed a title on book 1: *On Gems Produced by Nature, Their Quality, Size, Beauty, and Virtues*. He used the word "gems" instead of "stones" throughout book 1.

2. Leonardi is referencing Aristotle's *De caelo* 3.3, also known as *De caelo et mundo*. This was a cosmological treatise sometimes misidentified with the apocryphal work *De mundo* or *On the Cosmos* or *On the Universe*. Written in 350 BCE, the treatise was one of the most influential works on the nature of the cosmos until Copernicus's model of the universe supplanted it in the sixteenth century. See Aristotle, *De caelo* 3.3.

3. *De generatione et corruptione* was also known by the title of *On Coming to Be and Passing Away*, ca. 347–35 BCE.

4. Leonardi is quoting the *Canon of Medicine* or *al-Qānūn fī aṭ-Ṭibb* by Avicenna (Ibn-Sina a.k.a. Abu Ali Sina), 1.2.19. Completed by 1025 CE, this was probably his most famous work, as it was reputed to be a fundamental medical text by both the Islamic and Western world until the eighteenth century.

5. Book 1 of Aristotle's *Physics* (ca. 350 BCE) introduces the notions of matter and essence, causes and elements.

6. Leonardi is referring to Pietro d'Abano or Peter of Abano (1250/57–1315/16), professor of medicine in Padua, as well as a philosopher and astrologer who had been in the service of Pope Honorius IV. His most famous work, *The Conciliator* or *Conciliator differentiarum philosophorum [et] praeciupe medicorum*—or *Reconciler of the Differences Between Philosophers and Physicians*—was published in 1472 in Mantua and then Venice in 1476. The work tried to reconcile contradictions, or differences, between Aristotle's natural philosophy and medical systems such as that of Avicenna and Averroes.

7. The theoretical notions with which Leonardi begins his treatise show his dependence on Albertus Magnus's first two books of *De mineralibus*. Just as in Albertus, the theoretical notions were wholly derived from Aristotle (*The Heavens, Meteorology, Generation and Corruption*) and from Avicenna (*Canon of Medicine*), but the practical application to stones are solely derived from Avicenna's *De congelatione et conglutinatione lapidum*; see Albertus Magnus, *Book of Minerals* 1.1.2.

8. Aristotle's *Meteorologica* or *Meteora* was one of the earliest texts to discuss various natural weather phenomena as well as matters of geology, hydrology, and geography.

9. Dolce (6) explicitly stated the philosopher's name.

10. Leonardi seems to have used not only Aristotle's *Meteorologica* but also the pseudo-Aristotelian text *De mineralibus*.

11. Leonardi's quote derives not from Aristotle but from Avicenna, though he believed it was from Aristotle. The oldest translation of Aristotle's *Meteora* (fols. 84r–114r of Oxford Codex Selden supra 24) contains three chapters appended to book 4 that begin with "Terra pura lapis non fit" (Pure earth does not become stone). This is the first sentence of Avicenna's *De congelatione et conglutinatione lapidum*. These three chapters also bore the title *De mineralibus* and

NOTES TO PAGES 48–51

were a selection drawn from his *Kitâb Al-Shifâ '*—or more precisely, they were a Latin translation of the fifth chapter of the first treatise of the fifth section of the *Tabi Iyyat* from the *Kitâb Al-Shifâ '*. The conflation of the works of Aristotle (or attributed to Aristotle) and those of Avicenna was not unusual. Leonardi, therefore, is probably using a version of this widely circulated copy of Aristotle's *Meteorology* with the three additional chapters titled *De mineralibus*. See Avicenna, *De congelatione et conglutinatione lapidum*, ed. Holmyard and Mandeville; Otte, "Anonymous Oxford Commentary," 326–36; Lettinck, *Aristotle's Meteorology*.

12. Leonardi dispenses with having to list other scholars' "wrong" opinion as these were already discussed in Albertus Magnus, *De mineralibus* 1.1.4.

13. Leonardi continues following the order of arguments set forth by Albertus and uses the same comparison used by the latter in *De mineralibus* 1.1.5 to establish the manner in which the mineralizing virtue functions. Both Leonardi and Albertus are making use of Aristotle's notion of generation as expounded in his *Generation of Animals* and *Meteorology*.

14. Dolce (8r) omitted this last part of the sentence and ended instead with "secondo la disposition della materia" (according to the disposition of that matter).

15. Sentence missing in Dolce.

16. Sentence missing in Dolce. Albertus Magnus uses the same exact reference to Plato's Timaeus in *De mineralibus* 1.1.5.

17. The discussion that follows is drawn from Aristotle's *Meteorology* as well as Albertus.

18. Sentence missing in Dolce.

19. In the *De anima* Aristotle imputes a form (defined as soul in the case of animate beings) to inanimate things, therefore allowing later commentators and scholars to suggest that stones were not just mere matter. Leonardi thus continues following Albertus's reasoning. It is in the wake of Aristotle's assertion that Albertus Magnus will suggest that a stone's form is manifested in its magnetic, medical, or magical actions as imparted by the heavens; Albertus Magnus, *De mineralibus* 1.1.6.

20. Either the author or the printer made an error in numbering this chapter as fifth, when it should have been the fourth. The following chapter was also designated as fifth. The 1502 and the 1533 editions both bear this error.

21. In this chapter Leonardi follows Albertus Magnus's *De mineralibus* 1.1.7, 8.

22. Leonardi is for the first time referring to the writings of Hermes Trismegistus, which Albertus had mentioned instead in *De mineralibus* 1.1.1. Hermes was believed to have been a contemporary of Moses and his writings were invested with great authority with regard to magic. Leonardi seems to have been aware of both the *Asclepius* as wells as the *Corpus hermeticum*.

23. Dolce (9v) added "o dei pianeti" (or of the planets).

24. This is an apocryphal text that was commonly included or referenced in early modern works of talismanic and astrological magic and that Leonardi unquestionably accepts as authored by the biblical figure.

25. Dolce (10) reads instead "de Dragoni, di Serpenti, e di altri simili animali" (of dragons, snakes, and other similar animals).

26. Dolce omitted the reference.

27. Beyond Gaetano of Thiene's *Comments on Meteors*, Leonardi also knew Avicenna's *De congelatione*, thus it is also possible that he read descriptions of meteorites there, as well as in Albertus Magnus's *Meteora*. He certainly read it in Pliny's *Natural History*, as the subsequent passage makes clear.

28. According to modern editions, Anaxagoras's prediction of stones falling from the heavens is actually mentioned in Pliny the Elder, *Natural History* 2.59.

29. Leonardi is referencing Aristotle's *De meteora* 1.7.

30. Dolce (10v) read *orbis* as "Cielo" (heavens).

31. Leonardi follows both Albertus Magnus, *De mineralibus* 1.1.8, as well as his *De natura locorum* or *The Nature of Places*.

32. Leonardi 1.4, 8v.

156 NOTES TO PAGES 51–56

33. The assertion is not found in Aristotle's work, and Leonardi is merely repeating Albertus Magnus's *De mineralibus* 1.1.8. Albertus himself may have used a wide variety of Aristotelian sources; for a list of possible authorities, see Albertus Magnus, *Book of Minerals*, 30n3.

34. Albertus Magnus, *De mineralibus* 1.1.7.

35. Following Albertus Magnus, *De mineralibus* 1.1.8.

36. Dolce naturally omitted the reference to Cesare Borgia.

37. Italics are mine. It is possible that the author might have meant Caprarola instead of Capriolo. The Caprarola estates, prior to the building of the Farnese Villa in the 1530s, were owned by the papacy and would therefore have been in the hands of Cesare's father, Pope Alexander VI. Regardless, Leonardi is concerned with the transformation of water into stone and thus substitutes Albertus's tale of the glove of Emperor Frederick II with a local reference that would have been immediately understood by his reader. Most interestingly, it shows that although Leonardi follows Albertus Magnus's example, he is keen to use examples from his own experience. Albertus Magnus, *De mineralibus* 1.1.8.

38. An explanation for fossils.

39. *Maris lauci* is translated by Dolce (11v) as "lito del Mare Dauco" and by U.E.T. (30) as "Lucan Sea." Albertus's mention of petrified wood is generally considered the first description of this phenomenon (*De mineralibus* 1.1.7).

40. Dolce (11v) added "cosa meravigliosa a vedere" (which was a most marvelous thing to see).

41. Leonardi now begins to follow Albertus Magnus, *De mineralibus* 1.2.1.

42. Aristotle's *De anima* is a treatise divided into three books: the first discusses previous thinkers' definitions of the soul; the second defines the soul and discusses the five senses and sensation in general; the third discusses the problem of awareness of sensation, imagination, and senses in animals.

43. Dolce omitted this reference since he dedicated the book to a wholly different patron whose door was presumably not decorated in a similar manner.

44. Albertus Magnus discussed issues of transparency in *De mineralibus* 1.1.3. Leonardi also discusses issues of colors that Albertus had instead included in *De mineralibus* 1.2.2.

45. The author is referring to Aristotle's *De sensu*, though it is likely that he knew it through Thomas Aquinas's commentary *Sentencia libri de sensu et sensato*. For Aristotle, color resulted from a mixture of white and black, that is, of light/transparency and darkness/opacity.

46. Leonardi's original reads "diaphano" but U.E.T. (35) corrects it to "dark." Ibn Rushd or Abu al-Walid Muhammad ibn Ahmad ibn Rushd, known to the medieval West as Averroes (1126–1198), was a medieval Andalusian thinker who wrote on a multiplicity of subjects, from medicine and mathematics to geography and physics. His commentaries to Aristotle's works were widely translated and Leonardi certainly knew them, as did Albertus. While Albertus does not specifically mention Averroes, Leonardi does, suggesting that he was familiar with the body of knowledge that his predecessor was referencing and that he might be specifically referencing Averroes's commentary on Aristotle's *On Generation and Corruption*. Avicenna's commentaries to *De sensu* might have further helped in expanding the argument.

47. Although U.E.T. (37) correctly translated *calidi* as "glowing," I have preferred to keep the literal translation, as it better takes into account the humoral theory on which Leonardi relies.

48. Albertus treated the same subject in *De mineralibus* 1.2.4. Dolce (15r) expanded the title by adding "overo Gemme" (that is of gems).

49. Dolce (15r) added "overo opertiva" (operative).

50. The notion that hardness and softness may be understood as degrees of moisture and dryness derives from Aristotle's *On Generation and Corruption*.

51. Dolce (15v) ends the chapter here and omits the latter part of the sentence.

52. Albertus treated the topic in Albertus Magnus, *De mineralibus* 1.2.6.

53. U.E.T. (41) read *ponderositate* as "porosity."

54. Leonardi, like Albertus, is following Aristotle's *On the Heavens*.

NOTES TO PAGES 56–61 157

55. Dolce (16v) ends the chapter here and omits the remainder of the sentence.

56. Albertus had not discussed the argument. Since Pliny is the most hallowed source to have written on the matter, Leonardi is certainly following his example. He was also aware of a number of post-Plinian sources in circulation since antiquity. The Papyrus Graecus Holmiensis (ca. 300 CE), also known as the Stockholm papyrus, is one of the oldest of such post-Plinian sources, listing seventy-one recipes for the making of false gems. Jean d'Outremeuse's *Tresorier de philosophie naturelle des pierres precieuses* (1382–90) was a more "recent" compilation of such recipes that would have been available to the early modern reader.

57. The sentence in brackets was added by Dolce (16v), but since it clarifies the meaning of the original I have included it, too. Leonardi is expressing the same concern for the consumer expressed by Pliny (37.75).

58. Pliny (37.76) mentions a similar notion with regard to a stone's brightness and its ability to reach and delight the eye. The Roman author even suggested testing stones early in the morning, prior to ten o'clock, to better assess their light.

59. Pliny (37.76) states that the first test for a stone is its weight, followed by temperature—genuine stones feel colder in the mouth—and structure. Leonardi seems to follow a similar order of importance, but the temperature he refers to is not that of the stone itself but one that the stone may survive. Other lapidaries, such as *Hortus sanitatis* (published in Germany in 1491), did not use similar "scientific" tests but relied on testing a stone's occult virtues to establish its authenticity. A garnet, for example, could be considered authentic by testing its power to repel bees while the wearer was smeared in honey.

60. U.E.T. (46) translated *atramento* as "Copperas," also known as green vitriol, which is a green hydrated ferrous sulfate used in the making of inks.

61. Giovanni di Fidanza di Bagnoregio, canonized as Saint Bonaventure di Bagnoregio by Pope Sixtus IV in 1482, was a medieval theologian. Leonardi is most likely referencing the *De reductione artium ad theologiam* (*Reduction of the Arts to Theology*).

62. Literally *compostelli vocum*. U.E.T. (46) translated it as "Dictionary of Words," though there is no such work among the writings of St. Bonaventure.

63. The sentence is not present in Dolce (17v).

Book 2

1. Dolce (18v) translated this last sentence as "accioche I Lettori sappiano, che non habbiamo scritto alcuna cosa da noi temerariamente" (so that the readers may know that we have not dared to write anything by ourselves).

2. U.E.T. (47) omitted this whole sentence.

3. Albertus, too, had begun his second tome with a discussion of the powers of the stones. Dolce (18v) labeled this chapter as "first" instead of "second."

4. Dolce omitted "by the specific form or substantial essence of a [specific] stone."

5. Leonardi lists the same examples—the magnet and the sapphire—used by Albertus.

6. Leonardi's original of *antraces curare* is translated by Dolce (19r) simply as "curano certe infirmità" (they heal certain illnesses) and by U.E.T. (49) as "cure Carbuncles." Since both anthrax (a zoonotic bacterial infectious disease) and carbuncles (a cluster of boils or furuncles) may present similar physical manifestations, and since I am not sure that these were seen as distinct illnesses in the fifteenth or sixteenth century, I have retained the original anthrax (*antraces*), rather than carbuncles as the U.E.T. did.

7. Leonardi is again following Albertus Magnus, who had begun this same section with a discussion of how the virtues of stones were first mentioned by Pythagoreans. Albertus, though, does not make any references to Solomon, as Leonardi does.

8. "Nescio quis teneros oculus mihi fascinate agnos" (Virgil, *Eclogues* 3.103). The Latin is variously rendered as "some evil is cast on my tender lambs" (*Virgil's Works*), or some "evil eye bewitches my tender lambs," *Eclogues, Georgics, Aeneid* (trans. Fairclough), or "Some evil eye my lambkins hath bewitched," *Eclogues* (Stevenson and Project Gutenberg). Compare also to a similar notion in Horace, *Satires, Epistles* 1.14.37.

158 NOTES TO PAGES 61–64

9. Gaius Julius Solinus (active in the third century) wrote a catalog of marvelous phenomena, the *Collectanea rerum memorabilium*, that was extremely influential in the intervening centuries. In it, he discussed sight, vision, and some of the marvels thereof. Leonardi would have naturally noted that both Pliny and Solinus reported similar descriptions of the evil eye.

10. Dolce (20r) adds "e si vede la esperienza in molti" (as is seen by direct experience in many other cases).

11. Leonardi is restating Albertus's own pronouncement on the Pythagoreans and Democritus; Albertus Magnus, *De mineralibus* 2.1.1.

12. Aristotle had mentioned Orpheus and the soul of animals in *De anima*.

13. Albertus Magnus, *De mineralibus* 1.1.6.

14. Niccolò dei Conti, Nicolaus Comes, or Niccolò de Comitibus of Padua was a well-known astronomer and astrologer whose work on astrology and weather prediction, *De motu octavae sphaerae*, had been dedicated to Malatesta detto dei Sonetti (1366–1429) of Pesaro. Copies of the works are now in the Biblioteca Laurenziana di Firenze, MS Ashburnham 134 (208–140), and the Biblioteca Apostolica Vaticana, Vatican City, MS Vat. Lat. 3379, fols. 1r–4v. See Thorndike, *History of Magic*, 4:250–55, and Azzolini, *Duke and the Stars*, 69–70. Given the description of him as "the greatest astronomer of our times," however, I wonder if Leonardi might instead be referring to Nicolaus Copernicus (1473–1543), who was present in those years in Italy, though in Bologna not Padua.

15. U.E.T. (54) omitted "so as not to bore our readers."

16. Although Aristotle had widely criticized Plato's philosophy of the ideas, Leonardi is using Albertus's clear and concise criticism (see 2.1.3). Albertus concludes his chapter criticizing Avicenna, whereas Leonardi ends it by stating that Hermes is the source to be followed.

17. Dolce (21r) reads instead "Astrologi" (astrologers).

18. U.E.T. (55) reads instead "Hermes, and other Astronomers, whose Contemplations are more exalted, say, that the Virtues of all inferior Things, proceed from the Stars and the Figures in the Heavens."

19. The second verse of the Hermetic text known as the *Tabula Smaragdina* (*Emerald Tablet*); see Manzalaoui, "Pseudo-Aristotelian *Kitāb Sirr al-asrār*."

20. Leonardi is referencing Ptolemy's *Tetrabiblos*.

21. This is a substantial departure from the argument of Albertus Magnus and one that will function as the fundamental underpinning of book 3 of Leonardi's own work.

22. Albertus Magnus discusses this in *De mineralibus* 2.1.4.

23. Leonardi reprises the topic from book 1, chapter 5, and from Albertus Magnus, *De mineralibus* 1.1.6. Aristotle had discussed the topic in both *On the Soul* and *Physics*.

24. Leonardi could be referring to Averroes, the commentator par excellence of Aristotle, or to his own teacher Gaetano of Thiene, who had also written a commentary on Aristotle. Albertus had also written commentaries on *Physics* and *Metaphysics*; while it is possible that Leonardi might be calling Albertus the great commentator, this was not the latter's usual moniker.

25. Dolce (22r) might have misread *individuale* since he translated this last sentence as "che dà l'essere indivisibile a questa materia" (which is then indivisible from this matter).

26. While Leonardi is repeating the same reference of Hermes used by Albertus, he expands on it, suggesting he might actually be using the same writings by Hermes that Albertus did, most likely the *Sacred Book of Hermes Trismegistus Addressed to Asclepius*, in which the virtues of matter are related to its composition.

27. Dolce (23r and 23v) lists all the authors listed by Leonardi, but in a slightly different order.

28. Pedanius Dioscorides (ca. 40–90 CE), principally known for the *De materia medica*.

29. As already seen, Leonardi made use of the *Metaphysics* (*Metaphysica*), *On the Soul* (*De anima*), *Physics* (*Physica*), *On the Heavens* (*De caelo* or *De caelo et mundo*), *Generation and Corruption* (*De generatione et corruptione*), and *Meteorology* (*Meteorologica* or *De meteoris* or *Meteora*). He also made use of pseudo-Aristotelian works: *The Secret of Secrets* (*Secretum*

secretorum) and the *Lapidary of Aristotle* (*Lapidarium Aristotelis* or *Liber Aristotelis de lapidibus*).

30. Given his ties with Lorenzo Bonincontri, he most certainly knew the *Corpus Hermeticum*, Marsilio Ficino's translation of the writings attributed to Hermes, which included the *Pimander* or *Poemandres*.

31. In the early modern period, Evax was thought to be the author of the *Power of Stones* (*De virtutibus lapidum*), today attributed to Damigeron. Though nothing is known about him, the text derives from the Greek *Lithica*, attributed to Orpheus. Since the Latin asserts that the work is a translation by a certain Evax for the emperor Tiberius, it was commonly known under that name. To add further confusion, Marbode's lapidary, which was based on this work, was often circulated under the name of Evax. Evax's *Power of Stones* discussed the engraving of stones to enhance magical powers.

32. U.E.T. (61) reads instead "Scapio." Leonardi is most likely referring to Serapion the Younger, though in the early modern period confusion was still made between Serapion the Younger and Serapion the Elder, also known as Yahya ibn Sarafyun, a Christian physician of the ninth century. Little is known of Serapion the Younger, and works attributed to him are thought to have been written somewhere between the twelfth and the thirteenth century. It is quite possible that the name Serapion is a pseudepigraph the anonymous author adopted to cast greater authority on his work by borrowing the name of the more renowned earlier physician. His most famous work was the *Book of Simple Medicaments*, which circulated in Latin under *Liber Serapionis Aggregatus in Medicinis Simplicibus*, or *Serapionis Aggregatoris de Simplicibus Comentarii*, or *Liber de Simplicibus Medicamenti*, or *Liber de Simplici Medicina*. An early translation from Latin to Italian (1390–1404) is also known as the *Carrara Herbal*.

33. Abus Ali al-Husayn ibn Abd Allah ibn Sina (ca. 980–1037), as mentioned above, was commonly known as Avicenna in the West. Leonardi appears to have known his *Canon of Medicine* (*Al-Qanun fi al-tibb*) and sections of the *Book of Healing* (*Kitab al-shifa*)—that is, the *De congelatione et conglutiantione lapidum*.

34. This is very likely Johannes Mesue or Meseu the Younger, an Italian physician who died in Cairo in 1015, published under the pseudonym of Mesue or Mesuae. The latter name was that of the celebrated Persian physician Yuhanna ibn Masawaih (ca. 777–857), whose works were circulated early on in Latin translation. By the sixteenth century there was great confusion between the two, with many of the works of the latter attributed to the first. The *Antidotarium Mesuae* by Pseudo-Mesue was widely circulated since the thirteenth century, and by the middle of the sixteenth century most of his works were also published in Italian translation; see Lieberknecht, *Die "Canones" des Pseudo-Mesue*.

35. A magical lapidary of astrological sigils was commonly attributed to the mythical biblical king.

36. Compiled by an unknown author and dated to the second century CE, the text may be thought of as a precursor to medieval bestiaries for it describes animals, birds, plants, stones, and mythical creatures, each of which was given a moral valence. It was commonly attributed to the Physiologus (i.e., the Naturalist), who is mentioned throughout the text.

37. Caius Julius Solinus (third century) authored the *Collectanea rerum memorabilium sive polyhistor*.

38. The *Lapidarius* is to be identified with Marbode's *Libellus de lapidibus preciosis*. The book circulated so widely, in both Latin and vernacular, that the author's name was sometimes elided and referred to simply as *Lapidarius*.

39. This is most likely Helinandus or Hélinand of Froidmont (ca. 1150–ca. 1237), author of a *Chronicon* that ends in the year 1204.

40. Isidore of Seville (Isidorus Hispalensis, ca. 560–636), author of the *Etymologies* (*Etymolagiarum sive originum libri XX*).

41. Arnaldus is most likely Arnold of Saxony (Arnoldus Saxo), about whom very little is known other than he might have been a cleric. Leonardi might have known his *De finibus rerum naturalium* (*The Purpose of Natural Things*).

160 NOTES TO PAGES 64–72

42. This is most certainly Juba II, who was known to have penned a number of scholarly books on a variety of topics including natural history, none of which have survived except for a few fragments. Juba is sometimes mentioned by lapidaries as a source of information about specific properties of stones. See, for example, Nicols, *Lapidary*.

43. Most likely Dionysius Periegetes, who was also known as Dionysius of Alexandria. Though not much is known about him, he is believed to have lived in the second century CE under the emperor Hadrian and to have authored a geographical text, *Periegesis of the Known World*, translated by the grammarian Priscian sometime in the late fifth or early sixth century; see Schulman, *Rise of the Medieval World*.

44. As is by now clear, this was Leonardi's principal source.

45. Vincent de Beauvais; the *Speculum historialis*, which was widely circulated, was but the last section of the *Speculum maius*.

46. Although Thetel Rabanus appears to have been given as a single name, it is very likely that the printer omitted a comma between the two names. As already noted by Thorndike (*History of Magic*, vol. 6, chap. 39), Leonardi made use of and referenced Thetel with regard to images on gems; this same source was also cited by Thomas de Cantimpré, while Rabanus was cited by Bartholomaeus Anglicus. Rabanus Maurus's (Hrabanus Maurus, ca. 780–856) *De universo libri XXII, sive etymologiarum opus* drew on Isidore of Seville's *Etymologies*. Book 17 contains a well-known *Apocalyptic Lapidary*. The lapidary of Thetel is a composite work that belongs to the astral image group of lapidaries and is most often attributed to Sal ben Bisr, or Zahel Benbriz, a Jewish author of the ninth century. The lapidary, *Liber sigillorum filiorum Israel quem fecerunt in deserto*, is often attributed to Thetel. Thomas de Cantimpré had included the work of Thetel in his encyclopedia. The author's name is variously spelled as Techel, Theel, Tetel, Thetel, Thechel, Tochel, Cehel, Cheel, Cethes, Cehtel, Chael, Detel, Ethel, Rechel, Ghehel, Asechel, and Zahel in both manuscript and scholarship. As noted by Mesler, the confusion is further enhanced by the fact that Leonardi also attached the names of multiple authors to the same material, including that of Solomon. On this matter and the influence of this text over later writers, see Pingree, "Diffusion of Arabic Magical Texts"; and Mesler, "Medieval Lapidary of Techel/Azareus."

47. This may be Bartholomaeus Anglicus. Thorndike, *History of Magic*, 6:300n8.

48. Marbode of Rennes, author of the *Book of Stones or Gems* (*Liber lapidum seu de gemmis*). The Christian lapidary the *Twelve Precious Stones in the Foundation of the Celestial City* was also attributed to Marbode. Albertus Magnus certainly knew the *Book of Stones* and made ample reference to it.

49. The putative name of the author of the *True Alchemical Practice* (*Practica vera alkimica*) (ca. 1386).

50. The *Liber pandectarum medicine, omnia medicine simplicia continens* was a work by Matthaeus Silvaticus of Mantua (ca. 1280–ca. 1342), which was dedicated to the king of Naples, Robert of Anjou, in 1337 and appeared in print around 1474. The treatise is a compendium of various pharmacological elements.

51. The *Thesaurus Cornu copiae et Horti Adonidis*, published in Venice by Aldus Manutius in 1496, was a compendium of texts by Greek and Byzantine grammarians, some of which were written in a number of Greek dialects.

52. A magical medical work of possible Greek origins assembled sometime in the fourth century CE. Its complex transmission and manipulation make it hard to know what particular edition Leonardi might have known.

53. *Liber de natura rerum* by Thomas de Cantimpré.

54. Marbode's list is in alphabetical order by stone, whereas Leonardi, as he himself tells us, first gives an alphabetical list by color.

55. U.E.T. omitted this passage along with the alphabetical list of each stone.

56. In order to convey the original alphabetical order each entry begins with the original Latin word. The list follows the exact order and the spelling used in the original.

57. U.E.T. (62) omitted any reference to book 3 since U.E.T. did not translate it.

NOTES TO PAGES 72–73 161

58. The following alphabetized entries follow the order used in the original. The reader might note that some of the spellings do not exactly match the stone's name listed above. In the early modern period, the variation of spelling of particular words was mainly due to the fact that no standardization rules had be set and most words were spelled phonetically. Thus I chose to accompany each entry with a note pointing other known spelling variations of a specific stone's name.

59. *Adamans, adams, adamst, dyamans, diamas, adamantinus*; in medieval Italian, *diamantes, diamante, adamant*. Theophrastus 18; Pliny 37.15; Solinus 52.23, 56; Philostratus 2.14; Isidore of Seville 16.13.2; Marbode 1; Hildegard von Bingen, *Physica* 4.17 (hereafter cited as Hildegard von Bingen); Damigeron 3; Neckam 2.92, 6.325ff; Bodleian Library, Oxford (hereafter cited as Bodl.), MS Digby 13.22, 13.49; Physiologus 25, 49; Bartholomaeus Anglicus, *De rerum proprietatibus* 16.9 (hereafter cited as Bartholomaeus Anglicus); Thomas de Cantimpré 14.4; Vincent de Beauvais 8.39, 8.41; Albertus Magnus, *Book of Minerals* 2.1.2 (hereafter cited as Albertus Magnus); *Picatrix* 2.10.5; *Hortus sanitatis* 5.1; Mandeville 1.2. It is a crystallized carbon gem. The first use of the word *adamus* or *adamantinus* occurs in Damigeron, prior to which the term most commonly used was *adamas*; it encapsulated the unbreakable quality of the gem, for *adamas* meant unconquerable in Greek. In early antiquity the term appears to have been used to refer to a hard metal, while by the first century it was used to refer to both hard stones like diamonds as well as stones that attracted metals, such as magnetites. Some lapidaries actually use the word *adams* to refer to the magnet; see, for example, the Cambridge Lapidary 5.19–52 and Vincent de Beauvais 8.34. The gem was listed as the third stone in the second row of the breastplate of the biblical high priest Aaron. While some writers considered it an antidote against poison, it could also be listed as a poison; see Cellini, *Autobiography*, 227.

60. The notion had already been mentioned in Pliny and was repeated by every author thereafter, though Alexander Neckam also mentioned vinegar as a possible dissolving agent; see *De naturis rerum* 2.92.

61. Diamonds were believed to have magnetic powers, or have the power to neutralize magnets, because of erroneous etymology: the word *adamant* was thought to derive from the Latin *adamare*, to be attracted to. The antimagnetic property had already been mentioned in Pliny (37.15).

62. Not all of these were diamonds. While the Indian was most certainly a diamond, the Cyprian was most likely rock crystal also known as a diamond of Baffa. The Macedonian was probably rock crystal as well. The Arabian and the Syrian might have been diamonds.

63. It is notable that Hildegard von Bingen thought that its curative properties could be enacted by holding the diamond in one hand and making the sign of the cross in the other; see *Das Buch von den Steinen*. Knuth also reports that the French king Louis IX "declared the stone to be forbidden to women. Nearly two hundred years later the gender ban was broken. Agnes Sorel, Mistress of Charles VI, was the first woman recorded to wear diamonds" (*Gems in Myth*, 82).

64. *Achaten, acate, accaates, agathes, agattes, agapis, achates*; in medieval Italian, *agate*. Theophrastus 31; Pliny 37.54; Solinus 5.26; Damigeron 17; Isidore of Seville 16.11.1; Marbode 2; Hildegard von Bingen 4.16; Physiologus 23; Neckam 2.85.171ff, 6; Bodl., MS Digby 13.53; Arnoldus Saxo, *Liber de coloribus gemmarum* 4 (hereafter cited as Arnoldus Saxo); Bartholomaeus Anglicus 16.11; Thomas de Cantimpré 14.3; Albertus Magnus 2.1.4; Vincent de Beauvais 8.37–38; *Liber ordinis rerum* 139.13; Mandeville 1.3; *Hortus sanitatis* 5.2. A variety of chalcedony quartz. It was known to the Egyptians and the Sumerians, for its wonderful effects on sight are also described by Pliny, while the curative powers against scorpion bites are found in Damigeron. Graciousness and eloquence are attributes listed by Marbode.

65. The Latin reads *lapidarij*.

66. This origin story was reported in Theophrastus 31. Pliny must have been familiar with this source since he repeated it almost verbatim (37.54).

67. The Indian was certainly a moss agate.

68. The U.E.T. (64) reads instead "like a Filberd, with Gold veins or Drops."

162 NOTES TO PAGES 73-75

69. Agricola mentions Leonardi and this description of an agate in his *De re metallica* (6.627).

70. The U.E.T. (65) translated *mirti* as "myrrh," possibly misreading the *t* for a second *r*.

71. Dolce (29r) omitted this sentence.

72. The U.E.T. (65) omitted this sentence.

73. Dolce (29r) omitted this last sentence.

74. *Amathystu, amatistes, amaristes, amatiste, amesticus, amiscus*; in medieval Italian, *amatista*. Theophrastus 31; Pliny 27.40, 37.40; Epiphanius 9; Isidore of Seville 16.9.1; Marbode 16; Hildegard von Bingen 4.15; Neckam 6.217ff; Bodl., MS Digby 13.16, 13.53; Arnoldus Saxo 8; Bartholomaeus Anglicus 16.10, 16.19; Thomas de Cantimpré 14.2; Vincente de Beauvais 8.44; *Hortus sanitatis* 5.7; Mandeville 1.7. A variety of quartz, the gem was listed among those of biblical high priest Aaron's pectoral.

75. Dolce (29r) stated instead that they are more useful than the rest.

76. The stone's name derives from the Greek *amethustos* meaning "not drunken." The name may thus explain why it was believed to have the power to prevent drunkenness. However, it is likely that the stone's association with this virtue may find its origins in Egyptian astrology. The stone was associated with the zodiacal sign of the goat, an animal reputed to be the enemy of vines and vineyards; see Knuth, *Gems in Myth*, 42–45.

77. *Alectoriae, aelectorius, a(l)lectorius*; in medieval Italian, *electria petra de lo gallon*. Pliny 37.54; Solinus 1.77; Damigeron 19; Isidore of Seville 16.13.8; Marbode 3; Arnoldus Saxo 6; Bartholomaeus Anglicus 16.17; Thomas de Cantimpré 14.7; Neckam 2.89; Albertus Magnus 2.1.6; Vincent de Beauvais 8.43; Hermes 19; *Hortus sanitatis* 5.6. Mandeville 1.14. A mythical stone that was either a concretion, pebble, or crystal ingested by the rooster. The word derives from the Greek for cock/rooster.

78. Solinus 1.77. U.E.T. (67) omitted this sentence.

79. U.E.T. (67) misread the Latin and thus translated the word as "invisible."

80. The connection between quenching thirst (*sitim aufert*) and fighters (*luctantibus*) is not clear to me.

81. *Androdamans, androdamanta, andromanda, andromanta, andromantes, androdamma, androdragma, androdamantus, andromant, androdamanta, antrodiamanta, andravnias, auhetion, andro, amaradama, aramanda*. Pliny 36.38, 37.54; Marbode 48; Bartholomaeus Anglicus 16.15. *Androdamum* was thought to be as a type of hematite. It is possible that the name indicates either hematite, specular or talc, magnetite, or pyrite, though it may also be identified with a galena.

82. U.E.T. (68) omitted this sentence. Arabic texts referred to it as *elendhermon*.

83. *Astriotes, astrion, astrotes, astolos, asirites, astrites, alerites, asterytes, asteritus, asteria*. Pliny 37.47–49; Isidore of Seville 16.10.3, 16.13.7; Bodl., MS Digby 13.20, 13.48; Bartholomaeus Anglicus 16.16, 16.18; Vincent de Beauvais 8.46; *Hortus sanitatis* 5.11. Leonardi seems to be conflating *astrios* with *asterites* and thus grouping these stones together as if they were a variant on the same name. Pliny's description suggests they are different stones. An *asterias* was most certainly a star sapphire, which is what Leonardi describes, while the *astroites* was fossilized coral. The *astrion*, also known as *astrios*, was probably a moonstone (a feldspar endowed with adularescence).

84. Leonardi's text reads *quasi stella, & Ion imago*, which U.E.T (68) translated as "that is, a star, not an image." Dolce rendered the same phrase as "quasi stella, & son imagine." It is unclear how Ion's myth was attached to this particular stone.

85. *Alabandynia, alabandica, alabantina, alemandina, alamandina*. Pliny 36.13; Isidore of Seville 16.14.6; Marbode 21; Bodl., MS Digby 13.14; Arnoldus Saxo 5; Bartholomaeus Anglicus 16.14; Thomas de Cantimpré 14.9; Vincent de Beauvais 8.16 42; Albertus Magnus 2.1.5; *Hortus sanitatis* 5.3. This is natural manganese sulphate. Sometimes the term was used to refer to red garnets, suggesting it was thought of as a variety of the carbuncle.

86. Dolce (30r) translated *russus* as "gialaticcio."

87. U.E.T. (68) reads instead "Cardius."

NOTES TO PAGES 75–77 163

88. U.E.T. (69) omitted the latter part of the sentence.

89. It is quite likely this is a type of agate. Vincent de Beauvais 8.42.

90. Leonardi did not realize that *andromantes* was but a spelling variation of a stone he had just listed above (see the entry for *Androdamanta*).

91. *Anthracitis, antrachites, andrachithen, arachites*. Pliny 36.38; Isidore of Seville 16.14.2; Vincent de Beauvais 8.45; *Hortus sanitatis* 5.5. Leonardi seems to be describing a garnet, though it is possible that the name originally referred to a fossil stone that was also known by these names.

92. The U.E.T. (69) omitted the comparison to a carbuncle.

93. *Almandina, almandine, alabandine, alimendin, almechin, amandin, asmadus, esmundus.* Marbode 21; Arnoldus Saxo 7; Bartholomaeus Anglicus 16.14; Albertus Magnus 2.2.5, 7; *Hortus sanitatis* 5.4. *Almadine* or *almandite* is today used to indicate a red stone with a violet tint belonging to the garnet group.

94. *Asbestinon, abesios, absectos, abston, besteon, bestion, asbestos, asbostus, aspectus, aspecus, albestus, albeston, arbestos, abeston, abestione, abesto*. Pliny 19.4, 37.54; Marbode 33; Bartholomaeus Anglicus 16.12; Neckam 2.86; Albertus Magnus 2.1.1; Arnoldus Saxo 1; Thomas de Cantimpré 14.5. For a summary of the myths associated with this stone, see Alleman and Mossman, "Asbestos Revisited."

95. The U.E.T. (70) reads "Pagans."

96. On the myth of the fireproof salamander, see Slifkin, *Sacred Monsters*, 283–89.

97. *Assius*. Pliny 36.27; Dioscorides 5.124; Bodl., MS Digby 13.15; Avicenna, *Liber canonis* 2.2.30 (hereafter cited as Avicenna); Vincent de Beauvais 8.46; *Hortus sanitatis* 5.8.

98. U.E.T. (71) translated *rosaceo zucharo* as "Juice of Roses."

99. *Amiantos, amianthus, amiathon, amanthos, amiatus, amiliarius, amadites*. Pliny 36.31; Isidore of Seville 16.4.19; Dioscorides 5.138, 5.156; Thomas de Cantimpré 14.6; Vincente de Beauvais 8.27. A white variety of asbestos.

100. U.E.T. (71) omitted this last sentence.

101. It is possible that Leonardi might be adapting the German word *Agstein*, which could also be spelled *Augstein*. The term could variously designate amber, magnets, and jet.

102. Dolce identifies the emperor simply as Augustus.

103. *Alabaster, alabastrum, alabastron, alabausta, alabastrite, alabastrites, nycomar, nicomar*. Theophrastus 6; Pliny 36.12, 36.43, 37.18, 37.54; Dioscorides 5.135; Isidore of Seville 16.5.7; Hildegard von Bingen 4.24; Bodl., MS Digby 13.21; Bartholomaeus Anglicus 16.3; Vincent de Beauvais 8.16; Albertus Magnus 2.12.2; *Hortus sanitatis* 5.4. Leonardi is conflating the description for both alabastrite, a marbled onyx, and alabastrum. The latter indicated two stones: chalcedony and gypsum. Pliny uses the term to refer both to onyx marble as well as alabaster gypsum.

104. *Alabandra* or *alabandicus*. Pliny 36.13; Vincent de Beauvais 8.15.

105. *Aspisatis, aspisates, aspisatim, aspillatis, aspisalis*. Pliny 37.54. A mythical stone.

106. *Asbynthus, absectos, absictus, asyctos, asycto, apsycto, absuctos, absictos, absyctos, adsyctos, absictus, absintus, abaccintus, absiccos, absturt*. Pliny 37.54; Isidore of Seville 16.11.2; Marbode 52; Arnoldus Saxo 2; Bartholomaeus Anglicus 16.13; Albertus Magnus 2.1.3; Vincent de Beauvais 8.36; Thomas de Cantimpré 14.8; *Hortus sanitatis* 5.4.

107. No ancient source mentions this stone.

108. U.E.T. (73) misread the original and thus translated this as "the Maxillary cures Epilepsy, because it is found in the Jaw."

109. U.E.T. (73) omitted this sentence.

110. U.E.T. (73) omitted this sentence.

111. *Arabicus, arabus lapis*. Pliny 36.41 (describing what is most likely a chalcedony) and 37.54 (an onyx variety); Solinus 33.22; Isidore of Seville 16.4.11; Dioscorides 5.131, 5.149.

112. U.E.T. (74) reads instead "nervous Disorders."

113. U.E.T. (74) translated myrtle as myrrh instead.

114. Dolce (33) reads "serve al dolor de' denti" (it is useful for toothaches).

164 NOTES TO PAGES 77-78

115. See *Amianton* (above) and note 166 (below).

116. Dolce (33r) reads instead "restiste alla malie et incanti de Maghi" (it resists magicians' spells and enchantments).

117. *Antipathes, antipahites.* Pliny 37.54; Dioscorides 5.122. The term might be referring to either jet or an opaque black coral.

118. U.E.T. (74) again translated myrtle as myrrh.

119. U.E.T. (74) reads "witchcraft."

120. No ancient source for this stone could be located. Lecouteux suggests that this might be an ostracite/ostragite, which was variously described as resembling a seashell or an agate; Lecouteux, *Lapidary of Sacred Stones*, 50, 249. Leonardi's description of this stone, though, does not seem to fit that of ostracite/ostragite.

121. *Armenas, armenius.* Avicenna, fol. 550r; *Hortus sanitatis* 5.14. This stone might well be the azurite mentioned in Pliny 37.38.

122. This appears quite similar, as the name itself suggests, to the eagle stone. See the entry below for *Ethices*.

123. *Anancitis, anacitis, ananachitide, anatida, amantides, amathitis.* Pliny 37.15, 37.73; Isidore of Seville 16.15.22; Orpheus, "Lapidaire Orphique" 5.19-6; Damigeron 7; Vincent de Beauvais 8.32. Though Leonardi pays little notice to this stone, it was often mentioned in other lapidaries and identified as a diamond (Pliny) or a galactite in Orpheus, "Kérygmes Lapidaire d'Orphée" K2. See Lecouteux, *Lapidary of Sacred Stones*, 51.

124. Dolce (33r) reads instead "costringere" (to force).

125. *Argyrites, argirites.* Isidore of Seville 16.15.7; Bartholomaeus Anglicus 16.15.

126. See the entry below for *Crisocollus*.

127. *Aquilinus.* See the entry below for *Ethices*.

128. See the entry above for *Androdamanta*.

129. *Balagius, balascus, balandrus, palatius, halasius, halastus*; in medieval Italian, *balascio*. Arnoldus Saxo 10; Bartholomaeus Anglicus 16.26; Thomas de Cantimpré 14.13; Albertus Magnus 2.2.1; *Hortus sanitatis* 5.23, 5.96. Balas ruby was a misnomer for a red spinel; the label ruby is today reserved for the red corundum. In the Middle Ages, the stone traveled through the Badakhshan province in northeastern Afghanistan, which was on the route of caravans coming from Asia. The word *balas* might be a corruption of this locale.

130. Balas rubies could thus be thought of as female carbuncles.

131. Dolce (33v) omitted "house."

132. *Berillus, beryllos, berullos, berullios, barillus*; in medieval Italian, *beriella*. Pliny 37.20; Solinus 52.61; Isidore of Seville 16.7.5; Damigeron 35, 61; Marbode 12; *Kyranides* 1.2; Hildegard von Bingen 4.4; Neckam 2.90, 6.185ff; Bodl., MS Digby 13.13; Arnoldus Saxo 11; Bartholomaeus Anglicus 16.21; Albertus Magnus 2.2.3; Vincent de Beauvais 8.47-48; Thomas de Cantimpré 14.11; *Picatrix* 2.10.3; Mandeville 1.19; *Hortus sanitatis* 5.23; Ragiel 6; Solomon 18. The stone was listed as one of the twelve in Aaron's pectoral. It could also be a symbol of Thomas the Apostle; see Knuth, *Gems in Myth*, 49. This mineral includes a variety of gemstones, including emeralds and aquamarines. Colorless beryl is known as goshenite. Seawater-colored beryls are today identified as aquamarines. Morganite, a pink or pale yellow-orange beryl was named for J. P. Morgan, who collected precious gems. The term aquamarine was not used until 1609 by Anselmus de Boodt in his *Gemmarum et lapidum historia*. Cf. Knuth, *Gems in Myth*, 47; and Sinkankas, *Emerald and Other Beryls*, 614.

133. U.E.T. (76) translated *glauco* as "Sky Colour."

134. As also mentioned by both Pliny and Damigeron.

135. U.E.T. (77) reads instead "Incommodities to which they are liable."

136. *Nose*, from the Greek *botrax* or toad. Neckam 6.199ff (described but not named); Avicenna 2.2.706; Thomas Cantimpré 14.12; Vincent de Beauvais 8.49; Albertus Magnus 2.2.2; *Hortus sanitatis* 5.27. A mythical stone that was sometimes also referred to as chelonites or celonites.

NOTES TO PAGES 79–80 165

137. Dolce (34v) misread *nonnulli dicunt si gestetur* as *Alcuni lo chiamano Sigesteto* (some call it Sigesteto).

138. *Besuar, besar, beza, bezahar, bezaar, lapis expellens venenum.* Picatrix 2.10.78; *Hortus sanitatis* 6.24. The name is probably derived from the Persian *pâd-zâhr* or *bâd-zâhr*, meaning counterpoison; see Knuth, *Gems in Myth*, 238; and Lecouteux, *Lapidary of Sacred Stones*, 76. Given the high esteem in which this stone was held, it is not surprising that in 1625 the Swiss botanist Caspar Bauhin wrote a treatise on the special powers of the bezoar, *De lapidis Bezoari.* Most lapidaries mention that such a stone may be recovered from the innards of other animals such as deer, goats, pigs, or monkeys from Persia, thus making the bezoar not a stone but a simple calcification of matter found in animals' elementary organs, as in the bezoar goats from which it takes its name. By the early sixteenth century, Jesuits began to produce artificial bezoars in Goa, today known as Goa stones. These, too, were prized, especially because they originated in the East Indies. See Knuth, *Gems in Myth*, 238; Borschberg, "Euro-Asian Trade"; Stephenson, "From Marvelous Antidote"; Samerio Barroso, "Bezoar Stones"; and Fricke, "Making Marvels."

139. Dolce (34v) omitted this sentence.

140. Dolce (34v) omitted this sentence.

141. *Bolus armenicus, ramai, ramuy, rabri.* Albertus Magnus 2.16.2; Bartholomaeus Anglicus 16.85; *Hortus sanitatis* 5.26.

142. It is a clay rich in iron oxide.

143. *Emotoicis* or *empthoic* was a label used to identify patients who spit up blood. Given that such a symptom could be due to a number of illnesses, it is not clear to me whether physicians reserved it for a very specific illness.

144. A term used for those who suffered from melancholia.

145. This last sentence is missing in Dolce (34v).

146. *Belioculus, beli oculus, beloculus, belliculi, belleoculo*; in medieval Italian, *belocchio, occhio del gatto.* Pliny 37.15; Isidore of Seville 16.9.9; Bodl., MS Digby 13.12; *Hortus sanitatis* 5.25. Most likely an agate.

147. It was, in fact, often referred to as the eye of Belus.

148. U.E.T. (79) misread *invinctu* as "invisible."

149. *Basanitis.* Pliny 36.11; Isidore of Seville 16.4.36. A volcanic rock that corresponds to our modern basalt.

150. *Brontia, brontea, brontes.* Pliny 37.55; Isidore of Seville 16.15.24; Vincent de Beauvais 8.32.

151. U.E.T. (79) translated *testudinis* as "Head of a Shell."

152. *Balanytes, balanita.* Pliny 37.55 (he seems to be referring to a fossil, possibly pentremite); Isidore of Seville 16.15.10; Vincent de Beauvais 8.47.

153. *Carbunculum, carbun.* Pliny 37.25; Solinus 28.1; Isidore of Seville 16.14.1; Marbode 23; Hildegard von Bingen 4.14; *Kyranides* 2.10; Neckam 6.242ff; Bodl., MS Digby 13.17, 13.47; Arnoldus Saxo 13; Bartholomaeus Anglicus 16.26; Thomas de Cantimpré 14.13; Vincent de Beauvais 8.51–52; Albertus Magnus 2.3.1; *Hortus sanitatis* 5.29. Today's term for such a red gem is garnet. The label indicates a group of minerals with identical atomic structures but differing chemical structures. Pliny used the term *carbunculus* (little spark) to refer to all red gems, thus rubies, red spinels, and garnet were included in the carbuncle species. The Latin *carbunculus* translated the Greek *anthrax* (red hot coal). Thus the word could be used to refer to stones that were red and glowed red in the dark. Synonyms of carbuncles are also anthrax, rubinus, balasius, and granat. Wine-colored varieties of garnets were frequently referred to by the name of almandine or almandite. Leonardi used *alabandina.*

154. Dolce (35r) reads instead "Africa."

155. Rubies' flashing inner light and value is noted in Cellini's tale of a certain Jacopo Cola who found a carbuncle among his vines thanks to the light it emanated at night; see *Due trattati*, fol. 10.

166 NOTES TO PAGES 80–82

156. These were most certainly almandine/almandite garnets.

157. *Chalcedonius, chalconeus, calcedonius, calcydonius, carchedonia, carchedonius, calididi, carsydonius.* Chalcedony could also be known as *murrha, cerachates, leucachates, arabica, exhuebneus, eumeces, prassius, aerizusa,* or *boria.* Theophrastus 25; Pliny 37.30; Solinus 15.23; Dioscorides 5.99; Damigeron 27, 33; Marbode 6; Hildegard von Bingen 4.12; Neckam 6.145ff; Bodl., MS Digby 13.8, 13.26; Arnoldus Saxo 12; Bartholomaeus Anglicus 16.28; Thomas de Cantimpré 14.14; Albertus Magnus 2.3.2; Vincent de Beauvais 8.50; Mandeville 1.15; *Hortus sanitatis* 5.28. While chalcedony is a cryptocrystalline variety of quartz that includes a great variety of stones from agate and moonstones to carnelian and sardonyx, in antiquity as in the sixteenth century, the term chalcedony was usually used to identify a pale white or blue-gray translucent stone; see Knuth, *Gems in Myth,* 63.

158. Leonardi is referring to Pesaro. Dolce (35v) naturally omitted the reference to the city, as he dedicated the text to a different patron.

159. *Celidonius, celidonia, celydonius, gorgia.* Pliny 37.56; Isidore of Seville 16.9.6; Dioscorides 2.56; Damigeron 10.52; Marbode 17; *Kyranides* 3.39; Avicenna 2.2.490; Neckam 2.87, 6.219; Bodl., MS Digby 13.11; Arnoldus Saxo 16; Bartholomaeus Anglicus 16.30; Thomas de Cantimpré 14.17; Vincent de Beauvais 8.53; Albertus Magnus 2.3.5; Mandeville 1.21; *Hortus sanitatis* 5.33. Also known as the swallow stone, from the Greek word for the swallow bird, it was a mythical stone, though certain agates could be identified as such.

160. U.E.T. (82) rendered *cervi non nati* as "flung Hart."

161. *Corallus, corallius, curallis, curallium, corallium.* Pliny 32.11; 37.56; Solinus 2.43; Isidore of Seville 16.8.1; Orpheus, "Lapidaire Orphique" 5.510–609; Dioscorides 5.121; Damigeron 7; Marbode 20; Avicenna 2.2.124; Neckam 6.237ff; Bodl., MS Digby 13.10; Arnoldus Saxo 19; Bartholomaeus Anglicus 16.33; Thomas de Cantimpré 14.15; Vincent of Beauvais 8.56–57; Albertus Magnus 2.3.8; *Picatrix* 2.10.62; Mandeville 1.25; *Hortus sanitatis* 5.43. Pliny referred to it as *gorgonios.* Corals are not minerals but hardened calcium carbonate material excreted by small sea creatures known as coral polyps. Since the ancient Greeks associated it with the spilled blood of the Gorgon, it is not surprising it would be considered a powerful apotropaic against both illness and evil magic.

162. This sentence is missing in Dolce (36v). Leonardi is probably referencing Methrodorus of Scepsis (ca. 145–70 BCE); see Perea Yébenes, "Magic at Sea," 481n100.

163. Dolce (36v) omitted "and have often experienced it myself."

164. The practice was already mentioned in Pliny (32.11).

165. *Corneolus, cornelionus, corneol, cornelius, cornelio*; from the Latin *cornum,* or cornel berry, the word was used to refer to either a carnealin or a chalcedony. Marbode 22; Bartholomaeus Anglicus 16.34. While medieval writers spelled it *corneolus* (and its already listed derivatives), in the fifteenth century this became *carneolus,* in the mistaken belief that the Latin root of the word was *carnem* and not *cornum.*

166. Dolce (36v) omitted the reference to it being worn on the finger.

167. *Crystallus, chrystallus, cristallus*; from the Greek *krystallos* (clear ice). Pliny 36.1–2, 37.9–10; Solinus 15.29–31; Isidore of Seville 16.13.1; Orpheus, "Lapidaire Orphique" 5.171–90; Marbode 41; Hildegard von Bingen 4.20; Neckam 2.15, 6.309ff; Arnoldus Saxo 23; Bartholomaeus Anglicus 16.31; Thomas de Cantimpré 14.19; Vincent de Beauvais 8.63; *Picatrix* 2.10.44; Albertus Magnus 2.3.12; *Hortus sanitatis* 5.39. This quartz was thought to be petrified ice; Knuth, *Gems in Myth,* 173.

168. Dolce (37r) omitted this sentence.

169. *Chrysoprasus, chrysoprasius, chrysoprasssus, chrysoptasius, crisoprassis, crisopis, crisoffras.* Pliny 37.20, 37.32, 37.34; Solinus 52.62; Isidore of Seville 16.7.7; Hildegard von Bingen 4.13; Neckam 6.205ff, 321ff; Bodl., MS Digby 13.24; Marbode 15; Bartholomaeus Anglicus 16.27; Vincent of Beauvais 8.61; Albertus Magnus 2.3.10, 2.3.14; *Hortus sanitatis* 5.37. It is a variety of chalcedony that corresponds to the contemporary apple-green chrysoprase from the Greek word for leek green or golden. Originally brought to Europe during the Crusades, the stones

NOTES TO PAGES 82–83 167

were often confused with emeralds. Chrysoprasus was associated with Saint Thaddeus and is mentioned in the Bible by the John the Apostle; see Knuth, *Gems in Myth*, 68.

170. *Chrysolitus, chrysolitheos, crisolitus, chrisolicotus, crisolimus, crisolensis, chrysolie, cosolitus, crisorius, petra asini*; in medieval Italian, *crisolita*. Pliny 37.42; Isidore of Seville 16.15.2; Damigeron 47–48; Marbode 11; Neckam 6.179ff; Arnoldus Saxo 22; Bartholomaeus Anglicus 16.29; Thomas de Cantimpré 14.20, 14.23; Vincent de Beauvais 8.60; Albertus Magnus 2.3.11; Mandeville 1.18; Ragiel 48; Chael 6; Thetel 4; *Hortus sanitatis* 5.38. The name chrysolitus is today used only by few gemologists to indicate a light yellow or greenish-yellow peridot. Leonardi's descriptions suggests instead topaz, particularly in regard to the Indian variety. The name could also be used to refer to jacinths. It was one of the stones listed in Aaron's pectoral.

171. U.E.T. (86) reads "night-hags."

172. Dolce (37v) reads "cattive femine" (evil women); U.E.T. (86) reads instead "those detestable Creatures call'd Witches."

173. Dolce (37v) reads "caccia la sete" (chases away thirst).

174. Arnoldus Saxon, Bartholomaeus Anglicus, Thomas de Cantimpré, and Albertus Magnus all duplicated the entry for this particular stone. Marbode instead calls it criselectrus. It is quite likely that the confusion between chryselectrum/crilectus and chrysolitus may be traced back to Pliny, who used chryselectrum to indicate amber and crylsectroe to indicate a stone of a golden amber hue (perhaps citrine). Cf. Pliny 37.12, 37.43.

175. Dolce (38r) reads "quegli, che sono offesi dall'arme" (those that have been wounded by weapons).

176. *Celonite, cenolite, celiconites, celidanius, ceronites, celontes, chelonian, chelonites, cephalicus*. Pliny 37.56; Isidore of Seville 16.15.23; Damigeron 11, 57; Marbode 39; Neckam 2.87, 6.305ff; Arnoldus Saxo 17; Vincent de Beauvais 8.32, 8.54; Albertus Magnus 2.3.6; *Hortus sanitatis* 5.34. The word derives from the Greek *chelone*—that is, resembling a tortoise—though by the sixteenth century Leonardi was conflating it with chelonititdes, a stone believed to be found in the heads of tortoises. Pliny's and Damigeron's description suggest the fossil echinites.

177. Sometimes a toad, in which case this mythical stone is called toadstone; see the entries for *Borax* and *Crapondinus*.

178. Leonardi's *ad sextam horam quottidie* is rendered as "alla decima hora" (at the tenth hour) by Dolce (38r) and "Six o'Clock" by U.E.T. (87). The sixth hour roughly corresponded to 12:00 p.m.

179. U.E.T. (88) reads "Masters of their Destinies."

180. *Chogolitus, cogholitus, cogolithos; gecolitus, iudaica, indyarus, lapis agapis, lapis marinus, lapis liberans a glarea*. It might actually be the spine of a fossilized sea urchin.

181. Dolce (38r) omitted the word altogether. From the Greek *strangouria* (a drop of urine squeezed out), it refers to a condition of the bladder accompanied by urgency and pain and caused by a blockage between the bladder and the urethra.

182. *Ceraunius, ceraunia, ceranitis, ceraumus, ceravinus, ceraolus, betannus, teranus*. Pliny 37.48, 37.51; Solinus 20.15; Isidore of Seville 16.13.5; Damigeron 12; Marbode 28; Neckam 6.239; Bartholomaeus Anglicus 16.32; Thomas de Cantimpré 14.21; Vincent de Beauvais 8.55; Albertus Magnus 2.3.4; *Hortus sanitatis* 5.32; Ragiel 17. Originally from the Greek word for thunderbolt, the term referred to a number of objects, fossils, prehistoric axes, and meteorites.

183. Sotacus. Dolce (38v) read it as Locatus. Pliny mentions Sotacus a number of times as an important source in the description of various stones in books 36 and 37. Modern authors have suggested that Sotacus might have been a Persian physician or at least a physician at the Persian court; see Bartlett Bridgman, *Gems*, 7.

184. Damigeron 12.

185. Dolce (38v) stated simply "o da altro accidente" (or any other accident).

186. U.E.T. (89) omitted this sentence.

187. *Corvia, corvina lapis*. A mythical stone sometimes also known as a cabot stone.

188. U.E.T. (89) reads "cabot fish."

168 NOTES TO PAGES 83–85

189. *Cinediae, cinedios, cynaedia, cinaedia, cimidia, kinedius, cinedius, cinedies.* Pliny 37.56; Bodl., MS Digby 13.146; Vincent de Beauvais 8.54; *Kyranides* 1.10; *Hortus sanitatis* 5.34. A mythical stone.

190. Dolce (39r) added "nuntiar . . . e cosi' le fortune" (of foretelling fortune).

191. *Calchophonos, chalcophthongos, calcopahanes, calthosanus, calthosamus, chatophonus, calthofanus, calleoponos, galcophon, chalcofungos, calofanos, chelconphongos, calofagus.* Pliny 37.56; Solinus 37.22; Isidore of Seville 16.15.9; Marbode 53; Arnoldus Saxo 14; Bartholomaeus Anglicus 16.59; Thomas de Cantimpré 14.18; Vincent of Beauvais 8.50; Albertus Magnus 2.3.3; *Hortus sanitatis* 5.28, 5.32. It is very likely a basalt or a variety thereof.

192. *Callaica, gallaica, callais.* Pliny 37.56; *Hortus sanitatis* 5.28.

193. Dolce (39r) omitted this second part of the sentence.

194. Media roughly corresponds to the modern regions of Azerbaijan, Kurdistan, and parts of Kermanshah in northwestern Iran.

195. *Chrysocolla, crisogollo.* Pliny 33.26, 37.54; Isidore of Seville 16.15.7; Dioscorides 5.89; Vincent de Beauvais 7.103–4; *Hortus sanitatis* 5.36. It is a large, amorphous copper mineral. Pliny uses the term to refer to malachite. In antiquity the term was usually used to refer to any bright green copper mineral.

196. *Chrysoprasus, chrysoprassus, chrysoptasius, crisoprassis, crisopis, crisoffras, crisoptatio.* Pliny 37.20, 37.34; Solinus 52.62; Isidore of Seville 16.7.7; Hildegard von Bingen 4.13; Neckam 6.205ff, 6.321ff; Bodl., MS Digby 13.24; Bartholomaeus Anglicus 16.27; Vincent de Beauvais 8.61; Albertus Magnus 2.3.10, 2.3.14; *Hortus sanitatis* 5.37. It corresponds to chrysoprase, a variety of calchedony.

197. *Crisonterinus.*

198. *Cysteliothos, cisteolite, chiastolite.* A crystal whose name derives from the Greek letter *x*. When the crystal is sliced through, it shows a distinctive, cross-like marking. It is an opaque variety of andalusite.

199. *Cathochiten, cathotices, catochites, cactonite.* Pliny 37.56; Solinus 3.4–5; Vincent de Beauvais 8.27. It most likely is bitumen.

200. Dolce (39v) omitted this whole sentence.

201. *Corvina lapis.* See also the entry above for *Corvina*, a mythical stone.

202. *Capnitis, cambnite, cambites, cadmitis.* Pliny 37.56; Dioscorides 5.142; Damigeron 23.46; Bodl., MS Digby 13.47. Most likely a smoky jasper.

203. Dolce (40r) omitted this sentence.

204. *Cepolatitis, cepolames, cepotatites, cepothatites, cepites.* Pliny 37.56. Possibly white agate.

205. *Calorite* could be Pliny's *chloritos*, which he states could be found in the belly of the wagtail, suggesting that it was a concretion of sorts (37.56). Agricola listed it as a magi's stone (6.628).

206. I am not sure what type of bird Leonardi is referring to when he writes "Sille avis."

207. *Ceponides.* Pliny 37.56.

208. U.E.T. (92) reads "diamond."

209. Corinthian marble.

210. *Cyanea, cyanus.* Pliny 37.38; Dioscorides 5.91; Isidore of Seville 16.9.7. It might be azurite or lazulite.

211. *Cariteus, Carysteus. Hortus sanitatis* 5.31.

212. See the entries above for *Crisoprassus* and *Crisoprasius.*

213. *Choaspites, choaspitis.* Pliny 37.56; Isidore of Seville 16.7.16. Possibly a partially oxidized copper ore.

214. See the entry above for *Crisolitus.* Crisolansis may also be a spelling variant of chrysolampsis, though the description is wholly different.

215. *Chrysitis.* Pliny 37.66; Isidore of Seville 16.4.28; Dioscorides 5.62; *Kyranides* 1.23. Pliny uses *phlogitis/phloginos* as a synonym for this stone.

216. *Cadmitis, cadmia.* Pliny 37.56; Dioscorides 5.84. The original Latin is mistakenly missing the initial C. U.E.T. (94) omitted this entry.

NOTES TO PAGES 85–87 169

217. The original Latin is mistakenly missing the initial *C*. U.E.T. (94) omitted this entry. *Sirites* was a name for sapphire, thus it is possible that *celonia* is being in used in this manner, though it is also possible that Leonardi is using the word *celonia* incorrectly, for *celonia* is also an alternative spelling for *chelonian* and *chelonitis*, though neither looks like sapphire.

218. An alternative name for sapphire.

219. *Chrysoberulli, chrysoberillus*. Theophrastus 26; Pliny 37.20; Isidore of Seville 16.7.6. Today it is classified separately from beryls, which it surpasses in both rarity and value.

220. Isidore of Seville 16.4.31.

221. *Chrysopis, chrysoph, chrysopastus*. Pliny 37.56; Isidore of Seville 16.15.1; *Kyranides* 4.66; Bodl., MS Digby 13.24. It might be iron pyrite.

222. *Chalcites, chalcitis*. Pliny 37.73; Dioscorides 5.115; Isidore of Seville 16.15.9. U.E.T. (94) omitted this entry.

223. *Carcinias*. Pliny 37.72; Isidore of Seville 16.15.18.

224. The original Latin is mistakenly missing the initial *C*. See the entry above for *Borax*.

225. See the entry above for *Beloculus*.

226. *Chrysopteros*. Pliny 37.32.

227. *Deimonis, diamon, demonius*. Arnoldus Saxo 26; Albertus Magnus 2.4.1; Vincent de Beauvais 8.63; *Hortus sanitatis* 5.48. Possibly a mythical stone, unless it is meant to be the same as iris.

228. Albertus Magnus calls the rainbow the daimon's bow in *Meteora* 3.4.6 and 3.4.26.

229. *Dionysias, Dionysia*. Pliny 37.57; Solinus 37.18; Isidore of Seville 16.4.7; Marbode 58; Bodl., MS Digby 13.31; Arnoldus Saxo 28; Bartholomaeus Anglicus 16.35; Thomas de Cantimpré 14.25; Vincent de Beauvais 8.64; Albertus Magnus 2.4.3. It may be the same as medius, which Pliny described as tasting like wine (37.63).

230. *Diadochus, diadochuus, diadochos, dyadochen, diacodos, diacoda, diacodus, dyadotos, dyadotus*. Pliny 37.57; Damigeron 5; Marbode 57; Arnoldus Saxo 27; Bartholomaeus Anglicus 16.36; Thomas de Cantimpré 14.26; Vincent de Beauvais 8.64; Albertus Magnus 2.4.2; *Hortus sanitatis* 5.49. Quite possibly a beryl, or a mythical stone resembling a beryl.

231. *Dracontia, draconitis, dracontitis, dracontites, dracontias, drachonitis, dracontides, drachontos*. Pliny 37.57; Solinus 30.16; Isidore of Seville 16.14.7; Thomas de Cantimpré 14.24; Vincent de Beauvais 8.63; Albertus Magnus 2.4.4; *Hortus sanitatis* 5.47. Pliny describes it as a white stone. Hobart Ball thinks it might be a garnet; cf. *Roman Book on Precious Stones*, 179. Yet since the word *draco* was used to refer to a large snake, this might actually be an ammonite fossil.

232. *Drosolithus, drosolithos, drusolithos, droselitus, droseritus, proselitus, chrysolithus*. Pliny 37.73; Isidore of Seville 16.12.2; Vincent de Beauvais 8.63; *Hortus sanitatis* 5.48.

233. Since Leonardi stated that this mythical stone could also be found in the head of a rooster, this might be the same as the alectory stone; possibly also the same as donatides or radaim, as he suggests.

234. U.E.T. (96) translated *murilage* as "cat," while Lecouteux suggest that it might be a murex; see *Lapidary of Sacred Stones*, 131.

235. *Eliotropia, electropia, elitropie, elytropius, elitropus, elecoprius, elentropio, elotropia, eliotrapia, eitropia, alotropie, aldropi, latroe, alocripq; heliotropia, heliotropius, heliotropio*; in medieval Italian, *girasole*. Pliny 37.60; Solinus 27.36; Dioscorides 4.190; Marbode 29; Isidore of Seville 16.7.12; Damigeron 2; Arnoldus Saxo 30; Thomas de Cantimpré 14.29; Bartholomaeus Anglicus 16.41; *Hortus sanitatis* 5.54. This chalcedony was also known as bloodstone because of its red spots. Today the spotted green chalcedony is, in fact, known by the name of bloodstone. Jaspers at this time were also considered bloodstones; see the entry below for *Iaspis* regarding Christian lore on bloodstones.

236. Pliny mentions that it was used to observe solar eclipses (37.60). Damigeron emphasized its more magical properties, giving rise to the notion that it darkened the sun when placed in water (19).

237. Dolce (42r) omitted the reference to Solinus and refers to Libya as Africa.

170 NOTES TO PAGES 87–88

238. Dolce (42r) added the following sentence: "E di quì prese il Boccaccio la occasion della novella di Calandrino, che andava cercando questa pietra per lo Mergnone" (It is around this stone that Boccaccio wrote the novel *Calandrino*, who went searching for this stone [on the shores of] the Mugnone River).

239. A virtue that supposedly Vasari himself described when he praised Signorelli for having saved his life as a child by applying a bloodstone to his shoulder blades when he was seized by a fainting spell and nose hemorrhage. The story was first reported at the turn of the twentieth century by Péladan in "Le précurseur de Michel-Ange, Luca Signorelli" (88), and then repeated by Bellucci in *Il feticismo primitivo in Italia* (91). It was subsequently reported by Fobes in *Mystic Gems* (33–34) and Knuth in *Gems in Myth* (54), through whom it entered the realm of "common knowledge." Péladan gave no reference for his citation and Vasari does not mention it in the life of Signorelli, nor in his own short autobiography included at the end of the *Lives*.

240. *Emathisten, emathitis, emathittes, ematites, aemathites, hematites, haematitis, aematitis, ematites, emathites, emathytes*; from the Greek *haima* (blood or bloodlike). Pliny 36.37–38, 37.60; Solinus 30.34; Galen 2.5.15; Isidore of Seville 16.8.5, 16.4.16; Orpheus, "Lapidaire Orphique" 5.642–90; Damigeron 9; Dioscorides 5.126; Avicenna 2.2.241, 2.2.665; Marbode 32; Neckam 6.293ff; Bodl., MS Digby 13.33; Arnoldus Saxo 31; Thomas de Cantimpré 14.27; Bartholomaeus Anglicus 16.40; Vincent de Beauvais 8.68; Albertus Magnus 2.5.3; *Picatrix* 2.10.4, 2.10.54, 3.3.28; *Hortus sanitatis* 5.51. It is an iron oxide commonly found with iron ores. The description fits both hematite, a red oxide of iron, as well as a blood-red jasper.

241. Dolce (42v) reads "giallaticcia."

242. U.E.T. (98) omitted this sentence.

243. Dolce (42v) omitted the reference to Socatus. Leonardi is quoting from Pliny who mentions a now-forgotten author by the name of Socatus.

244. Galen 2.5.5, 2.5.15.

245. U.E.T. (98) reads instead "juice of a red apple."

246. The mixture of hematite powder in egg white was already used as a healing concoction in Egyptian medical texts; see Knuth, *Gems in Myth*, 120.

247. Dolce (42v) reads "scorpioni" (scorpions).

248. Dolce (42v) omitted this sentence.

249. *Aethitae, aetites, aetitis, etthites, etytes, ethitus, echites, echidne, ecithnes, echinides, actites, anchites, endes, lapis aquilaris/aquilinus/aquile*. Pliny 10.4, 36.39, 37.62; Solinus 37.5; Isidore of Seville 16.4.22; Damigeron 1; Dioscorides 5.160; *Kyranides* 1.1; 3.1; Bodl., MS Digby 13.45, 13.51; Marbode 25; Arnoldus Saxo 29; Bartholomaeus Anglicus 16.39; Thomas de Cantimpré 14.18; Albertus Magnus 2.5.1; Vincent de Beauvais 8.23; *Picatrix* 4.8.7; *Hortus sanitatis* 5.10. A concretion or hollow geode containing some type of geological material, this stone took its name from the Greek word for eaglestone; see Harris, "Loadstones."

250. *Enhydoros, enhygros, enidros, enydros, enidrus, elidros, elider, elidron, etindros, etnydors, erudros, exidro*. Pliny 37.73; Solinus 37.24; Isidore of Seville 16.13.9; Marbode 46; Neckam 6.299ff; Arnoldus Saxo 32; Bartholomaeus Anglicus 16.42; Thomas de Cantimpré 14.30; Albertus Magnus 2.5.5; *Hortus sanitatis* 5.53. Today the label refers to translucent chalcedony incorporating some water within.

251. *Epistites, epitusdes, epistrites, epistutuen, epischuten, epyscutes*. Marbode 31; Neckam 6.289ff; Bodl., MS Digby 13.6, 13.44; Marbode 31; Arnoldus Saxo 33; Bartholomaeus Anglicus 16.43; Vincent de Beauvais 8.70; Albertus Magnus 2.5.4; *Hortus sanitatis* 5.55. Possibly a garnet or pyrite.

252. *Hexecontalithos, hexaxontalithos, exacontalitus, exocontalitus, exacolit, exolicetus, hexeconta*. Pliny 37.60; Isidore of Seville 16.12.5; Marbode 38; Arnoldus Saxo 34–35; Bartholomaeus Anglicus 16.44; Albertus Magnus 2.5.6–7; *Hortus sanitatis* 5.50, 5.52. Probably an iris or an opal.

253. Iliac passion, also known as volvulus, is a painful occlusion of the bowels with retention of feces.

254. Appears to correspond to Pliny's *hormesion, hormiscion, hormision, ermistion*. Pliny 37.60; Isidore of Seville 16.14.11; Damigeron 14; *Hortus sanitatis* 5.50.

255. See the entry below for *Exacolitus*.

256. Dolce (42v) used the more generic "Africa."

257. *Exhebenus, exebenius, exebenus, ebenus*. Pliny 37.58; Isidore of Seville 16.9.11; Damigeron 8; Bodl., MS Digby 13.32; *Hortus sanitatis* 5.53. Might be some type of white clay mineral.

258. *Eumithres, eumerges, eumetres, emites*. Pliny 37.58.

259. While Leonardi is using an alternative spelling of *Eumetis*, listed above, he is describing a variety of marble.

260. *Aegyptilla, egippula, egypcilla*. Pliny 37.54; Isidore of Seville 16.11.3; *Hortus sanitatis* 5.53. A banded agate.

261. Leonardi's original reads "poracei coloris"; a 1664 Latin-to-English dictionary translates the term as green as a leak; see Gouldman, *Copious Dictionary in Three Parts*.

262. Leonardi's original reads "superstitiosa gemma."

263. *Hepahestitis, haephaestites, hefaeititis, hephesthitis, hepistitis, hephestionis, ephestits, epibretes, epilestitis, terristes, lapis vulcani*. Pliny 37.60; Isidore of Seville 16.15.15; Damigeron 15; Marbode 31; *Kyranides* 1.7; Bodl., MS Digby 13.44; *Hortus sanitatis* 5.53, 5.55. Probably pyrite or rock crystal.

264. *Elopsides, elopsitis*. No description is given in other sources, so perhaps it should be classified as a mythical stone.

265. An alternative name for the eaglestone Leonardi had described under ethices; see the entry above for *Ethices*.

266. Another name for jet or gagates; see the entry below for *Gagates*.

267. Another name for the eaglestone Leonardi had described in the entry above for *Ethices*.

268. *Echites, echyten, echitis*. Pliny 37.72; Solinus 37.17; Isidore of Seville 16.15.18; Orpheus, "Lapidaire Orphique" 5.346–56; and Orpheus, "Kérygmes Lapidaire d'Orphée" K15; Marbode 25.

269. *Filacterium*. Damigeron 17; Marbode 11; Albertus Magnus 2.6.2. As the name itself suggests, it was reputed to be ideal for the making of amulets, and Leonardi's comments suggest that he was familiar not only with Albertus Magnus (2.6.2) but also with Damigeron and Marbode, in which chrysolite is said to be a phylactery.

270. *Phengites, phingites*. Pliny 36.46; Isidore of Seville 16.4.23; *Hortus sanitatis* 5.104. Possibly a mythical stone.

271. Probably referring to the notion that Nero had the temple of Fortuna Seia built of this marble on the grounds of the Domus Aurea.

272. Leonardi might be using an alternative spelling of the more commonly used *phengite*.

273. *Falconos, falcanos, arsenicum, auripigmentum*. Arnoldus Saxo 36; Bartholomaeus Anglicus 16.6; Albertus Magnus 2.6.1; *Hortus sanitatis* 5.56. An arsenic mineral or a compound of yellow orpiment with red realgar.

274. *Phrygius*. Pliny 36.36; Isidore of Seville 16.4.9; Pseudo-Dioscorides 2.141; Vincent de Beauvais 8.25; Bodl., MS Digby 13.34; *Hortus sanitatis* 5.104.

275. Dolce (45r) reads "giallaticcia" (yellowish).

276. A tree similar to a cypress.

277. *Granat, granatus*. Avicenna 2.2.230; Marbode 14; Bartholomaeus Anglicus 16.54; Thomas de Cantimpré 14.31; Albertus Magnus 2.7.7; *Picatrix* 2.10.5, 3.3.31; Mandeville 1.8; *Hortus sanitatis* 5.60; Ragiel 3; Solomon 9. A garnet is one of the six varieties of mineral gemstones.

278. *Galactitis, galactides, galactydes, galactida, galactiles, galaritides, galaricides, galatrides, gallants, galaxias, galaxia, elebron, orachites, senochiten, graffites galbates, anachites, lacteus lapis, leucographitis*. Pliny 37.59; Solinus 7.4; Isidore of Seville 16.4.20, 16.10.4; Orpheus, "Lapidaire Orphique" 5.191–229; Orpheus, "Kérygmes Lapidaire d'Orphée" K2; Dioscorides 5.132, 5.134; Damigeron 34; Marbode 42; Avicenna 2.2.407; Neckam 2.95, 5.315ff; Arnoldus Saxo 41; Bartholomaeus Anglicus 16.50; Thomas de Cantimpré 14.35; Vincent de Beauvais 8.5, 8.73;

172 NOTES TO PAGES 90–92

Albertus Magnus 2.7.4; *Hortus sanitatis* 5.59. Either a mythical stone, a quartz, a chalk, or a limestone white in color, as *gala*—Greek for milk—is clearly meant to indicate the stone's color.

279. U.E.T. (105) reads instead "it facilitates the birth of a pregnant Ewe."

280. Dolce (45r) relates *immundo* not to the sheep, but to the salt, so it reads "con sale immondo."

281. U.E.T. (106) reads instead "it takes away its stinking smell."

282. *Gagatromeus, gagatromeo, gagatornica, gagatronica, gagacromeon, gargatramea, gegatroyneus, gachathrameo, galgatromeus, gegatron, geratrom, gelatromeus, bagates, agatromeus, agastus.* Damigeron 41; Marbode 27; Bodl., MS Digby 13.37; Arnoldus Saxo 39; Thomas de Cantimpré 14.36; Albertus Magnus 2.7.2; *Hortus sanitatis* 5.61. It is a mythical stone.

283. Dolce (45r) reads "Giallaticcia" (yellowish) perhaps because he conflated *russus* and *crocei*.

284. *Galactica, gelatia, gelacia, galacia, gelasia, gelosia, galatides.* Pliny 37.73; Marbode 37; Bartholomaeus Anglicus 16.51; *Hortus sanitatis* 5.61. From the Greek *chalazias* (hailstone). Pliny's *galactitis* (59.162) is not what Leonardi is describing.

285. *Gerachites, gerachitem, geraticen, yerachites, gerachirea.* Damigeron 38; Pliny 37.60; Marbode 30; Bartholomaeus Anglicus 16.52; Albertus Magnus 2.7.6; *Hortus sanitatis* 5.60. Possibly a misnomer for *hieracitis*, which could be recognized by the same test.

286. *Gargates, agastus, galerites, tabrites.* Pliny 36.34; Solinus 22.11–12; Isidore of Seville 16.4.3; Damigeron 20; Marbode 18; Orpheus, "Lapidaire Orphique" 5.474–93; Orpheus, "Kérygmes Lapidaire d'Orphée" K17; Dioscorides 5.128; Avicenna 2.2.324, 2.2.417; Bodl., MS Digby 13.5; Arnoldus Saxo 38; Neckam 2.97; Bartholomaeus Anglicus 16.49; Thomas de Cantimpré 14.32f; Vincent de Beauvais 8.22; Albertus Magnus 2.7.1; *Hortus sanitatis* 5.58. This is today known as jet, a hard variety of coal. The name *gargates* was also used for a mythical stone believed ideal to chase away demons away and cure scorpion bites; cf. Knuth, *Gems in Myth*, 243. According to Greek legends this stone took its name from the mythical river Gages (*Gagae*) in Lycia, where it was first found. The legend is mentioned by Galen, Nicander (quoted in Pliny), and Pliny (5.28).

287. Evidence of jet mining may be found in England as early as the bronze age (ca. 1500 BCE).

288. This stone's purported property made it particularly popular for crosses and rosaries.

289. Dolce (46r) omitted this last sentence.

290. *Garamantides.* Most likely an aventurine.

291. *Gassinades, gessidane.* A mythical stone or possibly a geode.

292. Pliny 37.59; Solinus 37.19; Isidore of Seville 16.15.17; *Hortus sanitatis* 5.62. The name was used to refer to stones today recognized as fossilized shark teeth. Because in the Middle Ages arrowheads were also sometimes called glossopetra, it is difficult to determine which one Leonardi is referring to.

293. *Hortus sanitatis* 5.61.

294. *Hortus sanitatis* 5.59; another name for aventurine.

295. *Galaxias.* Pliny 37.59; Dioscorides 5.134. Possibly iron-stained chalk or limestone.

296. *Hyaenia, hyaena, hyenia, ihena, ienia, iena, hyena, hymenia, hyenis, ena, yen, yena, bena, jena.* Pliny 7.44, 37.60; Solinus 27.25; Isidore of Seville 16.15.25; Marbode 44; Arnoldus Saxo 45; Bartholomaeus Anglicus 16.56; Vincent de Beauvais 8.32; Thomas de Cantimpré 14.42; Albertus Magnus 2.8.1; *Hortus sanitatis* 5.64, 5.68. Either a mythical stone, an eye agate, or an opal.

297. Dolce (47r) translated *ore abluto* as "bagnata con la bocca" (having wetted [the stone] with the mouth).

298. Dolce (47r) omitted this sentence.

299. *Hieracitis, ieracitis, geraciten, gerarchyten, gerarchites, geranites, garatides, gerattides, gratices, gelaticum, yrachiten, jerachites.* Pliny 37.60; Isidore of Seville 16.15.19; Damigeron 26; Marbode 30; *Kyranides* 1.22; Arnoldus Saxo 42; Bartholomaeus Anglicus 16.52, 16.102; Vincent

NOTES TO PAGES 92–94 173

de Beauvais 8.75; Albertus Magnus 2.7.6; Mandeville 1.24; *Hortus sanitatis* 5.64. The description suggests this is a jasper.

300. *Hammonis, hammonitis, hammonis cornu.* Pliny 37.60. Based on the Roman author's description, this is most certainly ammonite, a fossil shell.

301. *Hormiscion, hormision, ermistion, estimion, exmisson.* Pliny 37.60; Isidore of Seville 16.14.11; Damigeron 14; *Hortus sanitatis* 5.50.

302. U.E.T. (110) omitted *in extremitatibus* (at its edges).

303. *Cadmia, botrytis, tutia alexandrina, arabice climia.* Newton, *Index Chemicus Ordinatus*, 48, 157. The identity and detailed description of the stone does not appear in earlier sources.

304. Hysmeri was just another name for emeralds.

305. *Ammochrysus, amochrisus.* Pliny 37.73; Solinus 37.13; Isidore of Seville 16.15.15.

306. Dolce (47v) reads "vene doro e quadretti mescolati in lei" (golden veins and small squares mixed within it).

307. *Jacintus, hyancinthos, hyacinthus, iacinctus, jacinctus*; in medieval Italian, *jacinto, giarconsia.* Pliny 36.67, 37.41; Solinus 30.24, 32.33; Isidore of Seville 16.9.3; Marbode 14; Hildegard von Bingen 4.2; Neckam 6.207ff; Bodl., MS Digby 13.3, 13.43; Arnoldus Saxo 44; Bartholomaeus Anglicus 16.54; Thomas de Cantimpré 14.38; Vincent de Beauvais 8.76; Albertus Magnus 2.8.2; Mandeville 1.11; Hermes 10; *Hortus sanitatis* 5.65, 5.108. Jacinths are a variety of zirconium silicate; modern terminology prefers zircon, though some gemologists still use the term jacinth to refer to reddish-brown natural zircon and hessonite garnets. Pliny's description of the jacinth suggests instead a sapphire or rose quartz. This stone was associated with the Andrew the Apostle; see Knuth, *Gems in Myth*, 121.

308. Dolce (48) omitted the word *rubedinem* and inserted an ellipsis.

309. *Iaspis, jaspis, jaspen, hyaspidis, lapis*; in medieval Italian, *iaspes, diaspro.* Pliny 37.37; Isidore of Seville 16.7.8; Orpheus, "Lapidaire Orphique" 5.267–79; Orpheus, "Kérygmes Lapidaire d'Orphée" K6; Damigeron 13; *Kyranides* 1.9; Dioscorides 5.142; Marbode 4; Hildegard von Bingen 6.10; Neckam 6.167ff; Bodl., MS Digby 13.14; Arnoldus Saxo 43; Bartholomaeus Anglicus 16.53; Thomas de Cantimpré 14.37; Vincent de Beauvais 8.77; Albertus Magnus 2.8.6; Mandeville 1.13; Thetel 2, 5–9; Solomon 13; *Hortus sanitatis* 5.66. A quartz variety of semitranslucent to opaque chalcedonies. After 1569 the word jasper is sometimes used to describe jade, but neither Leonardi nor Dolce are referring to jade. The first mention of jasper is found in Theophrastus, though it was already widely known and used by the ancient Egyptians.

310. Such green jaspers were often used to carve the face of Jesus, artfully using the blood spots to mimic his dripping blood; see Knuth, *Gems in Myth*, 54.

311. U.E.T. (113) instead rendered this as "Gold."

312. *Yris, yrim, irim, irisites, iritis, virites, jyrim, hirritis, hirricis, inris, tride.* Pliny 37.52–53; Solinus 33.50; Isidore of Seville 16.13.6; Damigeron 39; Dioscorides 5.127; Marbode 47; Arnoldus Saxo 46; Bartholomaeus Anglicus 16.55; Thomas de Cantimpré 14.41; Albertus Magnus 2.8.3; Ragiel 12; *Hortus sanitatis* 5.67. From the Greek word for rainbow, quartz, or rainbow quartz.

313. *Idaeus, idaei dactyli, ideus.* Pliny 37.62; Solinus 11.14; Dioscorides 3.140; Isidore of Seville 16.15.12. Most likely a fossil.

314. *Ischistos, iscutos, iscustos, iscitus, icitos, istmos schiscos, schistos.* Isidore of Seville 16.4.18–19; Damigeron 64; Thomas the Cantimpré 14.40; Albertus Magnus 2.8.4; *Hortus sanitatis* 5.68. Schist is a coarse-grained metamorphic rock.

315. U.E.T. (114) reads "Saffron."

316. *Indicus, lapis indicus, lapis sindicus, senditicos.* Pliny 37.61; Dioscorides 5.92; Physiologus 27; Vincent de Beauvais 8.5.

317. *Iudaicus, iudaica, indyarus, lapis agapis, lapis marinus, lapis liberans a glarea.* Isidore of Seville 16.4.12; Dioscorides 5.137; Avicenna 2.2.404; Thomas de Cantimpré 14.39; Albertus Magnus 2.8.5; *Picatrix* 3. Most likely fossilized sea urchin spines.

318. Gem of Jove; see Pliny 37.61.

174 NOTES TO PAGES 94–95

319. This could possibly be a violet andalusite or apatite, or perhaps even an amethyst. The Greek word *ion* was also the name of a type of violet; see Pliny 21.14.

320. See the entry above for *Granatus.*

321. See the entry above for *Hieracites.*

322. *Kacabre, kabrates, craprates, chabrates, tabrices, karabrattes.* Arnoldus Saxo 48; Bartholomaeus Anglicus 16.58; Albertus Magnus 2.9.1–2. If this is the same as kacabre, then the stone might actually have been amber.

323. *Kacamon, kamen, kauman, kakman, kanmanu, gamaho, gamaheus.* Arnoldus Saxo 49; Bartholomaeus Anglicus 16.57; Albertus Magnus 2.9.2; *Hortus sanitatis* 5.69. The stone's name seems to derive from the Arabic *kamaa* (relief), suggesting it was used to identify stones like agates and jaspers in which figures could be naturally occurring. It could also be derived from the Greek *kauma* (fire).

324. U.E.T. (115) omitted this last sentence since the third book was not translated.

325. *Kacabre.* Avicenna 2.2.404, fol. 550r; *Hortus sanitatis* 5.70.

326. *Lacrimae cervinae, cerui lacryma. Hortus sanitatis* 5.69.

327. Dolce (49r) omitted the geographic reference to the East.

328. *Kinocetus, kinoceto.* Possibly a mythical stone used in cases of possession or epilepsy.

329. These might actually be two different stones. *Lychnis, lychynites, lynchinites, lychines, lychynes, lychynis, lychius, lygdinus, lichinis, lignis, lignites, letites, licnis, leniten, lithiten*; *ligurius.* Pliny 36.4, 37.29; Solinus 52.58–59; Philostratus 2.14; Isidore of Seville 16.14.4; Damigeron 28; Vincent de Beauvais 8.79; *Hortus sanitatis* 5.74; This could very well be a balas ruby. The second stone is *Lyncurium, lyncuris, lynguros, lyngurium, liguros, ligurius, lingurius, lincis, ligure.* Pliny 37.13; Solinus 2.38–39; Isidore of Seville 16.8.8; Damigeron 31, 43; Marbode 24; Dioscorides 2.81; Hildegard von Bingen 4.19; *Kyranides* 1.11; Arnoldus Saxo 50; Bartholomaeus Anglicus 16.60; Thomas de Cantimpré 14.44; Vincent de Beauvais 8.80; Albertus Magnus 2.10.1; *Hortus sanitatis* 5.72, 5.75. This might well be a red tourmaline or reddish yellow quartz. Pliny wrote of the stone's pyroelectric qualities, which Leonardi instead attributes to *Ligurius* (as did the *Hortus sanitatis*) without realizing it was merely a different spelling of the same stone listed here. At the time tourmaline was not distinguished from other stones of similar hues and characteristics.

330. *Ligurius, lygurius.* Theophrastus 28; Pliny 8.57, 37.13; Marbode 24; Bartholomaeus Anglicus 16.60; Albertus Magnus 2.10.1. From the Greek for "lynx water." This is probably a reddish yellow topaz or tourmaline, or possibly a zircon. Strabo used "lingurium" to refer to amber instead.

331. Dolce (49v) omitted this reference.

332. *Morbum regium* could be referring to either icterus or the king's evil. Given that he just mentioned jaundice, which is what icterus means, I have opted to translate it as the king's evil, which was either gout or scrofula. The latter was a swelling of the lymph nodes caused by tuberculosis and was thought to be healed by a king's touch. The practice seems to hail back to at least Edward the Confessor in England and Philip I in France. The anointing of the king's body during the coronation's ceremony was believed to grant him healing powers. "Cramp rings" and "touch pieces" (specially minted coins) that the kings had personally touched were eventually distributed to heal of the afflicted, who wore such items around their necks.

333. *Hortus sanitatis* 5.72.

334. Dolce (50r) omitted the references to jaundice; U.E.T. (117) reads instead "Fits of the Mother."

335. *Liparea, lipparis, luperius, lyparea, lupparea, lipparia, lypparia, litarea, leparaios, lipercoli, le pero.* Pliny 37.62; Orpheus, "Lapidaire Orphique" 5.691–747; Orpheus, "Kérygmes Lapidaire d'Orphée" K23; Isidore of Seville 16.15.22; Marbode 45; Arnoldus Saxo 51; Bartholomaeus Anglicus 16.61; Thomas de Cantimpré 14.43; Vincent de Beauvais 8.32; Albertus Magnus 2.10.2; *Hortus sanitatis* 5.75. A mythical stone that could be bitumen and whose powers were

NOTES TO PAGES 95–97 175

also mentioned in the apocryphal letter of Prester John; see Ross, "Prester John"; and Slessarev, *Prester John*, 67–79.

336. Dolce (50r) simply translated this as "Africa."

337. See the entry above for *Celonites*.

338. See the entry above for *Galatides*.

339. Dolce (50v) omitted this last part of the sentence.

340. *Leuchophthalmus, leuco ophtalmus, lycophthalmos.* Pliny 37.62. Most likely an opal or an eye agate.

341. *Lysimachos, lisimacus.* Pliny 37.62. Could very well be Rhodes marble with pyrite or gold quartz veins.

342. *Leuchochrysus, leucochrysos, leuchochryses, leuchochrysa, leocrisus, leochrysus.* Pliny 37.44, 37.62; Isidore of Seville 16.15.6. An inferior type of topaz.

343. Pliny 37.62. Probably an emerald.

344. Its virtue for attracting straw suggests that this stone might be Pliny and Strabo's lingurium or amber; see the entries above for *Lyncurius* and *Lyncis*.

345. Dolce (50v) omitted the reference to jaundice.

346. Pliny 36.4, 37.29. This may also be Pliny's lygdinus or lychnitem; see the entry below for *Lychnitem*.

347. Pliny 37.62; Orpheus, "Lapidaire Orphique" 5.286–87. Possibly a mica aggregate.

348. *Exhibitus,* which might have been a typographical error for *Exbibitus.* Dolce (51r) in fact translated it as "dato a bere" (if drunk). U.E.T. (119) omitted the sentence altogether.

349. *Bissino panno,* from *bisso,* which originally indicated a precious linen cloth, yellow in color. The term was eventually extended to indicate any type of fine and precious cloth, especially if made of silk. Dolce (51r) omitted *bissino* and inserted an ellipsis.

350. Dolce (514) omitted this sentence and wrote instead "difende l'uomo da molti dolori et incommode" (it protects man from many aches and pains).

351. *Logdinus, lygdinus, ligdinus.* Pliny 36.13.

352. Dolce (51r) added "et è buona ad altre infermità" (it is good for other infirmities as well).

353. *Lychnites, licnite.* Pliny 36.13. Although the spelling would suggest that this would be the same as *Lichinus or Lychinites* (see note for that entry above), the description shows that it is the same as *Ligdinus.* It may be called *lychnites* because it was quarried by lamplight.

354. Pliny 36.45, 37.68. According to Pliny, this stone could also be referred to by the name of *Lapis specularis.*

355. *Unio, bacca, perla, perna;* Pliny 9.54–58, 37.6; Solinus 53.23–29; Physiologus 24; Marbode 50; Hildegard von Bingen 4.21; Arnoldus Saxo 53; Bartholomaeus Anglicus 16.62; Vincent de Beauvais 8.81–83; Albertus Magnus 2.11.4; *Hortus sanitatis* 5.78. Pearls are concretions of mineral deposits formed by mollusks in response to foreign particles within their shell. The name *margarita* might "derive from the Persian Murwari, meaning pearl or 'child of light'" (Knuth, *Gems in Myth*, 165).

356. A single large pearl. The term is still used today. U.E.T. (200) translated it as "Onion."

357. *Stipticitate,* from *stipticitas,* suggesting that the naturally perforated pearls are more fragile and do not present as cohesive a glomerule.

358. Dolce (51v) omitted this section.

359. U.E.T. (202) read *sincopizantibus* as "pains of the stomach."

360. *Medius, medinus, medea, media, medos, metus, midicos, medoria, fedus.* Pliny 37.63; Isidore of Seville 16.11.4; Damigeron 21; Marbode 36; *Kyranides* 1.12; Neckam 6.275ff; Bodl., MS Digby 13.36; Arnoldus Saxo 54; Bartholomaeus Anglicus 16.67; Thomas de Cantimpré 14.48; Vincent de Beauvais 8.85; Albertus Magnus 2.11.5; *Hortus sanitatis* 5.84. Possibly alum slate.

361. Dolce (52r) reads instead "farà, che ella partorirà maschio" (it will help a woman to give birth to a male child).

362. Dolce (52r) omitted "if ground and mixed with gall ink."

176 NOTES TO PAGES 98–101

363. It is unclear what Leonardi means by *lipiciniis*. Dolce (52r) did not translate the word and placed an ellipsis in its stead. U.E.T. (203) translated it as "wet."

364. Modern Aswan, Egypt.

365. *Murrina, murrhina, myrrina, myrrhina, murrine, murrhine, murrha, myrrha*. Pliny 37.7; Isidore of Seville 16.12.6; *Hortus sanitatis* 5.82. It is a mineral used in vase making. Ancient descriptions suggest that the vessels appeared to be shimmering with opaque crystals of varying colors, possibly fluorite crystals. See Tressaud and Vickers, "Ancient Murrhine Ware."

366. *Myrrhitis, myrritis, murritis*. Pliny 37.63; Solinus 37.10; Isidore of Seville 16.7.14.

367. *Malachites, melonites, meroctees, molochites, molochitis, melochites, merochites*. Pliny 37.36; Solinus 33.20; Isidore of Seville 16.7.11; Marbode 54; Arnoldus Saxo 55; Bartholomaeus Anglicus 16.68; Albertus Magnus 2.11.6; *Picatrix* 2.10.6, 2.10.64; 2.10.78, 4.8.28; *Hortus sanitatis* 5.82. A copper ore.

368. Mallow plant of the Malvaceae family.

369. *Memphites, memphytes, memphyten, memfites, menfites, mensites, menophitis*. Pliny 36.11; Isidore of Seville 16.4.14; Dioscorides 5.140; Bartholomaeus Anglicus 16.65; Thomas de Cantimpré 14.46; Vincent de Beauvais 8.27; Albertus Magnus 2.11.7; *Hortus sanitatis* 5.83. Not a stone but most likely a plant.

370. Dolce (53r) omitted this part of the sentence.

371. *Magnet, magnetes, magneten, magnetis, magnessa, magniten, mangneta, magnesia, quini*. Pliny 34.42, 36.25; Solinus 57.27; Isidore of Seville 16.4.1–2, 16.13.3; Orpheus, "Lapidaire Orphique" 5.306–34; Orpheus, "Kérygmes Lapidaire d'Orphée" K11; Damigeron 30; Dioscorides 5.148; Marbode 19; Hildegard von Bingen 4.18; Avicenna 2.2.1474; Neckam 2.87, 2.94, 6.330; Arnoldus Saxo 52; Bartholmaeus Anglicus 16.63; Thomas de Cantimpré 14.45; Vincent de Beauvais 7.19–21; Albertus Magnus 2.11.1–2; *Picatrix* 2.10.2; *Hortus sanitatis* 5.77. A magnetic iron ore. "Plato tells us that the term *magnetis* was first connected to lodestone by the poet Euripides (480–405 BCE). Prior to this time the common name has been heraclean stone" (Knuth, *Gems in Myth*, 142). Pliny also described a black diamond or black *adamas* that may be a lodestone (ibid., 143).

372. The individual who discovered it was supposedly called Magnes.

373. Albertus Magnus discusses magnetism in his *Book of Minerals* but did not write any treatise on magnets. It is likely that Leonardi is attributing a different treatise to Albertus Magnus. As Thorndike (*History of Magic*, 6:300) mentions, it is possible that the treatise referred to is the thirteenth-century *Epistola de Magnete* by Petrus Peregrinus de Maricourt.

374. The term appears in the *Collectio Salernitana* and was used as an adjective to qualify a variety of maladies; see Renzi, *Collectio Salernitana*, vol. 4, p. 138, chap. 26; vol. 5, p. 34, chap. 2, art. 3. Dolce (54r) translated it as "il dolore dell'Arterie" (pain of the arteries); U.E.T. (209) as "cramp and gout."

375. Dolce (54r) omitted the word and inserted an ellipsis.

376. Dolce (54v) omitted the word.

377. U.E.T. (210) omitted this sentence.

378. *Magnesia*. Pliny 36.25, 36.66; Avicenna 2.2.476; *Picatrix* 4.8.29; Albertus Magnus 2.11.2; *Hortus sanitatis* 5.79. Either magnesia or manganese.

379. *Marchasita; marchasida*. Avicenna 2.2.475; *Picatrix* 2.10.2, , 2.10.8, 3.3.31, 4.8.29; Albertus Magnus 2.11.3; *Hortus sanitatis* 5.79. Early on, marcasite was used to indicate "common crystallized iron pyrites, an iron sulphide mineral; later the word became a misnomer for iron disulphide (pyrite or white iron pyrites) that is of the same chemical composition and resembles it but is of different structure and lower specific gravity" (Newman, *Illustrated Dictionary of Jewelry*, 193).

380. Dolce (55r) omitted this word.

381. A variant spelling of *medus*, though Leonardi did not realize it. See the entry above for *Medus*.

382. *Mormorion*. Pliny 37.63. The description suggests that it was a type of marble.

383. Dolce (55r) reads "Cepio."

NOTES TO PAGES 101–102 177

384. *Mixtrax, mirthridax, mitridas.* Pliny 37.63; Isidore of Seville 16.4.22. Possibly an opal.

385. *Melitite, militites.* Pliny 36.33; Isidore of Seville 16.4.26; Dioscorides 5.15; Bartholomaeus Anglicus 16.64.

386. The ancient Romans considered it a type of hematite; see Knuth, *Gems in Myth*, 121.

387. *Nitrum, natron, niter, baurach armenus, altin alamen.* Pliny 31.46, 36.65; Isidore of Seville 16.2.7; Avicenna 2.2.88, 2.2.522; Bartholomaeus Anglicus 16.70; Arnoldus Saxo 56; Albertus Magnus 2.12.1; *Hortus sanitatis* 5.89. It is a potassium nitrate salt compound.

388. Dolce (55v) reads "Sole" (sun) rather than salt.

389. Dolce (55v) omitted the sentence and briefly sums it up by stating "ne manda lontano esse pietre" (it throws far these stones).

390. A prescription for gun powder.

391. *Nassamonites, nasamonites, nasamonitis, nassonites, nassanites, nassamonites.* Pliny 37.64; Solinus 27.43. Possibly banded jasper.

392. Dolce (55r) reads instead "Secche di Barberia," that, is the shallows or sandbanks of the North African coast.

393. *Nemesitis. Kyranides* 1.13.

394. *Nusae.* Arnoldus Saxo 58; Albertus Magnus 2.12.3; *Hortus sanitatis* 5.87. While Leonardi thinks it to be alabaster, the *Hortus sanitatis*, Arnoldus Saxo, and Albertus Magnus suggest that this is borax or toadstone.

395. *Onychinus, onix, onycha onica, onychites, onichitis, onichilus, onochinus, onocinus, onchinius, enchiniu, enichius, orincles*; in medieval Italian, *onica.* Pliny 36.12, 37.24; Isidore of Seville 16.8.3; Dioscorides 5.135, 139; Marbode 9; Hildegard von Bingen 4.3; *Kyranides* 1.15; Neckam 6.163ff; Bodl., MS Digby 13.41; Arnoldus Saxo 59; Bartholomaeus Anglicus 16.72; Thomas de Cantimpré 14.49–50; Vincent de Beauvais 8.87; Albertus Magnus 2.13.1–2; *Picatrix* 2.10.2–3, 2.10.50, 2.10.63, 2.10.66ff, 3.1.5; 3.3.28; Mandeville 1.17; Ragiel 7; Solomon 10; *Hortus sanitatis* 5.91. A variety of chalcedony, though it was also used to refer to sardonyx and even alabaster.

396. Dolce (56r) reads "tre" (three).

397. Dolce (56r) reads "giallaticcio" (yellowish).

398. Dolce (56r) reads "giallaticcio" (yellowish).

399. Dolce (56r) omitted the references to carbuncle and chrysolite.

400. *Onycha.* Albertus Magnus 2.13.2. While the spelling suggests another name for onyx, the description suggests a material akin to amber.

401. U.E.T. (214) reads instead "hands."

402. *Opalus, apalius, opparlius, opallios, oppallius, optalius, optallion, ophtalius, ophtalmius, ophthalmus lapis, ostalamus, ostalnus, abtalmius, oltamius, astamus, ostenius, ostomus, ostola, paederos.* Pliny 37.21–22 (opalus), 37.46 (paederos); Orpheus, "Lapidaire Orphique" 5.281–91; Isidore of Seville 16.12.3; Damigeron 24; Marbode 49; Bartholomaeus Anglicus 16.73; Arnoldus Saxo 60; Albertus Magnus 2.13.3; *Hortus sanitatis* 5.90, 5.93. An amorphous, gelatinous, hydrous silicon in which the percentage of water varies. The name originates from the Sanskrit *upala* (precious stone). Known as the cupid stone by the Romans; it is described by Pliny, though the stone he was describing was most likely an iris quartz—especially since the principal source of opals, Hungary, appears not to have been known to the Romans, and the source Pliny identifies has never yielded opals.

403. Pliny 37.21 actually says two million (\$20 million today) rather than twenty thousand sesterces. Given that Pliny describes a gem "as large as a hazelnut," it is possible that the stone might be an iris quartz with similar luminous properties as an opal. U.E.T. (214) added "which amounts to something more than 200L Sterling" to render the value clearer to readers of that era.

404. Dolce (56v) erroneously added information that belonged instead to the following entry, *Obtalius*, which he instead omitted.

405. *Oritis, ortihes, oristes, oriten, ortites, onites.* Pliny 37.65, 37.67; Orpheus, "Lapidaire Orphique" 5.357–97, 5.418–60; Orpheus, "Kérygmes Lapidaire d'Orphée" K16ff; Damigeron 16;

178 NOTES TO PAGES 102–104

Marbode 43; Bodl., MS Digby 13; Arnoldus Saxo 61; Bartholomaeus Anglicus 16.74; Thomas de Cantimpré 14.52; Albertus Magnus 2.13.4; *Hortus sanitatis* 5.94. From the Greek for "mountain stone," possibly a mammillary crystal or a siderite.

406. *Orfanus*. Albertus Magnus 2.13.5; *Hortus sanitatis* 5.92. The description suggests a balas ruby, garnet, or fire opal; the word was in fact used to refer an opal. Scholars disagree on the origins of the term, some suggest that orphanus might have first been used to refer to a specific stone's uniqueness, but that it was eventually taken to indicate a species of stones; others suggest that the name derives from its being the single stone to adorn the crown of the Germanic Holy Roman Emperor.

407. *Opsianus, obsidius, obsiana, obsyontes, oprianus, obsidianum, obsidius lapis, absiamus*. Pliny 36.67, 37.65; Isidore of Seville 16.4.21; Damigeron 25. An obsidian is solidified volcanic lava in its crystalline form.

408. Dolce (57r) reads "Africa" instead of Libya; U.E.T. (216) reads "India" instead of Italy.

409. *Ostracitis, ostracite, ostricitin, ostraciten, osiracitim, ostrachitis, ostracea, ostrateas, ostratea, ostracios, ostragite, ostritis, ostrites, ostridis*. Pliny 37.65; Orpheus, "Lapidaire Orphique" 5.344–56; Orpheus, "Kérygmes Lapidaire d'Orphée" K14; Isidore of Seville 16.4.20, 25.16.15, 16; Dioscorides 5.146; Vincent de Beauvais 8.26; *Hortus sanitatis* 5.94. It probably was a flint stone, and might have also been known as cadmite.

410. Pliny 36.11. It was used to refer to serpentine and verd antique.

411. U.E.T. (217) reads "Holland" instead of Belgium.

412. While the name appears to be a variant of *ostrititis* and *ostracites*, the reference to the hyacinth renders it similar to the otriche stone. Leonardi does not give a description sufficient enough to solve this particular puzzle.

413. *Oficardelon, oficardelus, opycardelus, opphicardelus*. Pliny 37.65.

414. U.E.T. (217) added "in Greek signifying the Heart of a Serpent."

415. *Kyranides* 1.25.

416. The terms *okimae, okiteritis*, and *omidis* are found in a number of medical manuals of the period, though I was not able to ascertain the meaning of *omidis*. U.E.T. (217) translated the sentence more generally as "in the juice of certain Herbs" and omitted the reference to both okiteritis and omidis.

417. See the entry above for *Asinius*.

418. Pliny 37.65. If it was indeed another name for ceurania, it might have been a meteorite or prehistoric stone axe. The ceurania, mentioned by Pliny in 37.51, certainly fits the same description, while the one listed in 37.48 was probably inferior moonstone or possibly satinspar.

419. *Orca, oica, olca, iolca*. Pliny 37.65; Isidore of Seville 16.12.1.

420. U.E.T. (218) omitted "black."

421. *Prasius, pransius, praisitis, praxus, prase*. Pliny 37.34; Isidore of Seville 16.7.4; Marbode 40; Hildegard von Bingen 4.2; Arnoldus Saxo 64; Bartholomaeus Anglicus 16.77; Thomas de Cantimpré 14.55; Albertus Magnus 2.14.4; *Hortus sanitatis* 5.98. A green chalcedony that includes a variety of quartz, green jasper, and other green stones; from the Greek *prason* (leek green).

422. A bloodstone or heliotrope.

423. A banded green calchedony.

424. *Pantherus, pantheros, pantheron, panteron, panthera*. Pliny 37.66; Damigeron 44; Marbode 51; *Kyranides* 1.5; Neckam 6.351ff; Bodl., MS Digby 13.38; Arnoldus Saxo 62; Thomas de Cantimpré 14.54; Bartholomaeus Anglicus 16.80; Albertus Magnus 2.14.1; *Hortus sanitatis* 5.97. A distortion of the word *panchrous* (multicolored). Leonardi suggests that this is the same as the stone known as evanthus mentioned in the *Kyranides*, which was most likely an opal.

425. Pliny 37.66; Isidore of Seville 16.5.5; *Kyranides* 1.16; *Hortus sanitatis* 5.95. Possibly a moss agate or other variety of agate.

426. Dolce (58r) reads instead "pallida ma lucidissima" (pale but very shiny [or bright]).

427. Dolce (58r) omitted this sentence and the following two.

NOTES TO PAGES 104–106 179

428. Dolce reads "Demoni" rather than the singular *demonem*. It is quite possible that Leonardi is not referring to the devil per se, but rather to a simple demon.

429. *Paenitis, paeanitides, peanita, peaniten, paeanides, paonites, peanitus, peanites, peranites*; in medieval Italian, *peante, peonite, peantide*. Pliny 37.66; Solinus 9.22; Marbode 34; Arnoldus Saxo 63; Bartholomaeus Anglicus 16.79; Albertus Magnus 2.14.2; *Hortus sanitatis* 5.102. Possibly rock crystal, a clear quartz, or a geode.

430. U.E.T. (219) omitted this sentence.

431. *Pyr, pyrites, pyrite, pirites, piritides, piriten, perites, perithe, perithes, perites, petites, parides, parite, piridan, perithes, virites, piridonidiud, paragonius, peridonius, ypestionus*. Pliny 36.30; Solinus 37.16; Isidore of Seville 16.4.5, 16.11.8; Damigeron 56; Marbode 56; Dioscorides 5.125; Neckam 6.347ff; Bartholomaeus Anglicus 16.78; Thomas de Cantimpré 14.53; Vincent of Beauvais 8.24; Albertus Magnus 2.14.3; 2.19.3; Chael 13; Solomon 31; *Hortus sanitatis* 5.100. A metallic sulfide in its black-gray color, while the white variety, as Leonardi correctly states, is a marcasite.

432. *Phrigius*. Pliny 36.36; Isidore of Seville 16.4.9; Vincent de Beauvais 8.25; *Hortus sanitatis* 5.104.

433. Dolce (593) reads "Africana."

434. *Porphyrites, porphysites, porphirites*. Pliny 36.11, 36.19; Isidore of Seville 16.5.5; *Kyranides* 1.16; *Hortus sanitatis* 5.95.

435. *Paederos, pederotes, pedoros, pedorus, podoros, podetos*. Pliny 37.46; Solinus 33.22–33; *Hortus sanitatis* 5.103. Possibly an opal.

436. *Pancono, pangonus*. Pliny 37.66; Hermes 5; Solomon 38. Leonardi's explanation suggests a misunderstanding of the sources as the word *pangonia* in Greek means all angles; thus it cannot be confused with crystal because it has more angles or facets than the latter.

437. *Pumex, pumice, lapis vulcani, spuma maris, pumey*. Pliny 36.26 (Scyros); Isidore of Seville 16.3.7; Avicenna 2.2.613; *Hortus sanitatis* 5.105. A pumice stone or volcanic orthoclase feldspar.

438. *Preconisso*. Pliny 37.4. A misreading of Pliny's entry on emeralds where he mentions Stilon Praeconinus, or Lucius Aelius Stilo Praconinus of Lanuvium, an early Roman philologist.

439. Dolce omitted the last sentence and reads instead "il quale rende vagheza con alcuni segni simili al Calcedonio" (whose color renders it beautiful with some similarities to calcedonius).

440. *Lapis pavonnius, paonites, taconites, panchrus, pangrus, panchrodus*. Pliny 37.66; Damigeron 37; Isidore of Seville 16.12.1; Bartholomaeus Anglicus 16.80.

441. See entry above for *Punicus*.

442. Since pumice stones were and are still used to file down calluses, Leonardi must be referring to writers' callus, or that callus that appears on the index finger from long writing.

443. *Paragonnius, peragone*. Solomon 22–23; Ethel 26. See the entry above for *Pirites*; as mentioned above, a spelling error gave rise to the transformation of pyrite into paragnonius.

444. Dolce (59r) omitted the last part of the sentence.

445. *Phenacite, phoenicites, phenicites, fenicites, phenakite*. Pliny 37.66, 37.73; Damigeron 42. It is a pentremite, which resembles a quartz, thus the Greek name of *phenax* (deceiver).

446. *Phloginos*. Pliny 37.66; Damigeron 77; *Hortus sanitatis* 5.56. Probably a red ochre.

447. *Quirin, quirus, quris, quiritia, lapis de nido upuppe*. Damigeron 67; Arnoldus Saxo 65; Bartholomaeus Anglicus 16.83; *Hortus sanitatis* 5.106. A mythical stone.

448. U.E.T. (222) reads "a juggling Stone." Leonardi used *praestigiosus*, which Dolce (59v) interpreted as "con la quale si fanno strigherie and inganni" (with which are made witchcraft and illusions).

449. *Vulturis lapis, quanidros, quandros, quayndros, quinidros, quirindros*. Arnoldus Saxo 66; Bartholomaeus Anglicus 16.84; Albertus Magnus 2.15.1. A mythical stone.

450. *Radaym, radaino*. Arnoldus Saxo 68; Albertus Magnus 2.16.1; *Hortus sanitatis* 5.107. A mythical stone similar to alectorius.

451. *Ranio.* Bartholomaeus Anglicus 16.85; *Hortus sanitatis* 5.26 (bolus armenus).

452. *Picatrix* 2.10.51ff, 3.1.6, 3.3.31; Mandeville 1.1; Ragiel 1. Rubies are a red variety of transparent corundums (aluminun oxide).

453. *Saphrius, sapphirus, sappheiros, saphyr*; in medieval Italian, *safiro, zaffiro, zafiro.* Pliny 36.67, 37.39; Theophrastus 37; Isidore of Seville 16.9.2; Damigeron 14; Marbode 5; Dioscorides 5.139; Hildegard von Bingen 4.6; *Kyranides* 1.18; Neckam 6.135ff; Bodl., MS Digby 13.27; Arnoldus Saxo 60; Bartholomaeus Anglicus 16.87; Thomas de Cantimpré 14.57; Vincent de Beauvais 8.94; Albertus Magnus 2.17.1; Mandeville 1.4, 5; Ragiel 5; Solomon 7; *Hortus sanitatis* 5.109. A blue-colored, transparent corundum (aluminum oxide) whose description in the Greco-Roman sources corresponds with our modern lapis lazuli, although by the thirteenth century it came to indicate our modern sapphire, a blue corundum. The confusion between sapphires and lapis lazuli might at first seem puzzling, but as Knuth (points out, its cause may be found in the name's origin. As per Andreas, bishop of Caesarea (tenth century CE), sapphires were symbolic of St. Paul; see Knuth, *Gems in Myth*, 191, 197.

454. U.E.T. (224) read *Syrtes Lybica* as "the Lybian quicksands" rather than sandbanks or shoals. Dolce (60r) reads it as "Sirti di Barberia."

455. The belief in the healing properties of sapphires with regard to the eye may have its origins in Egyptian medical practices. "They used an oxide of copper mixed with boric acid as an eye wash. Known as lapis armenus, this astringent has been shown by modern medical research to be effective and is still prescribed. Later translations of Egyptian texts substituted lapis lazuli, assuming the more valuable material would be more effective. Medieval writers assigned the attributes of all blue gems to 'sapphirius'" (Knuth, *Gems in Myth*, 193). The shrine of St. Erkenwald in Old St. Paul's Cathedral included a sapphire presented in 1391 by Richard Preston with the express purpose of healing eye ailments (ibid.).

456. *Zmaragdus, smaragden, salaragdus*; in medieval Italian, *smeraldo.* Pliny 37.16–19; Solinus 15.23ff; Theophrastus 23–27; Isidore of Seville 16.7.1–2; Damigeron 6; Marbode 7; Hildegard von Bingen 4.1; *Kyranides* 1.6; Neckam 2.91, 6.153ff; Arnoldus Saxo 74; Bartholomaeus Anglicus 16.88; Thomas de Cantimpré 14.58; Vincent de Beauvais 8.102; Albertus Magnus 2.17.8; *Picatrix* 2.10.3, 2.10.7, 2.10.29, 2.10.68–72, 3.1.4; 4.8.2; *Hortus sanitatis* 5.113. A variety of beryl, although the term was often applied to other types of green stones, marbles, or glass. The Egyptian and the Ethiopian were certainly emeralds; the others might have been green turquoises, green sapphires, chrysocolla, or peridots. A number of green peridots, in particular, were easily thought to be emeralds and thus presented as gifts to the church; see Knuth, *Gems in Myth*, 170.

457. Pliny 37.16 is the source for this particular detail. Scholars today disagree as to how exactly Nero was using the emerald, while Knuth (*Gems in Myth*, 94–95) thought that it might have been a jasper stone through which he was indirectly watching the contests, as if on a mirror. This is very unlikely, as it would have required him to sit with his back to the audience, a detail that would have certainly attracted attention. It is much more likely that he was using some sort of emerald or green-colored stone lens, as certain cuts could lend the stone a magnifying property. Dolce (70v) uses the word *Pescatori* rather than *gladiatori*; he states "nel quale risguardava gli abbattimendi de' Pescatori" (in which he watched the fishermen's battles). His reference to fishermen suggests that he had in mind a specific type of gladiator, the *retiarus* or *retiarii.* The latter used a net that looked like a fisherman's net and were sometimes known as the fishermen of the arena.

458. *Cacosmaragdi*, from the Greek *kakos*, meaning bad, vitiated, and therefore in this context false or fake.

459. U.E.T. (226) reads "the six Species above named are not, however, so remarkable for their Largeness," combining the end of one sentence with the beginning of the following and thus mistranslating the passage.

460. The source seems to be Pliny 37.19.

461. Dolce 61r reads *pilam* as "Pilo" (pylon).

462. U.E.T. (226) ended the entry by simply stating "Many Virtues are fabled of it."

NOTES TO PAGES 107–108 181

463. According to Ahmed Ben Abdalaziz's *Treatise on Jewels*, an emerald's brilliance was said to have blinded the serpent in the Garden of Eden, reason for which many green stones were then given the properties of halting lust or sin. See Kozminsky, *Crystals, Jewels, Stones*.

464. Dolce (61r) omitted this sentence.

465. Dolce (61r) omitted this sentence.

466. Dolce (61r) omitted the last two sentences.

467. *Succinus, sunctinus, succinum, sucanus, sutenius, electonny, electrum, lambra*. Pliny 37.11–12; Solinus 20.9–13; Isidore of Seville 16.8.6–7; Thomas de Cantimpré 14.64; Bartholomaeus Anglicus 16.38; Albertus Magnus 2.17.10; *Picatrix* 4.8. Literally sap-stone. Early Romans, like the Greeks before them, believed that this organic material was the unctuous sweat of the sun that solidified when it touched sea water; Pliny the Elder might have been among the first to realize that it was an organic material—that is, petrified sap.

468. According to Ovid, the *populi gummi* was nothing other than the tears shed by Phaeton's sisters, the Heliads, whose bodies had taken root on the riverbank where their brother Phaeton was buried. In other sources, though, it is these gum resin tears that are called amber. Leonardi had not realized that this was another of the mythical legends on the origins of amber.

469. Leonardi reads *Anglia, Britannia*; considering that the first refers to England, the second must be referring not to England, but to Brittany (Bretagne). Dolce (61v) omitted *Britannia* and substituted the more generic "e in altri paesi" (and in other countries).

470. I have not been able to determine which island Leonardi is speaking of. In *Germania*, Tacitus speaks of an amber coast; see also Olcott, "Tacitus on the Ancient Amber Gatherers." This is today identified with the Baltic coast northwest of Kaliningrad, which at the time would have been considered German territory. Of course, Leonardi could be referring to any island along the northern European coast from current Denmark to Russia. It is still possible, for example, to find amber on the beaches of the town of Gedser Odde on the Danish island of Falster. Could Gessaria derive from Gedser? I suppose that U.E.T (227) omitted the reference to the island because he could not determine its identity.

471. Dolce (61v) omitted *paleas* (straw).

472. Dolce (61v) omitted the reference to women and children, while U.E.T. (227) expanded *monilia* to "Bracelets and Necklaces."

473. Amber was used in the making of goblets because of its ability to repel poisons.

474. Dolce (62r) read *venenosa* as "Demoni." U.E.T. (228) reads instead "poisonous Insects."

475. *Sardis, sardonia, sardinus*. Pliny 37.23, 37.31; Solinus 2.27; Isidore of Seville 16.8.2; Damigeron 50; Marbode 10; Hildegard von Bingen 4.7; Arnoldus Saxo 71; Bartholomaeus Anglicus 16.89; Thomas de Cantimpré 14.60; 14.67; Albertus Magnus 2.17.4; *Hortus sanitatis* 5.110. In most cases the stone corresponds to carnelian, but in some also to sard or red sardonyx, a variety of chalcedony.

476. Dolce (62r) omitted the second part of this sentence, as did U.E.T. (228).

477. Dolce (62r) omitted this sentence. U.E.T. 228 read *Sexum* as "Sextum" and thus wrote, "It has the sixth Place in the Distinction of Colours."

478. It is likely that it was named after the ancient Greek capital of Lydia, Sardis, as suggested by Damigeron. U.E.T. (228) instead read *Sardos* as "Sardiniana."

479. Dolce (62r) omitted the reference to Paros.

480. Dolce (62r) added "che ve ne sono di amendue i sessi" (for they are of both sexes).

481. Dolce (62r) omitted the reference to the flux of blood.

482. *Sardonix, sardonic, sardonicen, sardonycem; sartonix, sardone*; in medieval Italian, *sardonia*. Pliny 37.23, 37.31; Solinus 33.8–9; Epiphanius 1, 12; Isidore of Seville 16.8.4; Marbode 8; Hildegard von Bingen 4.5; Neckam 6.157ff; Bodl., MS Digby 13.25; Arnoldus Saxo 70; Bartholomaeus Anglicus 16.90; Thomas de Cantimpré 14.59; Vincent de Beauvais 8.33; Albertus Magnus 2.17.5; Mandeville 1.16; *Hortus sanitatis* 5.8. A variety of onyx, considered a cryptocrystalline quartz.

483. This stone was also considered the symbol of St. James, as per Andreas, bishop of Caesarea; see Knuth, *Gems in Myth*, 200.

182 NOTES TO PAGES 108–110

484. *Selenitis, salonites, solenites, sollentes, silente, silenites, sylenites, syleniten, sylonites, celonites, lapis lune.* Pliny 37.67; Solinus 37.21; Isidore of Seville 16.4.6; Damigeron 35; Marbode 26; Dioscorides 5.113, 5.141; Avicenna 2.2.412; Neckam 6.249ff; Bodl., MS Digby 13.39; Arnoldus Saxo 73; Bartholomaeus Anglicus 16.92; Thomas de Cantimpré 14.66; Vincent de Beauvais 8.5; Albertus Magnus 2.17.7; *Hortus sanitatis* 5.115. Probably corresponds to modern selenite, a form of gypsum, while siderite corresponds to magnetite.

485. U.E.T. (230) reads "as if anxious for some Damage sustain'd in the Heavens."

486. *Sami, samis, saumus, samolithos, sarmius, sarmia;* in medieval Italian, *sallio.* Pliny 36.50; Dioscorides 5.172; Isidore of Seville 16.4.13; Thomas de Cantimpré 14.63; Albertus Magnus 2.17.6; *Hortus sanitatis* 5.112.

487. U.E.T. (230) read *ad antiquas oculorum lachrymas sistendas* as "it stops the Running of Tears of aged People."

488. *Smyris, smirillus, smeriglius, smerillus, smyridos, hismiris, hysmeri.* Isidore of Seville 16.4.27; Dioscorides 5.147.

489. *Syrus, siris, sirius, surus.* Pliny 36.26; Isidore of Seville 16.4.10; Thomas de Cantimpré 14.61; Albertus Magnus 2.17.11. The description corresponds to a pumice stone, and the name might derive from the stone's geographical origins, the island of Syra. See the entry above for *Pumex.*

490. Pliny 37.67; Solinus 37.20; Bartholomaeus Anglicus 16.9; Mandeville 9. Possibly a girasol or a kind of feldspar like eastern venturine.

491. *Sagda, sagida, sadida, saga, sarga, agada.* Pliny 37.67; Solinus 37.8; Isidore of Seville 16.7.13; Marbode 35; Neckam 6.273ff; Arnoldus Saxo 72; Albertus Magnus 2.17.3; *Hortus sanitatis* 5.114. The description suggests barnacles rather than a stone.

492. *Sandrisita, sandristae, sandasirus, garamantica.* Pliny 37.28. An aventurine or quartz, possibly even aventurine feldspar.

493. Syriacs, Syrians, or Arameans.

494. *Sarcofagus, calophagus.* Pliny 36.27; Isidore of Seville 16.4.15; Thomas de Cantimpré 14.62; Vincent de Beauvais 8.26; Albertus Magnus 2.17.2; *Hortus sanitatis* 5.112. Marble or alabaster to which the authors attributed the properties of limestone.

495. *Siphinius.* Pliny 36.44.

496. *Siderate.* Pliny 37.68; Solinus 36.23; Isidore of Seville 16.15.11; Dioscorides 5.13; Damigeron 15. Possibly magnetite.

497. *Stuxites;* in medieval Italian, *strusite.*

498. Satyrion could be either a ragwort or a tulip. In the first case it is a plant of the *Orchis* genus (part of the orchid family), to which were attributed all sorts of aphrodisiac properties based on its phallic shape and its bulbous roots covered in small hairs. Parkinson, instead, suggests that it might be a tulip bulb, also known as *testiculos caninos* (dog's stones), *testiculos morionis* (fools' stones), or *testiculos vulpinos* (fox's stones); see *Theatrum botanicum,* 1343ff. It is possible that stuxites was a mythical stone whose name and existence derived from the popular names given to the bulbous roots of the orchid.

499. Dolce (64r) translated this sentence more euphemistically as "fa l'homo potente nelle cose di Venere" (it renders man potent in all the matters of Venus).

500. *Samothratia.* Pliny 37.67. Probably corresponds to lignite or jet.

501. Leonardi is referring to the Ardizio hill, which was then also known as Monte Castigliano because of the medieval castle that stood on its top. The latter was still extant in the eighteenth century. Fifteenth-century documents also refer to it as Monte Catejan, Monte Granaro, or Colle Sajano. The hill came to be called Ardizio sometime after 1468, the year in which the Milanese physician Gasparino degli Ardizi (a.k.a. Gasparino Ardizio) agreed to marry Pacifica Semperoli, Alessandro Sforza's mistress. A grateful Alessandro gifted the whole hill to Gasparino.

502. Today known as spinel, a gem that comes in a variety of colors and shades. Famous examples of this mostly unfamiliar stone are the Black Prince's Ruby, now set in the British Imperial State Crown (1937); the spinel set on the crown for the Empress Catherine II of Russia;

and the Timur Ruby now in the India Room at Buckingham Palace; see Knuth, *Gems in Myth*, 203.

503. Dolce (64r) omitted this last sentence and placed the entry at the end of the *S* section rather than after *Samothracia*.

504. *Sangineo* in medieval Italian.

505. U.E.T. (234) omitted this entry.

506. *Senedeg, sederego*. U.E.T. (234) reads instead "is the same as the *Ematrices*."

507. *Speculum*. Pliny 36.45; Isidore of Seville 16.4.37; Thomas de Cantimpré 14.65; Albertus Magnus 2.17.9.

508. *Sinondontitis, sinodontide, synondontitis, simodontides*. This corvine stone was thought to be found in the head of a fish, not that of a crow (corvus).

509. *Topazos, topazius, topazion, topadium, thopazius, tobasius, thopayus, toutpasse, tompase, tospasse, capasius, copasius, kaspasinus, caspasianus*; in medieval Italian, *topazio*. Pliny 37.32, 37.42; Isidore of Seville 16.7.9; Damigeron 29, 54; Marbode 13; Hildegard von Bingen 4.8; Neckam 6.193ff; Arnoldus Saxo 75; Bartholomaeus Anglicus 16.96; Thomas de Cantimpré 14.68; Vincent de Beauvais 8.106; Albertus Magnus 2.18.1; Ragiel 2; Solomon 14. The description suggests a peridot, olivine, or chrysolite rather than a true topaz. In antiquity citrine, a yellow-colored quartz, was not distinguished from topaz. Pliny (37.42) used the term chrysolite to refer to golden green stones that came from an island in the Red Sea. He stated that the island was called Topazos in ancient times and so he also called these same gems topazius. It is quite possible that he was mistaken, as already pointed in the eighteenth century by Gosselin in his analysis of Greeks' conceptions of geography of the Red Sea, *Géographie des grecs analysée*. In antiquity the stone's main deposits were found in Upper Egypt and Saxony.

510. Dolce (64r) reads instead "il quale è di tre sorti" (which is of three species).

511. Pliny mentions the island of Cytis twice, once in 6.34 and again in 37.32. Félix Ansart suggested that Cytis was to be identified with the modern island of Mehun; see Pliny the Elder, *Historiae naturalis libri XXXVII*, ed. Ansart.

512. Dolce (64v) omitted the second part of this sentence.

513. Dolce (65r) omitted the second part of this sentence.

514. *Turcois, turchois, turcoys, turkois, turchogis, turgei*; in medieval Italian, *turchiman*. Arnoldus Saxo 76; Bartholomaeus Anglicus 16.97; Albertus Magnus 2.18.2; *Picatrix* 2.10.4. The stone is a natural hydrated aluminum phosphate. Pliny's turquois might be a stone he refers to as callais or alternatively callaina (37.33, 37.56). The stone was often confused with lapis lazuli.

515. Dolce (65r) reads "Turchesa è pietra turchina" ("turquoise is a turquoise-colored stone").

516. Dolce (65r) reads "come vi fosse stato per entro mescolato mele" (as if it had been mixed in with honey). U.E.T. (236) reads instead "and if passed thro' Milk, is of a yellow Colour."

517. The yellow color of this secondary mineral suggests that the stone described might be the Egyptian turquoise, which presents a yellowish/greenish hue due to its higher iron content. The stone's origin and name etymology are first given by Arnoldus Saxo. Much of it was actually imported from the Sinai Peninsula and the Nishapur region of Persia through Turkey.

518. Dolce (65r) simply reads "e la difende da ogni contrario accidente" (and protects sight from any adverse accidents). References to this stone as a protective stone for riders are found in Arab lapidaries as turquoises were often used as talismans on the bridles of Arab and Persian equestrians. In the seventeenth century Anselmus de Boot mentions these very same talismanic properties; see Knuth, *Gems in Myth*, 218.

519. *Thracia, tracius*. Pliny 37.68; Isidore o f Seville 16.4.8.

520. *Thyrsitis, thirsitis, thirsites, tirsis, tiersus. Kyranides* 1.8.

521. Avicenna 2.2.695. A magnesian mineral with broad and smooth laminae commonly used in alchemy.

522. Both Dolce (65r) and U.E.T. (236) misread *laminosus* for *luminosus*, thus revealing their lack of alchemical knowledge; the material was often described as having scales or laminae.

184 NOTES TO PAGES 111–114

523. Dolce (65r) omitted the reference to the sublimation process.

524. *Techolitus, tecolithos, tegolithus, gegolitus, gecolitus, cegolit, cerogolit, celgelitus, cogolites, cegolitus, cegolites, telithos, telitos*. Pliny 37.68; Solinus 37.12; Marbode 55; Bodl., MS Digby 13.40; Arnoldus Saxo 18.25; Thoams de Cantimpré 14.34; Albertus Magnus 2.7.5, 2.3.7. Most likely a pentremital fossil.

525. Dolce (65r) reads "Parite."

526. See the above entry for *Tegolitus*.

527. Arnoldus Saxo 77; Albertus Magnus 2.19.1. Red ochre or cinnabar. Dolce (65r) lists this entry under the heading *Tarac*.

528. *Vernice*, in medieval Italian. Arnoldus Saxo 78; Albertus Magnus 2.19.2.

529. *Veientana, vientana, vegenterna, vejentana*. Pliny 37.69; Solinus 2.44; Isidore of Seville 16.11.5. Possibly gray tuff.

530. The name references the ancient Etruscan city of Veii, which sat on a tuff plateau northwest of Rome.

531. Dolce (65v) omitted the second part of the sentence.

532. *Vultore*, in medieval Italian.

533. Arnoldus Saxo 78; Albertus Magnus 2.19.3.

534. *Vatrachites, batrachites; vatrachio*, in medieval Italian. *Kyranides* 1.21.

535. *Unione*, in medieval Italian; Neckam 6.317.

536. *Xiphinos, xiphios. Kyranides* 1.14.

537. *Yetios, hyetities, yecticos, genos. Kyranides* 1.20.

538. See the entry above for *Enidros*.

539. See the entry above for *Crisoberillus*.

540. *Zimech, zimiech, zarites, zunichus, lapis lazuli*. Bartholomaeus Anglicus 16.103; Albertus Magnus 2.20.1. The description suggests that this is most likely lazulite, though it could also be lazurite, the mineral form of lapis lazuli. This blue mineral can have substantial pyrite inclusions that appear golden or yellow in color. Lazulite is not a lapis lazuli, though it can be confused for it. The word *lazuli* may find its roots in *Allazward* or *l'Azulaus*, that is, sky or blue. Pliny 37.38 describes lapis lazuli but calls it a sapphire (*sapphiros*).

541. Dolce (66r) omitted *flavus* (yellow).

542. *Zarite, zirite, zignites, zingnites, zegnites, zigrites*. Damigeron 30 (lignites); Albertus Magnus 2.20.2.

543. U.E.T. (239) omitted this second part of the sentence.

544. Dolce (66r) reads slightly differently: "Ed è mescolata di tanti diversi colori, che niuno riman nel suo grado: cioè nero, bianco, et che cosi rimane nella sua purezza" (and it is mixed with many different colors, so much that not one remains within its own hue: that is black, white, and [so that not one] retains its purity).

545. *Zmilampis; zmilace*, in medieval Italian. Pliny 37.70; Isidore of Seville 16.15.14. Possibly green alabaster.

546. *Zoraniscaea; zoronsyos*. Pliny 37.70.

547. U.E.T. (240) ended their translation here, omitting the whole third book.

Book 3

1. Albertus Magnus 2.3.1.

2. Most likely Thomas Aquinas in his commentaries on Aristotle's *De anima* 1.5.

3. Aristotle, *De partibus animalium*. The exact Latin phrase appears also in a fourteenth-century handwriting as a commentary to Ptolemy's *Almagest*, fol. 170–170v. It is also the prologue incipit for the Pseudo-Aristotelian *Liber complexionum*, BL, Harley MS 3843, fols. 100v–115v.

4. Dolce (67r) omitted this last sentence and concluded by appealing instead to his readers: "et i lettori ne habbiano quel gusto, che se ne puo havere" (and readers may derive from it whatever pleasure may be possible).

5. Sections of this chapter—specifically Leonardi's discussion of contemporary artists—were originally published by Garin in "Giudizi artistici di Cammillo Lunardi."

NOTES TO PAGES 114–116 185

6. Albertus Magnus 2.3.3. This could very well be Thābit ibn Qurra (826–901), a physician, astrologer, and mathematician who lived in Baghdad during the Abbasid Caliphate. It is not clear which of Thābit's works, if any, Leonardi would have had access to; see Carmody, *Astronomical Works*.

7. Dolce (67v) reads Greek instead of Roman.

8. A gem engraver active at the end of the fourth century BCE. There are no extant works by his hand. Pliny mentions him in 7.37 and 37.4.

9. From here onward, Dolce (67v–68r) completely rewrote the chapter to fit instead the later period he was writing in; see also the appendix to this volume.

10. Pliny 37.4.

11. It is difficult to identify this particular artist. He might be Giovanni Maria Falconetto, who was active in Mantua, at the service of the Gonzaga in the ducal palace of Palazzo D'Arco. Unfortunately, it is not known whether he was a gem engraver or merely a provider of designs for gem commissions now lost. Daniela Ferrari ("Appendice") has published a list of all the goldsmiths listed in the *Statuti dell'Arte* in Mantua between 1310 and 1694; though many of these workshops featured gem engravers, this artist's name does not appear in the list.

12. Vasari extolled Francesco Luigi Annichini for his skills; see *Le vite*. The 1906 journal *Numismatic Circular*, published by Spink and Sons (London; vol. 14, no. 9456), mentions a gem engraver by the name of Maria Giovanni solely on the strength of Leonardi's mention. It is impossible to know whether this Annichini might be a pupil or son of the well-known Annichini of Ferrara.

13. A Genoese gem engraver and diamond cutter active in the first half of the sixteenth century; see Soprani, *Delle vite de' pittori*, 20–21.

14. This is indeed Leonardo da Vinci. As per his own letter to Lodovico il Moro, Leonardo thought of himself as both a sculptor and painter. In fact, he most likely provided the designs for Sforza medals and coins executed by Cristoforo Caradosso Foppa. Leonardo was present in Pesaro between August 1 and 7 of 1502 at the service of Cesare Borgia as *ingegnere generale*—that is, as supervisor general of all engineering works. It is quite possible the Camillo Leonardi and Leonardo da Vinci met during those summer days. Leonardo might have discussed with Leonardi gem engraving and identified himself as being a designer of such gems.

15. Francesco Ribolini (1447–1517), also known as Il Francia, was born near Bologna, at Zola Pedrosa, which was then called Ceula. He trained as a goldsmith prior to his becoming a painter and was the head of the Bolognese Goldsmith Corporation in 1483, 1489, 1506–8, and 1512. The description of all that Francia could engrave on the *parvo orbiculo* recalls the famous ekphrasis of Achilles's shield in the *Iliad*.

16. Piero della Francesca (ca. 1415–1492).

17. Melozzo da Forlì (ca. 1438–1494), whose works were also present in Ferrara.

18. Giovanni Bellini (ca. 1430–1516).

19. Pietro Perugino (1446–1523).

20. Pliny 35.36.

21. Pliny 35.36.

22. Andrea Mantegna (1431–1506). Federico Gonzaga bestowed on him the title of *cavaliere* in 1484.

23. It is quite likely that Leonardi misspelled the first name of the artist he mentions, which he most likely found listed in Pliny. In the *Natural History* (35.40), Pliny mentions an artist who might fit the bill: a Pausias of Sicyon who was a pupil of Pamphilus, Apelles's teacher.

24. As acknowledged by Leonardi, Albertus began his tractate's third book with a similar discussion of the types of images—natural versus artificial—that could occur in sigils or engraved stones. Albertus Magnus 2.3.1–2.

25. The Greek general, statesman, and king of the Molossians, as well as king of Epirus and Macedon (318/19 BCE–272 BCE), was mentioned as the owner of this fabled agate in Pliny 37.3.5. Albertus mentions the same examples in 2.4.4. Leonardi shows that he carefully read his sources and made decisions on how to use them and whom to believe. Albertus Magnus, following

186 NOTES TO PAGES 116–119

Thomas Cantimpré, considered the stone to have been made human-made, whereas Leonardi follows both Pliny and Marbode in considering it a naturally occurring picture agate.

26. In relying on Albertus for the description of the jewel, Leonardi reproduces errors of description first committed by Albertus (2.3.2). The gem being described might be the Ptolemy Cameo, today in the Kunsthistorisches Museum of Vienna. In the late medieval period the cameo appears to have been used as part of the decorative apparatus of the Shrine of the Three Kings in the Cathedral of Cologne. In *Alexandria und Rom* (17) Möbius referred to it as the Cologne Cameo, thus strengthening the supposition that Albertus is describing the Ptolemy Cameo.

27. Dolce (68v) omitted the word.

28. Dolce (68v) writes "Pierio" rather than Pliny. It is either an error or he is referring to the Italian humanist Giovanni dalle Fosse, a.k.a. Pierio Valeriano Bolzanio (1477–1558), author of a well-known treatise on hieroglyphs titled *Hieroglyphica, sive de sacris Aegyptorium aliarumque gentium litteris commentatoriorum libri LVIII,* as well a treatise on the Italian language, *Dialogo della vulgar lingua,* which Dolce certainly knew.

29. Pliny 36.4.14.

30. Dolce (68v) simply reads "nella porta di certa casa" (on the door of a certain house).

31. *Physica* 2.3.3 in *Opera omnia*; *De secretis mulierum* was at the time wrongly attributed to Albertus Magnus. This sentence is wholly missing in Dolce (68v).

32. The reference to "Henricus . . . de Saxonia" is missing in Dolce (68v). Is Leonardi referring to Heinrich von Sachsen, a physician from Strasbourg, or did he make an error and he meant to say Arnoldus of Saxony? In the first case, perhaps the source Leonardi is using did not reach us. In the second case, Arnoldus of Saxony was a vital source on which even Albertus Magnus had heavily relied; see Arnaldus Saxonis, *Die Enzyklopädie des Arnoldus Saxo*; and Riddle and Mulholland, "Albert on Stones and Minerals," 230.

33. This sentence is missing in Dolce (68v).

34. *Physica* 2.3.3 in *Opera omnia*.

35. While Aristotle in his *Physics* (2.7.199, 2.7.33ff) states that monsters are errors of nature, Albertus in *Physica* 2.3.3 quoted Ptolemy's *Tetrabiblos* 3.8 and imputed the birth of monsters to the influence of the stars.

36. Leonardi's description of cameos and gem engraving suggests he was much more familiar with these arts than Albertus was. The latter's description appeals to the intervention of alchemical practices to explain how sigils were carved, and doubts the uses of diamond chips as carving instruments.

37. Word missing in Dolce (69v).

38. Albertus discusses these same problems in 2.3.3.

39. "Scultura" in Dolce (70r).

40. This appears to be a paraphrase from Aristotle, *On Rhetoric* 1.2.

41. This aphorism, attributed to Ptolemy, had already been quoted by Thomas Aquinas in the *Summa theologica* (q. 9, art. 5) and was derived from a collection of aphorisms, *Centiloquium,* attributed to the classical astronomer. Given the questionable authorship, the compiler of the *Centiloquium* is now referred to as Pseudo-Ptolemy. Interestingly, while Albertus discusses five principles to be followed with regards to the use of heavenly images, Leonardi does not follow suit, although both authors are referring to Ptolemy as an authority on the matter.

42. Dolce (70v) clarified by stating "soggiace alle stelle et a gl'influssi" (bound by the stars and the heavenly influences).

43. Leonardi is citing the same example used by Albertus Magnus (2.3.3), who in turn was citing an anecdote drawn from the pseudo-Aristotelian *Secrets of Secrets* in which Plato was mentioned.

44. Albertus Magnus 2.3.3.

45. As mentioned above, Leonardi seems to be using a manuscript related to Bodl., MS Digby 79, whose section 4, *De lapidibus,* is attributed to Thetel. Although confusion between

NOTES TO PAGES 119–122

Solomon's and Thethl's lapidary was quite common in the early modern period, Leonardi believed his source to be the work of Solomon.

46. Pseudo-Ptolemy, *Centiloquium* 9; Albertus Magnus 2.3.3.

47. Dolce (71r) translated it as "Haliozacle." I have been unable to identify the individual Leonardi is referring to; yet, since in that period Ali was often spelled Hali, I can only assume this may be a Muslim astronomer whose books he held in high esteem. I am left wondering whether he is misspelling the name of Abu Ishaq Ibrahim Yahya al-Naqqash al Zarquali al Tujibi, also known as Al-Zarkali or Ibn Zarqala (1029–1087). He was often referred to by the latinized name of Arzachel (the engraver). Two of his works, a *Zij* and an *Almanac*, were translated into Latin by Gerard of Cremona in the twelfth century. Gerard had also translated a pseudo-Aristotelian lapidary that Leonardi seems to have owned.

48. A thirteenth-century Tuscan astronomer and astrologer from Forlì, Bonatti (ca. 1210–1296/1300) was astrologer to Guido Novello da Polenta (Dante's patron in Ravenna) and to Guido I da Montefeltro, for whom he apparently correctly predicted the count's victory at the Battle of Forlì. He might even have advised Frederick II, Holy Roman Emperor. While Dante placed him in hell (*Inferno* 20.118), his *Liber decem continens tractatus astronomiae* of 1277 achieved great renown and was published in 1491, 1506, and 1550. His *Theoria Planetarum* was published in 1506.

49. Paraphrase of ideas contained in Ptolemy's *Tetrabiblos* 1.2.7 and 3.2 as well as in Albertus Manus 2.3.3.

50. Dolce (71v) omitted *ut ab Astrologis manifeste apparet.*

51. Dolce (71v) added a further clarification: "essendo segno igneo, cioè calido" (being that it is fire or hot sign).

52. Dolce (72r) uses the Venetian moniker for Crete, "Candia."

53. Ophiuchus, or the serpent bearer, is located around the celestial equator between Aquila, Serpens, and Hercules. It divides the constellation Serpens in two parts, Serpens Caput and Serpens Cauda.

54. Dolce (73r) erroneously repeated "sinistra" (left).

55. Leonardi is describing an abraxas.

56. Dolce (73r) translated *necromanticae* simply as "Astrologiche."

57. Dolce (73r) addressed instead a general reader: "E se alcuno ve ne troverà piu, le vi potrà aggiungere" (And if anyone will find more [images], they can add them here).

58. Leonardi now significantly diverges from Albertus. The latter is quite cursory and superficial in the description of both zodiacal trinities and constellations and their images; see Albertus 2.3.5. Leonardi is following a number of other medieval sources including Arnoldus Saxo and Thomas de Cantimpré.

59. Dolce (73r) again addressed a generic reader: "non creda il lettore" (the reader should not believe).

60. Dolce translated *ignobilis persona aut foemina* as "vil femmina" (vile female), thus conflating the two ideas.

61. Leonardi follows Albertus's own arrangement of the zodiacal triplicities. Ptolemy's *Tetrabiblos* (1.10, 2.3), instead, deemed Aries, Leo and Sagittarius to belong to the Northern Hemisphere and thus to be cold instead of hot and dry.

62. Agrippa von Nettesheim, *La Philosophie occulte* 2.36. Heinrich Cornelius Agrippa von Nettesheim (1486–1533/34) was in the service of Charles V as doctor and historiographer.

63. Dolce (73v) wrote "A Dio et agli huomini" (to God and men).

64. Albertus Magnus 3.5.1.

65. Ptolemy's *Tetrabiblos* considered this trinity as southern and hot.

66. A continuous inflammatory or rheumatic fever.

67. Albertus Magnus 3.5.4.

68. Ptolemy's *Tetrabiblos* considered this trinity eastern and dry.

69. A type of malarial fever that reoccurs every four days.

70. In Latin, *canina mania.*

188 NOTES TO PAGES 122–127

71. I have not been able to ascertain what Leonardi means by *ab illisci*, but since other sources on astrological medicine mentions paralysis, it is quite possible that this is what is meant here. Dolce (74r) omitted translating both *canina mania* and *ab illisci*.

72. Albertus Magnus 3.5.2.

73. Ptolemy's *Tetrabiblos* considered this trinity western and moist instead of northern, cold, and moist.

74. Dolce (74v) wrote "alba" or dawn instead of Leonardi's "crepusculum."

75. Leonardi or the printer used *ethica* rather than what is most likely meant, *hectica*; this was a type of fever characterized by steep changes in temperature through the course of a day, as typical of tuberculosis or other pulmonary abscesses; see McVaugh, "'Humidum Radicale'"; and Demaitre, *Medieval Medicine.*

76. It is difficult to ascertain whether the illnesses he speaks of include cholera or refer merely to bilious colics, which were accompanied by vomit and spasms.

77. Albertus Magnus 3.5.3.

78. The planets are listed from slowest to fastest in keeping with the Chaldean system.

79. Dolce (75r) read the Latin as *subtili* and thus translated *ac subtili pectore* as "e con petto simile" (with a similar chest).

80. This whole entry is missing in Dolce (75v).

81. Dolce (75v) simply stated instead "come ella fosse meza" (as if it were halved).

82. This sentence missing in Dolce (75v).

83. Dolce (76r) listed this chapter as chapter 10.

84. Dolce (76r) read the Latin *astronomi* as *astrologi* (astrologers).

85. Dolce (76r) inverted the order of presentation in the sentence and thus mentioned Ursa Minor and then Ursa Major.

86. Dolce (77r) slightly expanded *in somno res delectabiles* by stating "gli fa sognar cose vaghe e dilettevoli" (makes them dream beautiful and delightful things).

87. Dolce (77v) expanded this passage with "che l'amor tra loro sia fermo e perpetuo" (that their love be firm and eternal).

88. Dolce (77v) added "che gli assalgono" (that threaten it [the body]).

89. Dolce (77v) inverted the order of right and left, thus he stated "che ha nella manca una spada, e nella destra" (that it holds a sword in the left and in the right).

90. Dolce (77v) rendered Leonardi's *fascinationes* as *strigherie* (witchcraft).

91. Also known as Ophiuchus.

92. Leonardi might be mixing up the constellation of Aquila, also known as Vultur Volans, with that of Vultur Cadens, which was and is still known by the name of Lyra. Yet, since both were similarly represented, he could be saying that they are both indicated by the same iconography.

93. The arrow might be a reference to the star Sagitta.

94. As in the above entry, Leonardi might be mixing up the constellations of Pisces and Delphinus, though he might be grouping them together because they were similarly represented.

95. Today it is often referred to by the name of the whale, Cetus, which in Greek mythology denoted a sea monster, a whale, a shark, or large fish.

96. Argo Navis was subdivided into the constellations of Carina, Puppis, and Vela.

97. Canis minor.

98. Dolce (78v) repeated the same sentence about the constellation's location: "Ha luogo nel segno del Cancro nella parte meridionale" (It is placed in Cancer in the Southern Hemisphere).

99. Dolce (79r) translated *lebete* as "lavezzo." A *lavezzo* or *ollare* is a tender, dull green stone found mainly in Valmalenco, Italy. It was traditionally used for small ornamental objects as well as pottery because of its heat-retaining properties, as mentioned in Pliny 36.44.

NOTES TO PAGES 127–130 189

100. Alhabor was the Arabic name of Sirius, the brightest star in the constellation of Canis Major. The name was often used in the hermetic tradition.

101. The constellation was most often designated by the name of Turibulum until the eighteenth century. The nomenclature was then changed to Ara, which is still in use today.

102. Dolce (79r) simply stated "havrà podere di costringer li Spiriti, e far, che a lui obediscano" (it will have the power to foce the spirit so that they have to obey him).

103. The urn or cup might be the constellation of Crater, while the raven might be that of Crow.

104. Dolce (79v) clarified the sentence by adding "Gli Astrologi la pongono" (astrologers place her).

105. Dolce (79v) simplified this by stating "e far l'huomo ripieno di allegria" (and it fills man with cheer).

106. Dolce (79v) reads "Caratiere, Latinamente detto Auriga" (the Charioteer, called Auriga in Latin).

107. This would be Capella, the brightest star of Auriga.

108. By Vexillus (Flag) perhaps Leonardi means the constellation of Vela, though its description does not match other known descriptions of Vela in antiquity or the early modern period.

109. By Ragiel in Latin, or Ragel in Italian. Renaissance authors were referring to the angel Raziel. The *Liber Razielis*, which probably originated in Jewish contexts, was a medieval text of magic claiming that the angel Raziel first revealed the key to accessing the mystic meaning of words and letters to Adam, who then passed that knowledge down the generations from Seth to Enoch, to his son Lemach, and lastly to Noah. In the medieval period, this "knowledge," which Solomon was believed to have also known, circulated under the name of *the Liber Institutionis Raziel* or *Liber Razielis* (*Book of Raziel the Angel*). The book dealt with natural magic, astral magic, as well as ritual magic, and it would have been of interest for Leonardi for it specifically dealt with magical rings. The *Sefer Raziel Ha-Malakh* (given to Adam) and *Sefer Ha-Razim* (given to Noah) derive from the same tradition, as demonstrated by the fact that large parts of the second book are found in the first, which in the medieval period was believed to have been written by Eleazar of Worms (Eleazar ben Judah ben Kalonymus, 1176–1238). Besides drawing from the *Sefer Ha-Razim*, the book also drew from the *Sefer Yetzirah*. The Latin edition was produced in the thirteenth century under Alphonse X of Castille. This Latin edition must have been familiar to Leonardi. As noted in the introduction, book 6 of the *Liber Raziel* was in fact based on the *Sefer Ha-Razim*. Eighteen of Leonardi's entries in this section of the book bear a strong similarity to the first book of the *Book of Secrets*. See Trachtenberg, *Jewish Magic and Superstition*; and Page, "Uplifting Souls."

110. Dolce (79v) clarified "E se sia portata dall'huomo" (if a man wears it). It is not clear whether Dolce used *huomo* to be specific about the gender of the wearer.

111. Dolce (81r) read *plasma*, thus referring to any generic green stone.

112. Dragontea (*Dracunculus vulgaris*) belongs to the Araceae family and was also called the stink lily because its flower reproduces the smell of putrefying flesh.

113. Dolce (81r) reads "a diverse altre cose" (to make them do various other things).

114. Chael is a deformation of the name Thetel, whose seals Leonardi also reported. As noted by Thorndike (*History of Magic*, 6:300), and as mentioned earlier, both were probably a corruption of the name Zael or Zehel—that is, Sahl ibn Bishr al-Israili. Sahl ibn Bishr al-Israili was also known as Rabban al-Tabari or Haya al-Yahudi. He was an astrologer and mathematician of the eighth and ninth centuries who is believed to have been the first translator of Ptolemy's *Almagest* into Arabic. Most of his works have not yet been translated into English and remain accessible only to Arabic speakers. Grimoires of talismanic and astrological magic usually do include the seals of Chael or Thetel as does our author; cf. British Library, Sloane 3822. This type of material is found in healing manuals as late as 1743. The first twenty-three images Leonardi lists bear strong similarities to Bodl., MS Digby 79, while images twenty-four

190 NOTES TO PAGES 130–133

to forty are similar to British Museum, Sloane 1784. This suggests that he was either using multiple sources or a singular source that combined aspects of Digby and Sloane that has not come down to us. Dolce (81v) used the word "figure" instead of seals.

115. Dolce (79v) omitted this last sentence and stated only "come si vedrà seguitando" (as we shall see in the following).

116. Symbol for Venus and the alchemical symbol for copper. None of the alchemical symbols were reproduced in Dolce's text. The symbols are placed to the left of each entry, midway through each paragraph; cf. https://archive.org/details/Speculumlapidumoon/page /LVII/mode/2up.

117. Dolce (79v) reads "La sua virtù è anco giovevole nelle infirmità, se l'huomo bevrà l'aqua, nella quale questa pietra sia lavata" (its virtues will also be useful in illnesses, if man will drink water, in which this stone has been washed).

118. Symbol for Mars and the alchemical symbol for iron.

119. Symbol for Jupiter and the alchemical symbol for tin.

120. Symbol for Venus and the alchemical symbol for copper.

121. *Pistacia terebinthus* also known as turpentine tree; its resin and fruits have been used for medical purposes since antiquity. The resin fluid or distillation was also known as trementine.

122. Symbol for Saturn and the alchemical symbol for lead.

123. Symbol for Mars and the alchemical symbol for iron.

124. Symbol for first quarter moon and the alchemical symbol for silver.

125. Symbol for first quarter moon and the alchemical symbol for silver.

126. Symbol for Mercury and the alchemical symbol for quicksilver.

127. This is quite possibly a description of the sign of Capricorn.

128. Symbol for Venus and the alchemical symbol for copper.

129. Perhaps a description of the third decan of Cancer.

130. Symbol for Mercury and the alchemical symbol for quicksilver.

131. Symbol for Saturn and the alchemical symbol for lead.

132. In stating "Vulture" Leonardi seems to be reproducing a transcription error; it should read *Turtur* or Dove rather than *Vultur*; see Mandeville 2.2.21.

133. Symbol for first quarter moon and the alchemical symbol for silver.

134. Dolce (83r) reads instead "faranno il medesimo effetto" (they will have the same effect).

135. Leonardi's entry reads *Hominis armati figura*. This might be another transcription error; the original might have been *aranti* rather than *armati*, as found in earlier sources. In that case, the entry should read "Plowing Man"; cf. Thomas de Cantimpré 16.70.7; and Vincent de Beauvais 8.77.

136. The image of a man holding a coin is most likely the result of another transcription error. The original probably read *diaboloum* rather than *obolum*; cf. Thetel as found in Cantimpré 16.70.9; and Mandeville 2.2.25.

137. A stone resembling a beryl.

138. I am unclear as to what he is referring to here or in the entry below. It seems to be a stone that may be either black or gold. Could it be a paragon stone? Or perhaps pyrite?

139. Dolce (84r) reads "se sarà scolpita in alcuna pietra" (if it will be sculpted on any stone).

140. This is an abraxas gem.

141. Most likely a volcanic stone; see, for example, the entry above for *Effesstis*.

142. No mention of a setting in gold in Dolce (84v).

143. *Columbina carne* might be dove, rather than pigeon flesh. The man's description fits that of Jupiter.

144. Pliny (26.22) calls it *tripolium*. Scholars disagree on the herb's identity, which is given as either plumbago, aster tripolium, teucrium polium, sea starwort, or statice limnonium.

145. Literally *capito* (head).

146. This part of the sentence is missing in Dolce (85r).

NOTES TO PAGES 133–136 191

147. Dolce (85r) omitted the word *stanneo*.

148. One of the few instances in which Leonardi gives indication of the time of day in which something needs to be used, suggesting this might be the case for many more of the rings listed in this section.

149. After mentioning the serpents, Dolce (85v) simply added "e fa diversi altri utili effetti" (and it has other various useful effects).

150. *Urginea maritima*.

151. Dolce (85v) reads "caccia ogni ombra and spiriti nocivi. I Dimoni gli obediranno, e gli discovrianno thesori" (It chases away any shade or ill-intentioned spirit. Demons will obey him and will reveal treasures).

152. In Greco-Roman myths the eagle is a symbol of Jupiter, which a number of lapidaria, such as Damigeron's, state clearly. Thus, even if it is not said, it can be safely assumed that this particular image was symbolic of Jupiter.

153. This is certainly an astrological image, as the hare stands for the constellation of Lepus.

154. Dolce (86) omitted *habentis in manu palmam*.

155. Another astrological image. Mandeville 10 suggests that this image was symbolic of the planet Venus.

156. Leonardi is most likely referencing the *Azareus*, a lapidary attributed to a mythical king Azareus. The text is a composite since it contains material from the Techel tradition. See Mesler, "Medieval Lapidary of Techel/Azareus."

157. Thetel, alias Cethel, Gethel, Fethel, Techel, Tethel, Téchef, and Ethel, is to be identified with Sahl ibn Bishr or Zahel Benbriz, a Jewish writer of the ninth century, who, as mentioned above, is believed to have been the first translator of Ptolemy's *Almagest* into Arabic. Medieval lapidaries often reference it, but Leonardi only lists eleven images, whereas Cantimpré listed thirty-one and Mandeville thirty-four. See Pingree, "Diffusion of Arabic Magical Texts," 67; and Mesler, "Medieval Lapidary of Techel/Azareus."

158. Thomas Cantimpré mentions a simple cross image, so it is quite possible that this entry is an abbreviation of a similar entry found in the lapidary attributed to Solomon. See Lecouteux, *Lapidary of Sacred Stones*.

159. An astrological image of the constellation Lupus. The description is similar the constellation of Lepus; see both the entry for *Lepus* and for *Hare*. Both are to be carved on jasper and both protect against deception, though in the case of Lepus it is made clear that demons are the originators of such deceptions or illusions.

160. Same virtues listed as for the constellation of the hunting dogs, Canes Venatici.

161. Dolce (86v) reads "La imagine di questo innocente animale" (the image of this innocent animal).

162. Instead of cygnus, as noted in the *Cignus* entry above.

163. This might be another image of Jupiter.

164. Dolce (87) added "insino ai piedi" (reaching to her feet).

165. The planet Venus.

166. An image of Venus; cf. Mandeville 2.1.9.

167. Leonardi seems to be using a manuscript related to Bodl., MS Digby 79, fols. 178v–179r attributed to Thetel. Confusion between Solomon's and Thetel's lapidary was quite common in the early modern period. Solomon was believed to have authored a book of spells and seals—the *Clavicula Salomonis*—and to have owned a magical ring that gave him power over demons. See Gal, *La magie dan sun manuel italien*; Gal, Boudet, and Moulinier-Brogi, *Vedrai mirabilia*; Véronèse, "La transmission groupée des textes de magie 'salomonienne'"; and MacGregor Mathers, *Key of Solomon the King*.

168. The use of the incipit letter suggests that Leonardi wanted his readers to understand that he was now reporting the exact wording of Solomon's text.

169. Corresponds to the seal of Mercury.

170. Corresponds to the seal of Mars.

192 NOTES TO PAGES 136–138

171. Dolce (87v) omitted translating *calchatricem*, which, according to the medieval Tuscan bestiary, denoted a large serpent; see Squillacioti, "Il Bestiario del *Tesoro* Toscano."

172. Corresponds to the seal of Jupiter.

173. The scientific name of Leonardi's *herba bethonica* is *Stachys officinalis*; it is also known as wood betony, purple betony, or common hedge nettle.

174. Corresponds to the seal of Venus.

175. Dolce (88r) stated instead that it must be set in gold. Corresponds to the seal of the moon.

176. Perhaps the seal of Capricorn.

177. An image of Hercules.

178. *Fragulae*, certainly an error. Earlier Leonardi had used *Vulturis Imago*. Digby 79, fol. 1789, reads *Turtur*; BL, Harleian 80, fol. 1052, reads *inveneris turturem et olive ramum tenentem*. Considering the prior sources, he probably meant to say either *vulturis* or *turturis imago*. Dolce (88r) repeated the error: "Fragola. Una figura di Fragola" (Strawberry. The image of a strawberry). It should clearly read "dove."

179. Dolce (88v) added "e del medesimo volere" (and be of your same mind).

180. Usually images of mermaids had pinecones in their hand, so it is possible that that this, too, might be a mistranslation of sorts.

181. Dolce (88v) added "e sarà invisibile a guisa di Angelica, quando chiudeva l'Anello in bocca" (and will become invisible like Angelica when she held the ring in her mouth). The reference is to a character in Ludovico Ariosto's *Orlando Furioso* (1516).

182. Boötes.

183. Most likely this is an image of the first decan of Taurus.

184. The inscription follows Solomon 15, but Dolce (89r) reports it differently by writing in two symbols that appear to be alchemica and that might derive from a deformation of alpha and omega: "BB, PP, N. E ⅃ and Ȣ." The formula as reported by Leonardi is likely a deformation of one that has come down to us in an Anglo-Saxon charm against evil witches and elvish trickery, dated to the tenth century: BeppNNIKNETTANI (BL, MS Royal, 12.D.xvii, fol. 52b). The formula also included the letters alpha and omega. Thus Dolce might have been familiar with this type of charm. Scholars have suggested that the charm includes, in Greek letters, the name Saint Veronica. See Storms, *Anglo-Saxon Magic*, 268–69; Cockayne, *Leechdoms, Wortcunning, and Starcraft of Early England*, 2:138–39; and Fisher, "Writing Charms," 191. Lecouteux mentions that Veronica was followed by GVTTANI, which recurs on a number of medieval objects and rings as THEBAL GVT GVTTANI. The charm is found on a Florentine silver broach, too. Such a charm seems to have been used against cramps and spams. See Lecouteux, *Dictionary of Ancient Magic*, 71, 145, 315; and Lecouteux, *High Magic of Talismans and Amulets*.

185. Dolce (89r) added "nella guerra sarai gran Capitano" (in war you will be a great captain).

186. Bodl. Digby 17.2.

187. Greek Basilisk would be the Latin Regulus, a star in the constellation of Leo.

188. Dolce (89r) simply stated "volendo combattere con alcuna bestia selvaggia" (if you wish to fight any wild beast).

189. Once again, it is likely that the original word was *idolum*, not *obulum*.

190. Dolce (90r) read it as *paragone* (paragon stone).

191. Dolce (90r) omitted *folium*.

192. Dolce (90r) simply stated "nella pietra dell'oro" (in the gold stone), suggesting that he thought it to be the paragon stone, that is, the philosophical stone that transmuted matter into gold.

193. Seal of Jupiter.

194. Dolce (90v) read *Lignum aloes* as if they were separate substances: "legno, aloe, e . . ." (wood, aloe, and . . .).

NOTES TO PAGES 138–141 193

195. *Polipodium* might be *polium* or *tecrium polium*—that is, felty germander—which was commonly used to treat a range of illnesses from indigestion to diabetes. *Polypodium vulgare* is also known as false licorice. Pliny (21.21) also mentions that it was useful for the acquisition of fame and honors.

196. Seal of Hermes.

197. A description of the constellation of Hydra with two mistranslations: *virum* instead of *urnam*, and *corium* instead of *corvum*. Dolce (90v) slightly expanded the entry by stating "e parimenti accorto e astuto" (and it will be equally shrewd and astute).

198. Dolce (91r) omitted this entire entry.

199. Dolce (92r) translated *Epilepticos* as "quei, che receuono sangue" (those who receive blood).

200. Dolce (92r) omits the note about the image having to be found engraved on an ethices stone.

201. Leopardi's *mutationem* is translated by Dolce (92r) as *la mutatione*. The meaning of the word in this context is unclear. Norman lapidaries translated it as "sword."

202. Dolce (92r) added "e legandosi in uno anello d'argento" (setting it on a silver ring).

203. A reference to the constellations of Ursa and Draco.

204. The constellation of Hercules.

205. Spica is the brightest star in the constellation of Virgo.

206. Mars and Venus are here conflated.

207. The whole entry is missing in Dolce (92v). Also cf. Albertus Magnus 3.5.

208. The last part of the sentence on charms is missing in Dolce (92v).

209. *Liber Hermetis de Quindecim Stellis quindecim lapidibus quindecim herbis et quindecim imaginibus* was also known as the *Quadripartite*. Leonardi does not report all fifteen images, but rather fourteen, skipping the image for Capricorn's tail. The same information is also reported by Agrippa in his *De occulta philosophia* 2.47. Leonardi is using the same source that Agrippa used, though he did not make any reference to herbs, specific stars, or magical symbols, which are instead found in Agrippa. Dolce (93r) added "ho volute esse ancora appresso l'altre aggiungere per piena sodisfation di coloro, che questa nostra fatica leggeranno" (I have wished to place these after the former to fully satisfy those wishing to read this great effort of ours).

210. Hermes 3; Algol or Beta of Perseus.

211. The last part of the sentence is missing in Dolce (93r).

212. Hermes 2; Pleiades.

213. Hermes 1; Aldebaran or Alpha Tauri.

214. Hermes 4; Alioth or Ursa Major.

215. Sirius, Canis Major, or Alhabor. Dolce (93r) reads "Cane. La figura d'un Leprettino scolpita in berillo, valle a grandissimi honori, et ricchezze" (Dog, the image of a little hare engraved on beryl lends great honors and wealth). Canis Leporini may be a mistranscription of Canis Alabor or Alhabor, which is thus understood as related to the word *lepor*. Ulisse Aldrovandi (1522–1605) in his *Monstrorum Historia* (529–30) describes a Canis Leporini and illustrated it on plate 3.

216. Algomeisa, Procyon, or Canis Minor.

217. Dolce (93r) omitted *apud homines*.

218. Arexal, Regulus, or Alpha Leonis. Lecouteux, *High Magic of Talismans and Amulets*, 159. The meaning of *murilage* is unclear. Dolce (93v) did not translate it either.

219. Algorab, the Raven's Wing.

220. Alaazel, Spica, or Alpha Virginis. Lecouteux, *High Magic of Talismans and Amulets*, 159.

221. Dolce (93v) translated "Aut hominis sedentis sub Centurione as un'huomo, che siede sopra un'altro huomo" (a man, sitting over another man). It is unclear what Leonardi means; it might be possible the author committed an error of transcription.

222. Alchameth, Arcturus, or Alpha Boötis.

NOTES TO PAGES 142–145

223. Alkaid, the tail of the Big Bear / Ursa Major. The figure of the bull in Hermes has become a wolf in Leonardi.

224. Corona Borealis, Alphecca, or Alfeca, also designated as Lucida because of its brightness. Lecouteux, *High Magic of Talismans and Amulets,* 159.

225. Dolce (93v) omitted *Deo et Hominibus.*

226. Antares or Alpha Scorpii.

227. Vega or Alpha Lyrae.

228. Though Leonardi appears to suggest that the following list comprises figures not listed above, most of them he had already described. In Dolce's text the list follows Leonardi's order until entry 5, after which Dolce inserted a number of images that do not appear in Leonardi's 1502 edition. Thus, whereas Leonardi's list comprises only twenty-two entries, Dolce's comprises thirty-one.

229. The constellation of the hunting dogs, Canes Venatici. Dolce (94r) translated "et illos qui in nocte hinc inde vagantur" solely as "e somiglianti" (and similar).

230. *Kyranides* 1.2; Damigeron 35.

231. Jupiter.

232. Venus.

233. Dolce (94r) omitted "ne in aqua submergetur." At this point, he also inserted thirteen entries that do not appear in Leonardi.

234. Mars and Venus. This entry is omitted in Dolce.

235. Orion. Dolce resumes following Leonardi's list with this entry, which appears at the bottom of the page in Dolce (95r).

236. Mars.

237. While the peacock is often cited in Mandeville, there appears to be no specific source for this particular image.

238. After this entry, Dolce inserted eighteen others; cf. Dolce (95v–96v).

239. Hercules. With this entry Dolce resumed following Leonardi. The entry appears toward the bottom of the page of Dolce (96v).

240. Cassiopea.

241. Dolce (96v) skipped *alacrem.*

242. Once again this is the constellation of the hunting dogs, Canes Venatici.

243. Dolce (97r) omitted *freneticum liberare.*

244. This image is associated with Venus in Mandeville 15.40.

245. Dolce (97r) omitted *in regione sua.*

246. Mercury.

247. Jupiter.

248. No specific source could be found for this image, though it is quite likely that it might be a decan, perhaps the second decan of Virgo, which could look like an ant. It could also be a reference to the Spica of Virgo.

249. Perhaps a reference to Alhabor as found in Hermes 5. The crown would be a reference to the Corona Borealis.

250. This stone was also referred to as alectorius, as stated in an earlier entry.

251. Pegasus.

252. Dolce (97r) inserted one more entry under the heading of *Gatta* (cat).

APPENDIX

1. All additions and omissions are noted in the annotated translation of Leonardi's original text.

2. The poet and dramaturg Apostolo Zeno (1668–1750) was perhaps the first to notice this appropriation, in a letter dated to December 7, 1737, addressed to Annibale degli Abati Olivieri;

see *Lettere di Apostolo Zeno*, 5:320. For a modern assessment of Dolce's literary activity and appropriations, see Terpening, *Lodovico Dolce*.

3. De Bellis, "Astri, gemme e arti."

4. Giovanni Battista Campeggi (1507–1583) was the son of the renown cardinal Lorenzo Campeggio (1474–1539). Just like his father, he studied law in Padua, where he earned his digree "in utroque iure" in 1532. He was elected bishop of Majorca in 1532, appointed in 1539, and ordained as its bishop in 1541.

5. Samuels, "Benedetto Varchi."

6. Terpening, *Lodovico Dolce*, 130.

7. Dolce 67v.

BIBLIOGRAPHY

ARCHIVAL COLLECTIONS

Biblioteca Apostolica Vaticana
Biblioteca Estense, Modena
Biblioteca Laurenziana di Firenze
Biblioteca Malatestiana di Cesena
Biblioteca Oliveriana, Pesaro (BOP)
Bodleian Library, Oxford (Bodl.)
British Library, London (BL)
British Museum, London

PRINTED SOURCES

Adams, Frank Dawson. *The Birth and Development of the Geological Sciences*. Baltimore: Williams and Wilkins, 1938.

Agricola, Georgius. *De re metallica libri XII*. Basel, 1556. Facsimile, Brussels, 1967.

Agrippa von Nettesheim, Cornelius Heinrich. *De occulta philosophia, libri tres*. Edited by Vittoria Perrone Compagni. Leiden: Brill, 1992.

——— [Henri Corneille-Agrippa]. *La Philosophie occulte, ou, la Magie*. Paris: Bibliothèque Chacornac, 1910–11.

———. *Three Books of Occult Philosophy*. Edited by Eric Purdue. Rochester, VT: Inner Traditions, 2021.

Akopyan, Ovanes. *Debating the Stars in the Italian Renaissance: Giovanni Pico della Mirandola's "Disputationes adversus astrologiam divinatricem" and Its Reception*. Leiden: Brill, 2021.

Alberti, Leon Battista. *On Painting and On Sculpture: The Latin Texts of "De Pictura" and "De Statua."* Edited and translated by Cecil Grayson. London: Phaidon, 1972.

Albertus Magnus. *Book of Minerals*. Translated by Dorothy Wyckoff. Oxford: Clarendon Press, 1967. https://archive.org/details/308059821ALBERTUSMAGNUSTheBookOf Minerals.

———. *De natura locorum*. Vienna: Hieronymus Vietor, 1514. https://play.google.com/books /reader?id=m3lSAAAAcAAJ&hl=en_US&pg=GBS.PP1.

———. *Meteora*. In *Alberti Magni Opera Omnia edenda curavit Institutum Alberti Magni Coloniense Bernhardo Geyer praeside*, book 6, vol. 1. Münster: Aschendorff, 1951–.

———. *Opera omnia*. Vol. 5. Edited by Auguste Borgnet. Paris: Vives, 1890.

Aldrovandi, Ulisse. *Monstrorum Historia, cum paralipomenis historiae omnium animalium*. Bologna: Nicola Tebaldini, 1642.

Alighieri, Dante. *La Divina Commedia*. Milan: Mondadori, 2007.

al-Kindi. *De radiis*. Edited by Marie-Thérèse d'Alverny and Françoise Hudry. Paris: J. Vrin, 1975.

198 BIBLIOGRAPHY

Alleman, James E., and Brooke T. Mossman. "Asbestos Revisited." *Scientific American*, July 1997.

Aquinas, Thomas. *Commentary on Aristotle's "De Anima."* Translated by Kenelm Foster, OP, and Sylvester Humphries, OP. New Haven, CT: Yale University Press, 1951. HTML version edited by Joseph Kenny, OP, https://isidore.co/aquinas/english/DeAnima .htm#11L.

———. *Summa theologica.* Edited and translated by Thomas Franklin O'Meara and Michael John Duffy. London: Eyre and Spottiswoode, 1958.

Aristotle. *De caelo.* Translated by J. L. Stocks. Oxford: Clarendon Press, 1922. https://archive .org/details/decaeloleofricooarisuoft/page/n5/mode/1up?view=theater.

———. *De meteora.* Translated by E. W. Webster. Internet Classics Archive by Daniel C. Stevenson, 1994–2009, http://classics.mit.edu/Aristotle/meteorology.1.i.html.

———. *De partibus animalium.* Translated by William Ogle. Internet Classics Archive by Daniel C. Stevenson, 1994–2009, http://classics.mit.edu/Aristotle/parts_animals .html.

———. "Liber Aristotelis de lapidibus." In *Das Steinbuch des Aristoteles*, edited by Julius Ruska, 127ff. Heidelberg: C. Winter, 1911.

———. *On Rhetoric.* Translated by W. Rhys Roberts. New York: Modern Library, 1954. http://classics.mit.edu/Aristotle/rhetoric.1.i.html.

———. *Physics.* Translated by R. P. Hardie and R. K. Gaye. Internet Classics Archive by Daniel C. Stevenson, 1994–2009, http://classics.mit.edu/Aristotle/physics.html.

Arnaldus Saxonis. *Die Enzyklopädie des Arnoldus Saxo.* Edited by Emil Stange. Erfurt: Bartholomäus, 1906.

———. *Liber de coloribus gemmarum.* Transcription and commentary by Claude Lecouteux. https://sites-recherche.univ-rennes2.fr/cetm/lapidaire/arnaldus.htm.

Attrell, Dan, and David Porreca, trans. *Picatrix: A Medieval Treatise on Astral Magic.* University Park: Penn State University Press, 2019.

Avicenna. *The Canon of Medicine.* New York: AMS Press, 1973. https://archive.org/stream /AvicennasCanonOfMedicine/9670940-Canon-of-Medicine_djvu.txt.

———. *De congelatione et conglutinatione lapidum.* Edited by Eric John Holmyard and Desmond Christopher Mandeville. Paris: Paul Geuthner, 1927.

———. *Liber canonis.* Venice: Pagininis, 1507.

Azzolini, Monica. *The Duke and the Stars: Astrology and Politics in Renaissance Milan.* I Tatti Studies in Italian Renaissance History. Cambridge, MA: Harvard University Press, 2013.

Baffioni Venturi, Luciano. *Alla ricerca della libreria perduta: La biblioteca di Giovanni Sforza, signore di Pesaro.* Pesaro: Metauro, 2013.

———. "Camillus Leonardus, medico e astrologo alla corte di Giovanni Sforza Signore di Pesaro." *Storie degli Sforza Pesaresi*, July 2019.

Ball, Sydney Hobart. *A Roman Book on Precious Stones: Including an English Modernization of the 37th Booke of the History of the World by C. Plinius Secundus.* Los Angeles: Gemological Institute of America, 1950.

Bartholomaeus Anglicus. *De rerum proprietatibus.* Frankfurt: Wolfgang Richter, 1601.

———. *Van den proprieteyten der dingen.* Haarle: J. Bellaert, 1485.

Bartlett Bridgman, Helen. *Gems.* Brooklyn, NY, 1916.

Bellucci, Giuseppe. *Il feticismo primitivo in Italia e le sue forme di adattamento.* Perugia: Unione Tipografica Cooperativa, 1907.

Belozerskaya, Marina. *Luxury Arts of the Renaissance.* Los Angeles: J. Paul Getty Museum, 2005.

Bertozzi, Marco. *La tirannia degli astri: Aby Warburg e l'astrologia di Palazzo Schifanoia.* Livorno: Sillabe, 1999.

———. *Lo zodiaco del principe: I decani di Schifanoia di Maurizio Bonora.* Ferrara: Tosi, 1992.

BIBLIOGRAPHY

Betz, Hans Dieter. *The Greek Magical Papyri in Translation, Including the Demotic Spells.* Vol. 1. 2nd ed. Chicago: University of Chicago Press, 1992.

Blake, Robert P., and Henri de Vis. *Epiphanius De Gemmis.* London: Christophers, 1934.

Boerhaave, Herman, attr. *An Essay on the Virtues and Efficient Cause of Magnetical Cures.* London, 1743.

Bonner, Campbell. *Studies in Magical Amulets, Chiefly Graeco-Egyptian.* Ann Arbor: University of Michigan Press, 1950.

Borschberg, Peter. "The Euro-Asian Trade in Bezoar Stones (Approx. 1500 to 1700)." In *Artistic and Cultural Exchanges Between Europe and Asia, 1400–1900: Rethinking Markets, Workshops and Collections,* edited by Michael North, 29–43. Farnham, UK: Ashgate, 2010.

Bourdeille, Pierre de. *Memoires de Messire Pierre de Bourdeille, Seigneur de Brantome: Contenans les vies des hommes illustres et grands capitaines estrangers de son temps.* Leiden: Jean Sambix, 1664.

Bradford, Sarah. *Cesare Borgia: His Life and Times.* London: Penguin, 1976.

Bradley, Ritamary. "Backgrounds of the Title *Speculum* in Medieval Literature." *Speculum* 29, no. 1 (1954): 100–115.

Brasavola, Antonio Musa. *Examen omnium simplicium medicamentorum, quorum in officinis usus est.* Lyon: Sub scuto Coloniensi, 1537.

Bremmer, Jan N., and Jan R. Veenstra, eds. *The Metamorphosis of Magic from Late Antiquity to the Early Modern Period.* Groningen Studies in Cultural Change 1. Leuven: Peeters, 2002.

Bridgeman, Jane, ed. and trans. *A Renaissance Wedding: The Celebrations at Pesaro for the Marriage of Costanzo Sforza and Camilla Marzano d'Aragona (26–30 May 1475).* Latin poems edited and translated by Alan Griffiths. London: Harvey Miller; Turnhout: Brepols, 2013.

Brown, Clifford M. "Isabella d'Este Gonzaga's 'Augustus and Livia' Cameo and the 'Alexander and Olympias' Gems in Vienna and Saint Petersburg." *Studies in the History of Art* 54 (1997): 84–107.

———. *Per dare qualche splendore a la gloriosa città di Mantua.* Rome: Bulzoni, 2002.

Burnett, Charles. *Magic and Divination in the Middle Ages: Texts and Techniques in the Islamic and Christian Worlds.* Aldershot, UK: Variorum, 1996.

Caley, Earle R., and John F. C. Richards. *Theophrastus on Stones: Introduction, Greek Text, English Translation, and Commentary.* Columbus: Ohio State University Press, 1956.

"Cambridge Lapidary." In Studer and Evans, *Anglo-Norman Lapidaries,* 154–200.

Campanini, Giuseppe, and Giuseppe Carboni. *Nomen: Il dizionario della lingua e della civiltà latina.* Milan: Paravia/Scriptorium, 2011.

Cannella, Anne-Françoise. *Gemmes, verre coloré, fausses pierres précieuses au Moyen Âge: Le quatrième livre du "Trésorier de philosophie naturelle des pierres précieuses" de Jean d'Outremeuse.* Bibliothèque de la Faculté de Philosophie et Lettres de l'Université de Liège 288. Liège: Université de Liège, 2006.

Cantalamessa, Leandro. *Astrologia: Opere a stampa (1472–1900).* Florence: Leo S. Olschki, 2007.

Capodieci, Luisa. *Medicaea Medaea: Art, astres et pouvoir à la cour de Catherine de Médicis.* Geneva: Droz, 2011.

Cappelli, Adriano. *Lexicon abbreviaturarum quae in lapidibus, codicibus et chartis praesertim medii-aevi occurrunt: Dizionario di abbreviature latine ed italiane usate nelle carte e codici specialmente del medio-evo.* Milan: Ulrico Hoepli, 1899.

Carmody, Francis J, ed. *The Astronomical Works of Thābit b. Qurra.* Berkeley: University of California Press, 1960.

———. *Phisiologus latinus versio Y.* University of California Publications in Classical Philology. Berkeley: University of California Press, 1941.

BIBLIOGRAPHY

Cellini, Benvenuto. *Autobiography*. London: Penguin, 1956.

———. *Due trattati, uno intorno alle otto principali arti dell'oreficeria*. Florence: Valente Panizzi and Marco Peri, 1568.

Chael. *Trinum Magicum, Sive Secretorum Magicorum*. In Camillo Leonardi, *Speculum Lapidum*, III, edited by Cesare Longinus, 94–103. Frankfurt: n.p., 1673.

Cicogna, Emmanuele Antonio. *Delle inscrizioni veneziane raccolte ed illustrate*. 6 vols. Venice: Giuseppe Picotti, 1830.

Ciriaco d'Ancona. *Cyriaci Anconitani nova fragmenta notis illustrate*. Pesaro: Gavellis, 1763. https://archive.org/details/bub_gb_CJp12QUfQB4C.

Clough, Cecil H. "A Note of Purchase of 1467 for Alessandro Sforza's Library in Pesaro." *Studia Oliveriana* 13–14 (1965–66): 171–78.

Cockayne, Thomas Oswald. *Leechdoms, Wortcunning, and Starcraft of Early England*. 3 vols. London: Longman, Green, Longman, Roberts and Green, 1864–66.

Cocks, Anna Somers, ed. *Princely Magnificence: Court Jewels of the Renaissance, 1500–1630*. London: Debrett's Peerage in association with the Victoria and Albert Museum, 1980.

Cohen, Simona. "Elisabetta Gonzaga and the Ambivalence of Scorpio in Medieval and Renaissance Art." *Magic, Ritual, and Witchcraft* 13, no. 3 (2018): 408–46.

Copenhaver, Brian P. *"Hermetica": The Greek "Corpus Hermeticum" and the Latin "Asclepius" in a New English Translation, with Notes and Introduction*. Cambridge: Cambridge University Press, 1995.

———. "Scholastic Philosophy and Renaissance Magic in the *De vita* of Marsilio Ficino." *Renaissance Quarterly* 37, no. 4 (1984): 523–54.

Damigeron. "Les lapidaires grecs." In *Les lapidaires grecs*, 191–290.

de Bellis, Carla. "Astri, gemme e arti medico-magiche nello speculum Lapidum di Camillo Leonardi." In *Il mago, il cosmo, il teatro degli astri: Saggi sulla letteratura esoterica del Rinascimento*, edited by Gianfranco Formichetti, 67–114. Rome: Bulzoni, 1985.

Delatte, Armand, and Philippe Derchain. *Les intailles magiques gréco-égyptiennes*. Paris: Bibliothèque nationale de France, 1964.

Delatte, Louis, ed. *Textes latins et vieux français relatifs aux Cyranides*. Bibliothèque de la faculté de philosophie et lettres de l'université de Liège. Liège: E. Droz, 1942.

Demaitre, Luke. *Medieval Medicine: The Art of Healing, from Head to Toe*. Santa Barbara, CA: Praeger, 2013.

Dioscorides. *Pedanii Dioscuridis Anazarbei De materia medica libri quinque*. Edited by Max Wellmann. 3 vols. Berlin: Weidmann, 1958.

Dodoens, Rembert. *Stirpium Historiae Pemptades VI, sive Libri XXX*. Antwerp, 1583.

Dolce, Lodovico. *Libri tre di m. Lodovico Dolce, nei quali si tratta delle diverse sorti delle gemme che produce la natura, della qualità, grandezza, bellezza e virtù loro*. Venice: Giovan Battista, Marchio Sessa et Fratelli, 1565.

Draelants, Isabelle. "The Notion of Properties: Tensions Between *Scientia* and *Ars* in Medieval Natural Philosophy and Magic." In Page and Rider, *Routledge History of Medieval Magic*, 169–86.

Duling, Dennis C. "Testament of Solomon." In *The Old Testament Pseudepigrapha*, edited by J. H. Charlesworth, 935–88. Garden City, NY: Doubleday, 2010.

Ebeling, Florian. *The Secret History of Hermes Trismegistus: Hermeticism from Ancient to Modern Times*. Ithaca, NY: Cornell University Press, 2005.

Evans, Joan. *Magical Jewels of the Middle Ages and the Renaissance, Particularly in England*. Oxford: Oxford University Press, 1922.

Fanger, Claire. "Introduction: Theurgy, Magic, and Mysticism." In Fanger, *Invoking Angels*, 1–33.

———, ed. *Invoking Angels: Theurgic Ideas and Practices, Thirteenth to Sixteenth Centuries*. University Park: Penn State University Press, 2012.

Federici Vescovini, Graziella. "Gli affreschi astrologici del Palazzo Schifanoia e l'astrologia alla corte dei duchi d'Este tra Medioevo e Rinascimento." In *L'art de la Renaissance*

entre science et magie, edited by Francesca Alberti and Virginie Schmitt, 55–82. Rome: Académie de France à Rome, 2006.

Ferrari, Daniela. "Appendice: Elenchi degli orefici di Mantova dagli statuti dell'arte (1310–1694)." In *Il cammeo Gonzaga: Arti preziose alla corte di Mantova*, edited by Ornella Casazza, 119–27. Milan: Skira, 2008.

Fisher, Rebecca. "Writing Charms: The Transmission and Performance of Charms in Anglo-Saxon England." PhD diss., University of Sheffield, 2011.

Flint, Valerie. *The Rise of Magic in Early Medieval Europe*. Princeton, NJ: Princeton University Press, 1991.

Fobes, Harriet Keith. *Mystic Gems*. Boston: R. G. Badger, 1924.

Freitas, Robert A., Jr. "Mechanical Damage from Ingested Diamond." In *Nanomedicine, Volume IIA: Biocompatibility*. Georgetown, TX: Landes Bioscience, 2003. http://www.nanomedicine.com/NMIIA/15.1.1.htm.

Fricke, Beate. "Making Marvels—Faking Matter: Mediating *Virtus* Between the Bezoar and Goa Stones and Their Containers." In *The Nomadic Object: The Challenge of World for Early Modern Religious Art*, edited by Christine Göttler and Mia M. Mochizuki, 342–67. Intersections 53. Leiden: Brill, 2017.

Frieda, Leonie. *Catherine de Medici: Renaissance Queen of France*. London: Weidenfeld & Nicolson, 2003.

Gabelchover, Wolfgang. *Curationum et observationum medicinalium centuriae*. 2 vols. Frankfurt and Tubingen, 1611–27.

Gaffarel, Jaques. *Curiositez inouyes, sur la sculpture des Persans, horoscope des patriarches et lecture des estoilles*. Paris: Hervé de Mesnil, 1629.

———. *Unheard-of Curiosities: Concerning the Talismanical Sculpture of the Persians; the Horoscope of the Patriarkes; and the Reading of the Stars*. Translated by Edmund Chilmead. London: Humphrey Mosely, 1650.

Gal, Florence. *La magie dans un manuel italien du milieu du XVe siècle*. Paris: Université Paris Nanterre, 2002.

Gal, Florence, Jean-Patrice Boudet, and Laurence Moulinier-Brogi. *Vedrai mirabilia: Un libro di magia del Quattrocento*. Rome: Viella, 2017.

Galen. *Method of Medicine*. Edited and translated by Ian Johnston and G. H. R. Horsley. Cambridge, MA: Harvard University Press, 2015.

Garin, Eugenio. *Astrology in the Renaissance: The Zodiac of Life*. London: Routledge & Kegan Paul, 1983.

———. "Giudizi artistici di Cammillo Lunardi." *Rinascimento* 2 (June 1951): 191–92.

Gennaioli, Riccardo. *Le gemme dei Medici al Museo degli argenti*. Florence: Firenze Musei and Giunti, 2007.

Gontero-Lauze, Valérie. *Sagesses minérales: Médecine et magie des pierres précieuses au Moyen Âge*. Paris: Éditions Classiques Garnier, 2010.

Gosselin, Pascal-Francois-Joseph. *Géographie des grecs analysée*. Paris: Didot l'Aîné, 1790.

Gouldman, Francis. *Copious Dictionary in Three Parts*. London: John Field, 1664.

Grant, Edward. *Planets, Stars, and Orbs: The Medieval Cosmos, 1200–1687*. Cambridge: Cambridge University Press, 1994.

Green, Nile. "Ostrich Eggs and Peacock Feathers: Sacred Objects as Cultural Exchange Between Christianity and Islam." *Journal of the Medieval Mediterranean* 18, no. 1 (2006): 27–78.

Greenblatt, Stephen. *The Swerve: How the World Became Modern*. New York: W. W. Norton, 2012.

Greer, John Michael, and Christopher Warnock, trans. *The Complete "Picatrix": The Occult Classic of Astrological Magic*. Iowa City: Adocentyn Press, 2011.

Grillot de Givry, Emile. *Witchcraft, Magic, and Alchemy*. Translated by J. Courtenay Locke. Mineola, NY: Dover, 2009.

Gruenwald, Ithamar. *Apocalyptic and Merkavah Mysticism*. Leiden: Brill, 1980.

Halfond, Gregory. "*Tenebrae Refulgeant*: Celestial *Signa* in Gregory of Tours." *Heroic Age* 15 (October 2012). http://www.heroicage.org/issues/15/halfond.php.

Harris, Nichola Erin. "The Idea of Lapidary Medicine: Its Circulation and Practical Applications in Medieval and Early Modern England, 1000–1750." PhD diss., Rutgers University, 2009.

———. "Loadstones Are a Girl's Best Friend: Lapidary Cures, Midwives and Manuals of Popular Healing in Medieval and Early Modern England." In *The Sacred and the Secular in Medieval Healing: Sites, Objects, and Texts*, edited by Barbara S. Bowers and Linda Migl Keyser, 182–218. London: Routledge, 2016.

Heilen, Stephan. "Lorenzo Bonincontri's Reception of Manilius' Chapter on Comets (*Astr.* 1.809–926)." In *Forgotten Stars: Rediscovering Manilius' "Astronomica,"* edited by Steven J. Green and Katharina Volk, 278–310. Oxford: Oxford University Press, 2011.

Hendrix, John Shannon, and Charles H. Carman, eds. *Renaissance Theories of Vision.* Farnham, UK: Ashgate, 2010.

Henig, Martin. *Classical Gems: Ancient and Modern Intaglios and Cameos in the Fitzwilliam Museum, Cambridge.* Cambridge: Cambridge University Press, 1994.

Hermes. *Trinum magicum.* Edited by Cesare Longinus. Frankfurt: Conrad Eifridi, 1673.

Hildegard von Bingen. *Das Buch von den Steinen.* Translated by Peter Riethe. Salzburg: Otto Müller Verlag, 2006.

———. *Physica.* In *Patrologia Latina*, vol. 197, ed. Jacques-Paul Migne, 1247–66. Paris: Garnier, 1882.

———. *Physica.* Translated by Priscilla Throop. Rochester, VT: Inner Traditions, 1998.

Hill, George. *Medals of the Renaissance.* Revised and enlarged by Graham Pollard. London: British Museum Publications, 1978.

Hills, Paul. *Venetian Colour: Marble, Mosaic, Painting and Glass, 1250–1550.* New Haven, CT: Yale University Press, 1999.

Hindman, Sandra, with Ilaria Fatone and Angélique Laurent-di Mantova. *Toward an Art History of Medieval Rings: A Private Collection.* London: Paul Holberton, 2014.

Horace. *Satires, Epistles, and Ars Poetica.* Edited by H. Rushton Fairclough. Cambridge, MA: Harvard University Press, 1929. http://www.perseus.tufts.edu/hopper/text?doc=Perseus%3Atext%3A2008.01.0539%3Abook%3D1%3Apoem%3D14.

Hortus sanitatis. Mainz: Jacob Meydenbach, 1491.

Isidore of Seville [Isidori Hispalensis Episcopi]. *Etymologiarum sivi Originum libri XX.* Vol. 2. Edited by Wallace Martin Lindsay. Oxford: Oxford University Press, 1911.

———. *The Etymologies of Isidore of Seville.* Edited and translated by Stephen A. Barney, W. J. Lewis, J. A. Beach, and Oliver Berghof. Cambridge: Cambridge University Press, 2007.

Janson, Horst W. "The 'Image Made by Chance' in Renaissance Thought." In *De Artibus Opuscula XL: Essays in Honor of Erwin Panofsky*, edited by Millard Meiss, 1:254–66. New York: New York University Press, 1961.

Juste, David. "The Impact of Arabic Sources on European Astrology: Some Facts and Numbers." *Micrologus* 24 (2016): 173–94.

Juste, David, Benno van Dalen, Dag Nikolaus Hasse, and Charles Burnett, eds. *Ptolemy's Science of the Stars in the Middle Ages.* Turnhout: Brepols, 2020.

Kay, Paul, Brent Berlin, Luisa Maffi, and William Merrifield. "Color Naming Across Languages." In *Color Categories in Thought and Language*, edited by C. L. Hardin and Luisa Maffi, 21–56. Cambridge: Cambridge University Press, 1997.

Kemp, Martin, ed. *Leonardo on Painting.* New Haven, CT: Yale University Press, 1989.

Kieckhefer, Richard. *Magic in the Middle Ages.* 2nd ed. Cambridge: Cambridge University Press, 2014.

———. "The Specific Rationality of Medieval Magic." *American Historical Review* 99, no. 3 (1994): 813–36.

Klaassen, Frank. *The Transformations of Magic: Illicit Learned Magic in the Later Middle Ages and Renaissance.* University Park: Penn State University Press, 2015.

Knight, Jeffrey Todd. *Bound to Read: Compilations, Collections, and the Making of Renaissance Literature*. Philadelphia: University of Pennsylvania Press, 2013.

Knuth, Bruce G. *Gems in Myth, Legend, and Lore*. Parachute, CO: Jewelers Press, 2007.

Kornbluth, Genevra. *Engraved Gems of the Carolingian Empire*. University Park: Penn State University Press, 1995.

Kozminsky, Isidore. *Crystals, Jewels, Stones: Magic and Science*. 1922. Reprint, Lake Worth, FL: Ibis Press, 2012.

Kunz, George Frederick. *The Curious Lore of Precious Stones*. Philadelphia: J. B. Lippincott Company, 1913.

Die Kyraniden. Edited by Dimitris Kaimakis. Meisenheim am Glan: Anton Hain, 1976.

Lapidaires astrologiques. Transcription with commentary by Claude Lecouteux. Accessed December 11, 2022. https://www.sites.univ-rennes2.fr/celam/cetm/lapidaire/lapidaires_astrologiques.html. [Attributed to Ragiel, Chael, Hermès, and Solomon.]

Les lapidaires grecs: Lapidaire orphique, kérygmes lapidaires d'Orphée, Socrate et Denys, lapidaire nautique, Damigéron-Evax. Translated by Robert Halleux and Jacques Schamp. Paris: Les Belles Lettres, 1985.

Lecouteux, Claude. *Dictionary of Ancient Magic Words and Spells: From Abraxas to Zoar*. Rochester, VT: Inner Traditions, 2014.

———. *The High Magic of Talismans and Amulets: Tradition and Craft*. Rochester, VT: Inner Traditions, 2005.

———. *A Lapidary of Sacred Stones: Their Magical and Medicinal Powers Based on the Earliest Sources*. Translated by Jon E. Graham. Rochester, VT: Inner Traditions, 2012.

Lemay, Richard. "Origin and Success of the *Kitab Thamara* of Abu Jafar ibn Yusuf ibn Ibrahim: From the Tenth to the Seventeenth Century in the World of Islam and the Latin West." In *Proceedings of the First International Symposium for the History of Arabic Science, April 5–12, 1976*, edited by Ahmad Yusuf Al-Hassan et al., 2:91–107. Aleppo: Aleppo University, 1978.

Leonardi, Camillo. *De Lapidibus Liber Secundus*. Transcription of book 2, chap. 7, of Camillo Leonardi's *Speculum Lapidum*, with commentary. https://sites-recherche.univ-rennes2.fr/cetm/lapidaire/leonardi%20de%20lapidibus%202.html.

———. *De Lapidibus Liber Tertius*. Transcribed, edited, and annotated by Claude Lecouteux. https://sites-recherche.univ-rennes2.fr/cetm/lapidaire/leonardi_de_lapidibus.htm.

———. *The Mirror of Stones*. [Translated by U.E.T.] London: J. Freeman, 1750.

———. *The Mirror of Stones: Speculum Lapidum, Book III*. Translated and annotated by Margherita Fiorello. Tumwater, WA: Revelore Press, 2022.

———. *Les pierres talismaniques: "Speculum Lapidum," livre III*. Edited, translated, and annotated by Claude Lecouteux and Anne Monfort. Paris: Presses de l'université Paris–Sorbonne, 2002.

———. *Speculum Lapidum*. Venice: Giovan Battista Sessa, 1502.

———. *Speculum Lapidum*. Venice: Giovan Battista Sessa, 1516.

———. *Tehorice planetarum nuper aedite cum declarationibus additionibus ac figuris peroptime sicnatis quae sine aliquo commento intellegi possunt*. Pesaro: Hieronymum Soncinum, 1508. https://archive.org/details/bub_gb_Q8wtJjAbZ1YC/mode/2up.

Lettinck, Paul. *Aristotle's Meteorology and Its Reception in the Arab World*. Leiden: Brill, 1999.

Lewis, Charlton T. *An Elementary Latin Dictionary*. Oxford: Oxford University Press, 1981.

"Liber Hermetis de Quindecim Stellis quindecim lapidibus quindecim herbis et quindecim imaginibus." In *Textes latins et veiux Français relatifs aux Cyranides*, edited by Louis Delatte, 237–89. Bibliothèque de la faculté de philosophie et lettres de l'université de Liège. Liège: E. Droz, 1942.

Liber ordinis rerum (esse-essencia-glossar). Edited by Peter Schmitt. 2 vols. Tübingen: Niemeyer Verlag, 1983.

Liber Sigillorum Ethel. Ms. Digby 79, fol. 178ff. University of Oxford, Bodleian Library.

Liber Sigillorum Techel [*Tethel*]. In *Thomas Cantimpratensis, "De Natura Rerum I,"* edited by Helmut Boese, 371–73. Berlin: De Gruyter, 1973.

Lieberknecht, Sieglinde. *Die "Canones" des Pseudo-Mesue: Eine mittelalterliche Purgantien-Lehre.* Quellen und Studien zur Geschichte der Pharmazie 71. Stuttgart: Wissenschaftliche Verlagsgesellschaft, 1995.

Lindberg, David Charles. *Theories of Vision from al-Kindi to Kepler.* Chicago: University of Chicago Press, 1981.

MacGregor Mathers, S. L. *The Key of Solomon the King: A Magical Grimoire of Sigils and Rituals for Summoning and Mastering Spirits; "Clavicula Salomonis."* San Francisco: Weiser Books, 2016.

Mandeville, John. *The Travels of Sir John Mandeville.* [London, 1496.] Early English Books Online Text Creation Partnership, http://name.umdl.umich.edu/A06811.0001.001.

Manfredi, Antonio, Francesca Curzi, and Stefania Laudoni, eds. *Per una storia delle biblioteche dall'antichità al primo Rinascimento.* Vatican City: Biblioteca Apostolica Vaticana, 2019.

Manzalaoui, Mahmoud. "The Pseudo-Aristotelian *Kitāb Sirr al-asrār*: Facts and Problems." *Oriens* 23–24 (1974): 147–257.

Marbode of Rennes. *De lapidibus.* Edited by John M. Riddle. Wiesbaden: Franz Steiner Verlag, 1977.

Margalioth, Mordecai. *Sefer Ha-Razim.* Jerusalem: Keter, 1972.

Massinelli, Anna Maria, and Filippo Tuena. *Treasures of the Medici.* New York: Vendome Press, 1992.

Mastrocinque, Attilio. "Le gemme gnostiche." In *Sylloge Gemmarum Gnosticarum*, edited by Attilio Mastrocinque, 49–112. Rome: Istituto Poligrafico e Zecca dello Stato, 2003.

———. *Gemme gnostiche e cultura ellenistica: Atti dell'Incontro di studio: Verona, 22–23 ottobre 1999.* Bologna: Pàtron, 2002.

———. *Les intailles magiques du département des Monnaies, Médailles et Antiques.* Paris: Bibliothèque nationale de France, 2014.

———. *Kronos, Shiva, and Asklepios: Studies in Magical Gems and Religions of the Roman Empire.* Philadelphia: American Philosophical Society, 2011.

———, ed. *Sylloge Gemmarum Gnosticarum.* Bollettino di Numismatica Monografia, Part 1. Rome: Istituto Poligrafico e Zecca dello Stato, 2003.

McLaughlin, Martin L. *Literary Imitation in the Italian Renaissance: The Theory and Practice of Literary Imitation in Italy from Dante to Bembo.* Oxford: Clarendon Press, 1995.

McVaugh, Michael. "The 'Humidum Radicale' in Thirteenth-Century Medicine." *Traditio* 30 (1974): 259–83.

Mély, Fernand de. *Les lapidaires de l'antiquité et du Moyen Âge.* 3 vols. Paris: Ernest Leroux, 1898–1902.

Mesler, Katelyn. "The Medieval Lapidary of Techel/Azareus on Engraved Stones and Its Jewish Appropriations." *Aleph* 14, no. 2 (2014): 75–143.

Michel, Simone, Peter Zazoff, and Hilde Zazoff. *Die magischen Gemmen im Britischen Museum.* London: British Museum Press, 2001.

Mirabella, Bella, ed. *Ornamentalism: The Art of Renaissance Accessories.* Ann Arbor: University of Michigan Press, 2011.

Möbius, Hans. *Alexandria und Rom.* Munich: Verlag der Bayerischen Akademie der Wissenschaften, in Kommission bei Beck, 1964.

Monaca, Mariangela. "Gemme magiche e divinazione." In *Gemme gnostiche e cultura ellenistica: Atti dell'Incontro di studio: Verona, 22–23 ottobre 1999*, edited by Attilio Mastrocinque, 135–52. Bologna: Pàtron, 2002.

Moore, Thomas. *The Planets Within: The Astrological Psychology of Marsilio Ficino.* Hudson, NY: Lindisfarne Press, 1990.

Morel, Philippe. *Mélissa: Magie, astres et démons dans l'art italien de la Renaissance.* Paris: Hazan, 2008.

Morgan, Michael A., trans. *"Sepher Ha-Razim": The Book of the Mysteries.* Chico, CA: Scholars Press, 1983.

Morra, Eloisa. *Building the Canon Through the Classics: Imitation and Variation in Renaissance Italy (1350–1580)*. Leiden: Brill, 2019.

Nagy, Arpad. "*Daktylios pharmatikes*: Magical Healing Gems and Rings in the Graeco-Roman World." In *Ritual Healing: Magic, Ritual and Medical Therapy from Antiquity Until the Early Modern Period*, edited by Ildikó Csepregi and Charles Burnett, 71–106. Florence: Edizioni del Galluzzo, 2021.

Neckam, Alexander. *"De naturis rerum, libri duo," with the Poem of the Same Author, "De laudibus divinae sapientiae."* Edited by Thomas Wright. London: Longman, Roberts, and Green, 1863. https://archive.org/details/alexandrineckamooneckgoog/page/n4/mode/2up?view=theater.

Newman, Harold. *An Illustrated Dictionary of Jewelry*. London: Thames and Hudson, 1994.

Newman, William R., and Anthony Grafton, eds. *Secrets of Nature: Astrology and Alchemy in Early Modern Europe*. Cambridge, MA: The MIT Press, 2001.

Newton, Isaac. *Index Chemicus Ordinatus*. https://docplayer.net/86480513-Index-chemicus-ordinatus.html.

Nicols, Thomas. *A Lapidary, or the History of Pretious Stones*. Cambridge: Thomas Buck, 1652.

North, John D. "Celestial Influence: The Major Premiss of Astrology." In *"Astrologi hallucinati": Stars and the End of the World in Luther's Time*, edited by Paola Zambelli, 45–100. Berlin: De Gruyter, 1986.

North, Michael, ed. *Artistic and Cultural Exchanges Between Europe and Asia, 1400–1900: Rethinking Markets, Workshops and Collections*. Farnham, UK: Ashgate, 2010.

Le nozze di Costanzo Sforza con Camilla di Aragona, celebrate in Pesaro nel M.CCCC.LXXV. Edited by B. Gamba. Venice: Tipografia di Alvisopoli, 1836.

Olcott, Marianina Demetri. "Tacitus on the Ancient Amber-Gatherers: A Re-evaluation of Germania." *Journal of Baltic Studies* 16 (1985): 302–15.

Orpheus. "Kérygmes Lapidaire d'Orphée." In *Les lapidaires grecs*, 125–78.

———. "Lapidaire Orphique." In *Les lapidaires grecs*, 1–124.

Otte, James K. "An Anonymous Oxford Commentary on Aristotle's '*De generatione et corruptione*.'" *Traditio* 46 (1991): 326–36.

Otto, Bernd-Christian, and Michael Stausberg, eds. *Defining Magic: A Reader*. Sheffield, UK: Equinox, 2013.

Outremeuse, Jean d'. *Tresorier de philosophie naturelle des pierres precieuses*. https://gallica.bnf.fr/ark:/12148/btv1b90608081/f1.item#.

Page, Sophie. "A Late Medieval Demonic Invasion of the Heavens." In *The Sacred and the Sinister: Studies in Medieval Religion and Magic*, edited by David J. Collins, 233–54. University Park: Penn State University Press, 2019.

———. "Love in a Time of Demons: Magic and the Medieval Cosmos." In *Spellbound: Magic, Ritual and Witchcraft*, edited by Sophie Page, Marina Wallace, Owen Davies, Malcom Gaskill, and Ceri Houlbrook, 19–63. Oxford: Ashmolean Museum, University of Oxford, 2018.

———. "Uplifting Souls: The *Liber de essentia spirituum* and the *Liber Razielis*." In Fanger, *Invoking Angels*, 79–112.

Page, Sophie, and Catherine Rider, eds. *The Routledge History of Medieval Magic*. Abingdon, UK: Routledge, 2019.

Pagel, Walter. "Paracelsus and Techellus the Jew." *Bulletin of the History of Medicine* 34, no. 3 (1960): 274–77.

Paravicini Bagliani, Agostino. *Medicina e scienze della natura alla corte dei papi nel Duecento*. Spoleto: Centro Italiano di Studi sull'Alto Medioevo, 1991.

Parkinson, John. *Theatrum Botanicum*. London: Tho. Cotes, 1640.

Péladan, Joséphine. "Le précurseur de Michel-Ange, Luca Signorelli." *Revue Bleu* 40, no. 2 (1903): 84–90.

Perea Yébenes, Sabino. "Magic at Sea: Amulets for Navigation." In *Magical Practice in the Latin West: Papers from the International Conference Held at the University of*

Zaragoza, 30 Sept.–1 Oct. 2005, edited by Richard Lindsay Gordon and Francisco Marco Simón, 457–86. Leiden: Brill, 2010.

Perrone Compagni, Vittoria. "La magia ermetica tra Medioevo e Rinascimento." In *La magia nell'Europa moderna: Tra antica sapienza e filosofia naturale: Atti del convegno, Firenze, 2–4 ottobre 2003*, edited by Fabrizio Meroi with Elisabetta Scapparone, 3–24. Florence: Leo S. Olschki, 2007.

Philip, Alexander. "*Sefer ha-Razim* and the Problem of Black Magic in Early Judaism." In *Magic in the Biblical World: From the Rod of Aaron to the Ring of Solomon*, edited by Todd Klutz, 170–90. Journal for the Study of the New Testament Supplement Series 245. London: T & T Clark International, 2003.

Philostratus. *Life of Apollonius of Tyana*. Edited and translated by Christopher P. Jones. Loeb Classical Library. 2 vols. Cambridge, MA: Harvard University Press, 2005.

Physiologus. *A Medieval Book of Nature Lore*. Translated by Michael J. Curley. Chicago: University of Chicago Press, 1979.

Pingree, David, ed. "The Diffusion of Arabic Magical Texts in Western Europe." In *La diffusione delle scienze islamiche nel medio evo europeo (Roma, 2–4 ottobre 1984): Convegno internazionale promosso dall'Accademia Nazionale dei Lincei*, 57–102. Roma: Accademia Nazionale dei Lincei, 1987.

———, trans. *Picatrix: The Latin Version of the Ghayat al-Hakim*. London: Warburg Institute, 1986.

Pliny the Elder. *Historiae naturalis*. Edited by Ludwig Jan. 6 vols. Leipzig: Teubner, 1865–78.

———. *Historiae naturalis libri XXXVII: Pars secunda continens Geographiam*. Edited by Felix Ansart. Paris: N. E. Lamaire, 1828.

———. *Natural History*. Translated by John Bostock and H. T. Riley. London: Taylor and Francis, 1855. http://www.perseus.tufts.edu/hopper/text?doc=Plin.+Nat.+toc.

Pointon, Marcia. *Brilliant Effects: A Cultural History of Gem Stones and Jewellery*. New Haven, CT: Paul Mellon Centre for Studies in British Art and Yale University Press, 2009.

[Pseudo-Dioscorides]. "Perì lithon." In *Les lapidaires de l'antiquité et du Moyen Âge*, by Fernand de Mély, 3:35–46. Paris: Ernest Leroux, 1898–1902.

[Pseudo-Ptolemy]. *Ptolemy's Centiloquium*. Translated by Henry Coley (1676). Transcribed and annotated by Deborah Houlding (2006). https://www.skyscript.co.uk/centilo quium1.html.

Ptolemy. *Tetrabiblos*. Translated by F. E. Robbins. Loeb Classical Library. Cambridge, MA: Harvard University Press, 1940.

Ragiel. *Trinum Magicum, Sive Secretorum Magicorum Opus*. In *Speculum Lapidum II*, by Camillo Leonardi, edited by Cesare Longinus. n.p.: n.d.

Rampling, Jennifer, and Peter M. Jones, eds. *Alchemy and Medicine from Antiquity to the Enlightenment*. London: Routledge, 2017.

Rebiger, Bill, and Peter Schäfer, eds. *Sefer ha-Razim I und II: Das Buch der Geheimnisse I und II*. 2 vols. Tübingen: Mohr Siebeck, 2009.

Renzi, Salvatore de, ed. *Collectio Salernitana*. 5 vols. Naples: Filiatre-Sebezio, 1852–59.

Riddle, John M. "Lithotherapy in the Middle Ages: Lapidaries Considered as Medical Texts." *Pharmacy in History* 12, no. 2 (1970): 39–50.

Riddle, John M., and James A. Mulholland. "Albert on Stones and Minerals." In *Albertus Magnus and the Sciences, Commemorative Essays, 1980*, edited by James A. Weisheipl, 203–34. Toronto: Pontifical Institute of Mediaeval Studies, 1980.

Ross, E. Denison. "Prester John and the Empire of Ethiopia." In *Travel and Travellers of the Middle Ages*, edited by Arthur P. Newton, 174–94. 1926. Reprint, London: Routledge, 1996.

Rossi, Roberto. *Montelabbate. Memorie di una Comunità: Dalle Origini all'Inizio del XX Secolo*. Urbania: Grafiche Stibu, 2002.

Roy, Bruno. "Richard de Fournival, auteur du *Speculum Astronomiae?*" *Archives d'histoire doctrinale et littéraire du Moyen Âge* 67 (2000): 159–80.

Rutkin, H. Darrel. *Sapientia Astrologica: Astrology, Magic and Natural Knowledge, ca. 1250–1800.* Cham: Springer Nature Switzerland, 2019.

Sabatini, Rafael. *The Life of Cesare Borgia.* London: Stanley Paul, 1912.

Samerio Barroso, Maria do. "Bezoar Stones, Magic, Science and Art." In *A History of Geology and Medicine*, edited by C. J. Duffin, R. T. J. Moody, and C. Gardner-Thorpe, 193–207. Geological Society Special Publication 375. London: Geological Society, 2013.

Samuels, Richard S. "Benedetto Varchi, the Accademia degli Infiammati, and the Origins of the Italian Academic Movement." *Renaissance Quarterly* 29, no. 4 (1976): 599–634.

Scarisbrick, Diana. *Jewellery in Britain, 1066–1837: A Documentary, Social, Literary and Artistic Survey.* Norwich, UK: Michael Russell, 1994.

———. *Rings: Jewelry of Power, Love and Loyalty.* London: Thames and Hudson, 2007.

———. *Tudor and Jacobean Jewelry.* London: Tate, 1995.

Schulman, Jana K., ed. *The Rise of the Medieval World, 500–1300: A Biographical Dictionary.* Westport, CT: Greenwood Press, 2002.

Seneca. *Epistles.* Vol. 2, *Epistles 66–92.* Translated by Richard M. Gummere. Loeb Classical Library 76. Cambridge, MA: Harvard University Press, 1920.

Signorini, Rodolfo. *Fortuna dell'astrologia a Mantova: Arte, letteratura, carte d'archivio.* Mantua: Sometti, 2007.

Sinkankas, John. *Emerald and Other Beryls.* Prescott, AZ: Geoscience Press, 1989.

Slessarev, Vsevolod. *Prester John: The Letter and the Legend.* Minneapolis: University of Minnesota Press, 1959.

Slifkin, Natan. *Sacred Monsters: Mysterious and Mythical Creatures of Scripture, Talmud, and Midrash.* Jerusalem: Zoo Torah, 2007.

Solinus, Caius Iulius. *Collectanea rerum memorabilium.* Edited by Theodor Mommsen. Dublin: Weidmann, 1979.

Solomon. *Trinum Magicum.* In Camillo Leonardi, *Speculum Lapidum III*, edited by Cesare Longinus. Venice, 1502.

Soprani, Raffaele. *Delle vite de' pittori, scultori ed architetti genovesi.* Genoa: Giuseppe Bottaro and Giovan Battista Tiboldi, 1674.

Soranzo, Matteo. *Poetry and Identity in Quattrocento Naples.* London: Routledge, 2014.

Spezi, Giuseppe. *Lettere inedite del card. Pietro Bembo e di altri scrittori del secolo XVI.* Rome: Tipografia delle scienze matematiche e fisiche, 1862.

Spink and Son. *Numismatic Circular* 14, no. 9456 (1906).

Squillacioti, Paolo. "Il Bestiario del *Tesoro* Toscano nel ms. Plut XLII 22." *Bollettino dell'Opera del Vocabolario Italiano* 12 (2007): 265–353.

Stapleford, Richard, ed. and trans. *Lorenzo de' Medici at Home: The Inventory of the Palazzo Medici in 1492.* University Park: Penn State University Press, 2013.

Stephenson, Marcia. "From Marvelous Antidote to the Poison of Idolatry: The Transatlantic Role of Andean Bezoar Stones During the Late Sixteenth and Early Seventeenth Centuries." *Hispanic American Historical Review* 90, no. 1 (2010): 2–39.

Storms, Godfrid. *Anglo-Saxon Magic.* The Hague: Martinus Nijhoff, 1948.

Strabo. *Geography.* Edited by H. C. Hamilton and W. Falconer. 3 vols. London: George Bell and Sons, 1903.

Strong, Gordon. *The Way of Magic.* Cheltenham: Skylight Press, 2012.

Studer, Paul, and Joan Evans, ed. *Anglo-Norman Lapidaries.* Paris: Édouard Champion, 1924.

Tacitus. *Germania.* Translated with introduction and commentary by J. B. Rivers. Oxford: Clarendon Press, 1999.

Terpening, Ronnie. *Lodovico Dolce, Renaissance Man of Letters.* Toronto: University of Toronto Press, 1997.

Tester, Jim. *A History of Western Astrology*. Woodbridge, UK: Boydell, 1987.

Theophrastus. *De lapidibus*. Edited by David E. Eichholz. Oxford: Oxford University Press, 1965.

Thomas de Cantimpré [Thomas Cantimpratensis]. *Liber de natura rerum*. Part 1, *Text*. Edited by Helmut Boese. Berlin: De Gruyter, 1973.

Thorndike, Lynn. *A History of Magic and Experimental Science*. 8 vols. London: Macmillan, 1923–58.

———. "John of Seville." *Speculum* 34, no. 1 (1959): 20–38.

Toussaint, Stéphane. "L'*ars* de Marsile Ficin, entre esthétique et magie." In *L'art de la Renaissance entre science et magie*, edited by Francesca Alberti and Virginie Schmitt, 453–68. Rome: Académie de France à Rome, 2006.

Trachtenberg, Joshua. *Jewish Magic and Superstition*. New York: Atheneum, 1939.

Tressaud, Alain, and Michael Vickers. "Ancient Murrhine Ware and Its Glass Evocations." *Journal of Glass Studies* 49 (2007): 143–52.

Ullmann, Manfred. *Die Natur- und Geheimwissenschaften im Islam*. Leiden: Brill, 1972.

Vasari, Giorgio. *Le vite de' più eccellenti pittori scultori e architettori: Nelle redazioni del 1550 e 1568*. 6 vols. Edited by R. Bettarini and P. Barocchi. Florence: Sansoni, 1966–87.

Venturelli, Paola. "Gioielli e oggetti preziosi nell'Inventario Stivini." *Quaderni di Palazzo Te* 6 (1999): 75–80.

———. "Introduction." In *Le gemme di Medici al Museo degli Argenti*, by Paolo Gennaioli and Ornella Casazza, 21–37. Florence: Giunti, 2007.

Vespasiano da Bisticci. *Vite di uomini illustri del secolo XV*. Florence: Barbèra, Bianchi, 1859.

Vernarecci, Augusto. "L'incendio della libreria di Giovanni Sforza." *Archivio storico per le Marche e per L'Umbria* 3 (1886): 790–92.

Véronèse, Julien. "La transmission groupée des textes de magie 'salomonienne' de l'antiquité au Moyen Âge: Bilan historiographique, inconnues et pistes de recherche." In *L'antiquité tardive dans les collections médiévales: Textes et représentations, VIe–XIVe siècle*, edited by Stéphane Gioanni and Benoît Grévin, 193–223. Rome: École Française de Rome, 2008.

Vincent de Beauvais. *Speculum naturale*. Douai: Baltazar Belierus, 1624.

Virgil. *The Bucolics and Eclogues*. 2008. Project Gutenberg, https://www.gutenberg.org/files/230/230-h/230-h.htm#book03.

———. *The Eclogues*. Latin ed. Edited by J. B. Greenough. Boston: Ginn and Co., 1900.

———. *The Eclogues*. Internet Classics Archive by Daniel C. Stevenson, 1994–2009. http://classics.mit.edu/Virgil/eclogue.html.

———. *"Eclogues," "Georgics," "Aeneid."* Translated by H. R. Fairclough. Loeb Classical Library. Cambridge, MA: Harvard University Press, 1916. https://www.theoi.com/Text/VirgilEclogues.html.

———. *Virgil's Works: "The Aeneid," "Eclogues," "Georgics."* Translated by J. W. Mackail. Introduction by Charles L. Durham. New York: Modern Library, 1934. https://elfinspell.com/ClassicalTexts/Virgil/Mackail/Eclogues.html.

Wagner, Bettina. *Die "Epistola presbiteri Johannis": Lateinisch und deutsch*. Tübingen: Niemeyer Verlag, 2000.

Warburg, Aby. "Italian Art and International Astrology in the Palazzo Schifanoia, Ferrara." In *Aby Warburg: The Renewal of Pagan Antiquity*, translated by David Britt, 563–59. Los Angeles: Getty Research Institute for the History of Art and the Humanities, 1999.

Weill-Parot, Nicolas. "Astral Magic and Intellectual Changes (Twelfth–Fifteenth Centuries): 'Astrological Images' and the Concept of 'Addressative' Magic." In *The Metamorphosis of Magic from Late Antiquity to the Early Modern Period*, edited by Jan Bremmer and Jan Veenstra, 167–87. Groningen Studies in Cultural Change 1. Leuven: Peeters, 2002.

———. "Cecco d'Ascoli and Antonio da Montolmo: The Building of a 'Nigromantical' Cosmology and the Birth of the Author-Magician." In Page and Rider, *Routledge History of Medieval Magic*, 225–36.

—. "Le 'contact virtuel' entre un esprit et un corps et l'action à distance." In *Body and Spirit in the Middle Ages: Literature, Philosophy, Medicine*, edited by Gaia Gubbini, 255–70. Berlin: De Gruyter, 2020.

—. "I demoni della Sfera: La nigromanzia cosmologico-astrologica di Cecco d'Ascoli." In *Cecco d'Ascoli: Cultura, scienza e politica nell'Italia del Trecento; Atti del convegno di studio svoltosi in occasione della XVII edizione del Premio internazionale Ascoli Piceno (Ascoli Piceno, Palazzo dei Capitani, 2–3 dicembre, 2005)*, edited by Antonio Rigon, 103–34. Rome: Istituto Storico Italiano per il Medio Evo, 2007.

—. *Les "images astrologiques" au Moyen Âge et à la Renaissance: Spéculations intellectuelles et pratiques magiques (XIIe–XVe siècle)*. Paris: Honoré Champion, 2002.

Weill-Parot, Nicolas, with Julien Véronèse. "Antonio da Montolmo's *De occultis et manifestis* or *Liber Intelligentiarum*: An Annotated Critical Edition with English Translation and Introduction." In Fanger, *Invoking Angels*, 219–93.

Willard, Tom. "How Magical Was Renaissance Magic?" In *Magic and Magicians in the Middle Ages and the Early Modern Time: The Occult in Pre-Modern Sciences, Medicine, Literature, Religion, and Astrology*, edited by Albrecht Classen, 637–55. Berlin: De Gruyter, 2017.

William of Auvergne. *De universo*. In *Opera omnia*, 1:593–1074. Paris, 1674. Reprint, Frankfurt am Main: Minerva, 1963.

—. *Opera omnia*. Paris, 1674. Reprint, Frankfurt am Main: Minerva, 1963.

Winckelmann, Johann Joachim. *The History of Ancient Art*. New York: F. Ungar, 1969.

Zambelli, Paola. *L'ambigua natura della magia: Filosofi, streghe, riti nel Rinascimento*. Milan: Il Saggiatore, 1991.

—. *The "Speculum Astronomiae" and Its Enigma*. Dordrecht: Kluwer Academic, 1992.

—. *White Magic, Black Magic in the European Renaissance*. Leiden: Brill, 2007.

Zambon, Francesco, ed. *Bestiari tardoantichi e medievali: I testi fondamentali della zoologia sacra cristiana*. Milan: Bompiani, 2018.

Zeno, Apostolo. *Lettere di Apostolo Zeno, Cittadino Veneziano. Istorico e Poeta Cesareo.* 2nd ed. 6 vols. Venice: F. Sansoni, 1785. https://archive.org/details/lettere03forcgoog /page/n326/mode/2up.

Zwierlein-Diehl, Erika. "'Interpretatio christiana': Gems on the Shrine of the Three Kings in Cologne." In *Engraved Gems: Survivals and Revivals*, edited by Clifford Malcolm Brown, 63–84. Washington, DC: National Gallery of Art, 1997.

INDEX

Aaron, high priest, 161n59, 162n74, 164n132, 167n170
abdomen, 20
abeston, 42, 67, 76
abestus. See *abeston*
abistos, 42, 69, 77
abortion, 78, 88
abraxas, 33
abscesses, 75, 81, 95, 188n75
accademia degli infiammati, 145
accidents, 41, 52, 53, 55, 56, 59, 94, 97, 98, 111, 129, 140, 142, 167, 183
achates, 42, 67, 68, 70, 73–74, 161n64
 See also agate(s)
Achilles, 90, 127
acorn, 91, 105
Adam, 189n109
adamas (Diamond), 27, 42, 65, 67, 72–73, 161n59, 161n61, 176n371
Adriatic, 10, 80
adultery, 100
Aeolian Islands, 105
Africa, 165n154, 169n237, 171n256, 175n336, 178n408
 african, 87, 177n392, 179n433
agape, 75
agapis, 42, 66, 75
agate(s), 21, 30, 54, 67, 68, 70, 73, 85, 116, 120, 125, 141, 143
 of King Pyrrhus, 73, 116
 See also *Achates*
agirites, 42, 65, 77
Agrippa, Heinrich Cornelius, 193n209
Agrippa, von Nettesheim, 187n62
Agusteum, 76
alabandicus, 76
alabandina, 75
alabaster, 66, 89, 98
 See also *Alabastrum*
alabastrites. See *Alabastrum*
alabastrum, 42, 66, 76
albedo, 90
Albertus Magnus, 1, 8, 9, 22, 24, 25, 28, 29, 30, 33, 47, 51, 63, 64, 75, 78, 86, 93, 100, 107, 116, 119

alchemist(s), 89, 100
alchemy, 9, 35
alectorius, 42, 66, 74, 162n77, 179n450, 194n250
 See also alectory
alectory, 74, 169n233
 See also *alectorius*
Alexander the Great, 114, 146, 148n22
Alexander VI (pope), 12, 156n37
Alexandria, 76
 alexandrian, 99
aloe, 133, 192n194
 wood, 138
alopecia, 100
Alphonse the Magnanimous (king), 150n66
Alphonse X of Castile (king), 189n109
Alps
 northern, 81
 Ethiopian, 82
alum, 76, 77, 83
amandinus, 42, 71, 75
amber, 19, 67, 91, 102, 107–8, 130, 132, 133, 136, 139
 See also *succinum*
amethistus, 42, 74
 See also amethyst
amethyst, 57, 70, 74, 102, 129, 134, 136, 142, 174n319
 See also *amethistus*
amianton, 42, 65, 68, 76
amiantus. See *amiatus*
amiatus, 42, 77
amites, 42, 68, 69, 71, 77
ammonite, 169n231, 173n300
amulet(s), 2, 3, 5–7, 9, 13, 20
anancinthidus, 77
androa, 42, 65, 77
androdamanta or *andromadas*, 42, 75, 77
andromantes, 42, 75
anger, 75, 80, 89, 90, 111
Anselmi, Giorgio, 7
anthrax, 26, 60, 79, 157n6, 165n153
antidote, 74, 75, 161n59
Antiochian (from Antioch), 99
antiphates, 77
antitaneus, 77

212 INDEX

Antonio da Montolmo, 7, 10
antrachas. See antracites
antracites, 42, 68, 75
ants, 84, 86, 106
Anubis, 20
aquileus, 42, 77, 88
aquilinus limphaticus, 42, 77
Aquinas, Thomas, 9, 14, 28
Arab, 4, 5, 7, 75, 152n112, 153n122, 183n518
Arabia, 8, 76, 77, 82, 96, 98, 102, 109
 arabian, 73, 74, 87, 94, 98, 108, 110, 161n62
arabica, 67, 77
arabus. See arabica
Arctic, pole, 99, 124
Aristotle, 24, 26, 28, 46–53, 63–64, 93, 118,
 153nn130–31, 154n2, 154nn5–8, 154nn10–11,
 155n13, 155n17, 155n19, 155n29, 156n33,
 156n42, 156nn45–46, 156n50, 156n54,
 158n12, 158n16, 158nn23–24, 159n29,
 184nn2–3, 186n35, 186n40
arm(s), 125
 left, 73, 80, 84, 88
armed, 123, 126, 129, 131, 140, 142, 143
Armenia, 79
Armenian, 74
 stone, 111 (see also *Vernix*)
armenus, 65, 77, 106
Arnold of Saxony, 54
arrow, 126, 129
arrowheads, 172n292
arsenic, 89, 171n273
artist(s), 20, 28, 29–30, 36, 115, 146
 Alessandro, 146
 Annichini, Francesco Luigi, 39, 114
 Apelles, 115
 Apollonides, 114
 Bellini, Giovanni, 115, 146
 Cataneo, Danese, 146
 Correggio, 146
 Cronius, 114
 Giovanni Maria of Mantua, 29, 114
 Leonardo da Vinci, 27, 29, 115, 146
 Lysippus, 146
 Mantegna, Andrea, 115, 146
 Melozzo da Ferrara, Forlì, 115
 Michelangelo, 146
 Pansius Sycionicus, 115
 Parmigianino, 146
 Perugino, Pietro, 115
 Phidias, 146
 Piero della Francesca, 115
 Pirgoteles, 146
 Protogenes, 115
 Raphael of Urbino, 146
 Ribolini, Francesco, "il Francia", 29, 115
 Salviati, Giuseppe, 146

Sansovino, Jacopo, 146
Tagliacarne, Giacomo, 29, 114
Tintoretto, 146
Titian, 146
Veronese, Paolo, 146
Zeuxis, 115
asbestos. See *abeston; amianton*
Asclepius, 5, 155n22, 158n26
ashes, 49, 76
Asia, 75, 82, 96
 asiatic, 99
asininus. See asinius
asinius, 77, 42, 66
asinus. See asinius; onagari
asius, 42, 66, 76
aspilaten, 42, 69, 76
ass, 77, 82
Assyrians, 89
asterites. See astrites
asterius. See astrites
asthmatics, 82
astrion. See astrites
astrites, 42, 66, 83
astrologer(s), 3, 9, 10, 13, 14, 17, 119, 158n17,
 188n84, 189n104
astrology, 3, 7, 9, 13–15, 17, 20, 28, 29, 113, 147n11,
 149nn45–46, 150n72, 158n14, 162n76
Astronomicon/Astronomica, 13, 14, 150n65
 See also Manilius, Marcus (poet)
astronomy, 114
Aswan, 176n364
Athaleus, river, 90
Avicenna, 24, 46, 64, 77, 81

Babylon, 78
Babylonian, 5, 33, 87, 107, 108
Baghdad, 185n6
balanites, 42, 67, 71, 79
balasius, 42, 78
balas ruby, 54, 57, 62, 70, 80
 See also *balasius*
basalt(em). See basanites
basanites, 42, 67, 79
Bartholomaeus Anglicus, 64
battle(s), 77, 80, 83, 84, 91, 107, 130, 133, 134, 139,
 141, 143
battlefield(s), 79, 125, 126, 128, 140, 142
bear, 129, 140
beast(s), 81, 134, 137, 139
beloculus, 42, 79, 86
belus, 79
Berillus, 42, 65, 69, 71, 78, 85
 See also beryl(s)
beryl(s), 47, 57, 65, 69, 71, 78, 85, 86, 109, 112,
 128, 129, 141, 142
 See also *Berillus*

bezoar, 42, 70, 79

birth, 77, 78, 88, 89, 91, 93, 97, 102, 104, 108, 110, 117, 137

bladder, 83, 88, 89, 112

blood, 4, 5, 20, 27, 73, 75, 81, 85, 87, 93, 95, 96, 101, 103, 104, 105, 108, 111, 112, 122, 129, 132, 133, 134, 138, 139, 141, 142

Boetius de Boodt, Anselmus, 36

bolus armenus, 42, 70, 79, 106

Bonatti, Guido, astronomer and astrologer, 119

Bonincontri, Lorenzo, 13–16, 22, 34, 150n68, 159n30

Book of Healing (Kitab al-shifa), 159n33

Book of Minerals (Aristotle's), 47, 48, 49, 50, 51

Book of Minerals (Albertus Magnus), 1, 9
 See also *De mineralibus*

Book of Precious stones (Solomon), 50

Book of Raziel the Angel, 13, 189n109
 See also *Book of Wings*; *Liber Raziel*

Book of Secrets, 153n140

Book of Simple Medicaments, 159n32

Book of the Soul, 52

Book of Wings, 128

borax, 42, 65, 69, 78, 86

Borgia
 Cesare (Caesar) duke of Valentinois, duke of Romandiola, 12, 39, 46, 51
 Lucrezia, 18
 Rodrigo (pope Alexander VI), 12, 13, 15, 18–21, 34, 35, 39, 151nn92–93, 152n116, 156n36, 185n14

Brasavola, Antonio, Musa, 23

brass, 75, 79, 98, 104, 105, 132, 136, 139

breast(s), 82, 90, 103, 108, 112, 129, 133, 138, 139

Britain, 91

Brittany, 107

bronia, 42, 79

calaminaris, 68, 85

calcedon. See *calcedonius*

calcedonius, 42, 70, 80, 108, 129, 179n439

calchophanus, 84

calcitis, 85

caldaicus, 42, 71, 84

callayca. See *caldaicus*

calorites, 42, 71, 85

cambnites, 84

camel, 76, 128

cameo(s), 19, 30, 117, 146, 186n26

camites, 85
 See also *ostracites*

Campeggio, Giovanni Battista, bishop of Majorca, 145

Canon of Medicine, 24

Cappadocia, 76, 89

carbuncle(s), 27, 54, 68, 75, 78, 79–80, 90, 95, 102, 106, 110

carbunculus. See carbuncle(s)

carcina, 85

caristeus, 42, 71, 85

carmania, 75

carnelian(s), 27, 81, 108, 129, 130, 132, 133, 136, 137, 138, 141, 143

Carrara Herbal, 159n32

catochites, 84

Cecco d'Ascoli, 10

cegolites. See *cogolites*

celiculus, 86
 See also *beloculus*

Cellini, Benvenuto, 20

celonia, 42, 85
 See also *sirites*

celonites, 82, 108, 129, 42, 70

celontes. See *celonites*

Centiloquium, 15, 150n72, 186n41, 187n46

cephalic, 77, 83

cepionidus, 85

cepites. See *cepocapites*

cepocapites, 42, 66, 85

ceranius, 83, 103
 See also *ceraunius*

ceraunius, 42, 66, 68, 129, 167n182
 See also *ceranius*

cerraolus. See *ceranius*

Chael, 3, 22, 34, 35
 images or seals of, 130–34

chalcedony(ies), 19, 80, 101, 142
 See also *calcedonius*

chaldean(s), 5, 109, 188n78

charm(s), 4, 5, 86, 89, 96, 102, 139, 141, 192n184
 charmed, 82, 90

chaste, 97, 100, 106, 138

chastity, 107, 127, 136

chelidonius, 80

chemites, 42, 67, 84

children, 77, 81, 84, 108, 118

chrysocolla, 84
 See also *crisocollus*

chrysolite, 102, 128, 129, 130, 135
 See also *crisoletus*

chrysolithus, 82
 See also *crisoletus*

chrysopteron, 42, 86

chrysoprase, 82, 84
 See also *crisoprasius*; *crisoprassus*

chrystal(s), 5, 19, 47, 57, 65, 72, 73, 75, 78, 81–82, 84, 85, 86, 88, 94, 105, 129, 132, 133, 136, 138, 139, 141, 143

chrystalline, 66, 67, 74, 78, 83, 86, 89, 94

cimedia, 83, 94, 42, 66

cimilanitus, 85

coal, 79, 100, 102
coaspis, 42, 71, 85
cogolites, 42, 68, 83, 94, 111
coin, 132, 137, 174n332, 185n14
 See also *obulum*
colics, 88
Cologne, 116
Conciliator differentiarum philosophorum [et] praeciupe medicorum (Reconciler of the Differences Between Philosophers and Physicians), 24, 46
Congelatione et conglutinatione lapidum (On the Congelation and Conglutination of Stones), 24
constellation(s), 124
 Andromeda, 125
 Aquila (Vultur Cadens), 126
 Auriga, 127
 Cassiopea, 125
 Canis, 127
 Canis Alabor, 127
 Censer, 127
 Centaurus, 127
 Cepheus, 125
 Cetus, 126
 Cignus, 125
 Corona Australis, 127
 Crown, 17, 102, 125, 127, 132, 143
 Draco, 124–25
 Hercules, 125
 Hydra, 17, 127
 Lepus, 127
 Navis, 126
 Orion, 126
 Perseus, 17, 125
 Pegasus, 126
 Pisces, 126
 Serpentary, 126
 Ursa, 124–25
 Vexillus, 128
coral, 4, 19, 70, 71, 73, 81, 194
 See also *corallus*
corallus, 42, 65, 70, 81, 92, 111
 See also coral
coranus, 42, 65, 85
Corinth, 85, 88, 89
 Corinthian, 66, 98
corintheus, 85
cornelius, 42, 81
 See also carnelian
cornu copiae, 64
Corpus Hermeticum, 35
Corsica, 84
corvia, 42, 84, 110
 See also *corvina*
corvina, 42, 65, 83, 84

cough, 96
 coughing, 84
crapondinus, 42, 86, 78
 See also *borax*
Crete, 73, 94
crisanterinus, 84
crisites, 42, 69, 85, 105
crisoberillus, 85
 See also *berillus*
crisocollus, 84, 42, 65, 77
 See also *chrysocolla*
crisolansis, 85
 See also *crisoletus*
crisolensis. See *crisoletus*
crisoletus, 42, 82, 85, 92, 42
crisolimus. See *crisoletus*
crisolitus, 42, 72, 82, 87
crisopassus, 42, 65, 85
crisopilon, 85
 See also *berillus*
crisopis, 42, 65, 85
crisoprasius, 84
 See also *chrysoprase*
crisopras(s)us, 42, 71, 84, 86
crisopressus, 84
 See also *crisopras(s)us*
crisoprassus, 42, 71, 82
crispressus. See *crisoprassus*
cristallus(m), 42, 65, 81–82
 See also crystal
crocodile, 130, 134, 136, 139
crow, 84, 138
crysopteron, 110
crystal, 5, 19, 57, 65, 72–73, 75, 78, 81–82, 105, 129, 132, 133, 136, 138, 139, 141, 143
Curationum et observationum medicinalium centuriae, 20
cyaneus. See *cyanica*
cyanica, 85
Cyprus, 4, 82, 87, 98, 101, 105
cysteolithos, 42, 84, 110
cytis, 110

Dacia, 107
daemonius, 86
Damascus, 76
Damigeron, 4, 5, 8
Darius (king), 89
dead, 9, 76, 129
 body, 84, 86
De anima, 24
De caelo, 24
De generatione animalium, 24
De generatinoe et corruptione, 154n3, 158n29
De meteora, 24
De mineralibus, 1, 9, 24, 25, 28

INDEX

Democritus, 61

demon(s), 7, 9, 34, 73, 77, 82, 86, 91, 94, 107, 127, 128, 129, 130, 135, 141, 142

demonic, 7, 8, 81, 127

 shadows, 134

De mutatione aeris, 61

dentrites. See *draconites*

De sensu, 24

De vita libri tres, 9, 10, 30

diacodos, 70, 86

diacodus, 42, 86

 See also *diacodos*

diamond. See *adamas*

digestion, 110

dionisia, 42, 69, 86

Dionysius Periegetes, "Dionysius of Alexandria", 64, 73

Dioscorides, 4, 64, 76, 90, 104

doctus, 87

 See also *crisolitus*

dog(s), 95, 124, 127, 130, 133, 139, 141, 142

 rabid, 107

doriatides, 42, 69, 86, 106

draconites, 42, 66, 86

draconius. See *draconites*

dragon(s), 50, 86, 111, 128, 129, 132, 134, 137, 139

dragontea, herb, 129

dream(s), 75, 78, 81, 82, 83, 89, 133, 135

dropsy, 84, 91, 93, 94, 100, 112, 122, 127, 137

drosolitus, 42, 86

drowning, 83, 124, 135, 140, 142

dysentery, 20, 81, 87

eagle(s), 88, 20, 123, 126, 132, 133, 134, 137, 140, 143

 stone, 5, 27, 88

echidnes, 43, 89

echistes, 89

 See also *ethices*

effesstis, 89

effestites, 89

 See also *effesstis*

egg(s), 19, 84, 87, 88, 151n96

Egypt, 74, 77, 79, 85, 98, 176n364, 183n509

 egyptian(s), 5, 8, 33, 73, 74, 90, 106, 108, 161n64, 162n76, 170n246, 173n309, 180n455, 180n456

egyptilla, 89

electioni, 89

 See also *gagates*

elitropia, 87

 See also *heliotrope*

elitropus, 87

 See also *heliotrope*

elopsites, 43, 89

emathites, 70, 87

 See also *emathitis*

emathitis, 42, 87, 110

 See also *hematite*

emerald, 5, 20, 57, 68, 85, 87, 90, 91, 93, 96, 98, 102, 103, 104, 106–7, 141, 142, 164n132, 167n169, 173n304, 175n343, 179n438, 180nn456–57, 181n463

Emerald Tablet, 158n19

emites, 43, 67, 89

emetrem, 43, 70, 89

emoptoics, 79, 87

enchantment(s), 77, 82, 91, 126, 129

endes, 88

 See also *ethices*

England, 107

enidros, 43, 66, 88

Ephesians, 148n18

epilepsy, 77, 80, 81, 88, 91, 94, 97, 102, 107, 139

Epiphanius, saint, 4

epistides, 43, 88

epistites, 70

epistrites, 88

 See also *epistides*

Epistulae morales, 35

eryndros, 88

 See also *enidros*

estimion, 43, 65, 88

ethices, 42, 70, 77, 88, 89, 92, 134, 140

Ethiopia, 79, 80, 82, 87, 90, 92, 93, 98, 103

 Ethiopian, 73, 77, 82, 99, 116, 180n456

eumetis, 43, 89

eunophius, 43, 89

 See also ethices

Euphrates, river, 85, 112

Europe, 166n169

 European, 2, 181n470

Evanthus, 104

 See also *panthera(us)*

Evax (king of Arabia), 5, 8, 64, 83, 89, 148n38, 159n31

 evil, 8, 95, 141

 accident(s), 94, 111

 beast(s) 139

 eye, 26, 60, 61, 89

 spirit(s), 8, 9, 100, 127, 129, 132, 134, 137, 140

 thoughts, 74, 80

exacolitus, 43, 67, 88

exebenus, 88

 See also exebonos

exebonos, 43, 88

execonthalitus, 43, 88

exmisson, 88

 See also *estimion*

eye(s), 5, 25, 26, 30, 57, 60, 61, 78, 79, 80, 84, 87, 92, 94, 95, 96, 97, 102, 104, 105, 106, 109, 115, 116, 136

 evil, 26, 60, 61, 89

216 INDEX

eyebrows, 139
eyelids, 85, 87
eyesight, 93, 100

falcon, 128, 143
falcones, 43, 70, 89
falconites, 66
Fano, 110
fetus, 77, 88, 92
fever(s), 77, 79, 80, 83, 86, 88, 91, 93, 95, 97, 107,
 122, 123, 125, 129, 132, 135, 137, 138, 142
 phlegmatic, 122
 quartan, 77, 83, 92, 97
 tuberculotic, 123
Ficino, Marsilio, 2, 9, 10, 14, 15, 27, 30, 35,
 149n48, 159n30
filaterius, 43, 71, 89
fingites, 43, 66, 89
fish(es), 19, 77, 83, 96, 126, 131, 133, 134, 135, 136,
 137, 138, 140
fistulas, 76, 90
flax, 76
Florence, 13, 14
flux, 111
 of belly, 95, 96, 97, 108
 of blood, 5, 87, 93, 95, 96, 108, 112, 134
 of eyes, 105
fongites, 43, 70, 89, 110
forehead, 96, 106, 116
foretell(ing), 61, 82, 83, 84, 87, 92, 96, 109, 128
fossil(s), 30, 156n38, 163n91, 165n152, 167n176,
 167n182, 169n231, 173n300, 173n313,
 184n524
 fossilized, 3, 152n96, 162n83, 167n180, 172n292,
 173n317
Fourth Book of Meteors, 46
France 18, 101
frigius, 43, 67, 71, 90

Gaetano da Thiene, 12, 24, 50
gagates, 43, 66, 69, 89, 91, 107, 108, 132, 137
galacidem, 43, 92
 See also *smaragdus*
galactica, 91
 See also *galatides*
galactides, 90
galaricides, 90
 See also *galactides*
galatides, 43, 66, 91, 110
galaxia, 69, 92
galgatromeus, 90
 See also *garatronicus*
Galen, 4, 87, 134, 172n286
gall, ink, 97
gallerica, 43, 91
Gallina, Tolomeo, 14, 15

Ganymede, 20
garamantica, 43, 91
garamantides, 43, 92
 See also *sandastros*
garatides, 91
 See also *gelachides*
garatronicus, 43, 90
gasidana, 43, 92
gelatia, 91
 See also *galatides*
gelachides, 43, 69, 91, 92
Gemmarum et Lapidum Historia, 36
gerades, 43, 70, 91
German, 87
 Germany, 80, 83, 84, 93, 94, 95, 98, 103
glass, 57, 58, 73, 76, 96, 100, 103, 112
glosopetra, 43, 92
goldsmith(s), 88, 105
Gorgon, 81
gout, 76, 90, 92, 97, 125, 174n332, 176n374
granate, 57, 70, 80, 92, 93, 94, 138, 141
 See also *granatus*
granatus, 90, 43, 70
grisoletus, 43, 92
 See also *crisoletus*
grogious, 92
gulosus, 92
 See also *glosopetra*

hammochrysos, 92
hamonis, 43, 92
head(s), 60, 77, 78, 79, 83, 86, 87, 89, 95, 100, 103,
 106, 112, 121, 123, 124, 125, 126, 127, 128, 130,
 132, 133, 134, 134, 135, 136, 137, 138, 139, 140,
 141, 142, 143
headache(s), 83, 96, 103
health, 2, 33, 40, 78, 80, 97, 103, 112, 125, 130,
 140
healthy, 127, 128, 129
heart, 79, 81, 82, 88, 90, 93, 97, 108, 111, 141
Hélinand of Froidmont, "Heliamandus", 64
heliotrope, 71, 87, 129
hematite, 4, 5, 27, 70, 75, 87, 130, 139
 See also *emathites*; *emathitis*
hemorrhoids, 81, 111, 132
Hercules, 107, 125, 140
 pillars of, 94
Hermes Trismegistus, 10, 24, 34, 35, 50, 62, 63,
 64, 141–42, 155n22, 158n16
 seals or images of, 141–42
hexaconta, 88
 See also *execonthalitus*
hieracites, 43, 92, 94
honey, 35, 82, 87, 91, 100, 101, 103
hoopoe, 105, 129, 133, 129
horcus, 43, 92

INDEX 217

hormesion, 43, 68, 92
Hortus sanitatis, 30
hunter(s), 95, 127, 130, 131, 135, 143
hyacinth, 5, 92, 103, 130, 131, 132, 133, 136, 137, 138
hyena, 43, 92
hysmeri, 43, 92

iacintus, 43, 70, 92–93, 103
 See also Hyacinth
iaguntia, 94
iaspis, 43, 72, 93
 See also jasper
Ibn Sina, Abus Ali al Husayn, ibn Abd Allah.
 See Avicenna
idaeus, 94
ierarchites, 43, 94
iliac, passions, 88
illusions, 80, 81, 107, 127, 142
incantation(s), 4, 5, 6, 9, 76
Index Librorum Prohibitorum, 35
India, 76, 78, 82, 94, 102, 178n408, 183n502
 Indian, 5, 73, 74, 76, 78, 80, 106, 108, 120,
 161n62, 161n67, 167n170
indica, 43, 71, 94
Indus, river, 27, 112
infant(s), 98, 102
insanity, 109, 112
intaglio(s), 19, 30, 145, 146
intestine(s) 74, 79
 intestinal, 83
Ion, 94
Iovis, 94
Iris, 43, 66, 86, 94, 129
iron, 26, 50, 55, 60, 63, 72, 73, 75, 76, 79, 85, 86,
 87, 94, 98, 99–100, 102, 107, 109, 110, 133,
 134, 136, 139, 140
Isabella d'Este, Marchioness of Mantua, 19, 20
iscistos, 43, 94
iscultos, 94
 See also *iscistos*
Isidore of Seville, 1, 5, 25, 64
Italy, 9, 10, 12, 13, 26, 61, 76, 98, 103, 114, 115, 145,
 158n14, 178n408, 188n99
iudaicus, 43, 83, 94
ivory, 67, 77, 84, 89, 96, 98

jacinth(s), 54, 70, 90, 93
 See also *iacintus*
jasper(s), 19, 47, 72, 85, 93, 108, 121, 129, 130, 132,
 134, 135, 136, 137, 138, 140, 142, 143
 See also *iaspis*
jaundice, 80, 95, 96, 174n332
jaw, 77, 78, 96
Juba II, 64
Jupiter, 20, 94, 122, 123, 125, 126, 127, 132, 133, 140
 Temple of, 107

kabrates, 66, 84, 94, 123, 143
kakabres, 94
 See also *kabrates*
kakamam, 94
 See also *kamam*
kamam, 65, 94
karabe, 43, 66, 94
 See also *succinum*
kenne, 43, 94
kidney(s) 50, 79
 stones, 83, 84, 95, 107
kimedini limphatici, 43, 94
al-Kindī, 7
kinocetus, 43, 94
Kyranides (Cyranides), 4, 64

lacteus, 43, 95
lamb, 97, 135
lapidaria
 genre, 3–4
 magical elements, 4–10
Lapidary, or the History of Pretious Stones, 36
lapis lazuli, 23, 112
lauraces, 43, 96
laurel, 102, 124, 135, 140, 142, 143
lawsuit(s), 76, 80, 130
lazolus, 43, 96
lepidotes, 43, 96
leprosy, 5, 78, 107
leucocrisos, 43, 72, 96
leucoptalmus, 43, 95
leucostictos, 43
leucostyctos, 96
Liber desideratus canonum equatorii coelestium
 motuum absque calculo, 15
Liber Hermetis de quindecim stellis quindecim
 lapidibus quindecim herbis et quindecim
 imaginibus, 34
Liber pandectarum, 64
Liber Raziel, 153n140
library of Costanzo Sforza, 14
Libya, 79, 87, 88, 95, 103
lichinus, 43, 94–95
ligdinus, 96
lightning, 74, 78, 79, 83, 92, 115, 126, 129
lignites, 43, 96
ligurius, 43, 66, 70, 72, 96
limacie, 95
limoniates, 43, 72, 96
limphicus, 43, 96
lion, 66, 75, 122, 125, 129, 131, 132, 134, 137, 139,
 140, 141, 142
liparia, 95
 See also *lippares*
lippares, 43, 95
lisimacus, 43, 65, 96

218 INDEX

litos, 43, 96
liver, 78, 83, 111, 123
lodestone, 99–100
 See also *magnes*; magnet
love, 60, 75, 90, 105, 107, 108, 122, 125, 133
 conjugal, 60, 78, 142
loved, 103, 132, 134, 136, 140, 142
Lunar Calendar (Lunario al modo de Italia
 calculato [sic]), 15, 16
lunarius, 43, 96
lunatic(s), 73, 80, 111, 127, 130, 135, 142
lust(y), 27, 75, 80, 83, 91, 93, 106
lychinites, 94
 See also *lichinus*
lychnitem, 43, 96
Lycia, 91
lyncis, 95
lyncurius, 95

Macedonia, 104
 macedonian, 73, 99
madness, 88, 111
magi, 112
magic, 4, 5, 9, 10, 18, 25, 26, 28, 29, 33, 35, 36, 45,
 84, 85, 90, 91, 106, 109, 114, 120, 121, 128,
 141, 146
 addressative, 6, 7, 29, 33
 astral, 3, 13, 34, 36
 astrological, 22, 34
 natural, 1, 3, 8
 ritual, 8
 sympathetic, 27
 talismanic, 20, 34, 36
magician(s), 76, 83, 85, 87, 90, 92, 123, 124, 125
magnasia, 43, 69, 100
magnes, 43, 68, 96, 99–100
 See also magnet
magnet(s), 26, 60, 63, 68, 73, 75, 84, 97, 99–100,
 107, 129, 139, 141
 See also *magnes*
magnosia, 100
 See also *magnasia*
malachite, 98, 43
 Manilius, Marcus (poet), 13, 14
melites, 43, 101
melitites, 101
manganese, 76, 176n378
Manilius, Marcus (poet), 13, 14, 150n65
marble, 12, 47, 76, 84, 85, 89, 96, 97–98, 103, 105,
 112, 116
Marbode of Rennes, 2, 5, 8, 22, 24, 25, 30, 64
marcasite. See *marchasites*
marchasites, 43, 65, 67, 100
margarita, 43, 65, 96–97, 112
 See also pearl

marmor, 43, 97–98, 103, 105
 See also marble
Mars, 122, 123, 125, 126, 127, 130, 140, 143
maxillary, 77
medea, 43, 65, 101
media, 84, 104, 168n194
Medici
 Catherine, 20
 Lorenzo, 19, 20
medicine, 13, 14, 15, 39, 56, 77, 81, 132
Medus, 43, 69, 72, 97
melancholia, 100, 111
melancholic(s), 77, 82, 89, 112, 142
melancholy, 80, 122
memory, 107, 115, 122, 142
memphitis, 43, 98–99
menstruation, 81, 91, 108, 132
Mercury, 122, 124, 125, 127
Meseu the younger, Johannes, "Giovanni
 Mesue", 64
Methrodorus, of Scepsis, 81
milk, 77, 82, 90, 95, 97, 106, 109, 111, 112, 129
mirites, 43, 68, 98
mirror(s), 16–18, 23, 40, 41, 78, 86, 87, 103, 107,
 131, 137
miscarriage(s), 109
miscarry, 93, 102
Mitridax, 43, 67, 101
Mohammed, prophet, 123
moon, 17, 46, 108, 109, 122, 123, 124, 133, 138
 new, 82
 waning, 82, 92
 waxing, 82, 83
morion, 69, 101
Moses, 34, 155n22
mouth, 5, 20, 74, 78, 81, 82, 84, 86, 90, 91, 92, 97,
 109, 126, 136
murilage, 86, 141
murina, 43, 98
musk, 132, 139
myrtle, 73, 77, 128

nassomonites, 71, 101
neck, 6, 10, 77, 78, 80, 81, 84, 89, 90, 95, 96, 102,
 103, 110, 112, 125, 126, 130, 131, 132, 133, 134,
 135, 136, 137, 138, 139, 140, 141
Neckam, Alexander, 161n60
necromancers, 87
 necromantic, 9, 33, 77, 106, 120
nemessitis, 101
Neoplatonism, 9, 15
Nero, emperor, 107
nest(s), 50, 51, 76, 80, 84, 88, 105
Niccolò dei Conti, "sir Nicholas de Comitibus
 Patavinus," 26, 61

INDEX 219

nicolus, 43, 68, 101
Nile, river, 90, 103
niter. See *nitrum*
nitrum, 43, 65, 101
nose, 43, 101
nosa. See *borax*

obsianus See *draconites*; *obsius*
obsius, 44, 103
obtalius, 43, 95, 102
obtalmius. See *obtalius*
obulum, 132
 See also coin
olea, 44, 103
ombria, 44, 103
 See also *ceranius*
onagari, 44, 103
On Generation and Corruption, 46
onicinus, 43, 102
onix, 65, 69
 See also onyx
On Physics, 46, 48, 40, 63, 116
On Sense and the Sensible, 53
On the Heavens and the World [or Cosmos], 46
onyx, 65, 69, 94, 101–2, 108, 116, 128, 134, 141
opal. See *opalus*
op(p)alus, 43, 102
ophicardelon, 44, 103
ophites, 44, 71, 103
opium, 98
oracles, 89
orfanus, 44, 72, 102–3
orient, 81, 86
 oriental, 24, 97, 110
orites, 44, 68, 69, 102
ornicus, 44, 103
 See also *saphirus*
Orpheus, 61
Orsini, Leone, 145
ostracites, 85, 103
ostratias, 44, 103

Padua, 12, 17, 24
pain(s), 77, 84, 99, 100
 birth 78, 110
 bladder, 89
 breast, 103
 eyes, 87
 heart 81
 hemorrhoids, 81
 nerve, 77
 stomach, 88, 95, 96
 wound, 75
panconus, 67, 105
panthera(us), 44, 54, 67, 104

paragonius, 44, 105
paralysis, 122, 125, 135
parangon(e), 132, 138
Paul of Middleburg, 15
pavonius, 44, 105
peace, 125, 129, 137
 peaceful, 106
peacock, 111, 143
peantes, 104
peantides. See *peantes*
pearl(s), 19, 65, 82, 96–97, 105
 See also margarita
penis, 110
Persia, 89, 98, 101
 Persian, 73, 85, 88, 98, 106, 108
Pesaro, 39, 40, 110, 116
pestilential, 80, 97, 75
phantasms, 73, 93, 98
pheonicites, 44, 105
philoginus, 44, 70, 105
Phrygian, 87, 88
phrygius, 105
Physiologus, 64
pirites, 44, 68, 69, 104, 111, 112
 See also pyrite(s)
pitch, 91, 110
plague, 13, 90, 127
planets, engraved images of the, 123–24
Plato, 48, 62, 64, 118
Pliny, the Elder, 5, 30, 50, 61, 64, 91, 95, 101, 102,
 107, 110, 114, 116, 148n16, 148n19, 148n22,
 155nn27–28, 157nn56–59; 158n9, 161nn59–61,
 161n64, 161n66, 162n83, 163n103, 164n121,
 164n123, 164n134
podros, 44, 67, 105
poison(s) 3, 5, 20, 21, 60, 73, 74, 75, 79, 86, 87, 94,
 97, 106, 107, 108, 109, 111, 120, 126, 129, 134
 poisoned, 20, 77, 88, 100
 poisonous, 77, 80, 88, 90, 107, 108, 112, 126,
 131, 137
polium, herb, 133, 138
pomegranate, 87, 90, 92
Pontano, Giovanni, 13, 14, 15
pontica, 66, 67, 68, 72, 104
Pontus, sea, 104
porphyry, 52, 70, 72, 93, 98, 105
praeconissus, 105
prassius, 44, 72, 103–4, 109, 129
prophirites, 44, 96, 105
 See also porphyry
prosperity, 2, 40, 80, 98
Ptolemy, 13, 15, 28, 33, 62, 118, 119
Ptolemy, Philadelphus, 111
pulmonary abscesses, 188n75
pumex, 44, 105

220 INDEX

pumice stone, 76, 103
punicus, 44, 105
pyrite(s), 83, 104, 105, 131, 133, 136, 139
 See also *pirites*

Quadripartite, 33, 34, 119, 141
quaidros, 44, 105
quarrels, 73, 78, 90, 102
quirinus, 44, 105
quirus. See *quirinus*

Rabanus Maurus, 64
rabri. See *ranius*
radaim, 44, 69, 87, 106
ram, 92, 122, 123, 128, 131, 136, 140
rami. See *ranius*
ranius, 44, 68, 71, 106, 112
Raziel, 3, 34
 Book of Raziel the Angel, 13, 189n109
 Book of Wings, 128
 Liber Raziel, 153n140
 magical images, 128–29
Red Sea, 75, 82, 94, 111, 183n509
rheum, 112
Rhine River, 81, 94
rings, 2, 3, 10, 19, 20, 23, 30, 34, 57, 192n184
rooster(s), 74, 87, 106, 121, 124, 134, 141, 143
rubinus, 44, 106
rubith, 80, 110
 See also carbuncle(s)
ruby, 54, 57, 62, 70, 78, 110, 128, 141

Sacred Book of Hermes Trismegistus Addressed
 to Asclepius, 5, 158n26
sadasius. See *sandastros*
sadda. See *sagada*
sagada, 109
sagda, 84, 44, 70, 182n491
salt(s), 58, 76, 90, 101, 121
samius, 44, 109
Samot(h)racia/Samothratia, 44, 69, 110
sanctus lapis, 44, 110
 See also *saphirus*
sandastros, 44, 68, 92, 109
sanguineus lapis, 44, 110
 See also hematite
saphirus, 44, 68, 103, 106, 110, 112
 See also sapphire
sapphire, 26, 57, 60, 62, 68, 80, 106, 128, 141,
 142, 143
 See also *saphirus*
sarcophagus, 109–10
sarda, 44, 108, 110
 See also *sardius*
sardis, 108
sardius, 27, 44, 68, 75, 108, 110

sardonius. See sardonyx
sardonyx, 27, 108
Saturn, 122, 123, 125, 126, 127
satyrion, 110
scabies, 102
Schifanoia, palace, 17
schist. See *iscistos*
Scorpion(s), 74, 75, 161n64, 170n247, 172n286
scrofula, 76, 174n332
Scythia(n), 82, 85, 106
seal(s), 6, 10, 34, 35, 108
 Chael, 130–34
 Hermes, 141–42
 Solomon, 135–41
 Raziel, 138–39
 Thetel, 134–35
 various, 142–43
sedeneg, 44, 110
 See also *ematites*
selenites, 44, 96, 108
Seneca, 35
senochitem, 44, 90, 110
 See also *galatides*
Serapion the Younger, 64
serpent(s), 87, 103, 109, 124, 126, 127, 130, 132, 134,
 136, 137, 138, 140, 143
Serpentarium, 120
serpentary, 126
Sforza
 Costanzo, 12, 13, 14, 16, 17
 Giovanni, 12, 13, 14, 15, 16, 18, 20, 22
Sickle, 134, 139
siderites, 44, 68, 108, 110
 See also *selenites*
sifinus, 44, 110
sigil(s), 28, 35, 113
silk, 19, 96
silver, 17, 19, 47, 75, 77, 78, 83, 92, 93, 96, 97, 100,
 111, 115, 130, 131, 136, 137, 138, 140, 141,
 193n202
sinodontides, 44, 110
sirites, 44, 67, 85, 108, 110
 See also *saphirus; selenites*
sleep, 86, 89, 100, 102, 105, 108, 111, 112, 125, 130,
 133, 138
 sleepwalkers, 142
smallpox, 106
smaragdus, 44, 91, 92, 106
 See also emerald
smiriglius, 68
smirillus, 44, 92, 109
snake, 5, 50, 76, 77 86, 91, 100, 116, 126, 131, 136,
 140, 155n25, 169n231
 bite, 5, 77, 79
 black, 116
 venom, 5, 74

INDEX 221

Socatus, 83, 87

Solinus, Caius, Julius 61, 64, 74, 84, 85, 87, 91, 158n9

solis gemma, 44, 67, 109

Solomon (king), 3, 10, 25, 26, 33, 34, 50, 54, 60, 64, 119

 Book of Precious stones, 50

 Engravings and Images of Solomon, 135–41

sorceries, 76, 110

Spain, 94

 Spanish, 83

spasm(s), 100, 106

specularis, 44, 110

 See also *fongites*

Speculum astronomiae, 7, 8, 29

spell(s), 88, 91, 96, 142

spinel, 80, 110

spinella, 110

 See also spinel

spirit(s) 8, 9, 18, 77, 81, 89, 90, 127, 133, 134, 139, 141, 142, 143

 Evil, 8, 9, 100, 127, 129, 132, 134, 137, 140

 Water, 129

spleen, 76

splenetics, 79, 111

spongius, 44, 110

 See also *cysteolithos*

squillae, 134, 139

stag(s), 91, 94, 124, 130, 135, 141, 142, 143

stomach, 79, 80, 81, 85, 88, 95, 96, 175n359

storm(s) 76, 78

strangury, 83

struxites, 44, 110

styptic, 87, 105

sublimation, 90, 111

succinum, 94, 107–8

 See also amber

sugar, 76, 97

Summa Theologica, 9

sun, 17, 50, 56, 78, 81, 87, 89, 91, 95, 98, 101, 104, 106, 107, 109, 112, 122, 123, 132, 133, 137

Superchi(o), Valerio, 16, 23, 39

swallow, bird, 80, 129

Syria, 109

 Syrian(s), 79, 161n62

syrius, 109

Tabula Smaragdina, 158n19

talc alchimicus, 111

tartis, 44, 111

teeth, 84, 91, 108, 109

 fish, 19

tegolitus, 44, 66, 111

 See also *cogolites; telitos*

telitos, 44, 111

 See also *tegolitus*

tempests, 60, 74, 80, 81, 107, 126, 129, 131, 137

terror(s), 89

 night, 73, 82

Tetrabiblos, 13, 28

 See also Ptolemy

Thābit ibn Qurra, 8, 29

Thebes, 76

Theophrastus, 4, 107

Theory of the Planets, (Tehorice [sic] planetarum), 15, 16

Thetel, 3, 5, 22, 34, 64, 114, 120, 160n46, 189n114, 191n157, 191n167

 images or seals of, 134–35

thieves, 100, 134, 139

thirsitis, 44, 111

 See also coral

throat, 78, 96, 108

Thrace, 50, 75

Tiberius Augustus, emperor, 74

toad, 78, 79

toga, 140, 142

tongue, 76, 82, 92, 133, 139

toothache, 90

topasion, 110

 See also *topatius*; topaz

topatius, 44, 67, 110–11

topaz, 55, 57, 67, 86, 110–11, 128, 142

 See also *topatius*

tornadoes, 83, 88

tortoise, 82, 83

trachius, 44, 69, 111

trapendanus, 44, 111

 See also *pirites*

troglodytes, 79, 99

tubercolosis, 108, 174n332, 188n75

 tuberculotic, 123

turchion, 44, 68, 111

turquoise, 68, 136, 138

 See also *turchion*

turtle, 79

ulcer, 81, 97, 105

unguent(s), 76, 103

unio, 44, 96, 112

 See also *margarita*; pearl

urine, 5, 91, 95, 108

urpine, 89

 See also *falcones*

varach, 44, 71, 111

vatrachius, 44, 112

 See also *ranius*

veientana italica, 44, 69, 111

Venus, 20, 122, 123, 124, 125, 126, 127, 133, 138

vernix, 44, 71, 111

Vincent of Beauvais, 64

222 INDEX

vinegar, 85, 99
viper, 74, 75, 120, 121, 134
Virgil (poet), 26, 61
virgin, 91, 107, 135, 140, 141, 142
 virginity 127
virites, 44, 112
 See also *pirites*
voice, 26, 80, 84, 97
 hoarse(ness), 26, 61, 80
vultur cadens, 126
vulture, 126, 130, 131, 133, 135, 138
vulturis lapis, 44, 105, 112
 See also *quaidros*

wax, 6, 95, 108, 131, 132, 133, 136, 137, 138, 139
William of Auvergne, 8, 9
wind(s), 81, 99, 107, 129, 141
wine, 5, 74, 77, 81, 84, 86, 87, 88, 89, 101, 105
wisdom, 29, 82, 89
witch(es), 96, 101
witchcraft, 126
wolf, 26, 61, 95, 135, 142
womb, 77
women, 5, 74, 77, 78, 82, 91, 102, 104, 108, 117, 137,
 141
 foolish, 96
 pregnant, 5, 91, 93
worm(s), 77, 78, 84, 112
wound(s), 75, 90, 100, 102, 105, 111
 wounded, 138

Xenocrates, 5
xiphino, 44, 112
 See also *saphirus*

ydrinus, 112
yectios, 44, 71, 112
ysoberillus, 44, 112
 See also beryl

Zachalis of Babylon, 5
ziazaa, 112
zirites, 44, 112
zmilaces, 112
zmilanthis. See *zmilaces*
zodiacal signs, 1, 5, 17, 33, 34, 120, 121–23, 124,
 130, 141
 Aquarius, 122, 126, 132, 138
 Aries, 120, 121–22, 125, 126
 Cancer, 123, 126, 127
 Capricorn, 122, 141
 Gemini, 122, 126, 127
 Leo, 121–22, 126, 128, 129
 Libra, 122, 127
 Pisces, 123, 126
 Sagittarius, 121–22, 125, 127, 129, 131, 136
 Scorpio, 123, 125, 126, 128, 136
 Taurus, 122, 125, 126
 Virgo, 122
zoronysios, 27, 44, 112
zumemellazuli, 44, 68, 96, 112

THE MAGIC IN HISTORY SERIES

FORBIDDEN RITES
A Necromancer's Manual of the Fifteenth Century
Richard Kieckhefer

CONJURING SPIRITS
Texts and Traditions of Medieval Ritual Magic
Edited by Claire Fanger

RITUAL MAGIC
Elizabeth M. Butler

THE FORTUNES OF FAUST
Elizabeth M. Butler

THE BATHHOUSE AT MIDNIGHT
An Historical Survey of Magic and Divination
in Russia
W. F. Ryan

SPIRITUAL AND DEMONIC MAGIC
From Ficino to Campanella
D. P. Walker

ICONS OF POWER
Ritual Practices in Late Antiquity
Naomi Janowitz

BATTLING DEMONS
Witchcraft, Heresy, and Reform in the Late
Middle Ages
Michael D. Bailey

PRAYER, MAGIC, AND THE STARS
IN THE ANCIENT AND LATE
ANTIQUE WORLD
*Edited by Scott Noegel, Joel Walker, and
Brannon Wheeler*

BINDING WORDS
Textual Amulets in the Middle Ages
Don C. Skemer

STRANGE REVELATIONS
Magic, Poison, and Sacrilege in Louis XIV's France
Lynn Wood Mollenauer

UNLOCKED BOOKS
Manuscripts of Learned Magic in the Medieval
Libraries of Central Europe
Benedek Láng

ALCHEMICAL BELIEF
Occultism in the Religious Culture of Early
Modern England
Bruce Janacek

INVOKING ANGELS
Theurgic Ideas and Practices, Thirteenth to
Sixteenth Centuries
Edited by Claire Fanger

THE TRANSFORMATIONS OF MAGIC
Illicit Learned Magic in the Later Middle Ages
and Renaissance
Frank Klaassen

MAGIC IN THE CLOISTER
Pious Motives, Illicit Interests, and Occult
Approaches to the Medieval Universe
Sophie Page

REWRITING MAGIC
An Exegesis of the Visionary Autobiography
of a Fourteenth-Century French Monk
Claire Fanger

MAGIC IN THE MODERN WORLD
Strategies of Repression and Legitimization
Edited by Edward Bever and Randall Styers

MEDICINE, RELIGION, AND MAGIC IN
EARLY STUART ENGLAND
Richard Napier's Medical Practice
Ofer Hadass

PICATRIX
A Medieval Treatise on Astral Magic
*Translated with an introduction by Dan Attrell and
David Porreca*

MAKING MAGIC IN ELIZABETHAN
ENGLAND
Two Early Modern Vernacular Books of Magic
Edited by Frank Klaassen

THE LONG LIFE OF MAGICAL OBJECTS
A Study in the Solomonic Tradition
Allegra Iafrate

KABBALAH AND SEX MAGIC
A Mythical-Ritual Genealogy
Marla Segol

SORCERY OR SCIENCE?
Contesting Knowledge and Practice in West African
Sufi Texts
Ariela Marcus-Sells